worlds in **play**

"*Worlds in Play* engages the newest of human media applied to one of the oldest human practices. The chapters in this volume advance our understanding of the expressive potential of digital games, their social context and politics, and their potential for education. They mark a deepening of focus, a closer application of analysis to particular artifacts and practices, a clearer differentiation of methodologies and assumptions, and a wider recognition of the need for multiple frameworks of investigation. They increase our critical vocabulary for analyzing and designing digital games, and perhaps most importantly for the future of research in this field, they display an increased understanding of the experience of the gamer and of the depth and diversity of pleasures that attract us to this compelling new medium."

Janet H. Murray, Professor & Director of Graduate Studies,
Digital Media & Information Design and Technology Programs,
School of Literature, Communication, and Culture, Georgia Tech

"This collection brings together fascinating work in game studies and also highlights one of the most exciting aspects of the field, its multidisciplinarity. Covering everything from narrative to player-created content, this is sure to be a book those researching games regularly turn to."

T.L. Taylor, Associate Professor, IT University of Copenhagen;
Author of Play Between Worlds *(2006)*

worlds in **play**

Colin Lankshear, Michele Knobel,
Chris Bigum, and Michael Peters
General Editors

Vol. 21

PETER LANG
New York • Washington, D.C./Baltimore • Bern
Frankfurt am Main • Berlin • Brussels • Vienna • Oxford

worlds in play

International Perspectives on Digital Games Research

EDITED BY

Suzanne de Castell + Jennifer Jenson

PETER LANG
New York • Washington, D.C./Baltimore • Bern
Frankfurt am Main • Berlin • Brussels • Vienna • Oxford

Library of Congress Cataloging-in-Publication Data

Worlds in play: international perspectives on digital games research /
[edited by] Suzanne de Castell, Jennifer Jenson.
p. cm. — (New literacies and digital epistemologies; v. 21)
Includes bibliographical references.
1. Computer games—Research. I. de Castell, Suzanne. II. Jenson, Jennifer.
GV1469.15.W67 793.93'2072—dc22 2007001943
ISBN 978-0-8204-8643-7
ISSN 1523-9543

Bibliographic information published by **Die Deutsche Bibliothek**.
Die Deutsche Bibliothek lists this publication in the "Deutsche
Nationalbibliografie"; detailed bibliographic data is available
on the Internet at http://dnb.ddb.de/.

Cover art by Dan Cox
Cover design by Joni Holst

The paper in this book meets the guidelines for permanence and durability
of the Committee on Production Guidelines for Book Longevity
of the Council of Library Resources.

Printed in the United States of America

Contents

Introduction

SUZANNE DE CASTELL AND JEN JENSON

This book can be read as a map of the "state of play" in digital games research today; it shows us a landscape of great variety and extreme contrasts. There is perhaps at present no other field of inquiry that is enriched by such a wide range of scholarly perspectives as digital games studies. Predictably enough, such strength can also become weakness if games researchers are unable to devise a framework and a language to communicate across the epistemic "divides" that have traditionally fractionalized and fragmented intellectual inquiry. Accordingly, a key challenge for us in editing this collection in and on digital games research has been how to devise an integrative framework that helps researchers avoid the pitfalls of critical fragmentation and allows them to speak to one another across disciplinary boundaries and beyond international borders. To expedite this, we have decided simplicity is the best approach. Rather than invoking a sophisticated conceptual framework, whether from ludology proper, or from any of the variegated fields and forms of knowledge which contribute to the disciplined study of digital games, we have reached beyond game studies culture altogether, and drawn upon an integrative theory of tool-mediated human activity to formulate a taxonomic order for this diverse array of work.

Canadian scientist Ursula Franklin, in her acclaimed Massey Lectures compiled as *The Real World of Technology* [1], warns against an 'artifactual' approach to any technology, insisting that we must learn to understand a tool or technology as a "system of social practice." This approach to games as tools or technologies compels us to widen our perspective and regard digital games as instances of tool-mediated social interaction, what socio-cultural psychologist Michael Cole calls "people-acting-in-a-setting-with-mediational-means." This view of the matter, further elaborated by James Wertsch in his treatment of *Mind as Action* [2], requires us to interrogate digital games first and foremost as intelligent, purposeful human (inter-) activity. Indeed, this is at least

one thing that *all* these variously located games researchers have in common: they study games, gamers, and gameplay *seriously*, as a specialized tool-mediated form of intelligent human action, even as so much popular press concerning games tends to stress concepts such as 'addiction,' sexism, violence, obsession, mindlessness, and a host of other, essentially dismissive and pathologizing perspectives.

This collection reflects on changing such views of the space and place of digitally supported play in an emerging global technoculture. It is about bridging narrow disciplinary perspectives on digital games research, and spanning sites and practices of play across cultural locations whose differences are not merely geographical. Wertsch observes, "As is the case with the three blind men with different images of the elephant . . . each provides a partial picture, but one that remains unconnected with others . . . and not just unconnected but unconnectable with the others" [2]. To escape this predicament of having no way of connecting together these various partial images into a more complete account, specialized perspectives must take their place within a larger, integrative conceptual framework capable of answering this very general question: "What is involved in accounting for human action and its motives?" Our goal here is, in Wertsch's words, "to arrive at an account— a kind of 'translation' at the crossroads" that would make it possible to link, but not reduce, one perspective to another. To do this we follow Wertsch in turning to Kenneth Burke's analytical method, a "perspective about perspectives" [3] that takes human action as the fundamental unit of analysis linking what Burke termed Act, Scene, Agent, Agency, and Purpose. This pentad of interlinked aspects invites multiple perspectives and emphasizes the need to attend to the relations and dialectical tensions existing between and among them. Hoping to cultivate a well-rounded and integrative vision of digital games research, we have adapted these elements to order and organize the chapters here presented in five parts: the first, **Foundations, Perspectives, and Points of View,** addresses how we define, delimit, classify, and categorize the 'what' of games research. The second, **Player/s**, or in Burke's terms, the *agent* is about the person or kind of person who acts. The third, **Spaces and Places of Play**, is about the background, context or situation (scene) the 'where' of games and where gameplay takes place. The fourth is **Making It Work: Design and Architecture**, and this group of chapters refers to what Burke called *agency,* that is, the means, tools or instruments used in order so to act. Finally in the fifth section, **Learning to Play: Playing to Learn**, we have included chapters that concentrate on *purposes,* and in this case largely on educational purposes, because we see in this emerging area what may be the most significant transformation in contemporary cultural views of play: that play can be 'serious,' its functioning significant for what is arguably any culture's most serious preoccupation—the upbringing of a new generation,

equipping them to the best of their ability with the dispositions, skills, knowledge, and understandings that we can at any given time envisage as indispensable to support human flourishing.

Of course because this is a framework of interlinked elements, every constituent part connects with all the others, so chapters compiled under "Player/s" might also be pertinent to the mechanics of play, its foundational conceptions and definitions, its purposes, its contexts, and so on. That means, for example, that of three chapters on the topic of interactive narrative, one is found in the part on "players," another in that on "purposes," and yet another in the section on "Making It Work," depending on each chapter's primary "thematic stress," that is to say, on that aspect to which it gives greatest emphasis.

Part I, then, is concerned broadly with defining games research, including the development of new frameworks for research and analysis. In its initial chapter, Janet Murray offers a persuasive starting point for digital games theory, grounded in evolutionary cognitive development and culture. Establishing a connection between play, games, and cognition, she thematizes links between play and understanding from the rich perspective of the evolution of human consciousness and its break with its primate heritage. More specifically, Murray elaborates on the role of games in the construction of both cognitive understanding as well as in social organization and culture, arguing that games might well be seen as potent contributors to our cognitive and cultural evolution, and digital games draw broadly on that history. In Chapter 2, Zagal et al. argue for an ontology of game analysis which attempts to provide a discourse for the study of games in general. Their work is foundational in its elucidation of a robust framework for studying games in terms of a "game design space." Ermi and Mayra, in "Fundamental Components of the Gameplay Experience," argue the important contributions of research focused on the study of gameplay experience, and they look particularly at three key types of "immersive" experience: sensory, challenge-based, and imaginative. Their work attempts to provide a methodology for future study of a wider variety both of games and contexts of play, a research agenda which underscores the complexity of documenting digital gameplay. Renata Gomes's chapter invokes narrative as a frame for investigating games, which might be employed not simply for in-game experience, but also for the provision of simulated immersions which could more readily be used to develop imaginative game worlds we have yet to experience. She attempts to foreshadow immersive simulation games beyond simply a re-creation or "simulation" of experience, to those that use narrative to develop and/or construct a theoretical standpoint. Ulrike Spierling moves the discussion of narrative within games to "interactive digital storytelling," providing a design model for the construction of narrative within a game. Such a model, she argues,

moves discussion from linear narrative perspective to a multi-level, hybrid, open-ended structure in which characters and players have "conversations" both inside and outside the game. The last two chapters in this section by Ian Bogost and Patrick Crogan shift the reader's perspective from methodology and narrative foundations to the development of a more actively political role for games (and game studies). Bogost offers an approach to analyzing political rhetoric in videogames, showing how three very different kinds of games (political, art, and commercial) can function as "ideological frames." He documents the ways in which these games reinforce, contest, and construct ideologies procedurally, rather than verbally, and urges the distinctive contribution of critical theory to understanding how frame and metaphor construct, constitute, and communicate ideological bias in game-based forms of public communication, as these gain increasing use and importance. Crogan critically interrogates arguments that simulation is the 'future' of game studies, urging that its critical potential may be compromised and undermined by its technocultural history: the development of simulation has been substantially directed and constrained by military technoscientific imperatives and priorities. He examines a range of experimental game-based theatrical, simulation and narrative experimental projects to show how they may actively undermine commonly held presumptions about play and games, and details the critical role that experimental forms may offer as fertile ground for future design, and in particular for the design of different futures.

In Part II, the emphasis is shifted from broad frameworks and classification systems to focusing on the player of digital games. Holin Lin and Chuen-Tsai Sun document the disruptive practices in massively multiplayer online role-playing games of the *griefer* or in the Taiwanese gaming culture the *white-eyed* player. They argue that such players tend to organize into two broad categories: those who want attention, are aware of their status, and work to maintain it and those "occasional griefers" who tend to dismiss their behaviors as mistakes, and delineate quite clearly between their practices and that of other white-eyed players. In Seth Gidding's piece, "Playing with Non-Humans: Digital Games as Technocultural Form," the emphasis shifts from particular player practices to Actor-Network Theory (ANT) as a framework for better understanding player agency, sociality, and new media technologies. ANT highlights the importance of the interaction between humans in a network, as well as between humans and non-humans. Digital gameplay, Giddings argues, "transgresses" the boundaries between subject and object through its conflation of game, machine, and player. As such, a player is an agent who acts within a network, in this case, simulation game software acts as an agent in the network. Here the notion of player is understood in a framework, which includes both playing and its technologies. Both Kenji Ito's and John Banks's pieces focus on players as creators of games. Ito's

chapter offers a very different angle on the relationship/s among players and designers, by describing Japanese amateur game-designers, as well as the role-playing games they produce and the differences between their "products" and commercial games. His work attempts to provide a socio-economic overview of game design, by focusing on non-commercial designs by amateurs, arguing that amateurs produce very different games than their commercial counterparts, and that such player-designers are therefore important experimentally given that they are able to design artistically, sociologically or philosophically tuned games. Finally, Banks describes a complex relationship between player/designers and commercial game development. In his account, he shows how fan-based, player-driven designs are incorporated into commercial game development, indeed how player/designers are relied heavily on to complete commercial production of the latest version of the game and he problematizes the economic, social, hierarchical, and potentially exploitative implications of "free" fan-based work in the development of a commercial product.

In Part III of the book, **Place and Space**, authors relate the complexities of "being in the game." Stephen Griffin gives a fascinating account of the relationship between game, play, and the gameplay button. He traces the history of the button in video game "play," showing its intimate relationship to players, pleasure, and playfulness, arguing that while it is highly successful in its scaffolding of "play," it is ultimately a reductive interactive "point" which cannot fully accomplish physical engagement. In the next chapter, "Evolution of Spatial Configurations in Videogames," the authors overview how games have been historically and are today spatially configured in relation to the player, the field of play, and what effect that configuration has on gameplay. Building on work they outline in Part I, setting out an ontology for video game study, they show how technological development has enabled larger and more complex spaces in games, and argue that the basic features of game spaces are unlikely to change given that the cardinality of game play and game world is already representative. Their chapter is an important addition to the understanding of game space generally, while William Huber's piece looks to a particular game, Final Fantasy XI, to ask how the space and the place of play are situated within a game environment. Huber chronicles how play in Final Fantasy XI is narrated and delimited by its quests, by players' uptake or refusal of these quests, and by the revelation of narrative through quest completion. The space of the play itself, he argues, serves to reinforce a type of complicity in players, which he then maps onto broader discourses in Japanese culture of "war, complicity and memory." For Debra Polson and Marcos Caceres, space and place are not confined to a screen-based medium. Instead, they take a hybrid approach to gameplay that integrates urban landscapes, sociality, and play, presenting the relatively new form

of location-based games, and describing their implementation of two such games in Australian urban landscapes. Their work problematizes the notion that space and place are contained within a game, and shows the potential of location-based games as sites of a different kind of embodied, localized play. The final piece in this part by Peter Edelmann turns to gamespace as a potential "legal space" in which there are lawful, "outside world" implications for play within a fictive space. He shows how both hardware and gameplay participants are already located within the legal jurisdiction of the actual world, specifying virtual- and real-world implications of the regulation of gameplay space.

Part IV, **Making It Work: Design and Architecture,** looks in detail at the construction of and design choices made by videogame developers. In the first paper, an embodied play project details "ambient" design in a physical play space. Their prototype game "relies on exploratory play with a conceptually structured interaction model." In other words, it attempts to structure embodied action within a gaming framework. The result is a game that encourages users to interact together with the game interface to reach its "goal" through a combination of sound/light patterns. Simon Niedenthal's work, "Shadowplay: Simulated Illumination in Game Worlds," considers the role of light in video game design and its effect on gaming experience, and the notable absence of a vocabulary to discuss or, therefore, to study, its key contributions to games and gameplay. Illustrations of the central role lighting can play in games, drawn from discussions of 'first person sneaker' (Thief 2) and 'survival-horror' (Silent Hill 2) examples are used to demonstrate both that we can adapt cinematic and other critical approaches to the study of illumination practices in games, but also that, and how, videogames are interactive game worlds with their own distinctive constraints and affordances very much connected to how and with what tools they are built, and require specific tools and forms of analysis. "Achieving Realistic Reactions in Modern Video Games" attempts to develop a system in videogames which supports and enables more dynamic interactions and character reactions within gameplay. The authors' work relates the development of just such a system, giving in-game characters a more dynamic set of 'cues' with which to respond to their network of relationships. This innovation offers new possibilities for character development within a game, without the usual persistent kind of pre-scripting. The next chapter, by Mary Flanagan, Daniel Howe, and Helen Nissenbaum, addresses the problem of the absence of women in technological fields, particularly computer science, and their design of a computer game aimed at teaching girls Java programming through play. Their game, RAPUNSEL, offered young women the opportunity to play within a collaborative social space, and program their in-game characters to perform more and less complex dance moves. Their work demonstrates how design meth-

ods, particularly those focused on values, might influence design processes. Charles et al.'s "Player-Centered Game Design" argues that games can be individually and dynamically adapted to individual players within the game. This work, like that of Flannagan et al., shows potentiality beyond the repetition of typical gendered dynamics through adaptive game design. The authors propose a framework for game developers to adopt in an effort to better model players within their design. Michael Mateas and Andrew Stern complete this section with a case study of their own game, Facade, to richly illustrate their contention that games studies has a lot to learn, not just through the study of existing games, but through the building of new games. They too stress that building new games outside of the commercial market allows for experimentation and novelty that might not otherwise withstand the pressures of commercial clichés. Their work importantly frames how the documentation, detailing and critique involved in building games can inform games studies.

In Part V, **Learning to Play: Playing to Learn**, relationships between playing digital games and learning are explicitly investigated. The opening chapters, "Interactive Story Writing in the Classroom: Using Computer Games" and "Games as a Platform for Situated Science Practice," present the implementation of two different educational videogames in classroom settings. The first, by Mike Carbonaro and colleagues, describes a videogame designed for use in a high school English classroom, which gives students the opportunity to "write" their own immersive stories without necessarily having the technical skills game modification usually demands. The second, by Rikke Magnussen, describes the implementation of a technologically supported, collaborative game for science, "Homicide," in which players are offered a deeper understanding of the inquiry process, through the simulated role-playing game. Diane Carr's chapter, while still focused on the classroom, describes the rich, complex choices that girls make when they choose to play videogames. Her work offers an important alternative to preference-based research which ascribes (most often) stereotypical gender tastes to players and Carr thereby troubles the notion that research can answer the question "What kinds of videogames do girls like?" She argues instead that context, gender, taste, and past experience converge to motivate any given "choice." James Paul Gee's work ends this section and the book with the question "Are Video Games Good for Learning?" He sets out and elaborates on key features in the design of videogames that are also recognizable features of good learning environments, explaining how these particular game-like features are employed within good videogames to support effective learning on the part of their players.

Like any framework, the one we suggest here is only as good as its functionality for the user, and while we of course hope that our readers will find

this a useful and appropriate way to consider these very diverse chapters, there are many alternative ways to forge meaningful relationships between and among the critical frameworks, theoretical approaches, practical designs, and new developments set out by the chapters in this collection, each offering a fresh perspective on a body of work that deserves to be read and then re-visited often, as readers' own perspectives and purposes change and grow.

We hope you will find here a wellspring of inspiring concepts, models, protocols, data, methods, tools, critical perspectives, and directions for future work, and that the organization of this text will be a useful guide to reading not only within but also across the fields of play represented here, across the wider scopes of disciplines and geography. Most of all, we hope this work will encourage all of us to broaden our foci to encompass the omni-dimensional phenomenon of "Worlds in Play" [4].

Acknowledgments

Sincere thanks are due to the members of the International Review Board of the DiGRA (Digital Games Research Association) conference "Changing Views: Worlds in Play." Their invaluable reading and careful selection from among many hundreds of submissions is the basis for this collection. We hope this volume in some small measure recognizes the importance of their contribution and is a fair reflection of their collective critical judgment in an evolving interdisciplinary field that can only be comprehended, defined, and illuminated collectively, by its expansive community of scholars. We regret that many outstanding papers could not be included for simple reasons of length; however, we hope this book at least suggests to its readers the vitality and promise of so much emerging work in this new field.

This work was supported, in part, by a grant from the Social Science and Humanities Research Council of Canada.

References

1. Franklin, U. *The Real World of Technology*, CBC Massey Lecture Series. Concord, Ontario, Anansi Press, 1990.
2. Wertsch, J. *Mind as Action*. New York, Oxford University Press, 1998.
3. Gusfield, J. R. (ed.) *Kenneth Burke on Symbols and Society*. Chicago, Chicago University Press, 1989, as cited in J. Wertsch, *Mind as Action*. New York, Oxford University Press, 1998.
4. See *DiGRA 2005 Conference*. Available at: http://www.digra.org/dl. [Last accessed March 15, 2007].

PART I

Foundations, Perspectives, and Points of View

1. *Games as Joint Attentional Scenes*

JANET H. MURRAY

The invention and striking global popularity of the new genre of computer games within the new digital medium is provoking a reconsideration of older cultural categories such as narrative, games, and play [1,2,3,4,5]. Our renewed interest in the distinguishing qualities of the ancient representational format we call "games" coincides with a moment of scientific focus and theoretical speculation on the prehistoric origins of mind and culture. One of the central puzzles of evolutionary theory is the problem of the short time span in which primates developed into humanoids and humanoids developed into human beings. There do not seem to have been enough iterations of birth and adaptation and death, for natural selection to have created the dramatic advantages that we hold over other related species.

Michael Tomasello [6] explains this compressed time scheme as the result of a single change in human cognition: the ability to understand conspecifics (other members of our species) as intentional agents like oneself. This foundational change underpins symbolic communication and allows us to engage in cultural learning. Culture is the key element here, because the human advantage over other species lies in our ability to share and transmit knowledge and patterns of behavior across historical time and in the raising of children.

To make clear the distinction between the cognition of humans and other primates who share much of our sensory experience and our social orientation, Tomasello lists five actions that non-human primates do not do in their natural habitats:

- Point or gesture to outside objects for others
- Hold objects up to show them to others
- Bring others to locations so they can observe things there
- Actively offer objects to other individuals by holding them out
- Intentionally teach other individuals new behaviors. (p. 21)

Human ontogeny, the development of the individual in childhood, seems to reproduce Tomasello's hypothesized phylogenic achievement. At about nine months of age a baby begins to recognize when it has the parent's attention, and then to be able to follow the parent's attention to external objects by following their gaze, and by fifteen months babies have usually begun pointing at things to direct the parent's attention to objects of interest. Human infants below the age of nine months, like non-human primates, have a limited concept of their conspecifics (members of their species) as having mental awareness and intentionality. But somewhere around their first birthday, human infants have begun to understand other persons as intentional agents: "animate beings who have goals and who make active choices among behavioral means for attaining these goals, including active choices about what to pay attention to in pursuing those goals" (p. 68). Tomasello further argues that the ability to follow on the attention of the adult leads to the child recognizing when she is herself the focus of the adult's attention and gaze, and begins to lay the framework for an understanding of the self as an actor in the social world. This cognitive leap, which happened for the species in relatively recent evolutionary time (the last 250,000 years or so) and for the individual at 9–15 months old, forms the basis for the communicative cultural tasks that make up the bulk of human achievement. It is the basis of sharing, negotiating, learning, and symbolic communication.

The framework in which the cognitive achievement of understanding intentionality leads to the acquisition of culturally transmitted knowledge is called a *joint attentional scene*. A joint attentional scene involves two participants, such as a parent and child, who both understand what the other is attending to. In babyhood it occurs in play or in caretaking situations when the adult and the child have a common interest (such as food, tickling, stroking, diapering) and exchange gestures, sounds, or looks that each recognizes as intentional and connected to whatever holds their common focus. Once a baby and its parent achieve this ability the baby's learning increases exponentially. Tomasello similarly believes that once early humanoids achieved this ability the possibility for cultural breakthroughs increased exponentially.

Tomasello's insight into the development of human cognition may shed light on one of the more puzzling aspects of games: why are they fun? What is the primary motivation to engage in them? We know that play is intrinsically pleasurable for animals and humans alike, and there are many theories about its evolutionary value, including rehearsal of adult skills and mastery of a flexible repertoire of responses [7,8]. We seem hardwired to play, to explore for the simple pleasure of exercising our faculties and exploring the world in non-survival ways. This exploratory play seems to serve the purpose of expanding our repertoire of responses, of offering a wider range of cognitive

patterns to apply to new situations. But games explicitly limit and channel the intrinsically pleasurable exploration characteristic of play. What is it about a game activity that is intrinsically enjoyable to those who choose to engage in it? What do games offer in return for limiting the exploratory delights of play?

Perhaps the enjoyment of games is hardwired into us, selected by thousands of years of cultural behavior to encourage us to seek out situations like Tomasello's joint attentional scenes. Indeed, the three defining characteristics of a joint attentional scene are similar to the social situation necessary for gaming:

- Shared limited focus on external objects and/or behaviors
- Mutually witnessed intentionality among participants within the shared context
- Symbolic communication between participants.

The ability to form this joint attentional scene makes it possible to engage in the activities characteristic of games: to treat abstract representations consistently, to behave according to negotiated rules, to limit one's actions and attention to the game pieces and game actions to what "counts" in the game, screening out other stimuli and actions. Joint attention organizes two of the core activities of games: turn-taking and synchronizing behaviors.

Tomasello's theory also suggests some of the core adaptive benefits of games, since they reinforce key benefits of joint attentional scenes:

- An understanding of the self both as an agent and an object within a community of other intentional agent/objects
- The ability to shift perspective from one's own point of view to the point of view of others, to imagine what someone else is thinking, and to see oneself from the point of view of the other
- The ability to intentionally teach and learn, which is the foundation of all human cultural development.

It is easy to think of a contemporary board game or one of its early precursors such as mancala or knucklebones as a joint attentional activity, composed of limited focus, mutually witnessed intentional acts, and symbolic manipulation. Taking turns dropping seeds into a special set of holes in the ground, or throwing pieces of animal bone or clay dice, the players are aware of each one's turn, of each one's separate actions and history in the game, and of the relative position of each to one another in the scoring of the game. Watching one another play is an opportunity for passive and active learning, for metacomments on the play of one another. Boardgames intensify the

opportunity for witnessing the actions of the other player and for keeping track of multiple positions within the same game. Sports games intensify the opportunity for intentional teaching and learning by focusing performance on goal-centered behaviors that are optimized for comparison between players and between turns. Games provide a framework for watching and critiquing iterative activities, and for working collectively for improved performance. These patterns of behavior are then available for survival activities.

If Tomasello is right and our ability to form joint intentional scenes was a prerequisite to the acquisition of language, then games may be understood as a foundational element in human culture, as the gestural starting point in the history of representational media. Although he does not mention games, I think that his work, considered in juxtaposition to other research on games and children's play, clearly points in this direction. For example, researchers at Duke University have studied toddler imitation games, such as taking turns jumping off a box, which are good examples of how joint attention is established and elaborated between cognitively matched, pre-linguistic children [9]. For Carol Eckerman [10] the important cognitive feature of these games is that they serve as a form of pre-verbal communication. She interprets their mirroring interaction as a kind of dialog without language:

> I expect that the children are using imitation of nonverbal actions as a way of reaching agreement on a topic for their interaction. So, when one child imitates another it may say something like "let's do this together" and when the first child imitates back it's kind of like a confirmation: "yes, I like this too."

Interestingly enough, Sutton-Smith [8], citing Kenneth Burke and Gregory Bateson, makes a similar suggestion about the function of play biting in animals. He suggests that:

> play might be the earliest form of a negative, prior to the existence of the negative in language. Play, as a way of not doing whatever it represents, prevents error. It is a positive behavioral negative. It says no by saying yes. It is a bite but it is a nip. (p. 22)

In both cases, the urge to play is a means of communicating in a situation in which intelligent creatures have not yet acquired language. A play action is a signal like a predator call, except that its referent is to the social world.

Most interestingly, Eckerman observed how imitation games can lead to the development of language in clearly differentiated steps. To paraphrase and summarize her observations:

- First, they direct each other: "Go," "Wait," "Jump," "Watch me."
- Then, they answer one another: "My turn" "You jump."

- Finally, they describe their actions as they do them: "I jump" or "Big jump!" while jumping off the box.

The game is organizing their behavior, providing practice in language exchange and in synchronized expectations and performance. The pleasure of the game lies as much in the communication as in the actions, and it lies particularly in the matching of language to action, and in the choreographing of both into a patterned social interaction. The pleasure of games reinforces the adaptive behavior of symbolic communication around patterned social behaviors.

Eckerman is particularly struck by the joyousness of the imitation game. Her work provides a dramatic parallel to Tomasello's hypothesized moments of evolutionary progress:

> You can infer from the laughing and smiling going on that they really enjoy interacting with each other. Perhaps in these imitative interactions they are experiencing both their similarity to others and their separateness. Perhaps they are learning that we each are intentional agents of action and that playing together is a very pleasant thing. [10]

These early games are based on mutually elaborated patterns that serve the same purpose as written rules. They are intrinsically social, and can in fact be understood as a celebration of the social, of the very presence of other intentional beings. The pleasure derived from sharing attention and witnessing and enacting intentional acts forms the framework for mastering complex physical and social skills. Spectatorship is as much a part of the experience as active performance, and in early games it is an alternating spectatorship: you do, I do; you do, I do. The elaboration of joint attentional scenes into ever more elaborate games sets up opportunities for performance, for presenting the self as a performer in a socially constructed arena, and for incorporating multiple individuals into flexible but predictable group structures.

The Co-Evolution of Games, Narrative, and Media

Thinking of games in terms of their possible evolutionary history, their adaptive value, helps us to think about the persistent conflict in game studies between those who emphasize the similarities between games and stories and those who emphasize their differences [11]. It is significant that Tomasello links the uniquely human understanding of conspecifics' consciousness with the uniquely human understanding of other unseen underlying causes. Tomasello believes that "human causal understanding evolved first in the social domain to comprehend others as social agents." Although there is "no way of knowing if this is true," he points to the cultural evidence that "many

of the people of the world, when they are in doubt as to the physical cause of an event, often invoke various types of animistic or deistic forces to explain it; perhaps this is the default approach" (p. 24). In other words the sensing of the unseen intentions of other humans is linked to an animistic view of the world that creates explanatory narratives of intention for other events as well. Cognitive theorist Mark Turner would agree that an abstract sense of cause and effect is an early human cognitive achievement and precedes the acquisition of language. Turner explicitly identifies this cognitive leap as narrative or "parable" making: the abstraction of causal sequences from the observed world. If we accept these theories of early cognition, then we can think of games and stories as driving and co-evolving with the development of language, leading to the development of more complex social patterns, more complex causal thinking, and more elaborate symbolic culture.

The Tomasello hypothesis can be interpreted as linking both games and stories to the single moment in which human consciousness first awakened. The moment has two key aspects:

- The understanding of one's fellow creatures as intentional beings, leading to the exploration of joint attention, *which can be understood as the birth of mimetic games.*
- The understanding of overt events as the result of invisible causes, *which leads to abstract thinking about causal patterns, which can be understood as the birth of narrative thinking.*

These two cognitive and cultural advances have one key effect:

- The elaboration of symbolic communication, starting with gesture and vocalization and developing into spoken language, which *can be understood as the birth of media.*

The italicized phrases represent my interpretation of Tomasello's theory. Just as culture and cognition co-evolve, I would argue that the elements of culture are also subject to an ongoing process of co-evolution. Mimetic games lead to greater social organization and closer attention to the world, which forwards causal thinking which leads to more complicated games, both of which produce a demand for more expressive language. This pattern—the co-evolution of games, narrative, and language—is visible in toddlers and children and imaginable as a narrative of prehistoric human life. It is also visible in the cultural patterns of historical time, if we think of human (spoken) language as a medium, and of later symbolic media as co-evolving in a similar way with ever more elaborate mimetic and causal (game and story) genres. In order to knit these different time scales together and motivate these rather broad generalizations, it is useful to turn to the work of Merlin Donald who

hypothesizes that modern human cognition arose in four steps starting with the split from our primate cousins: *episodic culture,* which we share with other mammals and primates, in which social relationships and even simple tool use develop on the basis of brain function that allows only discrete episodic structure and recall; *mimetic culture,* in which the early hominids can understand one another as intentional, conscious agents, and can communicate symbolically, allowing them to form bands, migrate, hunt, domesticate fire, and make simple tools; *mythic culture* in which sapient humans communicate through symbolic forms of representation such as oral language, mimetic rituals, and cave paintings, understanding the world in narrative terms; and modern *theoretical culture* which understands the world in terms of abstract formalisms and is based on massive externally stored memory systems such as print and computers [12,13].

The transition between the first and second stages is the one Tomasello describes as bringing an understanding of shared attention and abstract causes. The mimetic stage can be thought of as driven by games and rituals, the elaboration of the synchronized actions and communications of the humanoids with a capacity for joint attention. Gameplaying in this stage may have been mostly tied to survival, with the pleasure of synchronization adding energy to the acquisition of skills necessary for evading predatory animals or collectively hunting them. A sustained culture of rule-based coordinated behaviors would reinforce the development of language, which in turn would support more detailed and memorable stories. Mimetic behaviors survive in contemporary society, in pleasurable rituals like dancing and athletics. The earliest videogames were mimetic in that the gameplay was focused on the mastery of simple repetitive behaviors, moving a character through a maze, "eating" pellets. With the elaboration of the medium of videogames to include more detailed graphics and more responsive and complex programming, videogames offer us more complex patterns to absorb and perform. The toddler pleasure in joint attention and imitation is reproduced in a way by games that challenge us to synchronize our actions with machine, such as the arcade game *Dance Dance Revolution* (DDR) in which players must keep up with a pattern of dance steps. Like an oral culture game like Simon Says, which challenges children to conform their behavior to symbolic codes (spoken commands), DDR presents the dance steps not by example but in a spatial notation that must be quickly interpreted and acted on. Games like these may be helping us to elaborate a common symbolic language with our new electronic joint attentional partners.

The third stage, mythic culture, can be seen as driven by complex narratives, the result of more elaborated oral language and longer traditions of shared experience. Mythic thinking, characterized by heroic legends and ritually transmitted narratives, is apparent in the writings of antiquity, which

transcribe oral sources, and in pre-literate cultures. But forms of mythic thinking endure into our post-literate age, often reinforcing affiliations based on common identities as in families, ethnic groups, and political parties. When athletic events become mass spectator sports in which players embody the aspirations of spectator fans, they pass from mimetic into mythic culture, with larger than life performances of superhuman beings. Videogames often invoke this mythic state of mind by casting the player in the role of superhero or placing the action within a fantasy domain characterized by animism and supernatural "mythical" figures.

The fourth and current stage of human culture, according to Merlin Donald, is characterized by theoretical thinking. The transition from the mythic to the theoretical stage is the result of the invention of writing, which is first used as a commercial tool and for talismanic inscriptions of the names of gods and rules, and later as a way of recording oral culture such as stories and magical spells, and is then perfected by the Greeks as a means of recording the process of thinking and reasoning, thereby allowing for a sustained collective discourse that moves from mythic explanations to reasoned argumentation. In Donald's elegant analysis we move from Ape to Einstein in only three steps which we can think of in terms of symbolic exchange, cognitive strategies, or cultural building blocks: from joint attention to language to writing; from mimesis to narrative to argumentation; from ritual to myth to theory.

Though neither Tomasello nor Donald points to games as instruments of cognitive evolution, it is striking how often games are part of their arguments. Tomasello's experimental examples with apes and children are usually in the form of games. Both Tomasello and Donald point to children's superiority at games as evidence of fundamental cognitive differences that predate language acquisition.

> Human children play rule-governed games by imitation, often without any formalized instruction. They invent and learn new games, often without using language. Apes, like other animals, cannot learn similar games; they are restricted to games that, by our standards, are very simple . . . The problem of bridging from ape to human would thus appear to involve a great deal more than pinpointing the arrival time of vocal language. [12]

But though Donald instances mimetic games as one of the key components of hominid development, both cognitive scientists stop short of seeing games as a driving force of cognitive and cultural evolution. Yet the more one thinks about the elements of cultural cognition the more game-like they seem.

Digital Games and Joint Attention

I have argued elsewhere that the advent of the computer as a medium with its unique combination of procedural, participatory, encyclopedic, and spatial affordances is an advance in human culture comparable to the invention of print or moving image photography [5]. The new digital medium expands our cognitive powers by offering us new ways of representing the world (e.g., through parameterized simulations) and greater powers of organizing information (e.g., multimedia archives accessible through metadata). It is also a medium that is particularly well suited to games, because the rules of the game can be programmed into the computer and because the user can take on the role of the player. Playing games on the computer is similar to and different from pre-digital game playing. It conflates game and puzzle into a single form in that a game played against a mechanized opponent is really a procedural puzzle. It can eliminate turn taking by providing worlds that are always open to interruption and intervention at whatever pace the interactor is willing or able to sustain. The computer is not aware of our common focus because it is not conscious in the same way a human player is conscious. But it provides us with a partner whose thought processes we are aware of, and who represents the mediated consciousness of an implied human programmer. We engage with the computer as if it were an embodied opponent, but also as if it were similar to a painting or a book, the result of a prior act of conscious representation. Games can be thought of as socializing us into a new cyborg order, establishing rituals of commonality with proceduralized artifacts.

The computer is the most capacious pattern-making medium we have ever had. We have only begun to glimpse the new symbolic structures that we can build with it: cognitive scaffolds that will help us to organize and advance the traditions of thinking that have now brought us beyond the ability to represent our ideas in purely linear form. Given that games play a key role in giving birth to language in the individual and the species, we should not be surprised that they are playing a key role in elaborating the new symbolic language of interaction, in expanding the zone of proximal development for digital media.

Acknowledgments

This essay is excerpted from a longer argument, "Toward a Cultural Theory of Gaming: Digital Games and the Co-Evolution of Media, Mind, and Culture" *Popular Communication,* Volume 4, Number 3, p. 185–202. 2006.

References

1. Aarseth, E. J. *Cybertext: Perspectives on Ergodic Literature.* Baltimore, MD, Johns Hopkins University Press, 1997.
2. Bolter, J., and R. Grusin. *Remediation: Understanding New Media.* Cambridge, MA, MIT Press, 1999.
3. Laurel, B. *Computers as Theater.* Reading, MA, Addison-Wesley Publishing Co., 1993.
4. Manovich, L. *The Language of New Media.* Cambridge, MA, MIT Press, 2001.
5. Murray, J. H. *Hamlet on the Holodeck: The Future of Narrative in Cyberspace.* New York, Simon & Schuster/Free Press, 1997.
6. Tomasello, M. *The Cultural Origins of Human Cognition.* Cambridge, MA, Harvard University Press, 2001.
7. Bekoff, M., and Byers, J. A. (Eds.). *Animal Play: Evolutionary, Comparative, and Ecological Perspectives.* Cambridge, New York, Cambridge University Press, 1998.
8. Sutton-Smith, B. *The Ambiguity of Play.* Cambridge, Harvard University Press, 1997.
9. Didow, S. M., and C. O. Eckerman. "Toddler Peers: From Nonverbal Coordinated Action to Verbal Discourse." *Social Development* 10(2) (2001): 170–188, 19p.
10. Malcolm, K. "Studies Shed Light on Toddler Development." 2000. Available at http://www.dukenews.duke.edu/2000/06/toddler630_print.htm (Last accessed July 14, 2006).
11. Wardrip-Fruin, N., and P. Harrigan. *First Person: New Media as Story, Performance, and Game.* Cambridge, MA, MIT Press, 2004.
12. Donald, M. *Origins of the Modern Mind: Three Stages in the Evolution of Culture and Cognition.* Cambridge, MA, Harvard University Press, 1991.
13. Donald, M. *A Mind So Rare: The Evolution of Human Consciousness.* New York, W.W. Norton, 2001.
14. Schmarndt-Besserat, D. *How Writing Came About.* Austin, TX, University of Texas Press, 1996.

2. Towards an Ontological Language for Game Analysis

José P. Zagal, Michael Mateas, Clara Fernández-Vara, Brian Hochhalter, and Nolan Lichti

Introduction

This chapter introduces the Game Ontology Project (GOP) as a framework for describing, analyzing, and studying games. We begin by positioning the GOP in the context of other projects in the field of game studies. Next, we present the theoretical and methodological influences that have shaped both our conceptual understanding of the GOP and its development. We continue with an overview describing its structure and overall hierarchy. Finally, we outline a number of ways in which the GOP scaffolds and affords the exploration of interesting research questions and describe some future directions our work will take.

Related Work

Game designers have called for a design language [1,2,3,4], noting that designers currently lack a unified vocabulary for describing existing games and thinking through the design of new ones. Many of the proposed approaches focus on offering aid to the designer, either in the form of design patterns [3,5,6], which name and describe design elements, or in the closely related notion of design rules, which offer advice and guidelines for specific design situations [7,8]. Other analyses draw methods and terminology from various humanistic disciplines—for example, games have been analyzed in terms of their use of space [9], as semiotic systems [10], as a narrative form [11,12], in terms of the temporal relationships between actions and events [13], or in terms of sets of features in a taxonomic space, using clusters in this

space to identify genres [14].

The Game Ontology Project's approach is to develop a game ontology that identifies the important structural elements of games and the relationships between them, organizing them hierarchically. Our use of the term ontology is borrowed from computer science, and refers to the identification and (oftentimes formal) description of entities within a domain. Often, the elements are derived from common game terminology (e.g., level and boss) and then refined both by abstracting more general concepts and by identifying more precise or specific concepts. An ontology differs from a game taxonomy in that, rather than organizing games by their characteristics or elements, it is the elements themselves that are organized.

Our work is distinct from design rule and design pattern approaches that offer imperative advice to designers [7,8]. We do not intend to describe rules for creating good games, but rather to identify the abstract commonalities and differences in design elements across a wide range of concrete examples. The ontological approach is also distinct from genre analyses and related attempts to answer the question "what is a game?" Rather than develop definitions to distinguish between games/non-games or among different types of games, we focus on analyzing design elements that cut across a wide range of games. Our goal is not to classify games according to their characteristics and/or mechanics [15], but to describe the design space of games.

Our approach is well suited to exploring issues and questions regarding games and gameplay. The GOP provides a framework for exploring, dissecting, and understanding the relationships between different game elements. A few examples of research questions we have already begun to explore include: "How can we understand interactivity in games?," "How is gameplay regulated over the progress of a game?," and "What role does space play within games?"

In summary, we present an ontology in which we identify abstract elements capturing a range of concrete designs. Our ontology allows for generalizations across this range of concrete design choices as embodied in specific games. Its primary function is to serve as a framework for exploring research questions related to games and gameplay; it also contributes to a vocabulary for describing, analyzing, and critiquing games.

Theoretical Background and Method

The purpose of the Game Ontology Project is to categorize things we see in games. More specifically, it defines and classifies the things essential to the "gameness" of games. We have consciously chosen to focus on things that cause, effect, and relate to gameplay in order to help characterize and classify the design space of games.

The traditional Aristotelian view of classification was based on the notion of similarity or resemblance. Categories were, according to George Lakoff, "assumed to be abstract containers, with things either inside or outside the category. Things were assumed to be in the same category if and only if they had certain properties in common. And the properties they had in common were taken as defining the category" [16]. Research in cognitive science has shown that the classical view is insufficient and sometimes incorrect.[1] For many concepts there is no such list of properties that supports a binary category membership function. Membership can be highly dependent on context and culture.

Prototype theory provides an alternative to traditional classification. While a comprehensive review of prototype theory is beyond the scope of this chapter, we highlight some key concepts borrowed from prototype theory, explaining how they are useful in the generation of the ontology. Unless otherwise noted, the key concepts are taken from [16].

1. **Cognitive economy:** Categories must be both specific enough to reflect all essential information and general enough not to overwhelm with irrelevancies.
2. **Centrality:** Some members of a category may be better examples of that category than others.
3. **Membership gradience:** Some categories may have degrees of membership and no clear boundaries.
4. **Centrality gradience:** Members (or subcategories) of a category may be more or less central.
5. **Reference point, or "metonymic," reasoning:** Part of a category (i.e., a member or subcategory) can stand for the whole category in certain reasoning processes.
6. **Basic Level categorization:** Categories are organized hierarchically. Additionally, they are organized so that cognitively basic categories are in the middle of a general-to-specific hierarchy [17].

Rosch et al. [18] claim that the process of categorization is principled and depends on the attributes of what is perceived as well as the characteristics of the perceptual apparatus itself. In other words, we can only categorize on the basis of what we perceive and, all things being equal, that which is more easily perceived will be of greater significance to the categorization process [19]. This is relevant because the majority of the analyses of videogames that inform our ontology are black-box analyses. We do not necessarily presume to have any inside knowledge of the game designer's ideas or intentions, how the game was implemented or even the internal functioning of a game; our ontology is primarily based on that which we can perceive or experience as players.

According to the concepts of cognitive economy and basic level categorization, the mid-level elements of our ontology are presumably the most easily identifiable since they are observed over a broad range of games. If we observe something interesting in very few games, it is either too specialized to belong, or should be in the lowest (most specific) part of the ontology.

Many parts of the ontology have fuzzy boundaries regarding what games exemplify them (or have aspects that exemplify them). In general, we have tried to describe examples that could be considered central on account of how well known the game is or how closely it matches the definition of the ontological element. We also recognize that there are games whose use as an example deviates from the central or ideal with respect to the ontological definition. These examples are important because they help define the center of the category, and illustrate the nuances and interpretations an ontological definition may have. This is why we have developed the idea of "strong" and "weak" examples to account for the membership and centrality gradience we observe when applying the ontology to specific games.

While prototype theory describes the theoretical foundations that support our ontology, it does not explain how the ontology is generated. Our methodological approach borrows from grounded theory [20]; the elements and structure of our ontology are inductively developed from data gathered in the real world, including field notes of sessions of gameplaying activities, observations of other people playing games and documentation associated with games (manuals, reviews, screenshots, etc.). We make use of theoretical sampling and comparisons, in order to verify whether our ontology remains grounded in real games as opposed to being generated abstractly. These additional observations help identify new abstract categories which can be instances of the ones observed or generate specific categories that had not been salient from previous observations. Thus, our method is iterative, adaptive, and organic. The ontology is constantly adapting to reflect our knowledge and observations.

The ontology is not developed from the top (more abstract) or the bottom (concrete and specific). Rather, as prototype theory suggests, our ontology grows in a middle-out fashion—the obvious (most readily observable) categories tend to exist in the middle of the ontology. As we refine and revisit them, we discover both more abstract and more specific concepts.

The Ontology

This section describes some general characteristics and structure of the ontology. It describes the highest level of the ontology in detail as well as some of the elements directly beneath them. It also explains what has been purposefully excluded from the ontology and provides an example of a particular

entry in the ontology.

Our ontology abstracts away the representational details of games. Issues of setting (e.g., medieval castle, spaceship), genre (e.g., horror, sci-fi), and the leveraging of representations from other media (e.g., player's knowledge of the Star Wars universe) are bracketed by our analysis. Because our goal is to characterize the game design space, such bracketing is necessary in order to achieve broad coverage without having to abstractly characterize notions of setting and genre. Thus, we avoid the Sisyphean task of building an abstract model of the whole of human culture. A deep reading of any one particular game would require an analysis of its representational conventions, allusions and connotations. Our ontology helps position the more formal or structural elements of the game within the game design space; other methods and techniques would be required to unpack representational issues.

The top level of the ontology consists of five elements: interface, rules, goals, entities, and entity manipulation. The interface is where the player and game meet, the mapping between the embodied reactions of the player and the manipulation of game entities. It refers to both how the player interacts with the game and how the game communicates to the player. The rules of a game define and constrain what can or cannot be done in a game; they lay down the framework, or model, within which the game shall take place. Rules regulate the development of the game and determine the basic interactions that can take place within it (see [21] for an overview of other definitions of rules in the context of games). Goals are the objectives or conditions that define success in the game. Entities are the objects within the game that the player manages, modifies or interacts with at some level. This definition is broader than "game tokens" [22] since it also includes objects that are not controlled by the player. Finally, entity manipulation encompasses the alteration of the game made either by the player or by in-game entities. Entity manipulation thus refers to the actions or verbs that can be performed by the player and by in-game entities.

Each ontology entry consists of a title or name, a description of the element, a number of strong and weak examples of games that embody the element, a parent element, potentially one or more child elements, and potentially one or more part elements (elements related by the part-of relation). The examples describe how the element is concretely reified in specific games. As explained previously, we include both strong and weak examples; the weak examples describe border cases of games that partially reify the element. The parent/child relationship captures the notion of subtype (subset); child elements are more specific or specialized concepts than the parent element. Finally, the part-of relation captures the notion of compound elements that are constructed out of other elements (parts). Table 2.1 shows an example of a mid-level entry from the ontology.

Table 2.1: Example ontology entry—"to own"

Name	To own
Parent	Entity manipulation
Children	To capture, to possess, to exchange
Description	Entities can own other game entities. Ownership does not carry any inherent meaning, other than the fact that one entity is tied to another. Changes in ownership cannot be initiated by the owned entity. Ownership can change the attributes or abilities of either the owned or owning entity. Ownership can be used to measure performance, either positive or negative. Ownership is never permanent; the possibility of losing ownership separates ownership from an inherent attribute or ability of an entity. Ownership of an entity can change in variety of ways, including voluntary and involuntary changes of ownership.
	It is important to note the difference between owning an entity, and using an entity. For example, in *Super Mario Bros*, when Mario collides with a mushroom, the mushroom is immediately used and removed from the game world. Mario never owns the mushroom.
Strong Example	In *Super Mario World,* Mario can collect mushrooms (or fire flowers or feathers) to use later. Mario owns these entities and can make use of them later.
Weak Example	In *Ico*, the player character must protect a girl called Yorda. While the player only directly controls *Ico*, his actions are very closely tied to leading, guiding, and protecting Yorda. One could argue that *Ico*, in effect, owns Yorda because of the way they are tied to each other.

Interface

The interface provides the means by which the player experiences the game and takes action within the game. The presentation provides the sensory experience of the game, input devices provide a mechanism for the player to choose between physically distinguishable signals, and the input method maps the signal selected via the input device onto a game action (entity manipulation).

Since our ontology abstracts the representational details of games, the presentation hierarchy focuses on presentation as it directly serves gameplay, rather than on a cultural analysis of issues such as setting, tone, or genre. For example, in analyzing a game such as *Grim Fandango*, rather than exploring the game's excellent use of film noir and art deco visuals or the rich flavor that those visuals and the game's voice acting and music provide, we instead focus on the functional aspects of how presentation influences gameplay. Pre-

sentation consists of three parts: the cardinality of the game world, the presentation hardware and the presentation software. The cardinality of the game world can be distinct from the cardinality of the gameplay; see "The Roles of Space in Games" in the Discussion. The presentation hardware describes the physical details of the visual, audio, and haptic displays used in the game, while the presentation software describes how the game's state is communicated by means of the hardware. Entries in the presentation software hierarchy include point of view, categorizations of the information displayed in heads-up displays, and categorizations of types of game state feedback.

An input device is a piece of hardware used to gather input from the user. This includes such items as joysticks, joypads, game paddles, fishing controllers, light guns, pushbuttons, pedals, electro-sensitive mats, mice, and other devices through which players send messages to the game software.

Input devices differ from input methods in that the devices translate human action (typically motion) into electronic messages (physically distinguishable signals), which are then accepted and interpreted by the game software. Together, the input device and input method translate the physical actions of the player into a game action (entity manipulation).[2] Input devices and methods have changed significantly over the history of electronic games, typically following a trajectory of increasing bandwidth at the device level and more sophisticated handling of that input at the software level. While these advances have often appeared in parallel, we have chosen to keep the hardware and software layers of input handling distinct in the ontology since they can vary independently from game to game. That is, one can vary the hardware device from which a game receives input without altering the game's interpretation of that input.

Rules

In the context of our ontology, the rules and constraints of a game define what can or cannot be done in a game. They lay down the framework, or model, within which the game takes place. Rules regulate the development of the game and determine the basic interactions that can take place within it [23]. We note that rules should not be considered static or fixed; in some games, the rules can change as you play.

We define two types of rules: gameplay and gameworld rules. Gameworld rules define the virtual world where the game takes place, while gameplay rules impose rules and constraints on top of the gameworld. An example of a gameworld rule is "gravity" (unsupported objects tend to fall); an example of a gameplay rule is that the player has three "lives" (the game ends when the player has been killed three times). We will explore some specific gameplay rules in the Discussion section.

The distinction between gameplay and gameworld helps us to under-
stand the difference between "abstract" and "simulator" games. In abstract
games, most, if not all, the rules are gameplay rules. A simulator game, on the
other hand, may rely almost entirely on the gameworld to frame the game,
making use of few, if any, gameplay rules.

Games which make use of the same physics and graphics engines[3] share
many of the same gameworld rules. The differences between the games are
due primarily to differences in gameplay rules.

Additionally, we needed to account for emergent situations that were the
result of many rules together, without having to resort to a list of the partic-
ular rules that caused these emergent situations; we called these rules syner-
gies. Examples of rules synergies include economies of scale as well as
transitive and intransitive relationships. Thus, the rules section of the ontol-
ogy has three main branches: gameplay rules, gameworld rules and rules
synergies.

Goals

The goals section of the ontology accounts for the in-game objectives or con-
ditions that the player must meet in order to succeed at the game. These are
goals defined by the game, though they may or may not be explicitly com-
municated to the player: in fact, in the eyes of the player, they may not even
be defined.

When analyzing a game, we discover goals with different levels of granu-
larity. For all games the highest level goal may be win the game or play as
well as possible. However, in order to achieve that goal the player may have
to find a key or defeat a monster. Goals must be considered at the level in
which they affect the decisions the player is making. Some goals may be
short-term (cross the room) while others may be long term (solve the mys-
tery).

We consciously decided not to enumerate all the specific goals commonly
seen in videogames. In the first place, we could never hope to cover all the
specific goals, especially those that are narrative in nature (save the princess,
save the universe, etc.). More importantly, there exists a one-to-one corre-
spondence between goals and entity manipulation. This is not surprising,
since entity manipulation is the means by which players perform actions in
the game, as a means of achieving goals. For example, if the goal is to reach
the finish line, then the player will traverse the gameworld (traversal is in the
entity manipulation hierarchy). Therefore, goals that are equivalent to
actions, usually the lowest level of goals, are not included in this part of the
ontology.

Some goals are explicitly player-defined. For example, a person playing *Sim City* may decide to build a representation of the city she lives in. Another player may decide that he wants to play *Quake* without using any weapon other than the shotgun. Goals that players self-impose on their gameplaying experience are also not covered in the ontology.

Finally, though they are not goals per se, we account for how games evaluate and provide player feedback with regard to the degree of goal success. Thus, the ontology also has a branch dealing with goal metrics such as score, success level, etc. The goals section of the ontology has three main branches: agent goals, game goals, and goal metrics.

Entities

Entities are the objects that make up the reality of the game world (e.g., agents, walls, power ups, etc.). The entity hierarchy is currently the least developed section of our ontology. This may appear strange, since identifying the objects that compose game worlds seems like a logical first step in an ontological analysis. However, in keeping with our focus on gameplay, we initially focused on the actions (entity manipulation) that the player can take in the game world. Entities tend to be defined implicitly by entity manipulations. While we certainly intend to make the entity hierarchy explicit in the future, our current implicit definition of entities via entity manipulation has not been an impediment to our work.

Entity Manipulation

Gameworld objects (entities) posses a set of attributes (e.g., velocity, damage, owner, etc.) and a set of abilities (e.g., jump, fly, etc.). Entity manipulation consists of altering the attributes or abilities of gameworld entities.

Abilities are the "verbs" of entities, that is, the actions that entities are able to perform. Static entities have no abilities. They usually serve as obstacles, platforms (in games with gravity), or items/collectables. Dynamic entities possess abilities. Abilities can be gained permanently (gaining the speed boost in *Super Metroid*) or temporarily (eating a super pellet gives Pac-man the ability to eat ghosts).

Attributes are the "adjectives" of entities, and are altered by abilities. For example, the ability to move changes an entity's location attribute. The ability to vary speed changes the velocity attribute. Attributes can also be altered permanently (changing character statistics in a role-playing game) or temporarily (receiving a power up that changes the power of a character's punch for a short period of time). Abilities can also alter the existence of an entity (instantiate or destroy an entity).

There are cases where the line between ability and attribute is fuzzy. For example, in *Zelda: Wind Waker*, when Link gains the bow, he now has the ability to attack from a distance. One could argue that one of Link's attributes has been changed so that using the "attack" verb now does it at a distance. Contrarily, one could argue that Link now has the new ability "To Attack from a Distance." To distinguish between abilities and attributes in cases like this, we use the following heuristic: if the attribute/ability is utilized through an explicit player choice, then it is an ability; otherwise, if it occurs automatically, without an explicit player decision, it is an attribute. So, in our example, we would say that the bow bestows a new ability to Link, as the player must explicitly choose to use the bow during an attack in order to be able to attack at a distance.

Abstract examples of entity manipulation in our ontology include To Collide, To Create, To Own, and Compound Action (actions composed of several atomic actions).

Discussion

This section of the chapter illustrates how the GOP provides a framework for reasoning, exploring, and discussing issues in in-game studies. We present three short discussions related to research questions we have explored. Space constraints prevent us from fully fleshing out each discussion; their purpose is illustrative of the ontological approach rather than an attempt at providing fully developed answers to these questions.

How Can We Understand Interactivity in Games?

It is commonly noted that interactivity is one of the central characteristics of games [12, 24]. Focusing on the player input side of interactivity, our ontology helps us to understand what it means for a player to perform actions in a game.

If a person is playing a game on their computer using a mouse and a keyboard, is this any different from, say, a player using a gamepad? It depends on the game. For some games, the Input Device[4] that is used is a greater mediator or factor in interactivity than others. Input Devices translate human action (typically motion) into electronic messages which are then accepted and interpreted by the game software (the Input Method). So understanding the effect of different input devices requires understanding the relationship between the Input Device and the Input Method (Figure 2.1). Consider, for example, a discussion of the reasons why *Halo*'s[5] novel Input Method allowed it to succeed while being hampered by an Input Device (a gamepad)

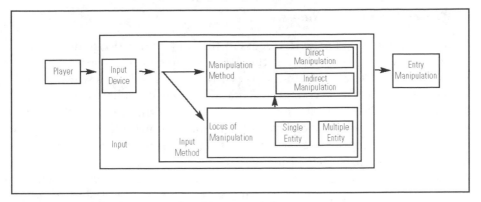

Figure 2.1: The input path of interactivity

which lacked the affordances that a mouse and keyboard have towards tradi-
tional first-person shooter games (aiming in FPS games is generally consid-
ered much easier to do with a mouse than a gamepad).

We have unpacked the term "input" past the level of the particular
devices and can start to ask questions related to what is actually being manip-
ulated in a game and how. While **Input Devices** constitute how user input
gets translated into electronic signals, **Input Methods** are the manner in
which the game software interprets those electronic messages. Therefore, is a
player manipulating several entities in a game or only one (e.g., multiple units
in an RTS game vs. an individual character in a platformer)? This is the **Locus
of Manipulation.** Additionally, there are games where the manipulation is
mapped directly to the input device. For example, if a player controls a space-
ship and presses the "left" button on the controller, the spaceship moves left.
This form of **Direct Manipulation** is very different from the **Indirect
Manipulation** present in a game where the player selects the actions he wants
his avatar to perform from a menu, such as in the battles of the *Final Fantasy*
series. So, the **Manipulation Method** (direct/indirect) as well as the **Locus
of Manipulation** play central roles in defining the interactivity of a game.
We could also delve deeper and explore the relationships between them in a
particular game. Are some entities controlled directly while others are con-
trolled indirectly? What particular forms of **Indirect Manipulation** are there
and what are their particular affordances?

This mini-analysis mirrors the overall hierarchy of the **Input** branch of
the game ontology (under **"Interface"**). Asking more questions led us to
explore deeper (more specific) parts of the ontology. Each level of "depth"
poses its own questions, while the overall structure situates the discussion rel-
ative to other design issues.

The Role(s) of Space in Games

Space is a complicated issue to discuss in the context of videogames. Part of the difficulty lies in the fact that there are multiple views of space within a game that, while related, are not necessarily equal. The broadest way of discussing space is at the level of representation. If one considers only what can be seen on the screen, what are the characteristics of that space? Is the representation two-dimensional or three-dimensional? How is that representation achieved? These aspects are part of the **Presentation** and are perceived by the player from a particular **Point of View.**

Most games convey a notion of place to the player, which we call the gameworld. However, we often find games where the Point of View describes a space that is different from what the representation suggests. For example, maybe all the characters in the game are rendered in a style that makes them appear as three-dimensional objects but they only act in two-dimensional ways, as is the case of *Super Smash Bros Melee*. In this case the Cardinality of the Gameworlds' space is different from the represented space. Additionally, consider what options of navigation or movement the player has within the gameworld. Is the Cardinality of Gameplay, the space the player can effectively act in, different from that of gameworld and the representation? So there are potentially three different levels at which one could discuss issues of spatiality in games (see Figure 2.2). They are interrelated and possibly share the same characteristics, but a comparative analysis of various games would have to take them into account.

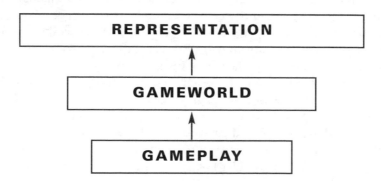

Figure 2.2: Levels of spatiality in games

Consider an example using a familiar game such as *Space Invaders,* but with a twist. Let us imagine that the invaders are not flat two-dimensional sprites but rather are beautifully rendered in 3D. At the representational level, we could argue that this version of *Space Invaders* is 3D. On another level, we observe what is happening in the game. The invaders march across

the screen from left to right and also, down towards the player. All their actions occur in a two-dimensional plane. *Space Invaders* has a **Two-Dimensional Gameworld**. The player, however, can only move her spaceship from side to side. The space of movement for the player is only one-dimensional. Thus, we say that *Space Invaders* has **One-Dimensional Gameplay**.

This mini-discussion shows how different parts of the game ontology relate to each other, in this case, elements under the top-level **Rules** and **Presentation** hierarchies. Interested readers are invited to [25] for further discussion of these issues.

Regulation of Gameplay Over Time

"Level," Wave," and "Checkpoint" are all common terms used to describe videogames. What do the terms really mean and what role do they play in a game? Our exploration of such a question led us to discover that all three terms are related to each other in unanticipated ways. Levels, waves, and checkpoints are ways of breaking down gameplay into smaller/shorter elements. In other words, they are each a form of **Segmentation of Gameplay**.

Segmentation of Gameplay is a more abstract concept than **Level** or **Wave,** thus it lies higher in the ontology. As we explored more games, we not only found new forms of segmenting gameplay, but also realized that they could be organized according to the general way in which they were applied. For example, some forms of segmentation were spatial in nature since they affected the gameworld, while others applied to time. Figure 2.3 shows how the concept of segmentation has evolved and grown within the ontology. As of this writing, the sub-hierarchy under **Segmentation of Gameplay** has more than twelve elements (not pictured in Figure 2.3). For an in-depth discussion of the concept of segmentation of gameplay, readers are invited to refer to [24].

The purpose of this mini-discussion is to illustrate how the process of generating the game ontology is situated in the context of concrete examples. We also emphasize that the ontology is not only growing constantly but also changing and adapting as we dig deeper into specific gameplay-related issues.

Conclusions

Our ontology, currently consisting of more than 150 elements, is a tool designed to inform and guide the analysis of games as well as provide a framework for the discussion and exploration of game design space. The future development of the ontology will be structured around specific questions such as those described in the Discussion.

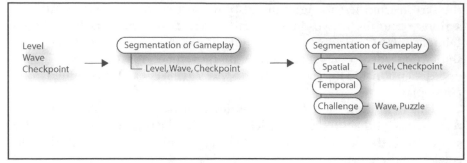

Figure 2.3: Part of the evolution of segmentation of gameplay within the ontology

Acknowledgments

The authors would like to thank the members of the Experimental Games Lab for their comments and contributions. Also, the following people have contributed to this project over the years as well as its many incarnations: Chaim Gingold, Yusun Jung, Heather Logas, Janet Murray, Marleigh Norton, and Daniel Rachels.

Notes

1. For example, robins are more representative of the category "bird" than ostriches. This contradicts the classical view in which each member of a category is just as good an example as any other.
2. See "How Can We Understand Interactivity in Games?" in the Discussion section for a description of this process.
3. Such as the Quake, Unreal for graphics and Havok for physics.
4. For the mini-discussions, words in bold text correspond to actual elements that are part of the Game Ontology. Their definitions can be found online at http://egl. gatech.edu/gamedesign/.
5. Halo is a first person shooter game originally for Microsoft Xbox. Halo and its sequel Halo 2 are the most successful games for Xbox in terms of sales and reviews.

References

1. Church, D. "Formal Abstract Design Tools." Game Developer, 1999.
2. Costikyan, G. "I have no words & I must design." Interactive Fantasy, 1994.
3. Kreimeier, B. "The Case for Game Design Patterns," 2002.
4. Kreimeier, B. "Game Design Methods: A 2003 Survey," Gamasutra, 2003.
5. Bjork, S., and J. Holopainen. *Patterns in Game Design*. Charles River Media Inc., Hingham, MA, 2005.
6. Bjork, S., S. Lundgren, and J. Holopainen. "Game Design Patterns." In *Level Up: Digital Games Research Conference 2003*, Utrecht, The Netherlands, 2003.

7. Fabricatore, C., M. Nussbaum, and R. Rosas. "Playability in Action Videogames: A Qualitative Design Model." *Human Computer Interaction* 17 (4) (2002) : 311–368.

8. Falstein, N. "The 400 Project," 2004.

9. Jenkins, H. "Game Design as Narrative Architecture." In N. Wardrip-Fruin and P. Harrigan (eds.), *First Person: New Media as Story, Performance and Game,* The MIT Press, Cambridge, MA, 2003.

10. Kücklich, J. "Perspectives of Computer Game Philology." *Games Studies: The International Journal for Computer Games Research,* 3 (1) (2003).

11. Carlquist, J. "Playing the Story: Computer Games as a Narrative Genre." *Human IT* 6(3): 7–53.

12. Murray, J. H. *Hamlet on the Holodeck: The Future of Narrative in Cyberspace.* The Free Press, New York, 1997.

13. Eskelinen, M. "Towards Computer Game Studies." *Proceedings of SIGGRAPH 2001,* Art Gallery, Art and Culture Papers, 83–87.

14. Aarseth, E., S. Smedstad, and L. Sunnanå. "A Multi-Dimensional Typology of Games." In *Level Up: Digital Games Research Conference 2003,* Utrecht, The Netherlands, 2003.

15. Lundgren, S., and S. Bjork. "Describing Computer-Augmented Games in Terms of Interaction." In *Technologies for Interactive Digital Storytelling and Entertainment (TIDSE),* Darmstadt, Germany, 2003.

16. Lakoff, G. *Women, Fire, and Dangerous Things: What Categories Reveal About the Mind.* Chicago, The University of Chicago Press, 1987.

17. Green, S. P. "Prototype Theory and the Classification of Offenses in a Revised Model Penal Code: A General Approach to the Special Part." *Buffalo Criminal Law Review* 4 (1) (2004): 301–339.

18. Rosch, E., B. Mervis, W. D. Gray, D. M. Johnson, and P. Bayes-Braem. "Basic objects in natural categories." *Cognitive Psychology* 8: 382–439.

19. Johnson, R. K. "Prototype Theory, Cognitive Linguistics and Pedagogical Grammar." Working Papers in Linguistics and Language Training (8): 12–24.

20. Glaser, B., and A. Strauss. *The Discovery of Grounded Theory: Strategies for Qualitative Research.* Aldine, Chicago, 1967.

21. Salen, K., and E. Zimmerman. *Rules of Play: Game Design Fundamentals.* Cambridge, Massachusetts, The MIT Press, 2004.

22. Zagal, J., C. Fernández-Vara, and M. Mateas. "Gameplay Segmentation in Vintage Arcade Games." In I. Bogost and M. Bittanti (eds.), *Ludologica Retro,* Volume 1: Vintage Arcade (1971–1984), Forthcoming.

23. Crawford, C. *The Art of Computer Game Design.* Osborne/McGraw-Hill, Berkeley, 1984.

24. Fernández-Vara, C., J. Zagal, and M. Mateas. "Evolution of Spatial Configurations in Videogames." In *International DiGRA Conference 2005,* Vancouver, Canada, 2005.

25. Zagal, J., M. Nussbaum, and R. Rosas. "A Model to Support the Design of Multiplayer Games." *Presence: Teleoperators and Virtual Environments* 9(5) (2002): 448–462.

3. Fundamental Components of the Gameplay Experience: Analyzing Immersion

Laura Ermi and Frans Mäyrä

Introduction: Players, Experiences, and Fun

There has been a relative boom of games research that has focused on the definition and ontology of games, but its complementary part, that of research into the gameplay experience, has not been adopted by academics in a similar manner. This is partly due to the disciplinary tilt among the current generation of ludologists: a background in either art, literary or media studies, or in the applied field of game design, naturally leads to research in which the game, rather than the player, is the focus of attention. Yet, the essence of a game is rooted in its interactive nature, and there is no game without a player. The act of playing a game is where the rules embedded into the game's structure start operating, and its program code starts having an effect on cultural and social, as well as artistic and commercial realities. If we want to understand what a game is, we need to understand what happens in the act of playing, and we need to understand the player and the experience of gameplay. In this chapter we discuss the ways in which the gameplay experience can be conceptualized, provide a model that organizes some of its fundamental components, and conclude with an assessment of the model with some directions for further research.

Human experience in virtual environments and games are made of the same elements that all other experiences consist of, and the gameplay experience can be defined as an ensemble made up of the player's sensations, thoughts, feelings, actions, and meaning-making in a gameplay setting. Thus it is not a property or a direct cause of certain elements of a game but something that emerges in a unique interaction process between the game and the

player. This has also led to suggestions that games are actually more like artifacts than media [1]. Players do not just engage in ready-made gameplay but also actively take part in the construction of these experiences: they bring their desires, anticipations, and previous experiences with them, and interpret and reflect the experience in that light. For example, a certain gameplay session might be interpreted as fun, challenging, and victorious until one hears that a friend of hers made a better record effortlessly, after which it might be reinterpreted more like a waste of time. Experiences are also largely context dependent: the same activity can be interpreted as highly pleasant in some contexts but possibly unattractive in other kinds of settings [2]. The social context is central in gameplay experiences, which was also illustrated by the example above.

Looking at the discourses of current digital game cultures, 'gameplay' is used to describe the essential but elusive quality that defines the character of a game as a game, the quality of its 'gameness.' In their book on game design, Rollings and Adams decline to define the concept because, according to them, gameplay is "the result of a large number of contributing elements" [3]. Yet, anyone who plays games long enough will form their own conception of bad or good gameplay on the basis of their experience. This experience is informed by multiple significant game elements, which can be very different in games from different genres, as well as by the abilities and preferences of the players. This starting point can further be illustrated by a quote from Chris Crawford:

> I suggest that this elusive trait [game play] is derived from the combination of pace and cognitive effort required by the game. Games like TEMPEST have a demonic pace while games like BATTLEZONE have a far more deliberate pace. Despite this difference, both games have good game play, for the pace is appropriate to the cognitive demands of the game. [4]

This definition actually translates gameplay into a particular balanced relation between the level of challenge and the abilities of the player. Challenge consists of two main dimensions, the challenge of speed or 'pace' and 'cognitive challenges.' The quality of gameplay is good when these challenges are in balance with each other, and what the appropriate balance is obviously depends on the abilities of the player. On the other hand, one of the most influential theories of fun and creative action, the flow theory by Mihaly Csikszentmihalyi [5], identifies the 'flow state' as a particular successful balance of the perceived level of challenge and the skills of the person. In this highly intensive state, one is fully absorbed within the activity, and one often loses one's sense of time and gains powerful gratification. Digital games are generally excellent in providing opportunities for flow-like experiences since the challenges they present are often gradually becoming more demanding and

thus players end up acting at the limits of their skills. In addition, the feedback given to the player is immediate. The activity of playing a game is a goal in itself.

People play games for the experience that can only be achieved by engaging in the gameplay. In other words, a game's value proposition is in how it might make its players think and feel [6] and "fun" is the ultimate emotional state that they expect to experience as a consequence of playing [7]. Expectations and enjoyment are shaped by the schemas that players have. A player can, for example, recognize the genre of a game by observing various genre-typical details and then use her schema of that genre to interpret those details [8]. Brown and Cairns [9] have noted that players choose games they play according to their mood, and it is to be expected that people especially seek games that elicit optimal emotional responses or response patterns [10]. Thus, when choosing to play a certain game, one might anticipate it to create certain types of experiences.

However, fun and pleasure are complex concepts. Playing games does not always feel fun: on the contrary, it quite often appears to be stressful and frustrating. Experiences that are usually classed as unpleasant can be experienced as pleasurable in certain contexts [11]. So, what makes, for example, failing fun? Klimmt [12] has applied Zillmann's excitation transfer theory and proposed that the suspense, anxiety, and physical arousal elicited by playing are interpreted as positive feelings because players anticipate a resolution and a closure such as winning the game or completing the task. When players manage to cope with a given situation successfully, the arousal is turned into euphoria, and the players experience this kind of cycle of suspense and relief as pleasurable. Klimmt has constructed a three-level model of the enjoyment of playing digital games, the first level of which consists of the interactive input-output loops, the second of cyclic feelings of suspense and relief, and the third is related to the fascination of a temporary escape into another world.

Grodal [13] regards digital games as a distinctive medium because they allow what he calls "the full experiential flow" by linking perceptions, cognitions, and emotions with first-person actions. The player must have and develop certain skills, both motor and cognitive, in order to engage in gameplay. It is widely acknowledged that digital gameplay experiences are based on learning and rehearsing [14,15], and according to Grodal [13] it is the aesthetic of repetition that characterizes pleasures of gameplaying. In the first encounter with a new game the player experiences unfamiliarity and challenge and starts to explore the game. After enough effort and repetitions the player can get to a point where she masters the game and game playing eventually reaches the point of automation and does not feel so fun any longer.

Thus, games can be considered as puzzles that the players try to solve by investigating the game world [16].

When playing games, it is not enough to just sit and watch and possibly activate some cognitive schemas. Instead, the player must become an active participant. When successful, this type of participation leads to strong gameplay experiences that can have particularly powerful hold on the player's actions and attention. This basic character of gameplay becomes even clearer when we study the way immersion is created in playing a game.

Immersion as a Component of the Gameplay Experience

Pine and Gilmore [17] have categorized different types of experiences according to two dimensions: participation and connection. The dimension of participation varies from active to passive participation and the dimension of connection varies from absorption to immersion. Absorption means directing attention to an experience that is brought to mind, whereas immersion means becoming physically or virtually a part of the experience itself. Four realms of experience can be defined with these dimensions: entertainment (absorption and passive participation), educational (absorption and active participation), aesthetic (immersion and passive participation) and escapist (immersion and active participation). In terms of this categorization, gameplay experiences can be classified as escapist experiences, where in addition to active participation, immersion plays a central role.

Furthermore, the concept of immersion is widely used in discussing digital games and gameplay experiences. Players, designers, and researchers use it as well, but often in an unspecified and vague way without clearly stating to what kind of experiences or phenomena it actually refers. In media studies, the concept of "presence" has been used with an aim to assess the so-called immersivity of the system. There are different ways to define the sense of presence, but on the whole, the concept refers to a psychological experience of non-mediation, i.e., the sense of being in a world generated by the computer instead of just using a computer [18]. As immersion can be defined as "the sensation of being surrounded by a completely other reality [. . .] that takes over all of our attention, our whole perceptual apparatus" [19] immersion and presence do not actually fall very far from each other, and are in fact often used as synonyms. However, since the term "presence" was originally developed in the context of teleoperations [20], it also relies heavily on the metaphor of transportation. In the context of digital games, we prefer using the term "immersion," because it more clearly connotes the mental processes involved in gameplay.

It is often taken for granted that a bigger screen and a better quality of audio equal greater immersion [16]. It is of course likely that the audiovisual

implementation of the game has something to do with immersive experiences, but it is by no means the only or even the most significant factor. McMahan [20] has listed three conditions to be met in order to create a sense of immersion in digital games: the conventions of the game matching the user expectations, meaningful things to do for the player, and a consistent game world. Genre fiction encourages players to form hypotheses and expectations and, according to Douglas and Hargadon [8], pleasures of immersion derive from the absorption within a familiar schema. On the other hand, meaningful play as defined by Salen and Zimmerman [21] occurs when the relationships between actions and outcomes are both discernable and integrated. Discernability indicates letting the player know what happens when they take action, and integration means tying those actions and outcomes into the larger context of the game. And just like any manipulation, acting in the game world requires relevant functionality and ways to access this functionality (i.e., usability) [22]. Thus, the audiovisual, functional, and structural playability as defined by Järvinen, Heliö, and Mäyrä [23] can be seen as prerequisites for gameplay immersion and rewarding gameplay experiences. On a very basic level, it can be argued that it is the basic visual-motor links that enable experiences of immersion even in games in which the graphics are not very impressive [12,13]. The increasing demand on working memory also seems to increase immersion [13]. For example, increase in the difficulty level may cause increase in the feeling of presence [10].

Brown and Cairns [9] have presented a classification that categorizes immersion into gameplay in three levels of involvement. Ranging from "engagement," via "engrossment" to "total immersion," their model is useful in pointing out how the amount of involvement may fluctuate. But this approach nevertheless fails to adequately respond to the qualitative differences between different modes of involvement, which is apparent also in the clear individual preferences different players have in different game types or genres. Brown and Cairns [9] see total immersion as a synonym for presence. They agree that immersion seems to have many common features with flow experiences. However, in the context of digital games, flow-like phenomena seem only to be fleeting experiences, which in turn suggests that they are something different from flow as traditionally conceived. Thus, the flow-like experiences related to gameplay could be called "micro-flow" [2] or "gameflow" [23], for example.

Funk, Pasold, and Baumgardner [24] have created a gameplay experience questionnaire in order to investigate the effects of exposure to fantasy violence. They developed a measure that concentrates on what they call "psychological absorption," but it does not differentiate between different kinds of gameplay experiences even though the theoretical model presented suggests that there are at least two kinds of experiences: absorption and flow. We

argue that in order to understand what games and playing fundamentally are, we need to be able to make qualitative distinctions between the key components of the gameplay experience, and also relate them to various characteristics of games and players. In this chapter we approach immersion as one of the key components of the gameplay experience and analyze its different aspects.

The Attractions of Digital Games

The starting point of our research was the twofold perspective we gained in 2003 while interviewing Finnish children who actively played digital games alongside their parents, who mostly did not play such games themselves [25]. The parents expressed concern because they thought that their children became emotionally too intensely immersed, or too involved with the game fiction, while playing. They agreed with the common conception that it was particularly the realistic and high-quality graphics and audio of contemporary games that explained the immersive powers. On the contrary, the children thought that the emotional immersion and involvement in fiction was typically stronger for them while reading a good book or while watching a movie. They emphasized the role of the characters and storylines in this kind of an experience, while they also acknowledged often becoming immersed in games, but in different ways than in literature or cinema, in the case of which emotional identification or engrossment was more common for them than in games.

> Well, you immerse yourself more into a book, I think. I don't know many reasons for that, but at least I lose myself more into books than in games. In games I usually only just play, or then I sort of follow the plot, but in books it is kind of more exciting, because the plot is having the main part, and in games the main part is moving things yourself and such, in games the plot is just secondary. (Boy, 12 years)

When discussing games, children stated that the main difference between games and novels or movies was the games' interactivity: the opportunity to make decisions, take actions, and have an effect on the gameplay. Some of them also considered this to be the most immersive aspect of games.

> In movies I do not identify with the main character at all. I just watch what he does. But in a book, if I read about the actions of some main character, then I identify with him as I would be the character myself. Or at least I immerse myself more into it. But in a game you immerse into it most of all, because you actually do things with that guy, with that character, most of all. (Boy, 11 years)

Another thing that clearly separated children's experiences with games from their experiences with books and movies was the social quality of game-

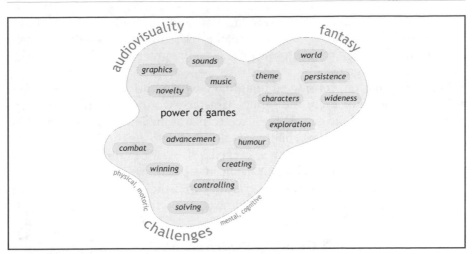

Figure 3.1: Elements related to pleasurable gameplay experiences that emerged in the interviews with the children [26]

play. Children often played together with their friends and siblings and games were notable discussion topics on schoolyards, etc.

> When in it [a book] you can go and figure with your own brain like, ok, now it [the character] is doing this and that. [. . .] Yes it [a game] is a bit different, as you can say to your friend that hey, look this is doing this and that, but in books you cannot really, because you are not reading with your friend. (Girl, 10 years)

As we were curious about these different ways of perceiving game "immersion," we studied the responses further and analyzed the children's accounts of playing games and the different holding powers they had recognized in games in order to shed some light on the structure of the experience.

In light of the interviews, the pleasures of gameplay derive from several different sources [26]; see Figure 3.1. According to the children, the **audio-visual quality and style** was one of the central aspects of good digital games. For example, good-looking graphics could make the game more appealing, and well-functioning camera angles were associated with good playability. However, children perceived game aesthetics in different ways. Some of them especially liked cartoon style graphics, whereas others felt they were too childish and preferred as realistic looking graphical style as possible.

Children also analyzed the various ways in which the **level of challenge** was balanced in games quite carefully.

The pleasure derived from playing was strongly related to experiences of succeeding and advancing, and uncertainty of the final outcome was an important factor in the overall suspense of playing. The challenges of gameplay seemed to be related to two different domains: to sensorimotor abilities

such as using the controls and reacting fast, and, secondly to the cognitive challenges. Even though pure puzzle games were not very popular, children liked games in which problem solving was an integral part of the storyline or adventure of the game.

Thirdly, children considered **imaginary world and fantasy** to be central in many games. For them the game characters, worlds, and storylines were central elements of the games they liked to play. One important aspect of the imaginary worlds was that children could do things in them that were not possible or even acceptable in their everyday lives, for example, beating up a policeman or having two children living in a big house without any adults. After analyzing these observations, we followed the principles of grounded theory approach to create a theory that accounted for the findings.

A Gameplay Experience Model

Our research suggests that the gameplay experience and immersion into a game are multidimensional phenomena. The issue here is not that parents would have drawn the wrong conclusions while observing their child's playing, or that the children themselves would not be able to understand their own immersion experiences. Rather, the answer is that immersion is a many-faceted phenomenon with different aspects that can appear and be emphasized differently in the individual cases of different games and players.

In the gameplay experience model presented here (abbreviated as SCI-model, on the basis of its key components; see Figure 3.2), gameplay is represented as interaction between a particular kind of a game and a particular kind of a game player. Our model is a heuristic representation of key elements that structure the gameplay experience. It is not intended to constitute a comprehensive analysis, but rather designed to guide attention to the complex dynamics that are involved in the interaction between a player and a game. The complex internal organization of a "game" and a "player" are particularly left schematic here, as the focus is on the consciousness structured by the interplay, rather than on an analysis of games or players in themselves. The gameplay experience can be perceived as a temporal experience, in which finally the interpretation made by the player takes into account also other information such as peer influence, game reviews, and other frames of socio-cultural reference.

The first dimension of a gameplay experience that we distinguish is the **sensory immersion** related to the audiovisual execution of games. This is something that even those with less experience with games—like the parents of the children that were interviewed—can recognize: digital games have evolved into audiovisually impressive, three-dimensional and stereophonic worlds that surround their players in a very comprehensive manner. Large

screens close to the player's face and powerful sounds easily overpower the sensory information coming from the real world, and the player becomes entirely focused on the game world and its stimuli.

Another form of immersion that is particularly central for games, as they are fundamentally based on interaction, is **challenge-based immersion**. This is the feeling of immersion that is at its most powerful when one is able to achieve a satisfying balance of challenges and abilities. Challenges can be related to motor skills or mental skills such as strategic thinking or logical problem solving, but they usually involve both to some degree.

In several contemporary games also the worlds, characters, and story elements have become very central, even if the game would not be classifiable as an actual role-playing game. We call this dimension of game experience in which one becomes absorbed with the stories and the world, or begins to feel for or identify with a game character, **imaginative immersion**. This is the area in which the game offers the player a chance to use her imagination, empathize with the characters, or just enjoy the fantasy of the game.

For example, multi-sensory virtual reality environments such as CAVE [27], or just a simple screensaver, could provide the purest form of sensory immersion, while the experience of imaginative immersion would be most prominent when one becomes absorbed in a good novel. Movies would combine both of these. But challenge-based immersion has an essential role in digital games since the gameplay requires active participation: players are constantly faced with both mental and physical challenges that keep them playing. Since many contemporary digital games have richer audiovisual and narrative content than, for example, classic *Tetris*, these three dimensions of immersion usually mix and overlap in many ways. In other words, the factors that potentially contribute to imaginative immersion (e.g., characters, world, and storyline) are also apparent in the interaction design (e.g., goal structures) and the audiovisual design (how goals, characters, and the world are represented and perceived) of well-integrated game designs.

The overall significance of a game for a player can be greater than the sum of its parts. In our model 'meaning' is the part through which a player makes sense of her play experience and constructs her interpretation of the game against the backdrop of the various personal and social contexts of her life. Thus it relates to the traditions of pragmatics, phenomenology, and cultural studies as much as to that of semiotics or psychology in a conceptual sense. The contexts of a gameplay experience also include factors such as who the player is (in terms of the rich complexities of personal histories), what kind of previous experience she has with this game or game genre, and how cultural and social factors affect the role games have in her life in more general terms. In addition, situational contexts can have a decisive role in structuring the experience: Who is the game played with? Is there a specific reason

to play this game right at that moment? Is the player playing to vent frustrations, for example, or is the significance of this gameplay in the shared moments with friends? All these various contextual factors have their distinctive roles in the interpretation of an experience and are therefore included in the model.

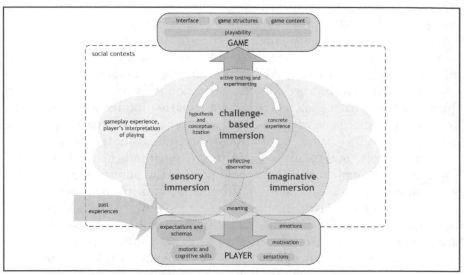

Figure 3.2: SCI-model identifies the three key dimensions of immersion that are related to several other fundamental components, which have a role in the formation of the gameplay experience

The Gameplay Experience Model in Practice

After creating the model, we were interested to find out how the different aspects of immersion actually appear in contemporary digital games. We constructed a questionnaire that initially consisted of thirty statements addressing the three aspects of gameplay immersion and responses given on a 5-point Likert scale. In March 2005, we invited players of certain popular games to evaluate their experiences of these games. The respondents were recruited from among a thousand Finnish participants that had filled in another game-related online questionnaire. The games were chosen on a twofold basis: on one hand we had to pick games that were played among the informants and on the other hand we tried to cover as wide a range of different kinds of game genres as possible. The games and the amount of the completed gameplay experience self-evaluation questionnaires are shown in Table 3.1.

Table 3.1: The distribution of the completed gameplay experience self-evaluation questionnaires into different digital games

World of Warcraft	35
Half-Life 2	34
Grand Theft Auto: San Andreas	25
Halo 2	21
Civilization III	19
The Sims 2	18
Star Wars: Knights of the Old Republic II: Sith Lords	16
Rome: Total War	15
Flatout	13
Pro Evolution Soccer 4	13
Nethack	11
Neverwinter Nights	7
NHL 2005	7
TOTAL	**234**

There were 193 respondents altogether, but since some of them evaluated two different games, the total number of completed gameplay experience self-evaluation questionnaires was 234. Almost all of the respondents were males (91%), *The Sims 2* being the only exception with 61% of the responses given by females. The age of the respondents varied between 12 and 40 years (mean 21.5 years). The platform used for playing was a PC computer in 71% of the cases, but *Halo 2* was played only on Xbox and *Grand Theft Auto: San Andreas* only on PlayStation 2. In the majority of the cases the game was played as a single-player game (75%), but *World of Warcraft* was played as a multiplayer game on the Internet. In a few cases the game was played as a multiplayer game in which the players also shared physical location.

After examining the correlations between the thirty questionnaire items with explorative factor analysis, some of the statements were eliminated so that the number of items was reduced to eighteen. The scale of sensory immersion consisted of four statements related to the capturing of senses done by the game (e.g., "The sounds of the game overran the other sounds from the environment"), the scale of challenge-based immersion of seven statements addressing the orientation to goals and flow-like experiences (e.g., "The game challenged me to strive to the limits of my abilities"), and the scale of imaginative immersion included seven statements that measured how involved the player and her imagination were with the game (e.g., "I identified with how the game characters felt in different situations"). Cronbach's alphas for this sample were 0.70, 0.74, and 0.82, respectively.

It is not possible to go through the results in great detail here, and again we emphasize that the main goal was to develop and validate our model. In that respect, the first obvious finding when looking at the data is that the immersion levels in the examined games were overall quite high so that no game with almost non-existent immersion experience was found. This is an understandable consequence of the fact that our informants were analyzing gameplay experiences from games that were their personal favorites. It would no doubt be possible to obtain results also from the different end of the spectrum if random or less-favored games and not so enthusiastic players would be examined. Nevertheless, the results appear to support the SCI-model and the questionnaire derived from it.

Comparing games that fall to the opposite ends of the scales is illuminating. The sensory immersion is experienced as particularly strong in *Half-Life 2* and lowest at *Nethack*, as we expected. The role of audiovisual technology is clear: the sensory experience provided by an old game from an ASCII graphics era appears distinctly different from that provided by the latest three-dimensional game engines.

The situation is different as we turn to the results from the analysis of challenge-based immersion. Here *Nethack* is the game that acquired the top score, followed by *Civilization III, Rome: Total War* and *Pro Evolution Soccer 4*. These games are interesting also in the sense that they probably provide players with distinctly different kinds of challenges: *Nethack* with those of a seemingly simple dungeon game that actually provides players with an endless supply of complex puzzles linked to randomly generated items and interactions, *Civilization III* and *Rome: Total War* with the predominantly strategic challenges in warfare and empire-building scenarios, and *Pro Evolution Soccer 4* testing players' reactions and coordination skills at a faster speed. The lowest challenge-based immersion rating of the examined games was that of *The Sims 2*, which can be related to its non-competitive and toy-like basic character.

Imaginative immersion, the third component of the model, is at its strongest in role-playing games and plot-driven adventure games, again confirming expectations of how the scale should operate. *Star Wars: Knights of the Old Republic 2, Half-Life 2,* and *Neverwinter Nights* lead the statistics, with *Pro Evolution Soccer 4*, the rally game *Flatout* and strategy games *Civilization III* and *Rome: Total War* inhabiting the other end of the scale. The result is logical since games with characters and storylines provide players with more possibilities to identify with something in the game and use their imagination (Figure 3.2).

There are several interesting aspects of the results that invite further research. Summing up mean values of all the three components of gameplay immersion, *Half-Life 2* appears to be the overall strongest game in immersing

Figure 3.3: The average amount of each immersion type reported by the players in different digital games
The total amount of immersion reported is highest on the left-hand side.

its players. On the other end, the experience of playing *The Sims 2* is apparently not felt as immersive. But it would be a mistake to claim *Half-Life 2* to be a better game than *The Sims 2* on this basis. It may well be that the more 'casual' character of *The Sims 2* gameplay is one of the reasons behind its appeal for these particular players. *The Sims 2* was also the only one of the examined games with a notable amount of female respondents, but the relatively low evaluation of immersion is not related to the gender of the informants, since females gave overall higher evaluations to the immersion in that game than men.

Conclusions and Future Work

> To each and every one of the above "explanations" it might well be objected: "So far so good, but what actually is the fun of playing? Why does the baby crow with pleasure? Why does the gambler lose himself in his passion? Why is a huge crowd roused to frenzy by a football match?" This intensity of, and absorption in, play finds no explanation in biological analysis. Yet in this intensity, this absorption, this power of maddening, lies the very essence, the primordial quality of play.
>
> Johan Huizinga, *Homo Ludens*

This research has been driven by a desire to understand better the nature of gameplay experience. In the existing research which we synthesized in the beginning of this chapter, there proved to be several useful observations and conceptualizations that address or can be applied to the study of gameplay. Nevertheless, there is a need for a game-specific model that would take the diversity of contemporary digital games into account, and that would address its full complexity. We have presented one version of such a model in this chapter, while also acknowledging the need for further research.

In the future we will test and fine-tune the questionnaire further, and also look into the applicability of the model for evaluation of gameplay characteristics both within a controlled environment, and as a part of pervasive gameplay experience evaluation. The games examined here represent only a fraction of the variety of games. For such purposes new applications of the model will be needed, as well as further extensions of the evaluation criteria to include dimensions of experience relevant to game types that are not played with a personal computer or game console and television screen. It is also necessary to broaden the conception and evaluation of gameplay experiences to include all the other components presented in the model besides immersion. For example, what is the role of emotions, social contexts and players' expectations and interpretations, and how do the different aspects of gameplay immersion link to the characteristics of the player and features of the game?

In a sense, this research has at this point opened more questions than it is able to answer. For example, it would be highly relevant and important to examine further the role of social and cultural contexts for the gameplay experience. Do the pre-existing expectations and experiences with related games determine the gameplay experience with a new one, and to what degree? And finally, what are the exact interrelationships and relative weights of the components included in our model? It might also be possible that game players are able to switch from one attitude or repertoire of game playing into another one, and the gameplay experience will vary on the basis of such "eyeglasses" or filters. How much does the situational context really affect the way games are experienced? As usual in research, when new knowledge is created, also new horizons into the unknown and unexplored are opened up.

Acknowledgments

This research is made in conjunction with several research projects in the Hypermedia Laboratory of the University of Tampere: *Children as the Actors of Game Cultures, Design and Research Environment for Lottery Games of the Future*, and *Mobile Content Communities*. We wish to thank all partners in these projects. We also thank all those children and adults who took part in the interviews and/or completed the questionnaires. Special thanks to Satu Heliö, and to Markus Montola for his comments on the content, and Suvi Mäkelä.

References

1. Hunicke, R., M. LeBlanc, and R. Zubek. "MDA: A Formal Approach to Game Design and Game Research." Available at http://www.cs.northwestern.edu/~hunicke/pubs/MDA.pdf. 2004.
2. Blythe, M., and M. Hassenzahl, "The Semantics of Fun: Differentiating Enjoyable Experiences." In M. A. Blythe, K. Overbeeke, A. F. Monk, and P. C. Wright (eds.), *Funology: From Usability to Enjoyment*. Kluwer Academic Publishers, Dordrecht, 2003, pp. 91–100.
3. Rollings, A., and E. Adams. *Andrew Rollings and Ernest Adams on Game Design*. Indianapolis, New Riders, 2003.
4. Crawford, C. The Art of Computer Game Design. Berkeley, CA, Osborne-/McGraw-Hill, 1982/1997. Available at http://www.mindsim.com/MindSim/Corporate/artCGD.pdf. (Last accessed July 14, 2006).
5. Csikszentmihalyi, M. *Flow: The Psychology of Optimal Experience*. New York, Harper Perennial, 1991.
6. Lazzaro, N. "Why We Play Games: Four Keys to More Emotion in Player Experiences." Paper presented at the Game Developers Conference (San Jose, March 2004). Abstract available at http://www.xeodesign.com/whyweplaygames/xeodesign_whyweplaygames.pdf.
7. Bartle, R. A. *Designing Virtual Worlds*. Indianapolis, New Riders Publishing, 2004.

8. Douglas, Y., and A. Hargadon, "The Pleasure Principle: Immersion, Engagement, Flow." In *Proceedings of the Eleventh ACM Conference on Hypertext and Hypermedia* (San Antonio, May 2000), ACM Press, pp. 153–160.

9. Brown, E., and P. Cairns. "A Grounded Investigation of Game Immersion." In *CHI'04 Extended Abstracts on Human Factors and Computing Systems* (Vienna, April 2004), ACM Press, pp. 1297–1300.

10. Ravaja, N., M. Salminen, J. Holopainen, T. Saari, J. Laarni, and A. Järvinen. "Emotional Response Patterns and Sense of Presence during Video Games: Potential Criterion Variables for Game Design." In *Proceedings of the Third Nordic Conference on Human-Computer Interaction* (Tampere, October 2004), ACM Press, pp. 339–347.

11. DeJean, P.-H. "Difficulties and Pleasure?" In W. S. Green and P. W. Jordan (eds.), *Pleasure with Products: Beyond Usability*. London, Taylor & Francis, 2002, pp. 147–150.

12. Klimmt, C. "Dimensions and Determinants of the Enjoyment of Playing Digital Games: A Three-Level Model." In M. Copier and J. Raessens (eds.), *Level Up: Digital Games Research Conference* (Utrecht, November 2003), University of Utrecht & Digital Games Research Association (DiGRA), pp. 246–257.

13. Grodal, T. "Stories for Eye, Ear, and Muscles: Video Games, Media, and Embodied Experiences." In M. J. P. Wolf and B. Perron, (eds.), *The Video Game Theory Reader*. New York, Routledge, 2003, pp. 129–155.

14. Gee, J. P. *What Video Games Have to Teach Us about Learning and Literacy*. New York, Palgrave Macmillan, 2003.

15. Koster, R. *A Theory of Fun for Game Design*. Scottsdale, Paraglyph Press, 2005.

16. Newman, J. *Videogames*. London, Routledge, 2004.

17. Pine, B. J., and J. H. Gilmore. *The Experience Economy: Work Is Theatre & Every Business a Stage*. Boston, Harvard Business School Press, 1999.

18. Lombard, M., and T. Ditton. "At the Heart of It All: The Concept of Presence," *Journal of Computer Mediated Communication* 3(2) (1997). Available at http://www.ascusc.org/jcmc/vol3/issue2/lombard.html. (Last accessed July 14, 2006).

19. Murray, J. *Hamlet on the Holodeck: The Future of Narrative in Cyberspace*. Cambridge, The MIT Press, 1997.

20. McMahan, A. "Immersion, Engagement, and Presence: A Method for Analyzing 3-D Video Games." In M. J. P. Wolf and B. Perron (eds.), *The Video Game Theory Reader*. New York, Routledge, 2003, pp. 67–86.

21. Salen, K., and Zimmerman, E. *Rules of Play: Game Design Fundamentals*. Cambridge, MA, The MIT Press, 2004.

22. Hassenzahl, M. "The Thing and I: Understanding the Relationship between User and Product." In M. A. Blythe, K. Overbeeke, A. F. Monk, and P. C. Wright (eds.), *Funology: From Usability to Enjoyment*. Dordrecht, Kluwer Academic Publishers, 2003, pp. 31–42.

23. Järvinen, A., S. Heliö, and F. Mäyrä. *Communication and Community in Digital Entertainment Services: Prestudy Research Report*. Hypermedia Laboratory Net Series 2. University of Tampere, Tampere, 2002. Available at http://tampub.uta.fi/tup/951-44-5432-4.pdf. (Last accessed July 14, 2006).

24. Funk, J. B., T. Pasold, and J. Baumgardner. "How Children Experience Playing Video Games." In *Proceedings of the Second International Conference on Entertainment Computing* (Pittsburgh, May 2003), Carnegie Mellon University, pp. 1–14.
25. Ermi, L., S. Heliö, and F. Mäyrä. *Pelien voima ja pelaamisen hallinta: Lapset ja nuoret pelikulttuurien toimijoina.* [Power and Control of Games: Children as the Actors of Game Cultures]. Hypermedia Laboratory Net Series 6. University of Tampere, Tampere, 2004. Available at http://tampub.uta.fi/tup/951-44-5939-3.pdf. (Last accessed July 14, 2006).
26. Ermi, L., and F. Mäyrä. "Power and Control of Games: Children as the Actors of Game Cultures." In M. Copier and J. Raessens (eds.), *Level Up: Digital Games Research Conference* (Utrecht, November 2003), University of Utrecht & Digital Games Research Association (DiGRA), pp. 234–244.
27. Cruz-Neira, C., D. J. Sandin, T. A. DeFanti, R. V. Kenyon, and J. C. Hart. "The CAVE: Audio Visual Experience Automatic Virtual Environment." *Communications of the ACM* 35(6) (1992): 64–72.

4. The Design of Narrative as an Immersive Simulation

RENATA GOMES

Introduction

In this chapter, I propose that a new concept of narrative is emerging, taking shape as the design of an immersive simulation to be experienced by the interactor in a video game. I face this new narrative status as the ongoing rearrangement of a creative process that was initiated in an attempt to generate, in digital format, a certain concept of narrative inherited from canonic cinema. Faced with the simulative nature of the video game format, I believe the process is being forced to take a different shape.

In this new format, one fundamental notion guides us and defines the premise for games as a narrative form, that is, the concept of agency as "the satisfying power to take meaningful action and see the results of our decisions and choices" [1]. In the case of the narrative video game, agency is what provides the interactor—the player—with the possibility of becoming a part of the story universe, making decisions as one of its characters. This is a scenario I oppose to the more common link made between games and narrative, the one that refers to the game's theme as its story. "A game's theme is nothing more than a justification for the game's material: a rational explanation that establishes the setting and makes up the global motivation for the game's iconography and the events that take place inside the game" [2]. What is important is the actual practice of the game, which implies a certain type of "kinesthetic acting" that becomes an end in itself [2]. This "kinesthetic acting" gives agency to the player, turning her into an agent of both story and enunciation, and is the most fundamental characteristic of a game.

From this perspective, I was able to outline, inside the sphere of games with a more clear narrative goal, two broad categories of games that attempt

to address the design of this narrative experience in terms of different agency dynamics, through differing sets of actions. One category, which I propose naming *character-oriented games,* focuses its efforts in the construction of a 3D navigable environment that becomes more and more sophisticated. Within this environment, the sensation of immersion and of a "vicarious presence" [2] aims to be strong enough to establish the emotional link that defines canonic narratives. Most games in this category structure their agency around a journey through a delimited time-space, which the interactor enters as its protagonist. Role-playing games (RPGs), action, adventure, and first-person shooters are part of this category, and games like the *Final Fantasy, Tomb Raider, Halo,* or *Deus Ex* series are some of the most popular character-oriented game examples.

The second category of narrative games, one that has a less obvious connection with cinema, is *simulation games* (Sim games). Here I focus my attention on those games in which play consists in the management of various parameters of a greater system. These games' roots can be traced to experiments with Artificial Life and computational modeling of complex systems that have a realistic basis. Unfolding practices are generated in games like the *SimCity* series, in which the interactor governs a city, controlling various parameters such as investments and urban planning. Real-time strategy games are also part of this category, their difference from management simulation being restricted basically to the time-scale aspect. In these games, the play consists primarily in the observation of the behavior of the system over time and the interactor plays the part of a god, or holds a god-like perspective, but is not "inside" the game environment.

Immersion, Presence and the Design of Affordables

Immersion and presence are two sides of the same coin. Within character-oriented games, being a character is, above anything, entering the spatial universe of the game through the body of the character. With the improvement of technology and of graphic chips that generate synthetic images in computers, the creation of ever more lifelike environments has been possible. Aspects of the photographic/cinematic image, culturally shared as "realistic," can be simulated in a more complete manner, creating for videogames the notion of "window to the world" that cinema has called its own until recently. Beyond emulating cinematic aspects such as depth of field, shades and textures, 'presence' in the game environment can only be fully implemented when a player's experience of contact in game objects and other elements can also simulate aspects of their *behavior* in the real world.

In other words, a player will have, immersed in a game world, a greater feeling of *presence*—and, as a consequence, greater agency potential—the

more a virtual body is capable of executing, or not, certain tasks required for participation in the virtual world. As Gibson states, regarding his concept of *affordances:*

> If a terrestrial surface is nearly horizontal (instead of slanted), nearly flat (instead of convex or concave), and sufficiently extended (relative to the size of the animal) and if this substance is rigid (relative to the weight of the animal), then the surface *affords support*. It is a surface of support, and we call it a substratum, ground, or floor. It is stand-on-able, permitting an upright posture for quadrupeds and bipeds. It is therefore walk-on-able and run-over-able. It is not sink-into-able like a surface of water or a swamp, that is, not for heavy terrestrial animals (. . .). [3]

> Beyond aiming greater and greater audiovisual realism, what might really matter in a video game is its construction of an "ecology, in which every object is a tool that extends the user's body and enables her to participate in the ongoing creation of the virtual world" [4]. As an interactor, one's perception of height might depend on whether or not one's virtual body is able to reach certain vertically distant points in the digital environment; one's perception of speed based upon, for instance, the interval in which one can traverse a certain terrain; one's perception of a gravitational constant through the act of walking, running, jumping, and so on. Being-in-the-world through the embodied presence of a character makes up for a good part of game play per se, and, for each challenge posed by the game, a great measure will be directly associated with the possibility of obtaining, from the body a player controls—be it an avatar, a first person perspective of, or more often than not, a dynamic combination of both—the perception, the action, and the precise and necessary response for its execution. This way, in a general manner, it can be said, "the avatar's body is the direct expression of their environment, written into the gamescape as a capacity for its distances." [5]

In video games, the question of embodiment may become, beyond the main condition for the experience of being-in-the-world, also the premise for a potentially sophisticated experience of alternative *Umwelts*. The concept of *Umwelt*, proposed by theorists Jacob and Thure von Uexkull [6], is defined by Nöth as "the way in which the environment is represented to the organism's mind and it comprises the scope of the organism's operational interaction with its environment" [7]. In a video game, *Umwelts* can represent a change of:

> point of view and physical abilities: our virtual bodies may fly or creep on the ground, see everything from high above or put up with the limitations of a terrestrial vision, embrace the whole universe or shrink down to the size of a Lilliputian. [4]

Or else, it is the possibility of making a change in actual world perception, through the embodiment of a character both physically and emotionally

in different contexts, that which turns the video game into a potentially revolutionary format. The act of being-in-the-world can gather more meaning than just immersion, presence, navigation: what still separates game from the status of an artistic experience, more than a total immersion technology seems to be connected to the creation of systems capable of turning an immersive experience into a *perceptive* living experience under the motivations of a character with real dramatic power.

Narrative as Simulation

The basic concept of simulation is essential to any attempt to understand a video game as an aesthetic form. Bettetine states, in his definition of simulation as an instrument essential to signification:

> when we talk about simulation, we are referring, first of all, to the creation of an interpretative model (theoretic hypothesis) related to a certain reality and, then, to the empirical verification of the model's functionality and adequacy. [8]

This way, even the character-oriented games, by using synthetic images—based upon a conceptual apparatus brought forth by photographic, cinematic and video imagery—are implementing a high degree of simulation to generate their immersive environments. Sim games go a step beyond in their explicit attempt to cover more aspects than the mere way things look and focus specifically on whole systems and general behavior types. In that sense, they try to generate computerized procedures for modeling the semiotic category of *thirdness*. In these systems

> component parts interact with sufficient intricacy that they cannot be predicted by standard linear equations; so many variables are at work in the system that its overall behavior can only be understood as an emergent consequence of the myriad behaviors embedded within. With complexity, characteristics and behaviors emerge, in a significant sense, *unbidden*. [9]

Here, the greatest advantage of the computer comes from its possibility of allowing the observation of these systems, composed of innumerous elements, in interaction over longer time scales. Basically, the computer allows the visualization of global effects that emerge, along the temporal axis, from the local interaction of the components of the system.

Conceptual Toys

A simulation game is radically different from a character-oriented game. In the latter and its relatives, one goal is established in the beginning of the game and the forthcoming experience proceeds as a quest to achieve this

goal. In opposition to this, most simulation games have no goal or victory attached to their achievement: the process itself is the toy. Playing consists in modeling, trying to infer the rules, and in a way to control the game more precisely, although likely never fully predictably. While quest games mark their conclusion with the end of the spatial journey, the end of a simulation game usually only comes from a decision by the interactor. Or, as Janet Murray explains, "electronic closure occurs when a work's structure, though not its plot, is understood" [1]. Apparently aware of this perspective, the distributors of the Sims series sell their games under the label of software toys, instead of games per se (Maxis Software Catalog).

While fundamentally different from character-oriented games in their narrative aspirations, Sim games still share this narrative mission. In spite of the absence of a clearer dramatic structure, I argue that, in most cases, the system's history—its change along the time axis—can be rich enough to be properly called a narrative. Most importantly, the construction of the diegetic universe through a systemic logic opens the game for full interactor agency and thereby provides important increments of complexity that could give narrative in the virtual world the artistic relevance it might lack.

While not aiming for the classic immersion effect made popular by canonic narratives—and pursed by the character-oriented genre—Sim games cannot be said to lack their very own ways of making the interactor an actual part of the game world. As a matter of fact, given the nature of their gameplay, well-developed simulations can provide more involvement with the game's systemic logic than the character-oriented competition. This way, being immersed into a Sim game has a more metaphorical concept:

> playing a simulation means becoming engrossed in a systemic logic which connects a myriad array of causes and effects. The simulation acts as a kind of *map-in-time,* visually and viscerally (as the player internalizes the game's logic) demonstrating the repercussions and interrelatedness of many different social decisions. Escaping the prison-house of language, which seems so inadequate for holding together the disparate strands that construct postmodern subjectivity, computer simulations provide a radically new quasi-narrative form through which to communicate structures of interconnection. [10]

The simulative nature of this game genre allows for a degree of freedom regarding player action that most strict character games have not been able to achieve, since the path to be traversed by the interactor in these games, although accessed in a few different ways, is essentially linear (one must clear point A and point B to get to point C). Yet, Friedman quite carefully warns that "however much 'freedom' computer-game designers grant players, any simulation will be rooted in a set of baseline assumptions" [10]. In spite of the improvement brought to the discipline of computer simulation by a more thorough understanding of the behavior of complex systems, including social

ones, whatever concepts used to model theses systems, be they real or imaginary, modeled into scientific experiments or for pure entertainment value, they will always to some extent be of an arbitrary, conventional and biased nature. This perspective, however, does not intend to frame computer simulation as *simulacra*. On the contrary, it aims at the poetic potential of simulation games, and recalls for its players that there is no such thing as a "perfect simulation" (and semiotically, this shouldn't even be an issue).

Conclusion

The point here is not to assume that the non-linearity inherent in this type of game will make it necessarily less arbitrary as a semiotic construction. Narrative, however, does seem to lose its predetermined, arbitrary convention, becoming a particular instantiation, when the interactor inhabits, plays, and becomes engrossed in the game. Instead of the probable and necessary cause-and-effect chain (as proposed by Aristotle [1]), which gave the feeling that things could have never taken place differently, now, narrativity migrates to the possibilities opened by the theoretical constructum. Narrative becomes an index of the thirdness modeled by the computer into that particular simulation, through which one can infer certain aspects of the theoretical (narrative) concept, by experimenting with it as a process, but very unlikely the concept in its whole. This is much like the development of personal narratives, which can point to the evolutionary history contained in our species' DNA, as well as the particular social and cultural context which we inhabit, and which allows for the fulfillment of some of our narrative possibilities, but not all of them.

The implementation of narrative as a simulation, more specifically of the immersive type, could be seen as a way to create, in video games, Soviet filmmaker Sergei Eisenstein's ideal—conveying conceptual discourse through a film's form, as opposed to its mis-en-scene only. Under this hypothesis, it's possible to envision a promising future of games that try to model, for instance, truly imaginary systems, that operate under a poetic set of guidelines, as opposed to just finding ways to restrain the interactor to a predetermined narrative path. Masterful literary works such as Franz Kafka's *The Process,* Jorge Luiz Borges' *The Garden of Forking Paths* or even Brazilians' favorite *Dom Casmurro (Lord Taciturn,* by Machado de Assis) could be "recreated" in the simulative/narrative form, to allow interactors to live the experience of Joseph K, for example, not following the book's protagonist step by step, but experimenting a world under the Kafkaesque logic portrayed in the novel.

References

1. Murray, J. *Hamlet on the Holodeck: the Future of Narrative in Cyberspace*. Cambridge, MIT, 1997.
2. Darley, A. "Genealogia y tradicion: el espetáculo mecanizado." In *Cultura visual digital. Espetáculo y nuevos géneros en los medios de comunicación*. Barcelona, Paidós, 2002.
3. Gibson, J. J. "The Theory of Affordances." In *Ecological approach to Visual Perception*. London, Lawrence Erlbaum Associates, 1986.
4. Ryan, M.-L. Narrative as Virtual Reality: Immersion and Interactivity in Literature and Electronic Media. Baltimore, Johns Hopkins University, 2001.
5. Oliver, J. H. "Polygon Destinies: The Production of Place in the Digital Role-Playing Game." In *COSIGN 2001 Conference Proceedings*. Available at http://www.cosignconference.org/cosign2001/papers/Oliver.pdf. (Last accessed July 14, 2006).
6. Uexküll, T. von. "Jacob von Uexküll's theory of the Umwelt." In *Galaxia 7: Revista Transdiciplinar de Comunicação, Semiótica, Cultura/ Programa Pós-Graduado em Comunicação e Semiótica da PUC-SP*. São Paulo: Educ; Brasília: CNPq, 2003.
7. Nöth, W. "Ecosemiotics." *Sign System Studies* 26.
8. Turkle, S. *Life on the Screen. Computers and the Human Spirit*. New York, Simon & Schuster, 1995.
9. Friedman, T. *Civilization and its Discontents: Simulation, Subjectivity and Space*, 2001-A. Available at http://www.duke.edu/~tlove. (Last accessed July 14, 2006).
10. Friedman, T. *Making Sense of Software: Computer Games and Interactive Textuality*, 2001. Available at http://www.duke.edu/~tlove. (Last accessed July 14, 2006).
11. Aristotle. *Poetics*. Translation and foreword by Malcolm Heather. London, Penguin, 1996.
12. Bettetine, G. "Por un establecimiento semio-pragmático del concepto de simulación." In *Videoculturas de fin de siglo*. Madrid, Cátedra, 1989.

5. Interactive Digital Storytelling: Towards a Hybrid Conceptual Approach

ULRIKE SPIERLING

Introduction

Influencing Disciplines

"Interactive Digital Storytelling" is a new topic of interest for a growing number of people from diverse disciplines. As to the context of the work presented in this chapter, there have been four aspects that have been most influential:

1. Generative computer graphics, animated storytelling for film production
2. Human-computer interaction (HCI)
3. Computer game design
4. Artificial intelligence.

First, people from the film production segment of special effects and computer animation began to automate the movements of virtual characters by defining their abilities as rule-based, "intelligent" behavior, and to think about populated virtual worlds. Second, there was an attempt within the disciplines of Human-Computer Interaction (HCI) to view "storytelling" as a means to make computer applications more understandable and compelling to the user by integrating narrative elements and seeing the computer as a stage, as Brenda Laurel argues in *Computers as Theatre* [1]. It was by combining aspects of disciplines within the community of computer graphics and interactive systems that a concept of "interactive storytelling" was constructed that viewed human-computer interactions as an entertaining con-

versation between agents. Laurel draws a parallel between the principles of drama from Aristotle's *Poetics* and principles of HCI, and presents the Aristotelian definition of an agent as: " . . . one who initiates and performs actions" [1]. In Laurel's conclusion, computer-based agency is present in all human-computer activities, regardless of whether the representation of agents on the stage has human-like (anthropomorphic) features.

Third, within the computer games community, an application of these ideas can be found in the provocative view of game designer Chris Crawford, who approaches computer games as an interactive artifact. According to Crawford and Stern [2,3], an artwork is "really interactive" only if it not merely "talks" to the audience, but also "listens" and then "thinks" over suitable reactions. That is to say, members of the audience experience "agency" while perceiving the artwork as active participants. Janet Murray has defined this notion of agency in *Hamlet on the Holodeck* [4] as: " . . . the satisfying power to take meaningful action and see the results of our decisions and choices." Whereas this prerequisite puts "the user" at the center of any told story, "Interactive Storytelling"—while first considered an oxymoron—nevertheless posed a real challenge for new computing concepts formalizing dramatic structure.

The dilemma with stories, unlike the more repetitive games, is that in order to be dramatic, their structure must have a far higher degree of complexity. In a novel or movie, this structure is tuned and laid out in a linear order by human authors. To add interactivity to a story following the approaches mentioned above, these authors have to be represented by computer agents that can "think" about the changes in the unfolding of a story during the runtime of the agent-like artifact.

Hence, Artificial Intelligence techniques have been employed to generate suitable plot developments in reaction to participants' free actions. Seminal research in this field was conducted in the early nineties [5]. The result is an emergent behavior of intelligent agents controlled by a drama manager. Within the last four years, there has been an increasing interest in building story engines with similar goals for automated narration in reaction to user input, or for planning actions of autonomous characters on a virtual stage. References can be found in the proceedings of new conference series on that topic [6,7]. In order to interact with believable representations of virtual characters through multimodal techniques, the research field of "Embodied Conversational Agents" also provides major contributions to the relevant state-of-the-art technology [8].

Motivation

The above-mentioned approaches have largely been tackled by computer scientists. "Conventional" storytellers who want to enter this field are currently

offered the advice that they would first have to learn to program [3]. If that were not enough, it seems that one would as well have to study the principles of natural language processing at a very deep level to create interactive verbal conversations. Following this advice, there have indeed been a number of artists coming up with interactive narrative installations [9]. For the time being, their resulting artworks are completed as a bundle of content with an engine. There is rarely a way to separate one from another, or to access authoring interfaces for one's own creations. These current trends towards building virtual agents point more towards a vision of creating full-fledged virtual humans with autonomous behavior for end users, than towards solving authoring problems for creators of interactive storytelling artifacts.

In the context of humanistic research into Interactive Narrative, philosophical debates from the hypertext era about authors' rights, and the co-producing property of users in a collective authoring process, are resuming [10]. In a slightly modified form, their assumptions continue to be contested in the recent academic debate between "ludologists" and "narratologists" [11], which is mainly carried out in web-logs, such as, for example, in Grand Text Auto [12]. In the following paragraphs, the term "authoring" is not being used to reference a specific standpoint on this debate, but rather as a technical necessity to produce interactive storytelling artifacts within technical boundary conditions. As the practical examples in the next section show, the context for envisioning entities of interactive storytelling is, for the most part, created by an instrumental view in that it is considered for educational purposes.

This chapter is not about the difference between stories and games. The motivation is based on the potential of both to offer structures for learning and entertainment. Instead of trying to draw a distinct line between them, conceptual models have to be defined for the creating authors, who are responsible for fleshing out a suitable design within a variety of forms. Design elements include aspects of drama and filmmaking, dialog design, as well as game design and game tuning. The actual challenge in designing learning applications with autonomous agents is the necessity that authors have to take on responsibility concerning the intended outcome and effect. In fact, they have to balance the bias between a pre-structured storyline (and possibly a timeline), which they may have strictly defined, and the agency that users shall experience through the design of the author. However, there is no one-dimensional borderline between the two extremes. In the following sections, a model is presented with several levels, which will help to form a more differentiated picture.

Example Projects

The conceptual work is based upon practical experiments within several research projects on edutainment, which employ conversations with virtual characters to convey information and to entertain. Mateas and Stern [13] used a similar integration of simulation and plot in the project Façade, which is acknowledged to be the first working example of interactive storytelling with both dramatic storytelling and user agency. By building several prototypes, different approaches were explored to combine plot-based interactive storytelling with character-based emergent conversations. Visual impressions of the example projects art-E-fact, Scenejo and Geist are shown in Figures 5.1 and 5.2.

In all examples, several virtual animated characters converse digitally with each other and with one or more users, who either type text with the keyboard, or apply choices, for example, with special hardware interfaces (compare Figure 5.2). The virtual agents are represented by 3D animations, as well as by a text-to-speech engine rendering their voices in real time. At the heart of the processing of the natural language conversation, open-source chatbot technology is used [14] and adapted to the particular needs of each application. Chatbot conversations in general are modeled by a so-called knowledge base, which primarily contains a huge number of text patterns that a user can potentially express, along with associated lines for the bot to answer. In up-to-date commercial applications of chatbots as company representatives on Web sites, there is no modeling of dialogs in the sense of a scripted screenplay or a goal-driven conversation—a digital answering machine is all there is, with a minimal ability to store a short-term dialog history, as well as several user properties and topics to talk about. The result is an emerging dialog that is almost impossible to anticipate as an author.

For interactive storytelling to be used in teaching and learning, the anticipation of possible conversations is necessary to a certain degree. The envisioned learning scenarios with text interaction will allow the training of verbal dialogs and the simulation of conversational behavior. By employing aspects of stories, factual information can be conveyed by the authored spoken text of virtual agents and different opinions can be rendered by mapping them on several agents in a dispute. Using gaming aspects, playful verbal interactions allow users to test their own decisions and opinions; they participate through active construction of a dialog. The overall goal is a middle ground between predefined narrative presentations and emergent conversations.

Authors need to control this semi-autonomous behavior of interacting agents. As a means to define the flow of a conversation, authoring interfaces with graph structures of "dialogue acts" proved to be a prevalent approach. Dialog acts refer to the idea of speech act theory, and support the definition

Figure 5.1: Example screens from applications with text interaction.
Top: art-E-fact—Two fantasy characters are challenging children with math
questions. *Bottom:* Scenejo—Emerging small talk between three virtual
agents and one user.

Figure 5.2: Special interfaces to interact with a story. *Left:* Geist—in
the Mobile-AR scenario, interaction occurs through finding ghosts by
walking in real locations. *Right:* art-E-fact—pointing gestures specify
regions in a painting to discuss.

of semantic and non-verbal statements. The nodes of the graph contain scripted content as contiguous actions of the virtual agents and transition edges describe possible user options or environmental conditions. The result initially has a branching structure, which then needs the addition of more complex rules within detailed nodes of the graph in order to achieve interactive experiences. Graph structures as a transition network of states can be used to model interactive experiences on several levels of detail, from the low-level utterances of single words up to scenes or sections of a timed narrative. Figure 5.3 shows examples of transition networks from the projects art-E-fact [15] and Scenejo [16].

The resulting conversations within the two mentioned projects differed in their approach to a middle ground between guided interactions and emerging conversations. In art-E-fact, easy story creation with predictable user interactions was supported by the authoring tool, which allows authors to work with the graph structure from the outset. Storywriters are able to

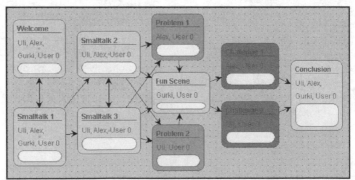

Figure 5.3: Transition network structures for conversations on several levels of detail. *Top:* Dialog moves in art-E-fact. *Bottom:* Scenes in Scenejo.

transfer a certain degree of factual knowledge through dialog, using the hierarchical and modular control approach. However, the affordance of the graph tool resulted in first creations that tended to be linear and determined, providing long-winded experiences with little user agency. Together with designed interaction tools beyond the keyboard, the "vocabulary" of the users—and, therefore, their "choices"—was limited to pointing gestures. More complex and free conversations can indeed be offered with the tool, but are difficult to handle by coding rules.

By contrast, in the Scenejo project, AIML pattern matching [14] is used from the start to provide free conversational interaction with users and between virtual agents. On a basic level, AIML can be used to model dialog acts; it can also be used for scripting a determined two-way dialog between virtual characters only by using appropriate keywords, but with the chance to let users intervene. In an interaction scenario with text input, little text-based games and simulations with high user agency are possible. As a next step in authoring, a story graph (see Figure 5.3, bottom) allows writers to line up conversational scenes and their parameters, including rules for transitions between scenes. Scenejo is an experimental improvisation stage, in that it provides a playful test environment for emergent conversations between chatbots, which are not easy to anticipate.

Conclusions on the Practical Experiments

Experiments using different forms of interaction and dialog modeling, as well as several application contexts, resulted in the following conclusion: The definition of "Interactive Storytelling" as a narrative representation that "allows the audience to influence the story" is not sufficient to explain the nature of that specific concept. There are different ways for interaction to influence the story, different levels of content at which the influence can take place, and different distributions of agency between authors, digital agents, and users. They shape mutations of possible artifacts, which all deserve to be justifiably named "Interactive Storytelling"—defining different genres with their respective conceptual models.

Storytelling is an art form that depends on talent and the will to shape and fine-tune the telling of events in order to achieve a certain experience. This notion is independent of the question of whether one strives for professional or casual storytelling: Humans are the storytellers, not "the computer." It is important to give talented authors from the traditional storytelling domain, as well as educators and instructors, the ability to access more complex stages of interactivity, beyond the definition of a determined story graph. However, for authors who decide to include experiences of user agency, it is necessary to anticipate the emerging situation to a certain extent.

This can only be learned by experience during phases of play testing. As an entry point to interactive storytelling, a graph structure with some variations can be the first access, working further from linear determinism to behavioral emergence resulting from rules and simulation models. It is also noticeable that "linear" storytellers have difficulty in explaining their wishes for a suitable authoring tool, because the complexity of the whole task is too high.

Simulation models and rules have to be technically defined on several levels of detail, as the whole experience of a theatrical play on a stage is formed by several elements of qualitative structure (for example, see Laurel's adaptation of dramatic principles to human-computer interaction [1]). Authors need to determine the technical quality on each level, either by scripting or by defining parametric values for a simulation, which set the boundaries for user interaction. In the following section, this is reflected in a conceptual model that allows the whole design task to be broken down into levels that can be thought about more easily. It can also be used for classifying a variety of forms.

Conceptual Models for Storytelling and Agency

Linear Storytelling

In Figure 5.4, a traditional modus operandi for the creation of computer-animated films is sketched at four abstract levels. In fact, the decision for a certain number of distinguishable levels may vary slightly from project to project. As shown later, each of the four levels was found to be suitable for the addition of interaction to form a classification.

This division into levels finds parallels in several theoretical and pragmatic contexts. At first, it reflects the design steps of a computer-animated story. At the top level of highest story abstraction, the overall dramatic outline is sketched. For example, there may be a story model of a hero's journey [17], including a dramatic configuration of characters, a situation that provides dramatic conflict, and an overall narrative arc that maps the story onto a time span. A timed arc can be divided into narrative functional elements, such as three acts, the twelve situations of Campbell's hero's journey, or a model similar to that defined by Propp for folktales [18]. Further, authors break down the story into scenes, which are handled at the next level. Each scene has to end with a result that drives the story to the next point in the dramatic arc, and is defined by a scene script. Within one scene, dialogs and interactions between actors are designed, and they lead to concrete stage directions. If being produced for an animated film, these directions are strictly mapped onto virtual actors by skilled animators, who define the exact way the virtual actors move and behave. The scenes and directions are ordered in time

Figure 5.4: The definition of a linear animated story at four abstract design levels

according to the planned course of narration, not to a chronological course of factual plot events.

This division into levels also has some theoretical equivalence to the Aristotelian six qualitative elements of structure in drama, discussed by Laurel [1] for their application to human-computer activity. From the highest level down to the lowest, these elements are action, character, thought, language, pattern, and enactment. There are causal relations between the levels, which can also be applied to the sketched production model of animation. Upper levels provide formal causes for lower levels, represented by directions from a productive point of view. Lower levels provide material causes for the upper levels, in that their experienced properties shape the next higher level—and finally the whole artifact—in the eyes of the audience.

Interactive Storytelling

When storytelling becomes interactive, the audience can "influence the storytelling." In fact, in games, as well as in constructivist scenarios for learning through a gaming simulation, users need to experience agency within a dramatic entity, and their roles change from being "members of the audience" to "participants." But what exactly constitutes a "storytelling" that can be influenced by users? Since several levels have been identified, providing intermediate representations as directions to the next lower level, these are the stages at which users also affect the outcome.

Figure 5.5: Four levels of semi-autonomy including agency

In Figure 5.5, the animation model (compare Figure 5.4) has been extrapolated according to the need to introduce user agency individually at each level. Opposite the author, a participant is modeled who now may contribute to the result of each level. In Aristotelian terms, these user interactions may build the material cause for the next higher level because they shape the material that constitutes upper levels. This is the reason why the participant in Figure 5.5 is depicted as starting to interact at the lowest level.

If authors intend to let users collaborate in the definition of the resulting artifact, the first implication for them is that it is not enough to just predefine databases of descriptions at each level, as was the case in the linear model. Instead, they have to code rules and simulation models, which control an autonomous and adaptive behaviour of virtual agents at each level in reaction to the participants. Next, it is possible to think of gradations of granted agency versus authored determination. Within Figure 5.5, this is indicated by the sliders between control and autonomy (of character agents) at each level.

The levels serve as conceptual stages for authoring rather than elements of software architecture. However, there is a further correlation of the model to levels of software architectural structures, which can be found within a number of existing game and story engine systems. An analog description of similar levels as software components has been provided in [19]. The sketched interactive storytelling software consists of a story engine, a scene engine, several character engines/conversation engines (one for each occurrence of a character), and avatar animation engines. The technical view is of course an important issue to be considered, as the design model has to have a technical correlation in the software in order to work. Here, the term "engine" could also be another word for "agent," underlining the fact that at

each level, a separate software agent can make autonomous decisions while adapting to user input on behalf of the absent authors.

Semi-autonomy occurs on the edges between factual information being predefined by authors, and rules for each level. The more rules there are on one level, the more complex the perceived behavior of a virtual agent can be, and, as a consequence, the more subjectively user agency can be experienced by potentially affecting the respective level. For example: In the Geist project (Figure 5.2, left), user interaction occurs by walking through the historic site of the Heidelberg castle. The goal is to track down virtual ghosts who tell stories about their past, resulting in an edutainment application providing history for tourists. The interaction is technically solved by a complex tracking system that provides information about the location and the line of vision of users. In effect, tourists cannot alter the storyline; at most, they can change the order of scenes slightly, depending on the route they choose. All the same, this is interactive storytelling with semi-autonomous agents. The constellation of the "autonomy-sliders" on the levels in the model is configured in such a way that user agency is experienced at the lowest level, but not at higher levels. Users are recognized and addressed personally through the adaptive behavior of the animated agent, and their route history is accounted for, while at the end of the day, a predetermined story is presented.

It is imaginable that participants only experience agency at the lowest level, as a feeling of presence in a scenario. In this case, everything is predefined, but avatars would still react to the visitor with nonverbal cues and recognize her, comparable to a virtual cursor that shows live status. At the conversation level, participants can, for example, have agency in an entertaining and informative chatbot dialog with the characters. They may not even be able to affect anything in the story logic, but may participate at the dialog level through speech acts. Agency at the scene level would result in real choices about the outcome of a scene. For example, the story of the game would have to change according to a user's actions. At the top level, players would influence the whole story of the application, if the "agency slider" were at 100% at the extreme right. For example, a simulation such as *The Sims* (Electronic Arts) can be located within this classification, since the players are the ones who eventually create stories with the toy.

For factual knowledge transfer in a didactic lesson situation, the highest level could stay predefined, while the lower levels allow for conversational interaction, however constrained. If authors only provide a rule base with little pre-scripted structuring, they achieve a conceptual model more like an exploration or gaming experience, depending completely on the action of the player. While arranging the bias at each level to various slider positions, several abstract genres of interactive digital storytelling can be represented in the model, which helps to specify exactly what kind of user experience an appli-

cation shall provide. It is a conceptual model that can be used to classify story-related games, and it particularly supports authors coming from linear media, who are just getting into interactive storytelling.

Conclusions for a Classification of Interactive Storytelling

The presented model can be used for classification of a variety of interactive entertainment and learning media, but not for all. In particular, a classification of "computer games" can only be done partially, and is restricted to certain genres—implying that the artifact shows some narrative structure, or at least a time structure with perceivable consequences of actions in a certain order. The underlying metaphor of "having a conversation" with a computer-based artifact as an agent is central to the approach taken here.

In Figure 5.5, the term "god game" is used. According to the above-mentioned discussion about authorship [16], this refers to simulation games, which put the player in the position of defining what is going to happen while playing with a designed model. In that sense, playful actions can lead to a narrative created by the participants. Following the fundamental categories of games specified by Roger Caillois [20]—competition (agon), chance (alea), simulation (mimicry), and vertigo (ilinx)—the mimicry aspect is the predominant value to look at. It can occur either as unstructured play (paidia), as well as in the highly structured category of ludus, in which Caillois also includes theatre spectacles. For Craig Lindley in [21], the competitive aspect of games is crucial for a description of a gameplay *gestalt*. In Lindley's terms, the conceptual model presented here does not explain a tension between narrative and gameplay, but focuses on the narrative *gestalt* at a performance level while discussing an axis between narrative and a model as a representation of a fabrication.

Playing with a simulation can support the fabrication of thought, when the simulation model is used as a medium for communication with oneself. It can also be seen as a virtual sparring partner for training and learning, stressing again the aspect of agency of the medium, and "open-ended-ness." Interactive storytelling, when seen as an agent-based conversation, has a huge potential to be successfully applied to learning applications. In the gaming landscape described by Jan Klabbers [22], the actual learning effect in gaming simulations occurs due to a subsequent "debriefing" phase, which provides reflections on one's own decisions and actions by observing the game phase "postmortem" from a critical distance. Thinking in narrative time structures, this is actually the phase where individual user experiences can be transferred into their own linear stories after the interaction has taken place. Putting actions into a story structure also means applying structures of identified causes and effects. During the open-ended interaction time with a sim-

ulation, hypotheses are tested while forming "what-if" stories, which are based upon known stories of causes and effects.

While these structures are present within a game genre, interactive story-telling takes place. For example, role-playing games have narrative aspects, while a fabricated world is conjointly constructed within a possibility range defined by an underlying model. Depending on the state of the upper level axis of dramatic structure, there can be a variety of shapes based on the degree of game master presence. Within and beyond existing game genres, interactive storytelling as an agent-based conversation can take several shapes, which can be explained through metaphors of real situations. Examples are the metaphor of a lecture with allowed questions, a guided tour, a moderated meeting, an un-moderated regulars table, a conversational test situation, a conversational training situation, or a conversational doll house (such as MMORPG).

As potential authors with a variety of expertise are approaching the new field of interactive storytelling, which also involves artificial intelligence and the construction of autonomous agents, the multi-level model presented in this chapter will support accessibility, particularly for those professionals coming from linear storytelling and education. The model provides a view of the overall possibility space that allows these newcomers to start thinking about it from a linear narrative perspective and to add interactivity partially and successively.

Acknowledgments

The discussed project examples and images of the research projects *art-E-fact* and *Geist* would not have been possible without the software platforms built by ZGDV, Department of Digital Storytelling, in Darmstadt, Germany. *Geist* has received German research funding from BMB+F, and *art-E-fact* was funded by the European Commission (IST-2001–37924). Thanks to Sebastian Weiss and Wolfgang Müller for their collaboration and technical support in our joint project Scenejo.

References

1. Laurel, B. *Computers as Theatre*. Addison-Wesley, Reading, MA, 1993.
2. Crawford, C. *The Art of Interactive Design: A Euphonious and Illuminating Guide to Building Successful Software*. No Starch Press, San Francisco, CA, 2002.
3. Stern, A. "Deeper Conversations with Interactive Art, or Why Artists Must Program." *Convergence: The International Journal of Research into New Media Technologies* 7(1) (2001): 17–24. Available at http://www.interactivestory.net/papers/deeperconversations.html. (Last accessed July 25, 2006).
4. Murray, J. H. *Hamlet on the Holodeck. The Future of Narrative in Cyberspace*. Free Press, Cambridge MA, 1997.

5. Carnegie Mellon University, School of Computer Science. Oz Project Publications (2003). Available at http://www-2.cs.cmu.edu/afs/cs.cmu.edu/project/oz/web/papers.html. (Last accessed July 14, 2006).

6. TIDSE Conference, Technologies for Interactive Digital Storytelling and Entertainment (2003, 2004, 2006). Available at http://www.zgdv.de/TIDSE06/. (Last accessed July 25, 2006).

7. Virtual Storytelling, International Conference on Virtual Storytelling (2001, 2003, 2005). Available at http://www.virtualstorytelling.com. (Last accessed July 25, 2006).

8. Cassell, J., T. Bickmore, M. Billinghurst, L. Campbell, K. Chang, H. Vilhjalmsson, and H. Yan. "Embodiment in Conversational Interfaces: Rea." In *ACM CHI 99 Conference Proceedings,* Pittsburgh, 1999.

9. Mateas, M., and A. Stern. "Façade—a one-act interactive drama." Available at http://www.interactivestory.net. (Last accessed July 14, 2006).

10. Pearce, C. "Emergent Authorship: The Next Interactive Revolution." *Computers and Graphics* 26 (2002): 21–29.

11. Frasca, G. "Ludologists love stories, too: notes from a debate that never took place." In Copier, M. and Raessens, J. (eds.), *Level up: Digital Games Research Conference,* Utrecht University, 2003.

12. GrandTextAuto, Group Weblog. Available at http://www.grandtextauto.org/. (Last accessed July 14, 2006).

13. Mateas, M., and A. Stern. "Integrating Plot, Character and Natural Language Processing in the Interactive Drama Façade." In *Proceedings of the Conference on Technologies for Interactive Digital Storytelling and Entertainment,* Darmstadt, 2003.

14. A.L.I.C.E. Artificial Intelligence Foundation. Available at http://www.alicebot.org/. (Last accessed July 14, 2006).

15. Spierling, U., and I. Iurgel. "'Just Talking About Art'—Creating Virtual Storytelling Experiences in Mixed Reality." In *Virtual Storytelling, Proceedings ICVS,* Berlin-Heidelberg, Springer, 2003.

16. Müller, W., U. Spierling, and S. Weiss, "Synchronizing Natural Language Conversation between Users and Multiple Agents in Interactive Storytelling Applications." In *Proceedings of TESI 2005 Conference,* Kent, UK, 2005.

17. Campbell, J. *The Hero of a Thousand Faces* (orig. 1946), Paladin Books, Reprint, 1993.

18. Propp, V. *Morphology of the Folktale.* University of Texas Press, Austin, TX, 1968.

19. Spierling, U., D. Grasbon, N. Braun, and I. Iurgel. "Setting the Scene: Playing Digital Director in Interactive Storytelling and Creation." *Computers and Graphics* 26 (2002): 31–44.

20. Caillois, R. *Man, Play and Games.* (orig.: *Les Jeux Et Les Hommes* 1958) University of Illinois Press, Reprint, 2001.

21. Lindley, C. "Narrative, Game Play and Alternative Time Structures for Virtual Environments." In *Technologies for Interactive Digital Storytelling and Entertainment, Conference Proceedings,* Darmstadt, Springer, *LNCS* (3105) (2004): 183–194.

22. Klabbers, J. "The Gaming Landscape: A Taxonomy for Classifying Games and Simulations." In Copier, M. and Raessens, J. (eds.), *Level up: Digital Games Research Conference,* Utrecht University, 2003.

6. *Frame and Metaphor in Political Games*

IAN BOGOST

Introduction

The 2004 U.S. Presidential election renewed world citizens' recognition of a deep ideological polarization in U.S. politics. Juxtaposing American morality against British class rifts, some cite religion as the key issue dividing the presidential vote. The American Electoral College, combined with the lack of a viable third-party, only increases the apparent split: massive, telecast Electoral College maps displaying won states in red (Republican) and blue (Democrat) suggested a geographic divide to many Americans, with the west coast, northeast, and Great Lakes voting Democratic and the heartland and south Republican. Yet more detailed maps that showed county-by-county vote balance proved that the division runs even deeper, with most counties appearing some shade of purple, a combination of "red votes" and "blue votes." In the aftermath of the election, Democrats have acknowledged that their messages have failed, just as Republicans recognize how much theirs have succeeded. The left is now scrambling to develop a new strategy. Ideas are plentiful: avoid candidates from the northeast [32]; focus more strongly on domestic issues [28]; seek better management [20]. But two influential political theorists have suggested that political success draws less from reality and more from representation.

Cognitive linguists George Lakoff and Mark Johnson proposed metaphor is central to human understanding [12,15]. Influenced by Lévi-Strauss, Clifford Geertz, and Jean Piaget, Lakoff and Johnson argue that our conceptual systems are fundamentally shaped by cultural constructions; metaphor is not for them a fanciful language reserved for poets, but an active, conceptual framework that is central to how we understand the world. For

example, the two unpack our understanding of "time as a commodity," showing how we relate our entire experience of time to monetary concepts of quantification (*you're running out of time; is that worth the time?*). Turning to politics explicitly, Lakoff argues that the most important consideration in political discourse is not how politicians respond to the "facts" of the external world, but how they conceptualize or "frame" that world in their discourse. Lakoff argues that political frames in the contemporary U.S. reflect metaphors of family management—conservatives frame political issues as "strict fathers" while liberals frame them as "nurturing parents" [13]. A self-professed liberal, Lakoff argues that if the left wants to regain political credibility, it needs to start crafting political speech with an understanding of liberal and conservative frames. The left needs to create words that reflect its ideas [14].

On the other side of the political fence, political scientist Frank Luntz specializes in helping conservatives frame their spoken discourse to create the greatest appeal possible—what he calls "message development" [17]. Luntz was responsible for much of Newt Gingich's 1994 "Contract for America," and more recently he has guided conservatives on the strategic use of such terms as "war on terror" instead of "war in Iraq" and "climate change" instead of "global warming." While Lakoff talks in terms of "frames," Luntz speaks of "contexts"—ways to repackage positions so they carry more political currency [18,19]. Some have criticized Luntz's message development strategy as misleading or immoral (cf. Luntzspeak.com, a website maintained by the National Environmental Trust whose sole purpose is to critique specific instances of Luntz's messaging strategy) but politicians take his advice to heart, and evidence of his influence and success are increasingly apparent [6,7].

In addition to becoming the year of an American political divide, 2004 was also the year when political videogames became legitimate. While there are early precedents, games that carry political messages [2,8,9], as well as independent games created to make political statements [10,16,22], 2004 was the first year that candidates and party groups created officially endorsed games to bolster their campaign for U.S. President [5,23], U.S. State Legislature [4], U.S. Congress [3], and even President of Uruguay [11]. As the worlds of political message strategy and political videogames gain momentum, an opportunity arises for each to inform the other. However, Luntz's message development and Lakoff's framed discourse both define strategies for *spoken or written* political rhetoric. This chapter offers an approach to analyzing political rhetoric in videogames intended to carry ideological bias, paying special attention to the work of metaphor and frame as procedural rather than verbal strategies. I argue for three ways games function in relation to

ideological frames: *reinforcement, contestation,* and *exposition* through examples of art games, political games, and commercial games.

Reinforcement

"Traditional" uses of language do have some place in videogame-based political messaging. The GOP's second game of the 2004 campaign, *Tax Invaders,* is a replica of the classic arcade game *Space Invaders,* but players defend the country against John Kerry's tax plans instead of an alien invasion [23,30]. The player controls a disembodied George W. Bush head, which she/he moves from side to side along the bottom of the screen in place of the original game's space gun. Instead of descending aliens, the player combats potential John Kerry tax cuts, represented as abstract rectangles bearing the value of the proposed tax. The player fires projectiles out of the top of Bush's head to "shoot down" the tax hikes and defend the country.

The game's implementation is extremely crude; if left idle long enough the taxes/aliens even pass over the player and off the bottom of the screen. But the written text used to contextualize the game actions enacts logic familiar to both Lakoff and Luntz: it casts tax increases as an anthropomorphized enemy, a thief against whom you must defend yourself. The game's opening text announces, "only *you* can stop the tax invader" and invites the player to "Save the USA from John Kerry's Tax Ideas." Lakoff would argue that such language reflects an underlying logic at work in conservative politics, that the people know what's best for them and that material success is moral and should not be punished. These points are evident in the language used to frame the game. *Tax Invaders* extends the verbal metaphor of "taxation as theft" to the tangible plane.

Released in early 2004 at the height of the second Gulf War, some might find it surprising that the GOP would choose to publish a depiction of George W. Bush *shooting anything.* But within the verbal rhetoric of conservative politics, taxation is a "battle" to be waged. Lakoff argues that from the conservative perspective tax increases are never proposals to improve the general social good, but always threats on the part of the government to steal what does not rightly belong to them. When someone breaks into your home, it is appropriate to brandish a gun; it's *your property* and you have to defend it. There is thus no political inconsistency in contextualizing tax opposition as hostility, indeed as violent hostility. In the context of *Tax Invaders,* George W. Bush's bullet-like projectiles are not akin to Army rifles wielded against innocent Iraqis, but rather to the policeman's sidearm wielded against a criminal.

A simple game like *Tax Invaders* could be said to wear its rhetorical frame on its sleeve; indeed, the instantiations of conservative contexts are almost

identical to their verbal counterparts; for example, we might talk about politicians "shooting down" a measure in Congress. The idea of a legislator "shooting down" a tax hike proposal is hardly preposterous; the game just makes such a verbal frame visually manifest. The game also frames the metaphors of its rhetoric; Bush *fires* projectiles at the tax cuts, representing the metaphor of tax hikes as enemy threat. Thus while *Tax Invaders* does little to represent actual tax policy, it frames tax policy in a way that reinforces a conservative position. Verbal language tends to remain imperceptible; its function as metaphor remains largely hidden to speakers because they are mired in their own fluency. I would argue that the game thus serves as an example of the *reinforcement* ideological frame. By drawing attention to the correlation between battle and taxation, the game not only makes its argument from within that frame, but also it explicitly draws attention to the frame itself.

Tax Invaders, and games like it, can thus serve opposing political purposes. For conservatives it reinforces the notion that taxes are an invasion and we need to "wage war" against them, like we would against alien invaders. This sort of rhetoric would be much more difficult, or at least more inappropriate, to enact on the soapbox. On the public pulpit, grandstanding politicians rely on the perlocutionary rather than illocutionary effect of their rhetorical frame. In speech act theory, an illocutionary act carries propositional content that the utterance expresses literally. A perlocutionary act carries an effect that is not expressed in the utterance, such as persuasion [1,29]. *Tax Invaders* offers the unique ability to convert perlocution into illocution. Instead of using verbal frames, the GOP has made the symbolic underpinning of their rhetorical context manifest in the game itself. In essence, *Tax Invaders* is a lesson in how to *think about* tax policy like a conservative. The game says "Think of taxation as an invasion meant to harm you" rather than "We must fight against tax increases." For liberals, *Tax Invaders* reinforces the conservative frame on taxation, namely, that it is a theft rather than a contribution to the common social good. Playing the game critically might assist liberals in orienting their frame in opposition to that of conservatives. Each perspective is one side of the same coin: while *Tax Invaders* offers only a very rudimentary treatment of tax policy, it offers a more sophisticated reinforcement of a conservative rhetorical frame on tax policy.

Contestation

Tax Invaders' political register still operates primarily through verbal language (the text inside the game) and macroscopic imagery. Yet games are fundamentally procedural, not written or visual. To understand the function of frame and metaphor in communicating ideological bias in videogames, we

must look at how the interactions of rules create similar frames as language-based political expression, equal in significance to families around the dinner table or a public figure at the podium but different—and perhaps differently successful—in form.

In Martin Le Chevallier's art installation game *Vigilance 1.0*, players seek out deviants on surveillance screen-like sections of an urban environment [16]. The game screen is divided into small squares each of which displays a different segment and scale of the detailed city. Citizens traverse the environment, completing tasks like shopping at the supermarket or relaxing in a park. The player is asked to watch these screens and identify improprieties ranging from littering to vagrancy to prostitution. Armed with a small circular cursor, the player must constantly scan the environment, pointing out infractions by clicking on offenders. For each success, the player is rewarded with points proportional to the severity of the offense. Erroneous identifications lose the player points for defamation. With every offender that passes by unnoticed, the more depraved the society becomes, and vice versa.

Vigilance's rules are incredibly simple. The player can censure citizens, successes are rewarded and failures punished, for each success the society becomes more pure, for each failure or omission more base. It is a game about surveillance guised as one about moral depravity, the sixteen rectangular segments of the screen akin to a security guard's video monitors. The player's "vigilance" quickly devolves into its own perversion, that of unfettered surveillance.

Because the game creates a positive feedback loop for depravity in the society, any attempt on the player's part to cease her/his vigilant oversight creates more corruption, reinforcing the need to monitor. By forcing the player to see the consequences of the metaphor of vigilance as comprehensive regulation, the game *challenges* the ideological frame it purportedly represents. The game's purpose is not to promote surveillance or moral purity, but to call it into question by turning the apparently upstanding player into one of the depraved whom he/she is charged to eliminate.

On first blush, *Vigilance* seems to reinforce the ideological frame of vigilance as safeguard. The game supports this sentiment through its rules, which provide positive feedback for increased surveillance. But over time, the player comes to realize that her/his adopted role as overseer is no less perverse than the game's abstract representations of moral depravity—prostitution, vagrancy, zoophilia. The game then affords the player a variety of ways to interrogate this challenge. For one part, it uses an arithmetic algorithm to control the amount of depravity to feed back into the system. Identifying more perverse acts increases the score more rapidly; for example, public drunkenness is worth +2, abandoned trash +1. The player could choose to target only the most egregious acts as a kind of strategy for more efficient

moral sanctity. But while watching for public urination or zoophilia, many more low-level acts will already have begun spiraling the society into further chaos. *Vigilance* thus provides a variety of player-configurable lenses through which to consider and reconsider the ideological frame of vigilance as inviolability.

Exposition

Both *Vigilance 1.0* and *Tax Invaders* seem like special cases, games created explicitly with ideological bias in mind. Commercial games may be less deliberate in their rhetoric, but they are not necessarily free from ideological framing. In *Grand Theft Auto: San Andreas,* players enact the life of an early '90s Los Angeles gangbanger [24]. Whereas previous iterations of the series favored stylized representations of historico-fictional times and places [25,26], *San Andreas* takes on a cultural moment steeped in racial and economic politics. Rather than taking on the role of an organized criminal, the player is cast as CJ, an inner-city gangster. *GTA*'s use of large navigable spaces and open-ended gameplay have been widely cited and praised, but in *San Andreas* open gameplay, expansive virtual spaces, and the inner-city characterization collide to underscore opportunity biases.

Some of these collisions are straightforward; for example, *San Andreas* added the requirement that CJ eat to maintain his stamina and strength. However, the only nourishment in the game comes from fast food restaurants (chicken, burgers, or pizza). Eating moderately maintains energy, but eating high fat content foods increases CJ's weight, and fat gangsters cannot run or fight very effectively. Each food item in the game comes at a cost, and the player's funds are limited. Mirroring real fast food restaurants, less fattening foods like salad cost much more than high calorie super-meals. The dietary features of *San Andreas* are rudimentary, but the fact that the player must feed his/her character to continue playing does draw attention to the material conditions the game provides for satisfying that need, subtly exposing the fact that problems of obesity and malnutrition in poor communities can partly be attributed to the relative ease and affordability of fast food.

More meaningfully, the game's use of open-ended virtual spaces also frames a discourse about crime and criminals. *San Andreas* intricately recreates representations of three huge cities (the equivalents of Los Angeles, San Francisco, and Las Vegas) along with rural spaces inbetween. CJ has recently returned to his hometown neighborhood (the Los Santos equivalent of LA's Compton) to avenge his mother's death. The player can customize CJ's clothes to some extent and, of course, steal nice cars for him, but he remains a black youth from Compton wearing classic gang-associated paraphernalia like do-rags. Thanks to the immense simulated space of the city, the player

can travel from neighborhood to neighborhood; the buildings, scenery, vehicles, and people adjust accordingly. But something remains the same everywhere in Los Santos, from its Compton to its Beverly Hills: no matter the location, the game's non-player characters (NPCs) respond to your semiautomatic-toting, do-rag wearing black gangsta character in roughly the same way.

While major technological challenges impede the development of credible large-scale character interactions [21], *San Andreas* makes no effort to alter character behavior based on race, social standing, or location. Bumping into a leggy blonde on Rodeo Drive elicits the same anonymous outcry as would jostling a drug dealer on Atlantic Drive. When mediated by the game's inner-city context, its procedural interaction of space and character creates a frame in which the player's street gang persona does not participate in any historical, economic, racial, or social disadvantage. The aggregate procedural effects in *San Andreas* thus *expose* an ideological frame, and perhaps a surprising one.

In *Moral Politics,* George Lakoff convincingly argues that the conservative frame for crime is an extension of the "strict father" model of seeing the world. The strict father disciplines his children and acts as a moral authority. Through this example, he instills discipline and self-reliance. Self-reliant, morally disciplined adults make the right decisions and prosper. Morally depraved adults do not deserve to prosper and may even be dangerous. Lakoff contrasts the conservative strict father with the progressive "nurturing parent." Unlike the strict father, the nurturing parent believes that support and assistance helps people thrive, and that people who need help deserve to be helped. Nurturing parents reject self-discipline as the sole justification of prosperity and allow for economic, cultural, or social disadvantages that might suggest some people deserve even more assistance.

By failing to generate responses across the socioeconomic boundaries of the game's virtual space, *San Andreas* exposes something closer to the conservative ideological frame on crime. If the game's NPC logic were to admit to cultural and economic disadvantages as factors that mediate interaction between characters, it would also have to admit that such factors are external to CJ (the player's character) and thus attributable to something outside CJ's character and self-discipline. To play *Grand Theft Auto: San Andreas* is to participate in the metaphor of crime as decadence. This is an especially troubling frame for the game to expose given that the player is the one in control of CJ. Despite its purported open-endedness, *San Andreas* offers incentives to play its missions, and thus incentives to engage in criminal behavior. While the story does problematize the notion that gang members have moral options—CJ is set up by a corrupt cop and sent on the run—once outside of the mission architecture the game has no procedure in place to mediate char-

acter interactions. Notably, the open-ended gameplay reorients the player back toward the missions; the game will not unlock cities beyond San Andreas unless the player reaches key waypoints in the missions. Despite its narrative gestures toward subverting the gang as a possible social adaptation, the game situates the story missions as small accidents in the broader urban logic. As the player exits the open urban environment and re-enters the missions, she/he does so willingly, not under the duress of a complex historico-social precondition. This rhetoric implicitly affirms the metaphor of criminal behavior as moral depravity.

Design Futures for Political Games

Politicians are already familiar with Lakoff and Luntz's strategies on framing political speech, especially public speech. Those who wish to create videogames as endorsed speech will undoubtedly need to pay more attention to the use of context in such games. A shift away from verbal contextualization and toward procedural contextualization in such games will likely take longer. Perhaps most promising is videogames' potential to help citizens change or "shift" frame through reinforcement, a task George Lakoff argues is the central one in contemporary progressive politics. Finally, unexpected ideological frames like those exposed in *Grand Theft Auto: San Andreas* do not necessarily indicate that commercial developers have a hidden political agenda. It is much more likely that they are unaware that the procedural interaction in the game can imply a particular ideological stance. Market forces are unlikely to expose such failing as imprudence, and thus the task of unpacking ideology in games like *San Andreas* will become the work of the critic.

References

1. Austin, J. *How to Do Things With Words.* Cambridge, Harvard University Press, 1962.
2. Barbu, L. *Crisis in the Kremlin.* Spectrum Holobyte, 1991.
3. Bogost, I. *Activism: The Public Policy Game.* Persuasive Games, 2004.
4. Bogost, I. *Take Back Illinois.* Persuasive Games / Illinois House Republicans, 2004.
5. Bogost, I. and G. Frasca. *The Howard Dean for Iowa Game.* Dean for America, 2003.
6. Booth, W. "For Norton, a Party Mission." *Washington Post* (January 8, 2001). Available at http://www.washingtonpost.com/ac2/wp-dyn/A29810–2001Jan7? language= printer. (Last accessed July 14, 2006).
7. Cart, J. "Bush Opens Way for Counties and States to Claim Wilderness Roads." *Los Angeles Times* (January 21, 2003). Available at http://www.propertyrightsre-

search.org/ bush_opens_way_for_counties_and_.htm. (Last accessed July 14, 2006).

8. Crawford, C. *Balance of Power.* Mindscape, 1985.
9. Crawford, C. *Balance of the Planet.* Chris Crawford, 1990.
10. Frasca, G. *September 12.* Newsgaming.com, 2003.
11. Frasca, G. *Cambiemos.* Frente Amplio Nueva Mayoria, 2004.
12. Lakoff, G. *Women, Fire, and Dangerous Things.* Chicago, University of Chicago Press, 1990.
13. Lakoff, G. *Moral Politics: How Liberals and Conservatives Think.* Chicago, University of Chicago Press, 1996.
14. Lakoff, G. *Don't Think of an Elephant: Know Your Values and Frame the Debate— The Essential Guide for Progressives.* New York, Chelsea Green, 2004.
15. Lakoff, G. and Johnson, M. *Metaphors We Live By.* Chicago, University of Chicago Press, 1980.
16. Le Chevallier, M. *Vigilance 1.0.* Dial 33 then 1 exhibition, Kiasma Museum, Helsinki, 2000.
17. Luntz, F. I. "The Environment: A Cleaner, Safer, Healthier America." Luntz Research Companies report, 2003.
18. Luntz, F. I. "The Best and Worst Language of 2004: Key Debate Phrases." Luntz Research Companies report, 2004.
19. Luntz Research Companies. "Energy, Preparing for the Future. Lunz Research Companies Report, 2002. Available at http://www.ewg.org/issues/MTBE/ 20031117/LuntzMemo_Energy.php.
20. Marinucci, C. "In postmortem on Kerry bid, Dems seek clues to new life." *San Francisco Chronicle* (November 7, 2004). Available at http://sfgate.com/cgi-bin/article.cgi?file=/c/a/2004/11/07/MNGQ09NJOC1.DTL. (Last accessed July 14, 2006).
21. Mateas, M. and A. Stern. "A Behavior Language for Story-Based Believable Agents." In K. Forbus and M. El-Nasr Seif (eds.), *Working Notes of Artificial Intelligence and Interactive Entertainment.* Menlo Park, CA, AAAI Press, 2002.
22. On, J. *Antiwargame.* Futurefarmers, 2001.
23. Republican National Committee. *Tax Invaders.* Republican National Committee/gop. com, 2004.
24. Rockstar Games. *Grand Theft Auto: San Andreas.* Take Two Interactive, 2004.
25. Rockstar Games. *Grand Theft Auto: Vice City.* Take Two Interactive, 2003.
26. Rockstar Games. *Grand Theft Auto III.* Take Two Interactive, 2001.
27. Schifferes, S. "Election Reveals Divided Nation." BBC News (November 3, 2004). Available at http://news.bbc.co.uk/1/hi/world/americas/3973197.stm. (Last accessed July 14, 2006).
28. Schifferes, S. "What next for the Democrats?" BBC News (November 3, 2004). Available at http://news.bbc.co.uk/2/hi/americas/3978689.stm. (Last accessed July 14, 2006).
29. Searle, J. *Speech Acts: An Essay in the Philosophy of Language.* Cambridge, Cambridge University Press, 1969.
30. Taito. *Space Invaders.* Taito, 1978.
31. Vanderbei, R. J. "Election 2004 Results" (2000–2004). Available at http://www.princeton.edu/%7Ervdb/JAVA/election2004/. (Last accessed July 14, 2006).

32. Wallsten, P. and N. Anderson, "Democrats Map Out a Different Strategy." *Los Angeles Times* (November 6, 2004). Available at http://www.latimes.com/news/politics/2004/la-na-dems6nov06,0,680680.story?coll=la-home-headlinesNovember%206,%202004. (Last accessed July 14, 2006).

7. Playing Through: The Future of Alternative and Critical Game Projects

Patrick Crogan

Introduction

This chapter explores a number of experimental game-based projects in order to interrogate the critical potential of computer games. This potential could be understood as the possibility of interrogating the relationship of games to their contexts of production and consumption. Games theorist and designer Gonzalo Frasca has linked this potential with the fact that computer games are a simulation-based form. This proposition will be evaluated with reference to philosopher of technology Bernard Stiegler's conceptualization of the mnemotechnical forms humans have developed for the recording and interpretation of cultural experience. In this light, simulation will be compared to narrative and theatrical forms, the forms to which Frasca opposes it in his account of simulation as the "form of the future." In analyzing the different ways the game projects under consideration construct critical gestures and user engagement, this chapter will set out to show the necessity of complicating the view that simulation is both the only cultural form facing the future, and is only facing the future in its temporal orientation. The past of computer simulation, a past dominated by military technoscientific developments, comes with it and must be considered in any theorization of its critical potential as a cultural form.

Theaters of Cruelty

Two experimental game projects, C-level's *Tekken Torture Tournament* and ////////fur//// art entertainment interfaces' Painstation 1 and

Painstation 2 attempt a critical interrogation of gaming culture by raising the stakes of playing the game. *Tekken Torture Tournament* is described on the C-level website as follows:

> *Tekken Torture Tournament* is a one-night event combining the latest video game technology, untapped public aggression and painful electric shock. Willing participants are wired into a custom fighting system—a modified Playstation (running Tekken 3) which converts virtual on screen damage into bracing, non-lethal, electric shocks. [19]

The Tournament has been run at a number of venues from 2001 to 2004.

The *Painstations 1* and *2* consoles allow for single or two-player contests in a tennis game modeled on the early console classic, *Pong* [2]. Pain is administered through both electric shocks and a small whip that is mechanically activated to strike the player's hand when the player loses a point. The *Painstation 2* boasts increased flexibility in pain administration, whip varieties and the inclusion of "different bonus symbols [that] appear on screen and result in multiplied pain, multiballs, shrunk bars [paddles], reversed directions etc." [2]. The Painstations have been exhibited and played at a range of events, conferences, and exhibitions from 2002 to 2004.

While both of these projects involve the technical modification of game consoles so that individuals have an altered encounter with game play, the theatrical nature of these game projects is central to their impact and their engagement with contemporary game culture—that is, with the contemporary audio-visual and technocultural milieu in which computer games have an increasingly prominent place. The exhibition of the game console makes the volunteer players part of a witnessed performance. Drawing on the practices of body performance work, and in particular those which include painful experiences for the performer(s), these game performances involve the audience in a dynamic of participant spectatorship in events and actions that challenge conventional frameworks for understanding and responding to game play. C-level's citing of "untapped public aggression" as one of the elements combined in the creation of *Tekken Torture Tournament* indicates the importance they place on this theatrical dimension of the work.

In relation to a characterization of the milieu out of which these game-art projects have emerged, the 'reality TV' phenomenon should also be noted. In particular, that strain of reality TV programming that energizes a ludic format with the same "untapped public aggression" that the makers of the Painstation solicit presents itself as a commercialized, mainstream form of these more ironic and critical theaters of cruelty. A comparative analysis between the theatricalization of pain and suffering in reality TV and the performance art traditions of these works is beyond the scope of this chapter.

When one considers, however, that *Survivor*, the immensely successful international format that has been the progenitor of many subsequent shows in the "game with painful consequences" category (for example, *The Fear Factor, The Weakest Link, My Big Fat Obnoxious Fiancée*), was devised by a former British Special Forces member, the connections being made by these art projects between gaming, entertainment and the history and technoscientific practices of military simulation and training could form the basis of such a comparative exercise.

On one hand—and literally, on the hand connected to the console—experimental game projects turn on a modification to the technical equipment providing the game experience, a modification that increases the real-world consequences of losing the contest. On the other hand this physical extension and intensification of the stakes of the game is what enables a theatricalization of the gaming situation, or, rather, a major transformation of the already performative element of competitive console game play. This performance, usually dedicated to the creation of an affirmative spectacle of personal skill and the victorious execution of game play, is replayed and complicated in and as a staging of painful physical interaction including sadistically (and/or masochistically) motivated gestures and affects circulating between players and spectators.

The bodily commitment each project demands from the volunteer players is an explicit response to the widely perceived "virtual" character of computer gaming. Through this process, however, the gaming situation is itself virtualized or, rather, theatricalized in Samuel Weber's terms [3]. That is, it is removed from the usual "real world" context in which competitive computer game play is taken as a familiar and recognized aspect of contemporary audiovisual, technocultural experience having predictable significance and outcomes. In other words, it is not allowed to take its usual place in the real. Its habitual occurrence is suspended, and game play is "put under a spotlight" temporarily, in the time of its theatrical staging by each work.

For Weber, theatricality is a process of turning a general space into a particular place that subtends and enables theater to exist. While it occurs in the theater as traditionally understood, theatricality is not limited to the space of conventional theater but is also to be found in other processes where "theaters" are created such as the military "theater of operations." As the military comparison suggests, this taking-place is understood by Weber to always be caught up in the difficulty of finding the "proper limits" to this place. The importance attached in military operations to "defining, delimiting, and controlling the space of conflict" is an extreme case of the general situation in which theatricality works with a space that is intrinsically unstable [3]. This is because theatricalized space is always the space in which a certain scene is

"staged," that is, actualized as both a determinate, local space and as one which is other than what, where and when it is.

The relation between theatricality and military operations is not irrelevant here. As "cruel theaters," these projects stage a military theater of operations playfully, inasmuch as the object of war, as Paul Virilio points out, is to create an environment for your opponent that is uninhabitable [4]. This is the principal winning strategy in the Painstation contests I witnessed, namely, to make your opponent leave the table. That is to say, the games within these performance artworks are either staging a scene of violent conflict—the Tekken fighting game as model for *Tekken Torture Tournament*—or, in the case of the *Painstation*'s evocation of virtual tennis, a theatrical "rematerialization" of a more sublimated form of war.

How do these specific stagings of game play help us to think about game play as we usually perceive it outside their theaters of cruelty? For one, they gesture reflexively toward a computer game's virtual suspension of the real. As forms that simulate a space and a context of competitive conflict, the computer games that are the subject of these experimental works render an experience of contestation in the register of entertainment supposedly distant from the serious business and high stakes of real-life conflict. The separation of entertainment and leisure activities from the sphere of the serious is, however, by no means unproblematic. These projects play a part in undermining the legitimacy of this separation; they each rework the space of electronically mediated competition. To play against an opponent is to take up a position within the technically determined milieu of computer-generated game play. That is, it is play in and through a virtual information space, a space negotiated via the characteristic bodily disposition of personal computing/console play. This requires engagement in a cybernetic circuit as a key node in feedback loops of rapid decision-making executed via a physical regime of local immobilization enabling continuous micro-movements of eye-hand coordination. As I have characterized it elsewhere, this modality of interpellation into/as a key communications node between the input and output devices of a computing system reproduces the "primal scene" of cybernetics: the "man in the middle" of a mechanically enhanced weapons system [5].

To reproduce a scene is not necessarily to repeat it identically. Moreover, as Bernard Stiegler points out (after Walter Benjamin), the act of reproduction is always the possibility of change, of differentiation, of invention [6]. There is, in fact, no other possibility of change. Computer games reproduce playfully cybernetic principles for improved control of systems and events. Their critical, reflexive potential, as well as their entertainment value, depends on this capacity to both adopt the technoscientific heritage and modify it. The *Painstation* and *Tekken Torture Tournament* reproduce the Playstation entertainment system theatrically to invoke reflection on the ludic adoption

of military technoscience in contemporary audio-visual culture. This reflection is made possible by the playing out of these theaters of cruelty, each time they are staged at a particular location. That is to say, design of the modified Playstations and the staging of the game tournaments incite participants to think about game play and game consoles and their historical relation to modern warfare and the history of computing. This does not mean, however, that the "content" of the game projects can be described and stabilized as a set of propositions about these histories. In this regard, Weber points out something crucial when he says that "theatricality is defined as a problematic process of placing, framing, situating rather than as a process of representation" [3]. As such, it works toward achieving a certain effect rather than taking that effect as given. It is principally projective rather than reflective, aesthetic or re-presentational, processes which can only commence in the security of a stabilized space of representation. This is in the future of these critical, theatrical projects which solicit one to participate in their forceful determination.

The future of the theatrical representation of the shared past of computer games, audio-visual culture and military technoscience in these two game projects depends on the speculations and imaginary projections they elicit from their future participants. These speculations will be about a past that has always already come before the participant in the work, inasmuch as he/she is an inheritor of the technocultural history it represents. That is to say, the past involvements of military technoscience and technoculture are, paradoxically but necessarily, "before" the participant's adoption of them in his/her particular manner; they will have been (in) his/her "future." This is why reflection on the past runs always and inevitably into speculation on the future possibilities arising from this curious future of the pre-existing past. As Weber has argued, the theatrical "taking place" sets to work this paradoxical, speculative reflection as constitutive of the potential formal, conceptual and aesthetic significance of events. The makers of the Painstations have indicated the speculative nature of their project on the "Concept" page of the "Old Painstation" website:

> Yes, the painstation does exist. And it's not only a construction, a machine, an automaton. No, it's rather the prophet of a future, not necessarily peaceful, but more-efficiency-civilization. [2]

The precise contours of this "more-efficiency-civilization" that the makers of the Painstations envisage (ironically, no doubt) in and through their creation could be the matter of substantial speculation. The point being, of course, that it creatively reproduces a game technology and culture of use—influential within today's audio-visual entertainment culture—in order to speculate on the future of contemporary technoculture and "civilization"

generally. To speculate on the future is first to make the means of speculation possible. This is something that Gonzalo Frasca will ascribe as a key element of the promise of experimentation with computer game design and form. This promise is in his view intricately bound up with the nature of computer games as instances of the simulation mode of cultural production that is becoming central to contemporary technocultural forms based on computing technology. In the next section, I examine this claim carefully because it seeks to identify the critical potential of computer gaming as such, that is, as simulational form. While the game projects discussed so far stage the distance between gameplay and "real life" in gestures that destabilize the habitual place computer gaming occupies "in" contemporary life, they do so precisely in response to the phenomenon of computer games as a predominantly simulation-based form which has come to pose its own questions about life now and in the future. Frasca sets out to show how games could activate a critical force for change by modifying simulation's questions "from within."

Simulating the Serious

In "Simulation versus Narrative: Introduction to Ludology," Gonzalo Frasca puts forward an argument about the future of media forms based on the interactive simulation model underlying computer games (and other new media forms) [7]. He states their future is tied to the fact that simulation deals in a futural temporal mode of user (player) engagement—a simulation, unlike narrative and drama, "is the form of the future. It does not deal with what happened [narrative] or is happening [drama] but what may happen. Unlike narrative and drama, its essence lays on a basic assumption: change is possible" [7]. He outlines a scheme that could be represented as follows:

Table 7.1

Narrative	?	Past
Drama	?	Present
Simulation	?	Future

Frasca argues we are only beginning to explore the rhetorical possibilities of the simulation form. Indeed, in this vision the future-directed modality of simulation opens up its own aesthetic development as a key element of the possible change it promises.

In another text Frasca argues that a key difference between traditional representational forms (such as the narrative representation of events) and a simulation is that traditional representation typically operates from the "bot-

tom up," that is, from the specific situation general reflections are drawn [8]. In a simulation, however, a "top down" process operates in which the general features of a system are modeled so that various specific, "hypothetical" situations can be deduced or examined. This projective or experimental characteristic of the functioning of simulation is what makes it in Frasca's view the "form of the future."

Frasca's is a provocative and insightful gesture toward a possible other future for games and gaming as cultural activity beyond the already well-established parameters of commercial entertainment gaming. He focuses on simulation as key to this possibility, responding to the widespread perception that simulation technologies are the decisively new element in contemporary technoculture. This is an entirely justified and, even, essential move for any attempt to characterize the wider situation making itself evident in a range of phenomena associated with "new media" and their impact on contemporary audio-visual culture. Espen Aarseth neatly sums up the importance of simulation for thinking computer games in this wider context:

> The question is what is the essence of computing? If there is such an essence we could say it is simulation: that is the essence from Turing onwards. Games of course are simulations and computers are a prime platform for doing simulations. [6]

Frasca's insight concerning the future orientation of simulation is, however, limited by its naïve apprehension of what simulation has to offer critical responses to contemporary mainstream technoculture. This limitation can be articulated as two significant and related aspects of his approach to simulation. First, the history of computer simulation is, as has been shown elsewhere, a history influenced substantially by military technoscientific prerogatives [5,9,10,11]. These prerogatives are reproduced in gaming and experimental adoptions of simulation and, while it is important to point out (see above) that any reproduction is also the possible mutation or innovation of what is reproduced, it is no less important to understand the nature and conditions which impose themselves on the invention of the new as reproduction of a given heritage. In other words, if simulation is for audio-visual, computer-based culture generally the "form of the future" this is in large part because of a history of specific, enchained, military-industrial technoscientific developments occurring in and as a particular cultural history which must not be discounted in assessing the significance and potential of simulation in general. The defining moment of this history would be the development of the digital computer across a number of military technoscientific projects in the 1940s. Other key links in the chain would be the rise of cybernetics, the birth of "cognitive simulation" research (later to become the discipline of Artificial Intelligence), the introduction of computer graphics and

interactivity in military flight simulation and the development of distributed interactive simulation networking software and protocols for multi-user, real-time simulation training.

Secondly, this forgetting of the past of simulation technology is echoed in the schematization of narrative, drama and simulation as forms whose predominant temporal user-engagement can be assigned as past, present and future. As has already been examined, Weber's notion of theatricality disturbs the placement of drama in the middle of this schema; a theatrical taking-place is fraught with an oscillating reflective-speculative solicitation of the participant in and as the present moment of the theatrical presentation. In Weber's terms, "securing the perimeter" is always part of the stakes of the theatrical event, however conventional the nature of the dramatic staging and performance.

Frasca indicates an awareness of the reductive dimension of this schematic conceptualization of the temporality of different cultural forms elsewhere in his writings. In "Videogames of the Oppressed," Frasca criticizes the overly Aristotelian dramatic orientation of the commercial gaming industry which he argues reproduces the "immersive" tendency of conventional entertainment forms [12]. He calls for a more Brechtian theatrical engagement of the gamer in a more critically active process of game design and game play. More precisely, he cites the work of Brecht-inspired Brazilian playwright and theorist Augusto Boal, developer of the "Theater of the Oppressed," as a major influence on his approach to simulation [12]. This alternative theatrical solicitation of the gamer would promote a reflexive gaming experience focused on real social-political issues or questions by means of game play that encouraged reflection and intervention in the models underlying the game as a simulation system. This would alienate the player from an uncomplicated, "passive" acceptance of the game's simulation of some real- or imaginary world and return him/her to the less assured process of "theatrical" taking-place (in Weber's terms) in order to produce critical reflections and speculations on the game's construction of the world—real and imagined, existing and potential.

In relation to the first term in this schema—narrative, drama, simulation—the viability of the conventional ascription of narrative as a form dedicated to the past also requires careful interrogation, inasmuch as it contributes to the determining of simulation as the form of the future. No complication or qualification of the placement of narrative in the schema is apparent in Frasca's work. In order to elucidate the problems of preserving the future for simulation we will examine some experimental and non-commercial, "serious" game projects that answer (or fail to answer) to Frasca's call for exploration of the critical or transformative potentiality of

simulation. This will enable us to identify how simulation engages the futural mode and where the past "is" in its experimentations.

Frasca's own *September 12th: A Toy World* (Newsgames, 2002) provides a powerful critique of the U.S.-led war on terror by means of a parodic evocation of the legion of shoot-em-up web-based games that populated the internet in the period following the September 11, 2001, attacks and during the ongoing U.S.-led "War on Terror" in Afghanistan and Iraq [13]. Users have a mouse point and click interface to target and shoot missiles at "terrorist" icons moving amongst "civilians" in a Middle Eastern-styled urban landscape seen from an overhead perspective. Terrorist icons carry guns and civilian icons do not. Identify the terrorist, put the cross hairs on him (always "him") and fire and forget. The designers have put a time lag on the firing and delivery of the missile so that it is very difficult to "hit" the target and, in all cases, civilians and urban structures are also hit. In the countdown to the next missile becoming available, it becomes evident that more terrorist icons are generated out of the rubble produced by the missile strikes. If one does not fire (the only alternative to using the available interface), the number of terrorists seems to remain stable.

September 12th: A Toy World announces itself with a screen that states "This is not a game. You can't win and you can't lose. . . . This is a simple model you can use to explore some aspects of the war on terror" [13]. It "answers" the numerous anti-terrorist java-script games that mobilize the shoot-em form in less parodic or reflective fashion, generating a political critique principally by means of its interruption of the expected routines of the target-and-shoot form of interface. The overhead point of view of the user elegantly evokes the remote control intervention of hi-tech weaponry in both its fallibility and its distantiation of the enemy from the space of the user/missile fire controller.

As a gesture to the future of gaming and simulation rhetoric, *September 12th* proposes a modulation of established game modeling of war in order to open up reflection on strategic, political, and cultural assumptions latent in mainstream shoot-em forms. In this it lives up to Frasca's call for critical gaming that goes beyond a simple parodic appropriation of existing games. By contrast, this would be an apt characterization of the project of *Donkey John* (Boughton-Dent, 2004) [1]. *Donkey John* is an advocacy game in support of East Timorese efforts to negotiate a better deal with Australia for sharing the revenue from oil and gas reserves situated in the Timor Sea. It cites the classic Nintendo handheld game *Donkey Kong*, substituting Australian Prime Minister John Howard for "Kong" and Timorese President Xanana Gusmao for the player-avatar. In this game the force of the political critique is carried by an appropriation of a familiar cultural work, the Nintendo gameboy game and character, that substitutes the political figures as the "monster" (game

challenge) and the player. No modification of the game model exists in this political game and consequently the game functions as an amusing, ironic reference to the "real situation" as a game of geo-politics and economic competition among unequal opponents.

In a similar vein, *Under Ash* and its successor, *Under Siege: Under Ash 2* (Akfarmedia 2002–2004), rely for their critical polemical impact on an appropriation of the existing commercial game format of the first-person shooter [14]. These games "invert" the expected scenario of a commercial counter-terrorist shooter by making the player-avatar in these single player games a member of the Palestinian Intifada battling against Isreali occupation forces. In my own experience, the impact of this reorientation in the brutal space of urban warfare is undoubtedly significant. The game developers state on their website that they wanted to provide an alternative leisure activity for Palestinians over 13 to one "previously filled with foreign games distorting the facts and history and planting the motto of 'Sovereignty is for power and violence according to the American style'" [14]. They pursue this propagandistic goal, however, in what is basically a reproduction—in a much less forgiving register—of the generic spaces, game challenges and non-player characters produced in the standard game engines of commercial first-person shooters.

Conversely, *September 12th* realizes a situation imagined by Sherry Turkle (and cited by Frasca in "Videogames of the Oppressed") in which a new critical practice would:

> take as its goal the development of simulations that actually actually help players challenge the model's built-in assumptions. This new criticism would try to use simulation as a means of consciousness-raising. [12]

This is an apt and concise summary of the project Frasca outlines in his discussions of the future possibilities of experimentation with the existent forms of computer simulation. In this projected and partly instantiated future of critical production, simulation is a tool for promoting critical thinking about the differences between the modeling of a situation or phenomenon and the "real" thing in all its social and political complexity. In Frasca's terms, it imitates the way Augusto Boal "uses theater as a tool, not as a goal per se" [12].

If simulation is a tool of sorts, like theater, then so is narrative. From this perspective, narrative could be thought of as a technology for selecting, arranging and understanding experience—as an "interpretation machine." Whether by means of the production of imagined or actual historical event sequences, characters and milieux, what is decisive for our argument is the capacity of narrative works—mythical/religious or historical/realist, theatrical or novelistic or cinematic or televisual—to function as exterior forms of

the remembering and archiving of human experience. Bernard Stiegler identifies narrative works as part of the mnemotechnics of a culture, by which he means that narrative works are dedicated, beyond the default memory-support function that every technical form has, to the retention of the experience of phenomena by living humans [15,16,17]. Mnemotechnics include the forms of language and writing (including narrative forms) and the forms made possible by more recent technologies of analog and digital audio-visual recording such as photography, cinema, audio recording, video, digital audio-visual technologies, and information processing and database technics. Computer simulation is a mnemotechnical form combining elements from these technologies.

As a mnemotechnical form, narrative is always already futural in temporal orientation. In other words, precisely as technics of orientation, narrative forms are ultimately future directed. The recording, arranging and interpretation of past experience produced and archived in narrative works—whether "really" lived or lived in/as imagined experience—is always accomplished with a view to the future; it is produced to be read, watched, witnessed in the future for a prospective audience or readership. The narrative work has the function of explaining to this audience-to-come what happened before they came to be the audience or readership of the work. This function links what has happened before today. Orientation is reflective and interpretative, but also an ultimately projective process: "Where to go from here? What to do next? What to become?" are the questions orientation is ultimately dedicated to answering [17].

Consequently, simulation cannot maintain a monopoly over other cultural forms for rendering human experience with regards to its capacity to engage people in their future. On the contrary, as a form that depends on the narrative mnemotechnical heritage, it is best understood as one which reproduces narrative's dedication to anticipating the future as change, potential, and as the not-yet-determined. This is evident in the way *September 12th* operates as an ironic, critical reprise of simplistic models of military-political goals and challenges. A constant theme of the history of war-gaming is at the heart of this operation, that of the tension between the historical record of warfare's complexity and unpredictability and the effort to model it. The dependence of each and every assumption in the war model on the historical archive of military conflicts produces this tension; these assumptions are literally unthinkable without the historical record.

It is because simulation is a particular, transformative reproduction of the narrative mnemotechnical tool that it is dedicated to the future in a specific, experimental, "hypothetical" manner. Like the narrative form that is a key part of its own back-story, simulation, as a new mnemotechnic, draws on the past with a view to the future. What Frasca calls its "top-down" process of

modeling a general situation draws on and synthesizes the understandings arising from the heritage of "bottom up" narrative and historical syntheses of the experiences of the past. While narrative gestures toward the "general element" in fulfillment of its orientational function, simulation mobilizes the calculative reason of technoscientific modernity to schematically map out the "general situation."

The undoing of the simplistic schematization of Table 7.1:

Narrative	?	Past
Drama	?	Present
Simulation	?	Future

means that simulation must be thought of as a new form of mnemotechnic before its specific critical potential can be adequately apprehended. It must be understood as a process of exterior memorization dedicated to the orientation of the individual/culture in time and space, here, today and into the future. Articulated at this level of conceptual generality, this is what simulation shares with narrative and the theater.

Like theatrical and simulation-based experimental projects, narrative-based works can also generate a critical encounter with simulation. Although it also relies on a theatrical staging of simulation, the Mixed Reality Lab and Blast Theory project *Desert Rain* (2000–2004) is one whose critical force arises from its historical reflection on simulation's role in recording and understanding the real [18]. This is done as part of the work's larger ambition to investigate the blurring of the distinction between mediatized representations and the reality of the 1991 Gulf War. One views the work only as a participant in a "game" in which one plays as part of a team of six. The team members are assigned the goal of finding a person whose identity is described on a small magnetic swipe card. The person must be found through cooperative action with other team members in navigating a virtual space. The simulation providing this activity is a VR-based modified military training simulation. Having successfully achieved the mission goals (or not as was the case with my team's experience of *Desert Rain*) the team members move to a kind of "debriefing" room via a passage covered in sand. This final room in the installation is a simulated hotel room with six monitors activated by the swipe cards. Testimony from the "target" people, including a "soldier in Iraq," a "tourist," a "peace-worker" and a "BBC journalist," concerning their experiences of the war and its aftermath are played on the activated monitors [18]. This is a very rich and complex work that explores themes of the representation and the perceived virtuality of war in an era of contemporary media. Its predominant mode of engaging participants is, I would argue, via solicitation of historical reflection on the war and on its representation.

The staging of the VR simulation, which is the centerpiece "attraction" of the project as "new media art installation," is devised so as to isolate that simulated experience from the passage to the "debriefing" space, in which historical accounts of war experience are represented. Ultimately, the participant/spectator is asked to compare these accounts with their experience of the mediation of war in *Desert Rain* and in their own mediated historical experience. In what is no doubt a complex staging of the challenges faced by historical discourse in the era of contemporary media technologies— indeed more complex than I have been able to indicate here—*Desert Rain* explores the struggle of narrative forms of understanding to operate in a simulated theater of operations.

Conclusion

Critical engagements with simulation and with the question of the relation of simulation to the real can be found in different combinations of narrative, theatrical, and simulation-focused mnemotechnical exploration. It is crucial to remember the common orientational function of these three forms when approaching the question of the novelty of simulation as a "form of the future." First and foremost one must challenge Frasca's assertion that simulation is the "form of the future." Simulation reproduces the projective potential of narrative and theater in a modality bearing a pre-emptive force unknown in these other mnemotechnical forms. This force is derived from the calculative ground of modern rationality in which war-gaming grew. Computer simulation developed out of the military technoscientific occupation of this ground in the century of warfare. The full implications of this for an understanding of simulation must await a future articulation. We can conclude, however, that while the simulation form inevitably opens up the possibility of its inventive recreation in a reflexive mode, as Newsgaming's *September 12th* has certainly shown, its pre-emptive tendency should not be ignored in a celebration of the critical promise of the future of "simulation in general." It may seem necessary to forget this heritage of looking to an alternative future for the simulation "tool." I have argued that on the contrary this heritage must be remembered in/as core to the proliferation of simulation in contemporary technoculture and, hence, to any adoption of it in the name of different futures.

References

1. *Donkey John* website. Available at http://www.donkeyjohn.com/donkeyjohn/. (Last accessed July 14, 2006).

2. *Painstation* pages on //////////fur//// art entertainment interfaces' website. Available at http://www.painstation.de/new/gameplay.html. (Last accessed July 14, 2006).

3. Weber, S. *Theatricality as Medium*. New York, Fordham University Press, 2004.

4. Virilio, P. *Bunker Archeology*. Trans. George Collins. New York, Princeton Architectural Press, 1994.

5. Crogan, P. "The Experience of Information in Computer Games." *Scan* 1(1) (January 2004). Available at http://www.scan.net.au. (Last date July 14, 2006).

6. Aarseth, E., and P. Crogan. "Games, Simulation & Serious Fun: An Interview With Espen Aarseth." *Scan* 1(1) (January 2004). Available at http://www.scan.net.au. (Last date accessed July 14, 2006).

7. Frasca, G. "Simulation versus Narrative: Introduction to Ludology." In B. Perron and M. J. P. Wolf (eds.), *The Video Game Theory Reader*. New York and London, Routledge, 2003, pp. 230–245.

8. Frasca, G. "Simulation 101: Simulation Versus Representation." Available at http://www.jacaranda.org/frasca/weblog/articles/sim1/simulation101d.html. (Last accessed July 14, 2006).

9. Crogan, P. "Wargaming and Computer Games: Fun with the Future." In *Level Up* (University of Utrecht, November, 2003). Available at http://www.digra.org. (Last accessed July 14, 2006).

10. Crogan, P. "Gametime: History, Narrative and Temporality in Microsoft's Combat Flight Simulator 2." In B. Perron and M. J. P. Wolf (eds.), *The Video Game Theory Reader*. New York and London, Routledge, 2003, pp. 290–305.

11. Crogan, P. "Logistical Space: Flight Simulation and Virtual Reality." In A. Cholodenko (ed.), *The Life of Illusion. Power Publications,* Sydney, forthcoming.

12. Frasca, G. "Videogames of the Oppressed." *Electronic Book Review* 3 (2004). Available at http://www.electronicbookreview.com/v3 (Last accessed July 14, 2006).

13. Newsgaming website. Available at http://www.newsgaming.com. (Last accessed July 14, 2006).

14. *Under Ash* website. Available at http://www.underash.net/emessage.htm.

15. Stiegler, B. *Technics and Time 1: The Fault of Epimetheus*. Stanford, Stanford University Press, 1997.

16. Stiegler, B. *La technique et le temps 2: La désorientaion*. Editions Galilée, Paris, 1996.

17. Stiegler, B. *La technique et le temps 3: Le temps du cinéma et la question du mal-être*. Editions Galilée, Paris, 2001, 288.

18. *Desert Rain* page, The Blast Theory website. Available at http://www.blasttheory.co.uk/bt/ work_desertrain.html.

19. *Tekken Torture Tournament* page on C-level website. Available at http://www.c-level.cc/tekken1.html.

Part II

Player/s

8. "White-Eyed" and "Griefer" Player Culture: Deviance Construction in MMORPGs

HOLIN LIN AND CHUEN-TSAI SUN

Introduction

A common phenomenon in Taiwanese massive multiplayer online role-playing games (MMORPGs) is the so-called *white-eyed* player, who acts in similar ways as a *griefer* in some online gaming communities.[1] A griefer behaves in a disruptive or distressful manner so as to negatively affect other players' gaming experiences for the sole purpose of deriving enjoyment from their behavior. In Taiwanese gaming culture, white-eyed playing includes a range of activities that transcend "grief play," although both terms are used to describe a phenomenon that sits at the core of MMORPG culture: deviancy in gaming societies. White-eyed players break the laws, codes, and rules of conduct of their game worlds, violate norms, and ignore the accepted etiquette of their communities.

Existing studies on grief play are limited in quantity and scope, with the phenomenon descriptively discussed from the perspective of anti-social behavior or alternative ways of achieving gratification. In other words, grief play is treated as a behavior that engages the griefers but remains relatively independent of other players' actions. However, the creation and circulation of white-eyed players as an accepted category suggest collective recognition and corresponding social reaction by griefers and non-griefers alike. Bringing all players into focus allows researchers to observe a wider spectrum of behaviors considered deviant in virtual communities and to study how various social control agents have shaped this process.

Analyses of grief players can also contribute to our understanding of how power emerges during social interactions. Power takes several forms in online

gaming worlds: *technopower* is written into system design and embodied in game codes, *administrative power* is wielded by game masters, and *normative power* is enforced by all participating agents via social discipline. In this study we will take a closer look at the negotiation of normative power (the least explored type) in online gaming communities. Our research questions include: Who are the griefers? How do players construct the griefer concept? What processes are involved in identifying certain actions as grief play and certain avatars as identifying griefers? What are the consequences of being labeled a griefer? How do players individually and collectively interact with griefers? How do griefers react to social punishment and discipline from other players?

In searching for social control mechanisms behind the white-eyed phenomenon, we found that the only individuals who are stigmatized as white-eyed players are repeat offenders. Beyond these explicit white-eyed players, the meaning of the white-eyed is fluid, ambiguous, and multiple. We will therefore introduce a second analytical approach, one that constructs the white-eye phenomenon as an othering process, to enhance and expand our understanding. By associating the griefer label with an imagined 'inferior group,' online gamers find ways to cope with anxieties associated with cross-age co-playing.

As we have stated in previous studies [1], we believe that one of the properties of online gaming that distinguish it from other games is the inability to tell the genders and ages of other players. When playing traditional games, humans tend to follow social conventions or implicit rules concerning playing partners—for instance, males play with males and females with females, and people in the same age cohort tend to play with each other. In many cases, those barriers remain uncertain in online game environments. Players try to guess the characteristics of other players behind their avatars, and feel anxious about the possibility of playing with cross-gender and cross-age strangers. In Taiwanese MMORPGs, two common put-downs expressed by offended players are "You girlboy go to hell!" and "You damned white-eye!" We found that name-calling situations involving white-eyed players usually entails the targeted player's imagined age cohort instead of their actual behavior.

Literature Review

When studying white-eyed players and reasons for their disruptive behaviors, researchers can be divided into those who take a *micro* perspective of player interaction (i.e., who try to understand griefers from their individual gaming motivations) and those who take a *macro* approach (i.e., those who examine griefers based on the rules and norms of the gaming society, thereby regard-

ing them as deviants).

Personal gaming motivations are essential to the micro perspective, but with considerable overlap. Rieber [2] created four categories of gaming motivation: play as power, as progress, as fantasy, and as self. The first category depicts griefers as doing whatever they like to do at the expense of others and feeling good when others are offended. Members of the second category want to make some quick progress by taking advantage of loopholes in game rules or taking shortcuts that other players consider unfair. White-eyed players in the third category can be viewed as exploring multiple self dimensions—for instance, achieving a better self-understanding by observing a "griefer self" in a game. Since they focus on individual player needs, the three categories largely ignore gaming contexts and complex player interactions.

In contrast, Bartle [3] emphasized interactions among various types of players. In his studies of multiple user dungeons (MUDs, considered early versions of MMORPGs), he employed two dimensions to analyze "the nature of fun": players' gaming approaches (acting/interacting) and gaming targets (gaming worlds/other players). According to this approach, players are classified as achievers, explorers, killers, and socializers; within this system, griefers are considered killers because of their aggressive attitudes. More recently, Bartle [4] has introduced a third dimension: self-awareness of player behavior (implicit/explicit). Within this more sophisticated framework, griefers are depicted as killers who are unaware of the consequences of their actions. In comparison, "politicians" are perceived as killers with conscious plans.

Bartle suggests that players transform over time—in other words, they go through different phases in their game lives. In this dynamic structure, griefers and opportunists are considered as members of "beginner" stages because they act in implicit ways toward unknown gaming environments. The variety of player types create a dynamic game world equilibrium in which griefers make a distinct contribution. Another research approach is a cultural perspective, where griefers are viewed as fulfilling a common practice of deviating from the norm. Social identity theorists (e.g., [5,6]) may provide insights into griefer behavior—for example, their collective self-concept and differentiation among individual griefers.

Before we use this perspective to analyze online games griefers, it is important to note Denegri-Knott and Taylor's [7] comment that in computer- and network-mediated environments, deviant behavior can be treated separately from the person who expresses it. Using Taiwan's MMORPGs as an example, once a player purchases a gaming account, he or she can play under three or four avatars, meaning that any player (but most likely experienced players) may choose to play as a griefer or a *red guy* (person-killer)[2] under one avatar in order to seek retaliation, express anti-social conduct,

explore special game features (e.g., "if you kill 99 avatars you will go to hell"), or make personal game progress (e.g., rob valuable objects from other players under the grief avatar, then transfer them to a non-deviant avatar). Thus, when asked to identify likely candidates for white-eyed roles, most gamers will respond that any player can be one.

However, responses are less vague to a question such as "What kind of person do you think is interested in being a griefer?" Many players associate griefers with a specific group of people—a practice of attribution known as *othering*, which is a way of defining and securing one's own positive identity through the stigmatization of an "other." It is important to identify which needs must be secured before we can understand why individuals select specific *othering* targets.

Another important issue is how to deal with griefers when they are identified, since it cannot be considered a normal example of a gaming situation. Instead, responses point to othering strategies behind griefer stigmatization. As Canales [8] notes, two types of othering serve to achieve different goals: *exclusive* for domination/subordination and *inclusive* for transformation/coalition. Seeing that some griefers are easily identifiable (sometimes openly organizing griefer pledges), one must ask whether associating them with a certain group is an example of exclusive or inclusive behavior.

We acknowledge that most griefers are not easily identifiable. For this reason, in this study we regard griefer roles as collective player reactions to a yet-to-be-normalized environment when we investigate their senses of fun and anxiety in online gaming worlds.

Methods

We chose the two most popular MMORPG games in Taiwan—*Lineage* and *Ragnarok Online* (RO)—as vehicles for finding answers to our research questions. Data for analysis were collected from several sources. A total of twenty individual interviews and nine focus group interviews (a total of fifty-three interviewees, among them twenty females) were conducted with griefers and non-griefers from the two games. Interview topics included player attitudes toward white-eyed play and strategies to resist it.

Purposive snowball sampling was used to create a diverse sample in terms of gender, age, and educational and occupational background. Ages ranged from eleven to fifty-four. Participants included twelve elementary school students, eight junior high school students, fifteen senior high school students, ten college students, four graduate students, two journalists, one social worker, and one junior high school teacher; four participants identified themselves as griefers. These individuals were asked additional questions aimed at

identifying the process by which they became deviant, their social situations, and their resistance to game world norms.

In addition to analyzing regulations and rules of conduct posted on the official websites for the two games, we also reviewed the griefer clans' self-representations and action reports as they appeared on game websites. We spent some time collecting and following grief play-related postings from discussion forums for the two games, investigated posts on Taiwan's two largest game discussion groups (*Bahamut* and *Gamebase*), and analyzed posts on Palmarama, Taiwan's largest Bulletin Board System and the official *Lineage* website. Other data were gathered via participant observations of online game worlds. Personal interactions with players allowed us to become familiar with meanings associated with griefer behavior. Finally, the authors' personal experience and observation from over 500 hours of online gaming provide a basic understanding of the gaming community.

Findings and Discussion

The data allowed us to identify two types of white-eyed MMORPG players. Explicit (identifiable and self-aware) players fit well with Bartle's [3] "politicians" in that their open organization efforts can be understood as rebellious responses to game rules. However, most of the grief players we found belong to the implicit category, since they perform their roles in unidentifiable ways with weak self-awareness, and give griefer stigmas to other age groups as a means of alleviating their anxiety in an era of cross-age playing.

Identifying and Punishing Griefers

The term "griefer" covers a broad spectrum of disruptive and annoying activities ranging from verbal rudeness to ninja looting to scamming to killing other players. A list of white-eyed behaviors mentioned by our interviewees and frequencies for each category is presented in Table 8.1. Interview content confirmed Foo and Koivisto's [9] observation that definitions of griefers are ambiguous, changing, and subjective. On bulletin boards and game websites, we observed that whenever someone called a certain behavior "white-eyed," there was almost always another individual willing to step forward to claim that it was not. Furthermore, interviewees who described themselves as non-griefers admitted that they occasionally exhibited some griefer behaviors—for instance, using bots to boost avatar rankings. However, they only described such actions as white-eyed when performed by other players.

Table 8.1: White-eyed behaviors mentioned by interviewees

White-eyed behavior type	Number of Mentions
Cursing others for no reason; using obscene words	13
Cheating to get valuable equipment	12
Stealing equipment or money popped by dead monsters killed by other players	12
Killing other players for no reason	11
Taking badly injured monsters from other players	9
Impolite language or actions	5
Newbies who don't do any homework before they start playing	4
Luring monsters to defenseless places	4
Begging for things	3
Begging for training their avatars	2
Using bots	2
Borrowing things and not returning them	1
Killing the pets of other players	1
New Taiwan (NT) dollar worriers*	1
Flooding public chat channels	1

*This term refers to a player who uses real currency (such as NT dollars) to purchase game currency, then buys valuable game equipment from other players via chat rooms and PayPal instead of earning it like the majority of players.

Some of the behaviors shown in Table 8.1 are clearly socially unacceptable and others are harder to judge. How do players draw the line between acceptable and deviant behavior? From discussions about white-eyed players on two bulletin boards, we learned that players tend to view or describe griefer behavior in three ways. The first is describing the grief facts, analyzing them, and criticizing the motivation behind them. Within this category, the issue of whether or not a player did something consciously was frequently discussed. Many participants describe white-eyed players as not understanding gaming situations; in contrast, they view someone who understands but still expresses white-eyed behavior as "bad guys" or "hypocrites" instead of griefers. Second, griefer behavior is differentiated in terms of avatar rankings, with newbies more likely to be described as white-eyed. Third, attributes are given to white-eyed avatars based on assumptions of their real-world identities (e.g., "junior high school kids") or characteristics (e.g., "with little knowledge"). Regardless of what is said about griefers on discussion boards, opposing opinions are almost always followed; in short, reaching a consensus on individual griefer actions is rare.

In terms of interactions with griefers, either individually or collectively, most gamers generally respond to white-eyed players and actions with anger, but believe that they are helpless in taking any meaningful action against them. One interviewee said that since griefers are unwilling to engage in legitimate fights in "person-killing fields," there are no means of retaliation

or retribution; the only option is to curse griefers and leave them alone. Since the game world is so huge, there is a strong possibility that an affected player will never interact with the same griefer a second time.[3]

Some offended players go as far as to post the names of individual griefers on game-related forums, but this tends to be an ineffective response because most viewers never bother to keep a record of posted IDs for later reference. Furthermore, since there is no universally accepted definition of a griefer, misunderstandings are common. On one Bahamut RO bulletin board, a poster called for a cooling down period before posting another player's ID as a means of reducing instances of misunderstanding. Perhaps for the same reason, game managers seldom get involved in grief behavior regulation in terms of creating and trying to enforce specific rules.

How Two Griefer Types Perceive and Respond to Stigma

Data from our personal interviews indicate the existence of two types of griefers. The first are well known (or infamous) for their griefer actions. They are easy to identify, aware of their white-eye status, and proud of it. One bulletin board poster said that he felt honored to be wanted by six player pledges. The second type is more vague; they occasionally express white-eye behavior but also occasionally accuse others of griefer activity. Different attitudes toward the game and responses to the white-eye stigma by the two griefers types are shown in Table 8.2.

Well-known griefers usually project an attitude of indifference toward game rules, with many claiming they create their own rules. One member of a griefer pledge told us, "Some players pay to play against unintelligent artificial characters, but I pay to play against you." Those who occasionally engage in griefer behavior believe that game rules should be followed, and are more likely to suggest that additional regulation is needed in order to maintain a safe and fair game world.

Some self-aware griefers use the tactic of professionalization when facing the stigma of being labeled a white-eye—that is, they claim that rules exist on how to be a good griefer, and that professional griefers follow them. These

Table 8.2: Differences between griefer types

	Attitude toward game	Response to white-eye stigma
Well-known, self-aware griefers	Pass over game rules	Professionalization
Occasional, unconscious griefers	Protect game rules	Othering

players often describe griefing as "no easy job." Professionalization is also claimed by white-eyed players who come together with like-minded players; by participating in a griefer pledge, they claim a right to define what a griefer is. As expected, most ordinary players do not recognize griefer activities as professional—in the words of one interviewee, "organized activities are not considered white-eye!"

"Occasional griefers" are more likely to use the othering mechanism when dealing with a white-eye stigma. By associating white-eyed behaviors with "childish" or "naïve" players, they can justify their griefer conduct as mistakes, thus putting a barrier between themselves and being stigmatized. According to our observations, there is little ambiguity in their references to others. Almost all interviewees described white-eyed players as "a special type of people," adding such comments as "I don't know them" and "they're not my kind." We found this us/them segregation to be very rigid, with no possibility of crossing boundaries.

But as we mentioned earlier in the chapter, any player is capable of griefer behavior. Furthermore, we found evidence indicating that ordinary players are very willing to empathize with griefer behavior. Jennie, a fifth-grade student, told us that a griefer's "private ideas drives him to do so, or maybe he's just more willing than others to show himself." However, they still feel obliged to criticize white-eyed players on occasion, perhaps as personal reactions to offensive griefer behaviors. It may be that accusing white-eyed players serves another social function in MMORPGs: by constantly reinforcing the stigma, ordinary players express a longing for order in the online gaming world.

The ability to hold multiple game identities makes the othering mechanism more sophisticated than simple stigmatization. Coco, a third-year graduate student, told us that "as long as the avatar that I need to interact with is straight, that's enough. I don't care if you play as a griefer with your other avatars." In other words, virtual societies provide spaces for multiple identities, which provides fundamental contexts for better understanding the griefer stigma.

Cross-Age Playing: Anxiety Behind the White-Eye Stigma

Based on our personal interviews and discussions on game bulletin boards, we learned that the imagined age of griefers is an essential factor in how they are perceived. Most speculations pointed to junior high school students. Table 8.3 lists eight interviewees by age group and real-world identity, and what they assumed to be the identity of white-eyed players.

Table 8.3: Examples of responses to the question, "Who are white-eyes"?

Interviewee	Identity/age group	White-eye image
Michael	Junior high student	Junior high students
Calvin	Senior high student	Junior high or elementary school students
Richard	Undergraduate student	Junior high or vocational school students
Mabel	Undergraduate student	Junior high or elementary school students
Kim	Undergraduate student	"The younger the more likely."
Peggy	Undergraduate student	Junior high or vocational school students
Leo	Post-graduate student	Teenagers
Coco	Post-graduate student	Kids

How did junior high students (or early adolescents) become griefer scapegoats? As mentioned earlier, gaming world environments develop social norms and exist as new spheres demanding their own identities that become embedded in the society. MMORPGs and their players still suffer from various stigmas that influence the white-eyed phenomenon and that trigger the othering mechanism. In Taiwan, many of the stigmas touch on maturity, with online game players being described as "not taking care of serious business" or "being out of touch," which causes many parents to wonder when their children will grow up and stop playing games. But the growing number of adult players raises the question of at what age should someone be considered too old to actively play online games? According to our interviewees, senior high school students already feel anxious about this social expectation, making junior high school the last stage of life in which it is acceptable to play games at an intensive level according to existing social norms. Of course, in the pre-video gaming world, children, adolescents, and adults had their own games that took up much of their time—for instance, team and individual sports, which they almost always played with their peers. Online gaming culture is less restrictive in terms of playing within one's own age group.

It can be argued that MMORPGs are the first vehicle to allow humans to share a cross-age playing stage on a large scale. Accordingly, we believe that playing griefer roles, working with griefer stigmas, and using the othering mechanism are results of anxiety over cross-age playing. In the MUD era, high entry thresholds regarding techniques and network resources meant

that players tended to be in the same age range; the general assumption for players at that time was that all other players were people just like themselves—twenty-something white collar workers or college students. At that time, identification anxiety primarily focused on gender [1]; the current focus is on age. A depiction of age distribution for Taiwanese online game players according to data collected by the Taipei-based Insight Xplorer Marketing Research Company (2004) is presented in Figure 8.1. As shown, the large majority of players (80%) are 19 years of age or older. This ratio is higher than the 60% reported by Griffiths et al. [10], who surveyed visitors to two *Everquest* fan websites.

Figure 8.1: Age distribution of Taiwanese online game players
Source: Insight Xplorer Marketing Research Company, 2004

The evidence suggests that where video games were strictly associated with adolescents in terms of social legitimacy, MMORPGs are an acceptable (even if borderline) activity for both adults and kids. Consequently, when three parties (kids, adolescents, and adults) play against each other behind their avatars, they are also fighting for the power to control and interpret the game. By accusing griefers of being childish (e.g., by using the word "little" before "white-eye"), adults are attempting to redefine the legitimate age for playing games. By othering griefers according to age, they are making a proclamation that "This is our game!" and denying or rejecting the stigma attached to the belief that playing games is childish.

In comparison, our elementary school-aged interviewees were less likely to give a specific description of white-eyed players, perhaps based on their perception that online games are just an opaque world for grown-ups. Therefore, they are more likely to avoid avatars that they identify as representing griefers. However, we also observed that some junior high school students feel the stigma of being identified as younger players. One ninth grader claimed on the Bahamut Lineage board that around the time when junior

high schools let their students go home for the day, certain older students in Internet cafés alert other game players to hide account and password information so as to exclude them. But other young students are more willing to accept the griefer stigma. Another interviewee told us that "Junior high students like us are the griefers. It's unlikely for a grown-up to be white-eyed."

Conclusion

We found evidence of two types of white-eyed players or griefers: one identifiable and deviant, the other faceless and fluid. We also learned that the purpose of a griefer stigma is twofold:

1. It takes effort to identify bad and inappropriate behaviors in order to confirm norms of good and acceptable behavior. Attempts to reduce the ambiguity of social interactions in the moral "grey zone" of virtual gaming communities are generally unsuccessful due to the ambiguity of proposed definitions of griefer behavior. Griefers control their identities. Those who enjoy their infamy justify their game-playing ways, with some openly joining forces with other griefers in a self-described effort to act in a "professional" manner. Furthermore, the griefer counter-culture serves as a fine illustration of deviant groups, with griefer clans developing their own identities and norms in opposition to those held by the mainstream gaming community. Their self-perceptions and group identities offer rich data for exploring deviance formation.

2. Since griefers are hard to identify and since almost all players are capable of engaging in white-eyed behavior (knowingly or otherwise), the griefer stigma does not have the purpose of creating a group of "outsiders" to serve as visible targets for social sanctions. Instead, its purpose is to label a group of "others" so that adult players can redefine gaming in their own manner. The terms "little white-eye" or "childish griefer" is not simply a strong criticism aimed at offensive players who hide behind their avatars, but also a response to a collective anxiety about the brand-new experience of cross-age playing.

Acknowledgments

This research was supported by the National Science Council, Taiwan (nos. NSC-94-2412-H-002-001 and NSC-95-2520-S-009-001).

Notes

1. In Taiwanese, the literal meaning of the term "white-eye" is "eyes without pupils." It is commonly used to describe someone who "looks without seeing." In Taiwan's online gaming communities, the term "little white" is used as a strongly derogatory term for behavior considered both childish (little) and causing grief (being white-eyed). We found that the word "little" is an important aspect of stigmatization, but for the sake of simplicity we will use "white-eye," "white-eye player," or "griefer" when referring to avatars who perpetrate offensive behaviors against other game characters.
2. In *Lineage Taiwan,* an avatar actually turns red after it kills another avatar, thus explaining the term "red guy" being used to describe obvious killers. According to game law, "red guys" lose their protection. Any avatar that kills a "red guy" does not turn red. This is an example of regulating deviant behavior via game rules.
3. We found similar situations on a Western website named "Ready, Set, Game: Learn How to Keep Video Gaming Safe and Fun. 10 Tips for Dealing with Game Cyberbullies and Griefers." The website provides suggestions such as "ignore them," "play on sites with strict rules," "play games that limit griefers," and "avoid using provocative names."

References

1. Lin, H., and C.-T. Sun. "Problems in Simulating Social Reality: Observations on a MUD Construction." *Simulation & Gaming* 34(1) (2003): 69–88.
2. Rieber, L. P. "Seriously Considering Play: Designing Interactive Learning Environments Based on the Blending of Microworlds, Simulations, and Games." *Educational Technology Research & Development* 44(2) (1996): 43–58.
3. Bartle, R. "Hearts, Clubs, Diamonds, Spades: Players who Suit MUDs." *Journal of MUD Research* (online) 1(1) (1996).
4. Bartle, R. "A Self of Sense, 2003." Available on April 9, 2005 at http://www.mud.co.uk/richard/selfware.htm.
5. Ellemers, N., R. Spears, and B. Doosje. "Self and Society Identity." *Annual Review of Psychology* 53 (2002): 161–186.
6. Hogg, M. A., D. Abrams, S. Otten, and S. Hinkle. "The Social Identity Perspective: Intergroup Relations, Self-Conception, and Small Groups." *Small Group Research* 35(3) (2004): 246–276.
7. Denegri-Knott, J., and J. Taylor. "The Labeling Game: A Conceptual Exploration of Deviance on the Internet." *Social Science Computer Review* 23(1) (2005): 93–107.
8. Canales, M. K. "Othering: Toward an Understanding of Difference." *Advances in Nursing Science* 22(4) (2000): 16–31.
9. Foo, C. Y., and E. Koivisto. "Defining Grief Play in MMORPGs: Player and Developer Perceptions." Paper presented at the International Conference on Advances in Computer Entertainment Technology (ACE) 2004, June 3–5, 2004, Singapore, 2004.
10. Griffiths, M. D., M. N. O. Davies, and D. Chappell. "Breaking the Stereotype: The Case of Online Gaming." *CyberPsychology and Behavior* 6 (2003): 81–91.

9. *Playing with Non-Humans: Digital Games as Technocultural Form*

SETH GIDDINGS

The relationship between the human and the technological has been a persistent concern in the dramas and images of digital games. Game worlds are populated with mutants, cyborgs, robots, and computer networks—avatars are augmented with headup displays, exoskeletons and impossible weaponry. Yet in significant ways digital games can be seen not only as representations of a putative future technoculture—as a technological imaginary of new media—but also as actual instances of a technoculture here and now. To play a digital game is to plug oneself into a cybernetic circuit. Any particular game-event is realized through feedback between computer components, human perception, imagination and motor skills, and software elements from virtual environments to intelligent agents.

This cyber-cultural language has been regarded with some suspicion within the humanities and social sciences. For intellectual traditions founded on social constructivism any sense of technological determinism is problematic—historical and cultural agency, it is presumed, resides solely in the human and the social. This chapter will argue that a full understanding of both the playing of digital games, and the wider technocultural context of this play, is only possible through a recognition and theorization of the reality of technological agency.

The chapter will draw in particular on theoretical positions developed within the Sociology of Science and Technology and Actor-Network Theory (ANT) to explore how social constructivism might be challenged by the consideration of the agency of technologies, and will, through an analysis of *Advance Wars 2* (for GameBoy Advance, Nintendo 2003), suggest ways in which this argument might shed light on the distinctive nature of the digital game and its play.

Theories of Technoculture

Disciplines concerned with the relationships between technology, culture and society (sociology, cultural studies, media studies, etc.) tend to approach the analysis of the reception and uses of media technologies from the "social shaping" model. A "social shaping" approach to digital games (within Media Studies for example) would, on one hand, see digital games and gameplay as broadly continuous with other forms of media technologies and their consumption in everyday life (the Walkman, television, etc.) and on the other, would view the forms and practices of this consumption (and hence the uses to which media technologies are put) as shaped by social agency. At the point of manufacture this agency is primarily economic, and at the point of consumption it is the users or consumers that negotiate the meanings and uses of these devices. Consumers—it is asserted—negotiate their desires and hopes for new devices with the preferred uses anticipated by manufacturers and advertisers in the context of the contingencies of their everyday life (Can they afford the device? Can they use it? Do they have to share it with other members of the household? How do issues of gender and generation affect access to such devices?). This focus on the social shaping of media technology through consumption tends to militate against conceptions of technological determinism, it foregrounds the conflictual, social nature of meaning generation. Producers' attempts to build in meanings, and then articulate them through promotion and advertising, can never result in anything more than "preferred readings" of their products. They may wish us to see the Betamax video format or laser discs as the future of home entertainment, but they cannot make them mean that. Early home computers in the 1980s were often sold as information technologies, but were widely consumed as games machines. All commodities and media, then, are "texts," "encoded" products, which may be "decoded" in their consumption to reveal a quite different message [1]. Accordingly:

> the effects of a technology [. . .] are not determined by its production, its physical form or its capability. Rather than being built into the technology, these depend on how they are consumed. [1]

However, significant problems follow from the extension of this textual metaphor to the consumption of new media technologies. Put simply, this textual model (and by extension the "social constructivist" paradigm from which it derives) limits any analysis of the *materiality* of media technologies, hence ruling any consideration of technologies as having "agency" or "effects" out of court. I would argue that the effects of a technology may not be *reducible* to its "production," "physical form," or "capability," but it is nonsense to assert that these factors have *no* effect. There may be uses for

a microwave other than cooking, but it cannot be used to sharpen a pencil. There is a danger of throwing a material baby out with technological determinist bathwater. As Mackenzie and Wacjman point out:

> It would be terribly mistaken, however, to jump from the conclusion that technology's effects are not simple to the conclusion that technology has no effects. [2]

"Social constructivism" in general and models based on textuality and representation in particular emphasize the meanings, the symbolic circulation, of media technologies, and in so doing elide their material existence as objects and devices, their uses constrained or facilitated by this material existence:

> What is being shaped in the social shaping of artifacts is no mere thought-stuff, but obdurate physical reality. Indeed, the very materiality of machines is crucial to their social role. [2]

This argument has significant implications for social constructivist theories of media and technology, and it also opens up new areas of enquiry. For if, on the one hand, the material world and the artifacts in it are "obdurate" and "physical" (as well as symbolic), and on the other (as we will see) society and the material world (technology, nature) can be seen as mutually constitutive, then it becomes difficult to maintain the assumption that humans are the only agents in the world, shaping and moulding artifacts, but never vice versa. It is clear that the implications of such questions pose fundamental challenges not only to the critique of technological determinism, but also to the theorization of society and culture in general.

Actor-Network Theory

Mackenzie and Wajcman introduce Actor-Network Theory (ANT) as identifying "the reciprocal relationship between artifacts and social groups" [2]. ANT is ambitious and the implications of its assertions far reaching:

> Both society and technology, actor-network theory proposes, are made out of the same "stuff": networks linking human beings and non-human entities ("actors," or, in some versions, "actants"). [2]

Bruno Latour, for instance, calls for enquiry into what he calls the "missing masses," that the mass of non-human devices and objects that, he asserts, make up the "dark matter" of society—unobservable using established sociological lenses, but theoretically necessary to the existence of human relationships and activities. He sometimes refers to these non-humans as lieutenants (from the French—holding the place of, or for, another):

If in our societies, there are thousands of such lieutenants to which we have del-
egated competences, it means that what defines our social relationships is, for
the most part, silently prescribed back to us by non-humans. Knowledge, moral-
ity, craft, force, sociability, is not a property of humans but of humans accompa-
nied by their retinue of delegated characters. Since each of these delegates ties
together part of our social world, it means studying social relations without the
non-humans is impossible. [3]

He argues that the idea that society is made up only of human agents is
as bizarre as the idea that technology is determined only by technological
relations:

Every time you want to know what a non-human does, simply imagine what
other humans or other non-humans would have to do were this character not
present. [3]

He uses the example of doors and automatic door closers to illustrate
these delegations. Asking us to imagine the effort it would take to get from
one side of a wall to the other—entailing presumably the breaking of a large
hole in the wall, and then bricking it up again afterwards. The simple tech-
nology of a hinged door is a delegate: it translates this hypothetical human
effort into a much more efficient and convenient operation. The door-closer
then acts as a delegate for, and translation of the effort of, the (unreliable)
human user of the door. Different kinds of door-closers have delegated to
them (or delegate to humans) different effects:

The door-closer will attempt to close the door regardless of whether anyone is in
the way or not. Door-users familiar with particular doors will be able to dodge or
anticipate the closing door, whilst others may find the door slamming in their
face. Thus, 'An unskilled non-human groom thus presupposes a skilled human
user.' It is always a trade-off. [3]

Though there are significant overlaps in approach between ANT and
social constructivism in that they both assert the fundamentally social nature
of technology, the former would also argue that societies are fundamentally
technological. The distinction between these two conceptual frameworks is
also significant then: ANT claims both the agency of non-humans and, more-
over, the *symmetry* of agency between humans and non-humans in any
network.

If human beings form a social network it is not because they interact with other
human beings. It is because they interact with human beings and endless other
materials too [. . .] Machines, architectures, clothes, texts—all contribute to
the patterning of the social. [4]

Indeed ANT claims that any firm conceptual distinction between the
human and the non-human is untenable. Steve Woolgar, for example, cri-

tiques what he calls "the object hypothesis"—that human and non-human entities are bounded and discrete from each other and from other entities and their environment [5].

It is one of the strengths of ANT that it has proved to be productive across a wide range of social enquiry and in application to a wide range of objects of study: from weapons systems to the Paris metro, from scallop fishing to allergies. There is a challenge here then: how to draw on these theoretical resources to address the specificity of media technologies in general and of digital game play in particular?

Digital Games and Non-Human Agency

Cyborgs or Circuits?

It has been argued that digital game play—given its centrality to the development and dissemination of popular computer hardware, software and cultural practices—is a privileged, even paradigmatic, instance of a popular, digital, technoculture [6,7]. In these terms digital game play is a vivid instantiation of Donna Haraway's figurative cyborg: an ambiguous and monstrous intimacy between the human and organic and the technological and inorganic [8]. Digital games aestheticize this cyborg world, but they also *realize* it: this is an aesthetics of control and agency (or the loss of these) through immersive, embodied pleasures and anxieties, rather than (just) of dramatic scenarios and screen-presented action [9,10]. The common experience of digital game play as characterized by the loss of distinction between game, software, machine and player resonates with the ANT critique of the object hypothesis. Of the boundaries under threat, perhaps the most significant is that between subject and object—precisely the boundary that digital game play transgresses. Yet this figurative cyborg is perhaps not the most productive model for understanding digital game play in technocultural terms. The cyborg tends to be figured as an augmented body, extended, armoured, with implants, etc. but still fundamentally a body—the "object hypothesis" barely troubled. Focussing on the game player we might see some mileage in this— the bodily systems of nerves, senses and motor action extended into the prosthetic devices and environments of controllers, dancemats and virtual worlds. Yet if we look at the event of gameplay itself we might rethink the human–non-human relationship as one not of an extended cyborg body but of a cybernetic circuit: a flow of information between organic and inorganic nodes, the initiation of which cannot be identified in either the player or the machine:

> By definition, a circuit consists in a constancy of action and reaction. In gaming, for example, not only is there the photon-neurone-electron circuit [. . .] there

are also macroscopically physical components of that circuit, such as the motions of finger, mouse or stick. [. . .] Through the tactile and visual interface with the machine, the entire body is determined to move by *being part of the circuit of the game*, being, as it were *in the loop*. [7]

There are resonances here with the actor-network and its rejection of the object-hypothesis in that it "shifts attention from the interactions between two discreet entities towards the cybernetic processes that, as it were, edit parts from each to create an indissociable circuit of informational-energetic exchange." Whilst this conceptualization of gameplay is compelling and suggests new avenues of enquiry into the distinctive nature of "immersive" play, it says little about the digital game as a game, as a new media form. I now want to shift the emphasis from the relationship between human and non-human to think through some ways in which digital games as software can be seen themselves as actors.

Emergence and Intentionality

Some commentators have identified the sheer complexity of the operations of computer software as threatening to established notions of human agency. As Espen Aarseth points out:

> When a system is sufficiently complex, it will, by intention, fault, or coincidence, inevitably produce results that could not be predicted even by the system designer. [11]

His examples include computer viruses and the complexity of global trade networks. These cybernetic phenomena are, he argues, genuinely autonomous. The global financial market is autonomous:

> since it cannot be controlled, shut down, or restructured by a single organization or even a country. Its machine-human borders are also unclear, since the interface could hide a human trader, a machine, or a cyborg, a combination of both. Such a system, even if it consisted purely of autonomous agents, is not a model or a representation of something else; it is itself, a cybernetic entity that communicates with all and answers to none. [11]

The notion of emergence has been addressed in game studies in the study of relatively "open" games the complexity of which facilitates actions and play strategies not anticipated by the game's designers [12,13]. The concept will be returned to in this chapter. For now I want to address Aarseth's third example of cybernetic automata: the chess programme that beats its programmer. This device is central to an influential essay of 1971 in which Daniel Dennett explored philosophical issues arising from research into artificial intelligence. The essay makes important points both about machines as

actors, and about a relationship between a human player and a digital game that is addressed neither by ANT nor cybernetic models. Moreover it is telling that Dennett's example is a computer game.

His argument runs as follows: the strategies of a sophisticated chess computer are so complex that they cannot be predicted by a human player. Hence it is only possible to play chess with a chess computer by ascribing intentionality to the computer, by reacting to it as if it were an intelligent player:

> when one can no longer hope to beat the machine by utilizing one's knowledge of physics or programming to anticipate its responses, one may still be able to avoid defeat by treating the machine rather like an intelligent human opponent.

This is the "intentional stance," and Dennett distinguishes it from the "design stance" in which a detailed knowledge of how the computer or program is designed would allow the designer (or user or player) to predict the system's response to any input or operation. In the case of chess, the design stance would entail the player knowing enough about the instructions coded into the game-as-program to definitively predict every move the computer would make. Yet:

> on occasion a purely physical system can be so complex, and yet so organized, that we find it convenient, explanatory, pragmatically necessary for prediction, to treat it as if it had beliefs and desires and was rational.

Dennett offers this concept as a practical, *pragmatic* way of understanding the operations and agency of complex systems that at once acknowledges the very palpable (and perhaps unavoidable) sense of engaging with a system as if it had desires and intentions, whilst rejecting idealist versions of anthropomorphism:

> The concept of an Intentional system is a relatively uncluttered and unmetaphysical notion, abstracted as it is from questions of the composition, constitution, consciousness, morality, or divinity of the entities falling under it. Thus, for example, it is much easier to decide whether a machine can be an Intentional system than it is to decide whether a machine can *really* think, or be conscious, or morally responsible. [14]

So this intentionality does not assume that complex systems have beliefs and desires in the way humans do, but that their behavior can, indeed often must, be understood *as if* they did. Or perhaps, and Dennett hints at this, their 'beliefs' and 'desires' are not so much metaphorical as analogical. This 'un-metaphysical' notion of the intentional system both resonates with Latour's non-human delegations and suggests ways in which we might theorize our material *and conceptual* engagement with complex computer-based media, sidestepping a whole range of largely unhelpful speculations on immi-

nent realization of actual machine consciousness. It suggests that the experience of playing (with) these games/machines be theorized as one of engagement with artificial intelligence without slipping into naive anthropomorphism or frenzied futurology.

I will now apply the issues raised so far to an analysis of the Nintendo GameBoy Advance game *Advance Wars 2* (2003). The game will be studied as a technological artefact, software constituted by various forms of agency.

Advance Wars 2 *as Simulation and Artificial Life*

Artificial Death: Simulation in Wars World

Day by day the antagonists launch missile strikes, generate new troops, weaponry and vehicles from factories, seize cities, calculate risks and trade insults. And yet it would be hard to generate a moral panic over the violence in this war-simulation game. The warfare itself is tactical in play and on defeat the units do not explode in the gibs of a fragged FPS avatar, but are rendered in generic animated sequences—gracefully sliding from the screen. The warriors are the Commanding Officers (COs): cartoon characters, a number of them apparently teen-aged, each with a set of characteristics, interests and moods familiar from the economical sketchings of personality traits of their television animation forebears.

The popularity and success of this game, *Advance Wars 2,* is due to the sophistication of its tactical and puzzle-based gameplay rather than the immersive cinematographic verisimilitude of other recent popular games. This is largely due to it being a GameBoy Advance game—it makes the most of the 2D graphics and the portability of this handheld console.

The basic dynamic of the gameplay is quite simple. The player commands an army against a computer-controlled enemy army on a battlefield—one of many maps in the game's presentation of itself as 'Wars World.' The armies are constituted by various units: infantry, artillery, different kinds of tanks, planes, and ships. Most battles require the defence of a base and the capture of the enemy base and most have a particular puzzle-like element that must be solved for victory. It may take a number of attempts at a battle, for example, to realize that an airport must be seized and held for victory to be possible. Play proceeds on a turn-by-turn basis. This fundamental temporal structure defines this game genre: it is a turn-based strategy game (TBS) rather than the now more popular real-time strategy game (RTS). The RTS was made possible by increased computer processing power and developments in game software design; however, the *Advance Wars* series exploits the more stylized pleasures of the more 'primitive' genre.

Each day/turn the player moves or refuels his or her units (according to their range of movement and the kinds of terrain they can traverse), generates new ones (funds and possession of factories permitting), and launches attacks on enemy units. Once all movement and attacks have been completed, the enemy (computer-controlled) CO takes its turn. At the end of this turn, the game-day ends and the cycle begins again. Game-battles can be over in four or five game-days, or can rage for game-months. Moreover, given the infinite iterability of both games (digital or otherwise) and software, any battle can be re-fought as often as desired. Or, given the progressive structure of the game, re-fought until victory finally allows the player to move on to the next battlefield and the next battle.

Though it may initially look on screen like animated cinematic or televisual representations of war, Wars World may be more productively conceptualized (along with many other computer applications) as 'code' rather than 'text,' or more specifically as 'simulation' rather than 'representation.'

Simulation, AI and Automata

There are two very broad ways in which the term simulation is put to use in the analysis of new media. One is Jean Baudrillard's identification of simulation as hyperreality. According to Baudrillard, simulacra are signs that can no longer be exchanged with 'real' elements, but only with other signs within the system. For Baudrillard reality under the conditions of postmodernism has become hyperreality, disappearing into a network of simulation. In postmodernist debates over the past few decades the nature of simulation over representation has been posited as of fundamental importance for questions of the future of human political and cultural agency.

The second is a more specific concern with simulation as a particular form of computer media. The two concepts overlap, however. Baudrillard's simulation, though formulated before the rise of computer media to their current predominance and predicated on—crudely speaking—the electronic media and consumer culture, is now widely applied to the Internet, Virtual Reality and other new media forms. Discussions of the nature of computer simulations often also entail a consideration of the relationships (or lack of) between the computer simulation and the real world. Both make a distinction between "simulation" (where a "reality" is experienced that does not correspond to any actually existing thing) and "representation" (or "mimesis," the attempt at an accurate imitation or representation of some real thing that lies outside of the image or picture)—though often with very different implications and intentions. A simulation can be experienced as if it were real, even when no corresponding thing exists outside of the simulation itself. There is another facet of simulation of direct relevance to the study of technological

agency. One root of the terms simulation and simulacra that is rarely picked up on in theories of media, games and cyber-culture is the automaton. Automata in general then are "self-moving things" (and historically this category has included animals and humans). Lister et al. [7] trace the concepts back to the classical differentiation (in the *Iliad*) within automata between the simulacrum and the automaton. Automata are devices that move by themselves, with simulacra as a subclass of self-moving devices that simulate other things (humans, ducks, etc.).

For the purposes of this paper I want to concentrate on simulation as software, with particular emphasis on software as, or mobilizing, self-moving agents or automata. Artificial Intelligence (AI) is perhaps the most commonly understood instance of simulation as autonomous agent in digital games. In a game, AI generally refers to the components of the program that respond most sensitively to the actions of the player. The term covers both the coding of the behavior and responses of NPCs and the overall sense of the game world as a system that is responding convincingly to the player's engagement with it. In this sense the playing of such a game involves Dennett's intentional stance: the player ascribes intentionality ("intelligence") to the game and its entities. Michael Mateas (a theorist and a game-designer) has outlined the key aspects of what he calls "expressive AI." On one hand firmly rooted in the discourses and technologies of computer science research, but on the other hand looking at the use of AI for non-scientific purposes, for interactive entertainment: "expressive AI" in games "covers a diverse collection of programming and design practices including path-finding, neural-networks, models of emotion and social situations, finite-state machines, rule systems, decision-tree learning, and many other techniques" [17].

The enemy units in *Advance Wars 2* are artificially intelligent. For each map they have both an "un-intelligent" strategy (for example, move towards the player's base to seize it, or to capture cities). Their tactics are artificially intelligent though: within the context of their overall motive, they will stop or divert to engage with the player's units. Importantly they respond to the contingencies of the player's units' positions and movements. The unerring mathematical basis of the enemy agents' AI facilitates *intentionally* fiendish tactics: hanging back just out of the player's units' range so that they can move forward to make the first attack, calculating all the options and risks and bringing them all to play in a manner beyond most of the capabilities of many human brains.

Artificial Life and Agency in Digital Games

Computer simulations based on Artificial Life (ALife) principles and algorithms have been widely used in computer-generated imagery in popular cin-

ema. The Disney films *The Lion King* (1994) and *Mulan* (1998) both use "flocking" routines in the generation of scenes containing a large number of moving characters—a stampede of wildebeest and the charge of an army, respectively. Flocking programmes instruct each individual entity (originally "boids," simulated birds in flight) to move autonomously, but only in relation to the general trajectory and proximity of neighbouring entities. Thus very simple instructions to move at random but without bumping into a neighbour result in highly complex yet patterned movement analogous to the actual flocking of birds.

Whilst these instances of ALife, once recorded and processed (hence artificially "killed") as animated sequences, are presented as a flow of images like all cinema, new media such as digital games maintain these entities' animate existence. Disney harnesses complexity and emergence for the economics of spectacle, whereas games exploit them for what Aarseth calls "unintentional sign behaviour":

> the possibility of unintentional sign behavior makes cybernetic media creatively emergent and, therefore, not subsumable by the traditional communication theories.

Another example of the application to digital entertainment of the generation of complex systems, "bottom up," from a simple set of rules (of particular relevance to *Advance Wars 2*) is that of cellular automata. This is most clearly illustrated in the famous *Game of Life*. The simple algorithms of this mathematical game—the simulation of cellular colonies (animated clusters of 0s on a monochrome screen), through generations of life and death according to the relationships between any particular "cell" and its neighbours—spawned entrancing patterns of emergent order and entropy. This simulation of cell colony growth obeys a very simple set of algorithms:

> **For a space that is 'populated':** Each cell with one or no neighbors dies, as if by loneliness. Each cell with four or more neighbors dies, as if by overpopulation. Each cell with two or three neighbors survives.
>
> **For a space that is 'empty' or 'unpopulated' :** Each cell with three neighbors becomes populated.

From these simple rules highly complex patterns can emerge. Some are of interest to the science of ALife, and some are sought for in a more exploratory, non-instrumental, even ludic spirit. *Advance Wars 2* has a more complex set of rules, and its units are constituted by their own capabilities for movement and firepower, its grid squares are differentiated into simulations of various terrains. Its complexities emerge not only through the blind iterations of automatic cell generations but also through the actions of the

human player guided, configured, by the demands of the game design as well as the simulacra. Yet as virtual worlds there are important similarities between *Advance Wars 2* and *Game of Life*. The battlefields of Wars World have the stylized flatness and iconicity of a board game, the "units" (ambiguous hybrids of personnel and technology) are cellular in appearance and in their uniform scale. Whilst the automota of *Game of Life* are strictly binary (each square is only ever "on" or "off"), those of *Advance Wars 2* are constituted by a scale of aliveness (or health) depending on their initial strength and the ravages of battle. Both *Game of Life* cell and *Advance Wars 2* unit, however, are always entirely coexistent with the square of the grid-terrain on which they rest. Neither have even the flexibility of Snakes and Ladders counters, for instance, to share a square. Through "movement" and proximity *Game of Life* cell cultures nurture new cells into life or abandon them to die; factory units in Wars World generate new units, and existing units supply friendly units and destroy enemy units. Whatever agency these simulacra exert, it is unguided by any moral or epistemological purpose.

The game is profoundly pragmatic about the nature of its automatic denizens, and the "cells" in a game of life are the product (one of a multitude of possible representations) of an algorithmic process. If there is "life" here it is to be found in the process and its emergent complexity, not in the blinking patterns on the screen. In *Advance Wars 2* we battle against not armies or an opposing general but against an intentional system that mobilizes itself through a variety of soft actors—units, COs and artificially intelligent "tactics." ALife in *Advance Wars 2*, then, can be regarded in a pragmatic manner similar to that with which Dennett regards "consciousness" in the chess programme. This line of enquiry should not ignore the real contribution that popular digital games can play in ALife research, however. See [15] for a thorough enquiry into ALife as technocultural form, and the game *Creatures* in particular.

The technological agency exercised through digital game play here is literal and un-metaphysical, everyday and playful. Yet this very mundanity and ubiquity may suggest a technoculture more far-reaching and significant than that once promised by enthusiasts for the exclusive experiences of Virtual Reality and "cyborg" prostheses.

Conclusion

Game studies has rightly devoted a great deal of attention to the specificity of the game as a cultural form. However, the conceptualization of digital games *as* digital, as simulations, as software and as technologies has been less consistently pursued. In this paper I have argued that games studies can learn from a range of existing theoretical frameworks and that digital games and

gameplay are paradigmatic instances of an everyday, actual technoculture. Attention to the technological nature of digital games—and in particular the distributions and delegations of agency between technologies and players in the act of playing—at once offers new frameworks for the analysis of digital games and play and suggests broader questions for the study of the relationships between technologies, culture and humans.

References

1. Mackay, H. *Consumption and Everyday Life*. London, Sage 1997.
2. Mackenzie, D. and Wajcman, J. (eds.), *The Social Shaping of Technology*, 2nd edition, London, Open University Press, 1999.
3. Latour, B. "Where are the Missing Masses? The Sociology of a Door." 1992, Online at: http://www.ensmp.fr/~latour/articles/article/050.html. (Last accessed March 14, 2004).
4. Law, J. "Notes on the Theory of the Actor-Network: Ordering, Strategy and Heterogeneity." Lancaster, Centre for Science Studies and the Department of Sociology, 1992. Online at: http://www.comp.lancaster.ac.uk/sociology/soc054jl.html. (Last accessed June 2002).
5. Woolgar, S. "Configuring the User: The Case of Usability Trials." In Law, J. (ed.), *A Sociology of Monsters: Essays on Power and Technology and Domination*, London, Routledge, 1991, pp. 58–99.
6. Turkle, S. *The Second Self: Computers and the Human Spirit*. London, Granada, 1984.
7. Lister, M., Dovey, J., Giddings, S., Grant, I., and Kelly, K., *New Media: A Critical Introduction*. London, Routledge, 2003.
8. Haraway, D. "A Manifesto for Cyborgs: Science, Technology, and Socialist Feminism in the 1980s." In L. J. Nicholson (ed.), *Feminism / Postmodernism*, London, Routledge, 1999, pp. 190–233.
9. Friedman, T. "Civilisation and its Discontents: Simulation, Subjectivity, and Space." In G. Smith (ed.), *On a Silver Platter: CD-ROMs and the Promises of a New Technology*. New York, New York University Press, 1999, pp. 132–150.
10. Lahti, M. "As We Become Machines: Corporealized Pleasures in Video Games." In Wolf, J.P. and Perron, B. (eds.), *The Video Game Theory Reader*, London, Routledge, 2003, pp. 157–170.
11. Aarseth, E. *Cybertext: Perspectives on Ergodic Literature*. Baltimore: Johns Hopkins University Press, 1997.
12. Juul, J. "The Open and the Closed: Games of Emergence and Games of Progression." In F. Mäyrä (ed.), *Computer Game and Digital Cultures Conference Proceedings*. Tampere, Tampere University Press, 2002, pp. 323–329. Online at: http://www.jesperjuul.dk/text/openandtheclosed.html. (Last accessed April 15, 2005).
13. Giddings, S. and H. Kennedy. "Digital Games as New Media." In Rutter, J. and Bryce, J. (eds.), *Understanding Digital Games*, London: Sage, 2006.
14. Dennett, D. C. "Intentional Systems." *The Journal of Philosophy* 68(4) (1971): 87–106.

15. Kember, S. *Cyberfeminism and Artificial Life*. London, Routledge, 2003.
16. Akrich, M. "Technology, Theory and Method: The De-scription of Technological Objects." In W. Bijker and J. Law (eds.), *Shaping Technology / Building Society: Studies in Sociotechnical Change*, Boston, MA, MIT Press, 1992.
17. Baudrillard, J. *Simulation and Simulacra*. Michigan, University of Michigan Press, 1994.
18. Du Gay, P., Hall, S., Janes, L., Mackay, H. and Negus, K. *Doing Cultural Studies: The Story of the Sony Walkman*. London, Sage, 1997.
19. Giddings, S. "Circuits: A Video Essay on Virtual and Actual Play." In *Level Up Digital Games Research Conference Proceedings CDROM,* Utrecht, Faculty of Arts, Utrecht University, 2003.
20. Frasca, G. "Simulation versus Narrative: Introduction to Ludology." In Wolf, J.P. and Perron, B. (eds.), *The Video Game Theory Reader,* London, Routledge, 2003.
21. Mateas, M. "Expressive AI: games and artificial intelligence." In *Level Up Digital Games Research Conference Proceedings & CDROM,* Utrecht, Faculty of Arts, Utrecht University, 1993.
22. Prensky, M. *Digital Game-Based Learning*. New York: McGraw-Hill, 2004.
23. Woolley, B. *Virtual Worlds—A Journey in Hype and Hyperreality*. Oxford: Blackwell, 1992.

10. Possibilities of Non-Commercial Games: The Case of Amateur Role-Playing Games Designers in Japan

KENJI ITO

Introduction

Recently, scholars of science and technology studies have been paying closer attention to the role of users in technology. In the market economy, users/consumers have been playing silent though often decisive roles in shaping many areas of technology. At times users come up with creative uses of a technological product that its manufacturer never imagined (the most consequential unintended use would be the use of airplanes by Al Quaeda as mentioned by Nelly Oudshoorn and Trevor Pinch [1]). Attention to users is expected to shed more light on neglected though highly relevant groups in society and to counterbalance hagiographic narratives, which make heroes out of prominent engineers. In this post-industrial age, the boundary between users and manufacturers need not remain the same. Advancement of information and communication technology might lower technical threshold and allow greater participation by users. In particular, in the area of digital games, everyone used to be an amateur in the time of William Higinbotham or Steve Russell. Even today, when the game industry has grown colossal, creative amateurs can find their roles. In content production, while technology continues to advance, and yesterday's technology becomes cheaper and cheaper, the one with the most advanced and expensive technology does not always produce the best product.

Amateur game-designers in the English-speaking world have already attracted the attention of some scholars. In particular, some scholars have

studied the activities of "modders"[2]. Whereas digital game cultures in Japan have been generally underrepresented in game studies within the English-speaking academy, non-commercial games are even less recognized, probably because amateurs generally do not bother to translate their work into English.

This chapter focuses on Japanese amateur game-designers and the role-playing games that they produce by using software called "RPG Tkool 2000." I examine how amateur game creators build a network to create games, how they circulate their games, how players interact with those games and their designers, and how those games differ from commercial games. In particular, in my analysis of amateur role-playing games, I focus on narratives and "cosmologies" of the game that regulate game play and storyline, not because I value narratology more than ludology, but because amateur designers of role-playing games seem to place more emphasis on stories than on game designs.

Methodologically, I attempt to synthesize two different approaches. As game studies grow into a burgeoning interdisciplinary field, we also see dissonance and incongruity in its methodologies and interests. Less mentioned than the alleged debate between ludologists and narratologists is an apparent rupture between socioeconomic studies of games and studies of game content, which is particularly visible and problematic in Japan. Some scholars study very thoroughly the economic effects of games, for example, or the management of game companies, but pay very little attention to games themselves [3]. Others focus on the narrative structures of games and their game mechanisms and play experiences by deeply engaging in actual game play. They are, however, often oblivious to how marketing concerns and relevant business models shape the content of games. Not many researchers attempt to synthesize these two [4]. How do socioeconomic factors shape game content and player experience? Answering such a question could be helpful in understanding why we see certain games around us. In order to answer that question, it seems appropriate to study cases under different socioeconomic conditions. This chapter attempts to carry out such an investigation by examining how free amateur games are different from commercial ones.

RPG TKool 2000

"RPG Tkool 2000" is the most popular tool to create RPG's in Japan (The name came from the Japanese word "tukuru" or "to make"). It allows only low-resolution 2D graphics, but it is extremely versatile, stable, and easy to use. Even though RPG Tkool 2000 is a commercial software product, because gamers can play games produced by RPG Tkool 2000 without buying the software itself, game-designers can distribute their games as freeware.

Enterbrain, Inc., which produces RPG Tkool 2000, is part of the largest publisher of books and magazines on digital games in Japan. The company was established in 2000 as a subsidiary of ASCII, Inc., which had sold previous versions of RPG Tkool series (ASCII stands for Advanced Strategy for Computer Information Intelligence). The company was established in 1977 by Kazuhiko Nishi, principally as a publishing house for magazines and books related to computers and computer games, but it also sold software, in particular, the company used to sell the Japanese versions of Microsoft products as well as some game titles for PlayStation 2.

In the late 70s and early 80s, the magazine ASCII played an important role in disseminating knowledge and techniques about personal computers among amateurs. It was a place where amateurs submitted what they programmed, of which many were games [5]. Having hobbyist programmers as major contributors to their magazines, it was natural that ASCII Corporation or its subsidiaries created various construction tools for amateur game-designers. ASCII and the readers of its magazines formed a kind of symbiosis wherein ASCII provided tools and a place to publish games and readers took the role of providing content to ASCII's magazines by submitting their games.

The earlier game construction tools from ASCII appeared in the late 80s. The first of the RPG Tkool series appeared in 1992, when NEC's PC-9801 series dominated Japan's personal computer market. Since then, there have been several different versions of RPG Tkool. The most recent one, called "RPG Tkool XP," was released in 2004. In addition to RPG Tkool, Enterbrain has tools to create games of other genres, like "Simulation RPG Tkool," "Fighting Game Tkool," "Shooting Game Tkool," and so on. Here, I focus on "RPG Tkool 2000," currently the most popular version of the RPG Tkool series.

RPG Tkool uses simple, low-resolution, 2D graphics, instead of 3D polygon model graphics (except for the PlayStation 2 version of RPG Tkool, which is not very popular). Games produced with this software are those in the age of Super Nintendo Entertainment System (SuperNES). Hence, the Tkool games appear old-fashioned to eyes familiar with recent games. For Japanese game players, however, the 2D graphic is not so much a disadvantage. Being immersed in the otaku culture of Japanese animation and comics, Japan's young game players can even find comic-like 2D graphics more appealing than photo-realistic 3D graphics.

Creating a game with RPG Tkool requires at least three things. First, the designer needs to design maps (possibly many maps) using the map editor, and place various non-player characters and objects on the maps. Second, the designer needs to assign behaviors to these characters and objects by attaching scripts to them. Third, the designer needs to set up a player character and

specify the initial position of the player character. For a minimum RPG (for example, one in which a character just says "hello world") the production time would be less than five minutes, much of which would be used to launch the program.

For the game to be more interesting, of course, the designer needs to do far more work. Usually, there are many maps (or rooms) in a game connected with each other in a very complicated way. Behaviors of characters can be very complex if the designer chooses to use many variables and if-statements available in the script. The designer can choose to design original graphics, instead of using the tiles of landscape and pictures of characters provided by the software package. The RPG Tkool package comes with many pieces of music for background and other sounds but the designer can also choose to compose and use original music. The designer can even choose to recruit actors to give characters real human voices. Thus, RPG Tkool allows for the development of a very wide spectrum of games, from very simple to extremely complicated ones.

RPG Tkool is extremely versatile. Although it is a construction tool for role-playing games, ingenious users can create games of many different genres because of its simple interface. This includes action RPGs, adventure games, puzzle games, strategy games, shooting games, and other action games. Some users have even created tools to make role-playing games or to design pictures of characters. These various uses of this software itself illustrate the creativity of its users.

RPG Tkool makes the technical threshold very low. For example, scripting consists of choosing commands and appropriate variables from menus. This makes scripting very easy for beginners, who do not have to memorize commands in a computer language. For those who are skilled in computer programming, however, choosing commands from menus is more cumbersome than typing. Similarly, low-resolution 2D graphics allow the designer to be unconcerned about specifications of the graphics board that players might be using although it also precludes the possibility of photo-realistic graphics. This is important for both designers and game players. They do not have to purchase a state-of-the-art computer to design or to play RPG Tkool games. This allows RPG Tkool games to be circulated among younger generations of game players who do not always have the technical resources to play high-end computer games.

What is more important to distribution is the cost the game players have to pay for playing the games. The RPG Tkool 2000 is commercial software that costs roughly 100 dollars. In order to play the games created by it, however, game players only need the run-time package downloadable freely from Enterbrain. Whereas a copy of *Neverwinter Nights* is required to play any

RPG created by it, amateur designers circulate RPG Tkool games entirely freely.

In sum, RPG Tkool 2000 has the following characteristics. It uses relatively old-fashioned graphics. Yet, it is very easy to handle and extremely versatile. Technically, it is not the tool to produce state-of-the-art games, but its ease of use can be considered an advantage. Moreover, game-designers can make their Tkool games available for free.

Tkoolers

There is an active community of users of RPG Tkool 2000 (or other versions of this series) who produce and circulate games for free. It is difficult to estimate the size of this community, but probably a few hundred people are actively involved in creating amateur games, because the official website of Enterbrain has four hundred links to the websites of RPG Tkool users [6]. A few hundred might not appear particularly large, but if each user produces one game per year, the total will be more than anyone could play.

Producing a game is an extremely time-consuming endeavor. Why are so many people willing to spend so much of their time to create games to please others without demanding compensation from game players? Who are users of RPG Tkool, or as they call them in Japan, Tkoolers?

In order to study the amateur game-designers who use Tkool 2000, I used the following approach. In the Japanese Internet community, there is a practice of posting "100 questions" on the web. It is a kind of virtual interview or survey. Usually a set of one hundred questions is intended for a specific kind of person. Owners of a website often post their answers to a set of one hundred questions on their website as a way of making a self-introduction. There happens to be a set of one hundred questions for Tkoolers on the web, and I was able to find over one hundred Tkoolers who post their answers to the questionnaire on their website. I used these answers to study the demography of Tkoolers and their motivation to become a Tkooler. This is methodologically not without problems. One problem is that respondents are not always accurate in their answers. They often try to be amusing rather than informative. For example, although one of the one hundred questions asks age, gender and ethnicity, many of Tkoolers refuse to divulge their personal information, especially their age. One writes that he is from out of the solar system and 150 years old. One woman claims she is fifteen years old while she writes that her occupation is housewife. Many respondents report their occupation even when they do not provide their age. Hence, there is a need to process the data accordingly (see Table 10.1). The analysis of this data involves considerable speculation and the result is not necessarily very accurate. In addition, the data is biased because the

respondents are a subgroup of the Tkoolers who are willing to answer 100 questions and post them on a website. In spite of these limitations, however, these web pages provide us with invaluable information about what Tkoolers are like.

First, Tkoolers are not necessarily computer enthusiasts. Since RPG Tkool does not require much CPU power, this software and the games created by it can run on a relatively old model of PC. Hence, Tkoolers need not own high-end machines, and younger users can make games with limited technological resources. Many confess their lack of knowledge about computers.

As for demography of Tkoolers, as one might expect, they are generally young males. I expected more Tkoolers in their thirties but as it turned out there are exceptionally few. Only a couple of Tkoolers are in their thirties, in both male and female groups. On the other hand, it is surprising that there are so many early teens, and even primary school pupils. Overall, since designing a game is a time-consuming hobby, Tkoolers are in the age groups with relatively less occupational and familial duty. It is also noteworthy that very young Tkoolers are mostly male, and female Tkoolers are older than male Tkoolers on average.

Table 10.1: Demography of 102 respondents of "100 Questions for Tkoolers"

	Male	Female	Unknown
22–	20	7	
18–22 College Student	23	6	
16–18 High School	17	2	
12–16	15	1	
–12	5		
Unknown	5		1
Total	85	16	1

One of the hundred questions asks what made the respondent start making games with Tkool. Tkoolers report various motivations. Apparently, very few have utilitarian motivations. Some do earn substantial amounts of money by winning prizes; others see the experience of designing games with RPG Tkool as a stepping-stone to becoming a professional game-designer. Very few, however, seem to have these considerations as their motivation to create games with RPG Tkool. Many of them characterize themselves as "driven" to produce games. They find it a very pleasing experience to give forms to their fantasies. This psychological process seems to be closely related to the experience of playing role-playing games. Gamers are attracted to role-playing

games at least partly because they can experience what they fantasize. That experience of playing a role in a game world is more realistic than just imagining a fantasy world. To such people, creating a game world in the way they imagined must be an even better experience than playing a role in someone else's dream world.

Other amateur designers say that they began creating games because they wanted to tell stories. For people who have more technical skills than literary talent, creating a role-playing game can be easier than to tell a story in the form of a novel. Games are obviously easier to circulate and to attract an audience. Just as amateur writers post their novels on their websites, these amateur designers use RPG Tkool to tell and distribute their stories.

Yet other amateur designers drew their inspiration from other games. After having played a commercial or non-commercial game, some gamers liked it so much that they wanted to prolong the experience of playing it. Therefore, they created a sequel, a clone, or a similar game to extend their time playing that game.

Thus, motivations can vary, but as long as creating a game is not technically too challenging, gamers report ample reasons to devote their time and enjoy doing it without seeking material compensation.

Production, Circulation, and Consumption of Tkool Games

The Internet plays a vital role in the production, circulation, and evaluation of Tkool games. While commercial game companies can have their own networks, individual amateur game-designers would be isolated and quite powerless without the Internet.

As mentioned above, with the package of RPG Tkool 2000, an individual who has a good game idea, a good story, and sufficient passion and patience can produce a role-playing game. In many cases, however, good Tkool games involve some sort of collaboration with others. The graphics and music included in the RPG Tkool 2000 package do not always suit the purpose of game-designers. Some amateur game-designers try to avoid using graphics and music supplied in the package because they do not want their games to look or sound like other Tkool games. In such a case, the game-designer goes to the Internet for suitable graphics and music. On the net, there are websites of the people who provide graphics and music to be used for games and websites. Some of them are specifically for RPG Tkool 2000. For example, a group called "Refmap" provides graphics for RPG Tkool and even posts sample games to show how to use their graphics [7]. Similarly, there are websites for background music. The website of Hyoseki Saia (pseudonym), which provides more than one hundred pieces of music for free, is

probably one of the most important sources of background music for Tkool games [8].

Some amateur game-designers, who use RPG Tkool 2000 and other game construction software, choose to form a collaborative network so that they can combine the different skills of different individuals. Even when a designer decides to work alone, it is usually essential to enlist dedicated testers at some point. They use the Internet to form a group and maintain collaboration. Most amateur designers have a website, which plays a pivotal role in their game production. On their website, they announce a game project and call for volunteer graphic designers, composers, voice actors, and testers. They post their games on the website or link to portal sites. Those websites have a discussion board for games, which enable interaction between the designer and game players. If game designing is easy enough to be fun, the process of producing a game itself resembles a multiplayer online RPG, in which, instead of slaying dragons, players cooperate in the task of producing a game.

The time required to complete a Tkool game varies, depending on the size and complexity of the game and the amount of original graphics and sounds to be used in the game. To complete a medium length game seems to take at least a few months. A large game requires a year or more. One amateur game-designer writes that he spent a hundred hours on his medium size game.

The principal means of circulation of free RPG Tkool games is, as mentioned, the Internet. There are also a few portal sites for this purpose. For example, Vector (www.vector.co.jp), the most important portal site for freeware and shareware in Japan, has a very large selection of games. Some amateur designers make their games downloadable directly from their website or provide on their website links to portal sites. In addition to online circulation, some games are still distributed through magazine CD-ROMs. For example, TechWin is Enterbrain's magazine for amateur games in Microsoft Windows, and the games submitted to the prize competition held by TechWin are initially distributed through this magazine. For distribution, Enterbrain's website is also important because it has a webpage for ASCII/Enterbrain's prize competition [9].

Review websites dedicated to freeware games are of great importance to players of Tkool games (or freeware games in general). Japan's infamous gigantic electronic bulletin board system, "Channel 2" (www.2ch.net), has threads for reviews of freeware games, and there is a website that classifies postings of this thread [10]. This is an invaluable resource that provides various viewpoints from very harsh and cynical players/reviewers. In addition, there are review websites for freeware games run by individuals [11,12].

Largely content with personal satisfaction, reward and evaluation are not essential motives for amateur designers in their production of games. Yet, evaluation clearly plays an important role in enhancing the quality of freeware games. Most important for its evaluative function is Enterbrain's *Internet Contest Park,* or *Kompaku.* This is a competition of freeware games on the TechWin magazine, and prize-winning games are published and circulated through the magazine's CD-ROM, as mentioned above. Other than this, there are online competitions and popularity votes. The result of competition used to be published on the web until June 2002 [9]. ASCII and Enterbrain used to host another series of amateur game competition, "ASCII Game Contest" (later, "Enterbrain Game Contest). Both competitions come with prize money, the highest prize being ten million yen (approximately one hundred thousand dollars).

After publishing and circulating games, even after being reviewed or awarded a prize, a Tkooler's job is not yet complete. Since amateur game-designers cannot have many testers, they continue receiving bug reports from players of their games. Players participate in the final process of game production as de facto testers. Beyond bug-testing, designers continue interacting with players to fine-tune the difficulty level of their games. In particular, relatively less experienced Tkoolers can make games unreasonably difficult, and in such a case, user support (like answering questions and providing hints and even spoilers) will be necessary. These interactions usually take place in the discussion board of the designer's website. In this way, production of Tkool games is open-ended (at least for a certain period) and players of Tkool games participate in the process.

RPG TKool Games

Different modes of production and different economic and social forces lead to different products. RPG Tkool games are not always crude imitations of commercial games. Being non-commercial allows freeware games to include more personal and artistic expressions of game-designers. Although one might consider commercial and freeware video/computer games as the same digital medium, the messages that they convey often differ considerably.

Certainly, there are many games that imitate popular commercial games. Many RPG Tkool games were inspired by earlier titles of the *Final Fantasy* series as well. There are action RPGs such as *The Legend of Zelda.* There are even "Wizardry"-like games. Many games are, however, quite original and different from commercial games. Since the RPG Tkool does not allow its users to produce technically impressive state-of-the-art graphics, users have to exploit other aspects of computer games in order to produce high-quality games. Narrative is one. Game design is another.

Since amateur game-designers do not intend to make money, they do not have to conform to mass tastes. They could include in their story, for example, things many people might find unpleasant; an RPG called "Seraphic Blue" by Tempura (pseudonym), which illustrates the highest standards that an amateur game can achieve. Tempura is the author of two very long Tkool RPGs, "Sacred Blue" and "Stardust Blue," both of which compete well with commercial role-playing games in their play time, extremely complex story lines, and quality of game play. "Seraphic Blue" excels in its innovative game design and masterful use of music and images. One of its most distinctive features is the very pessimistic undertone of its narrative. The main character, Vene Ansbach, is a female seraph, and as the main character of an RPG invariably does, she is destined to save the world. In her case, however, she remains ambivalent about her mission throughout the story. As a human, she was psychologically abused by her father, and later reborn as a seraph, she was treated like a lab animal again by her seraphic father. The latter attempted to train her to be devoid of any human feeling in order to best fulfill her role as the savior of the world. Resisting her determined role, she committed suicide by slashing her wrists, but she was forced to live. Her enemies try to bring an end to the world, and she actually agrees with them that this world should not exist and that the life here is not worth living. Just from the sense of obligation, however, she defeats the final enemy, her alter ego, the dark and promiscuous side of herself. After the completion of her task, she only finds emptiness with no goal in her life. She loses the will to continue her life and starts attempting to kill herself [13].

Throughout the game, doubt lingers about the justice of saving the world at all. The game repeatedly asks its player whether life is worth all the suffering it makes possible, and suggests that we might actually be better off had we never been born at all. The game reflects contemporary Japan, where the number of suicides is at a record high. It is also a critique of contemporary Japanese society where people are treated like tools of the system and find no meaning in their life. To the average player, it is more depressing than fun to play this game. To some, however, this game conveys a very powerful message. While commercial games remain faithful to dominant ideologies in society, amateur games like "Seraphic Blue" can afford to resist them [14].

While "Seraphic Blue" is a combination of medieval fantasy and scientific fiction like the Final Fantasy series, "Another Moon Whistle" by Kannazuki Sasuke (pseudonym) released in 2002, is more like Shigesato Itoi's "Mother" (a.k.a. "Earthbound"). The story takes place in contemporary Japan (or its recent and nostalgic past) and not in the USA. Against the background of this nostalgic ambience, the theme of the game is extremely serious. As the author admits, this game is not for everyone. The protagonist, Kazuto, is a kindergartner whose parents are separated. He lives with his father, and his

elder brother lives with their mother on an island. The story of the game takes place when Kazuto and his father come to the island to spend a summer vacation. During his days on the island, Kazuto is involved in various personal conflicts between those around him. He is asked to make judgments to resolve these conflicts. For example, when two of his friends or his parents quarrel with each other, Kazuto has to listen to what both parties have to say and decide which side he thinks is right. These quarrels are, however, the kinds in which both sides are right in some ways. Players of the game are faced with very serious moral conundrums and asked to make ethical judgments [15].

Since amateur designers do not have to please everyone, they can compose a story according to their interest, expressing their own concerns. Some deal with social issues in contemporary Japan. Since amateurs are occupationally diverse (at least more diverse than professional designers), their games incorporate these various perspectives and tastes. For example, the presence of female amateur designers is conspicuous because they often produce very original games. One example is an RPG called "Pureia-chan no yuki (The Courage of Preia)," which takes the form of an orthodox fantasy RPG, but actually deals with the issue of sexism. In this story, the protagonist helps a young girl, Preia, who wants to become an adventurer resisting the sexist prejudice of her native village. She leaves the village to become an adventurer and find a city where people live free of prejudice and convention [16]. A further example is "Rifu mura soncho monogatari" (The Story of the Rief Village Chief) by Hiro (pseudonym), the housewife who claims to be fifteen years old. Instead of a wandering adventurer, the protagonist of this RPG is a girl who has become a village chief. Rather than exploring unknown dungeons, her role is to protect the village from intruders and help it prosper [17]. This makes a nice comparison because exploration is an important gendered aspect of many RPGs for boys [18].

Like "The Courage of Preia," many games deal with contemporary social issues. Many are about discrimination and bullying among children, reflecting Japan's school life. As is often the case with Japan's popular culture, such issues as war and peace, the environment, or the dangers of science and technology are favored themes of amateur games. Unlike comics or anime, however, non-commercial games do not have to please their audience and do not have to pretend to be "good." One designer, for example, uses his games to satirize anti-smoking campaigns [19].

These themes and approaches are, if not impossible, at least very difficult for commercial computer game developers. As the production of a game becomes increasingly expensive, game-designers for commercial games have stricter limitations on the kind of games they can produce. Commercial games need to be popular, rather than expressive of the artistic sensibilities of

the game-designer. A commercial game, thus, cannot be always a medium of expression for a game-designer. Being non-commercial allows freeware games to embody more personal and artistic expressions of their game-designers.

In addition, unlike videogames for game consoles, these amateur games are open-ended and self-reflective in important ways. For those who have a copy of "RPG Tkool 2000," it is easy to modify games created by it. Designers can easily produce updated versions of their games based on user feedback. Some games take game designing by "RPG Tkool" as their theme. While many games are parodies of commercial games, a few games even satirize clichés of RPG Tkool games.

Symbolic of this aspect of Tkool games is a game entitled "Tsukura no yabo (The Ambition of a Tkooler)" by Tomonori Sato or Li (pseudonym). The title is an allusion to a famous series of historic simulation game "Nobunaga no yabo (Nobunaga's ambition)" by Koei, Inc., but it is an RPG of a Tkooler. The player plays the role of a Tkooler who is going to design an RPG with RPG Tkool. His ambition is to win the gold prize of Enterbrain's Contest Park. In order to design a good game, the protagonist has to walk around the town and find inspirations and good ideas for the game. What is fascinating is that the player also plays the game (itself an excellent action RPG) that the protagonist designs since the protagonist needs to run test plays of his own game. If the player is successful, the protagonist finds all the good ideas for his game and wins a gold prize. To complicate the boundary between reality and fiction, the author of this game did win a gold prize at the competition. Apparently, the relation and dynamism between designers and gamers are different in the Tkool games because many players are themselves amateur designers, and even if they are not, they are at least familiar with the production and competition of Tkool games. In Tkool games, individual names (even if they are pseudonyms) are more closely tied to Tkool games, and the author is often explicitly in the game.

Conclusion

At the Game Developers Conference in 2005, Will Wright, the famed designer of *SimCity*, expressed his concern that the data of recent games had become too large. Presenting his game under development "Spore," he proposed using procedural programming and player creativity. Seeing the market already saturated, some manufacturers of hardware tend to develop and put onto the market faster and more expensive machines (this, of course, is not the only alternative, as, for example, the success of Nintendo DS shows). Advanced machines require more development efforts for game developers because those machines enable more realistic graphics and more data capac-

ity. New games need to implement these new features; otherwise, consumers will not buy new and usually more expensive machines. As a result, developing new game software becomes increasingly expensive. Games become more striking in photo-realistic graphics and sound, but that does not mean the experience of playing them becomes correspondingly better. As it becomes more expensive to develop a game, it becomes riskier to develop a game. Some game companies try to manage large investments by increasing their scale through mergers. Others try to minimize risk by producing less risky games, such as sequels or games in conventional formats, which leads to less innovation and greater stagnation. Either way, as hardware continues to become increasingly sophisticated, it is less likely that the major titles of mainstream game companies can accommodate the diversity of expectations of each individual player.

Amateur designers are capable of creating games that commercial game companies cannot. Since amateurs do not have to sell games, they can produce the kind of games that please them. Whereas commercial computer games are likely to remain a form of entertainment as long as they are primarily concerned with commercial success, non-commercial games can potentially become a form of artistic expression. Personal tastes are diverse. What is fun about playing computer games varies. If commercial computer games rely too much on the use of new technology and too little on new ideas, their high cost will make it unlikely to accommodate the diversity of game players' tastes.

Undoubtedly, the amateur production of computer games has certain limits. Non-commercial games do not have cutting-edge AI, state-of-the-art 3D graphics or original music. That said, such technical aspects do not determine the quality of the gaming experience.

The success of amateur designers hinges on several factors. First, the key is the existence of software like RPG Tkool 2000. For amateurs to participate, game design needs to be easy enough. The community of amateur designers and their supporters plays an important role. The networks of those who provide digital content to be used in games alleviates the burden on amateur designers a great deal. Third, the genre is important. Computer games do not have to meet the rigorous standards of many other kinds of software. A bug in a computer game does not result in a life-threatening situation or a loss of multi-million dollars. Moreover, a game is something amateurs can enjoy designing. This makes games ideal for participation by amateurs.

Thus, non-commercial amateur role-playing games seem to present important possibilities. Because amateur designers do not have to make money, they can do what professional designers cannot. Amateur game-

designers can experiment with their non-commercial games, and make their games vehicles of artistic expression and address social or philosophical issues.

References

1. Oudshoorn, N., and Pinch, T. (eds.). *How Users Matter: The Co-construction of Users and Technology*. MIT Press, Cambridge, 2003.
2. For example, Olli Sotamaa, "Computer Game Modding, Intermediality and Participatory Culture" available at old.imv.au.dk/eng/academic.pdf_files/Sotamaa.pdf. (Last accessed August 11, 2006).
3. For example, Junjiro Shintaku et al. eds., Gemu sangyo no keizai bunseki Tokyo: Toyo Keizai Shimpo-sha, 2003.
4. One example is Richard Rouse III's analysis of classical arcade games in his *Game Design: Theory and Practice, 2nd ed.* Plano: Wordware Publishing, Inc., 2005.
5. Noda, M. *Konpyuta shinjinrui no kenkyu*. Bungei Shunju, Tokyo, 1987.
6. "Kurietazu rinku shu (Links of creators)." Available at www.enterbrain.co.jp/digifami/conpark/link/. (Last accessed April 15, 2005).
7. Refmap. "First Seed Material." Available at www.mogunet.net/~fsm/. (Last accessed April 15, 2005).
8. Hyoseki, S. "Freedom House, 2nd." Available at fhouse.s17.xrea.com/. (Last accessed April 15, 2005).
9. "Intanetto kontesuto paku." Available at www.enterbrain.co.jp/digifami/conpark/index.html. (Last accessed April 15, 2005).
10. Furisofuto de omoshiroi gemu matome peji." Available at www.frgm.org (Last accessed April 15, 2005).
11. "Sani garu." Available at sunny-girl.net. (Last accessed April 15, 2005).
12. "Furisofuto cho gekikara gemu rebyu." Available at uehashi.s2.xrea.com/. (Last accessed April 15, 2005).
13. Tempura (pseudo.). "Blue Field." Available at www2.0dn.ne.jp/~caq12510/. (Last accessed April 15, 2005).
14. As for resistance and videogames, see: John Fiske, *Reading the Popular,* London & New York: Routledge, 1989.
15. Kannnazuki S. (pseudo.). "Sasuke no moso gekijo Ver. 3." Available at www9.0cn.ne.jp/~ktataki/mousou/. (Last accessed April 15, 2005). As for "Another Moon Whistle," see in particular the following page: "Another Moon Whistle shokai peji," www9.0cn.ne.jp/~ktataki/mywork/another_moonw.html.
16. Mayn (Pseud.). "Pureia-chan no yuki." Available at homepage3.nifty.com/mayn/index2.html. (Last accessed April 15, 2005).
17. Hiro. (pseudo.) "Rifu mura soncho monogatari." Available at park2.wakwak.com/~hiros_room/soft/mura/mura1.html. (Last accessed April 15, 2005).
18. Jenkins, H. "'Complete freedom of movement': Video games as gendered play spaces." In J. Cassell and H. Jenkins (eds.), *From Barbie to Mortal Kombat: Gender and Computer Game*. Cambridge, MIT Press, 1999, pp. 262–297.
19. "Tukuru paradaisu." Available at userhost-1.cmo.jp/!hentaifilm/rpg/tukuru.html.

11. *Opening the Production Pipeline: Unruly Creators*

John A. L. Banks

Introduction

This chapter draws on material from an ethnography of the game developer-fan relationship [1,2]. It offers an analysis of the rapidly transforming, reconfigured relationships between users and media producers in the games industry through an ethnographic account of Auran, a PC game development company located in Brisbane, Australia, covering the period from mid-2000 through 2004.

From June 2000 my relationship with Auran shifted when I accepted employment as the company's online community relations manager. This role largely involves managing Auran's relations with an online rail-fan community that formed around the game development project, *Trainz* (http://www.auran.com/TRS2004): a train and railroad simulation released in December 2001. Auran has increasingly incorporated and involved train and rail fans in the process of designing and making *Trainz*. Using the tools provided with *Trainz*, users can make their own 3D rail world layouts and import 3D models of locomotives, and then share them with other users through the *Trainz* website. This end-user creativity and innovation is an integral part of the simulation's design. Fan-created content is an increasingly important feature of the PC game development process and of online PC game culture generally. These participatory culture initiatives in the games industry are potentially redefining entertainment software as an open-ended process in which users participate directly in design, production and marketing [3, p. 210], [4,5,6].

The commercial success of the *Trainz* project over a series of releases (most recently *Trainz Railroad Simulation 2004*) has come increasingly to

rely on the unruly assemblage of an *ad hoc,* distributed, co-production network of voluntary fan labor. In *The Internet Galaxy,* Manuel Castells reminds his readers that the information communication technologies of the Internet introduce a socio-technical form that turns users into producers, thereby generating innovation, creativity and potential for productivity growth [7, p. 5]. He argues that this collaborative, creative network is increasingly articulated with an entrepreneurial culture that seeks to assert the proprietary [7, pp. 36–38]. A gift economy of collaboration and open, free sharing of ideas, techniques and know-how is connected uneasily with networked forms of business organization and practice that increasingly rely on such forms of collaboration to generate innovation and productivity [4,5]. As Tiziana Terranova argues in *Network Culture,* the important point here is not just the linkage between the proprietary and the non-proprietary, but the necessary reliance of these business enterprises on the free labor and voluntary production of these collaborative, decentralized networks [8, pp. 73, 77–78, 94]

This reliance on a network of fan content creators raised questions concerning how Auran would manage such a relationship. The difficulty arises of how fan generated content will fit within the framework of a commercial development project. In short, what are the implications of opening the commercial game production pipeline to voluntary fan content creators? It would be a mistake, I argue, to view these emerging participatory culture relations as shaped and configured through an *opposition* between the commercial and the non-commercial, the corporate developer and the fan community [6]. Rather than being exterior and oppositional terms, these entities that are "Auran" and "the *Trainz* fan community" are immanent to proprietary–nonproprietary and commercial–non-commercial dynamics. There is no exterior position from which to safely critique these antagonisms. The problem is how to participate in these processes.

An Uneasy Alliance

Both *Ultimate Trainz Collection* (2002) and *Trainz Railroad Simulator 2004* (2003) incorporate third-party fan content as part of the official commercial release package. In effect, Auran now relies on a pool of fan labor and volunteer enthusiasm as a routine part of the *Trainz* project. Auran's strategy of increasingly involving the fans in the development and distribution of *Trainz* is, in part, a contingent response to a difficult commercial situation in which sales were not reaching anticipated levels. Drawing on fan content is an outsourcing strategy aimed at lowering the increasing costs of art production. The opening of the game industry production process to end-user involvement and labor is a strategy to extract and capture surplus value [3,4].

Auran management carefully assessed that, based on the then sales levels and the problems encountered with marketing and distribution, the costs associated with further internal art content creation at the scale required to support another release of *Trainz* could not be justified. The continuing commercial viability of *Trainz* relied on collaborating with the voluntary fan labor force. If it were not for the continuing support of the fan community, Auran would have stopped the project. In 2003, as Auran worked towards the next significant release, *Trainz Railroad Simulator 2004* (TRS2004), the decision was made to source new art content from the fan content-creator network. The Auran development team concentrated on introducing new core features and functionality. The inclusion of fan content with Auran's official release package was therefore a contingent and strategic response to a particular commercial situation. Fan creators wishing to contribute content for the *TRS2004* release entered into a non-disclosure agreement, joining the third-party support program that was managed with a private password-protected forum area. The Auran development team determined the range and type of content assets required for the release and identified the fan content creators who would be approached to make the needed content. Some members of the *Trainz* development team, particularly the producer, were skeptical about the viability of relying on fan volunteer creators to meet commitments for a commercial deadline. They were rightfully concerned that any problems or delays with finalizing the core *TRS2004* code would provide the fan creators with very little time to update and finish their content.

Once the new code was sufficiently stabilized, the content creators would need to undertake updates and modifications to ensure that their content functioned correctly with the code. Auran planned to provide the participating creators with early release builds of the new *TRS2004* code so that they had access to the new features and functionality. The problem was that this code might significantly change with the introduction of modifications, updates and fixes between builds as bugs and problems were identified. This would possibly invalidate work undertaken by the creators, requiring them to then undertake extensive revisions to successfully integrate their content with each successive build as we worked towards the final release version. This process of updating art asset content across builds can be a frustrating experience for internal game development team artists who have regular and close access to the programmers, let alone to an external distributed team of fan creators. The producer's concern was that the development team just would not have the time and resources available to adequately support the fan creators' efforts to finalize their content, as the team would be fully committed to the 'crunch phase' over the closing stages of development. He also worried that the fan creators would not create the content according to Auran's guidelines, and this would then require significant fixing and updating by the

Auran team before it could be included with the commercial release build. After taking into account the time and effort involved in communicating with the many creators, assisting them with information and help they needed, he argued that it may be less risky to undertake the artwork in house, even if this meant reducing the amount of content that would be included with the package. Despite these reservations, Auran management decided to continue with outsourcing art production through the third-party content program.

Many of the content creators were attracted to the *TRS2004* program by Auran's promise that they would enjoy early access to builds of *TRS2004* and, more importantly, to direct support from members of the *Trainz* development team. The creators who were pursuing commercialization of their content also viewed it as a valuable promotional opportunity, as having their content in the *TRS2004* release may encourage users to visit their websites and purchase their other content offerings. As the project progressed over the second half of 2003 it became increasingly difficult to meet the support expectations of the fan creators. The Auran developers received many emails, forum requests and telephone calls from creators seeking advice and assistance as they worked to finalize their content and get it in before the deadline. Fan creators were expressing dissatisfaction with the tardiness of replies from the Auran development team. Some abandoned their projects, feeling that it was just not possible to meet our commercial deadlines; after all, it was a hobby that they were pursuing on weekends and evenings after work. A few emailed me stating that it was no longer fun and was becoming more of a job, and therefore they had made the decision to resign from the group. They would still work on the content, but at their own pace and release the content, when it was ready, through the *Trainz* website. Influential creators were expressing concerns about Auran's management of the third-party content program for the *TRS2004* project. In June 2003, Prjindigo, a leading third-party content creator, emailed that the code builds they were receiving in order to test their content were "incapable of doing the testing and creation that we need to be doing." He added that:

> The lack of flexibility in scheduling that has been indicated to us with totally impossible fixed deadlines and a half-way announced inability to get us a working version of the first wide beta to do content for one week before it goes to full beta are real turn-offs to the content group . . . The larger proportion of the 3rd party group expected a more smooth and fair treatment in the concerns of time to build and time to test than this schedule has compressed upon them.

His main concern was that the content creators were not being provided with the level of information and support that they needed:

> I've seen quite a few people who barely got started on their work and then saw how the group was being handled like a third class citizen and so decided to give

it a skip. If I didn't have the extra time to figure out what you may be doing or needing in the content before I make it and get it done, I'd have given it a skip too. While the amount of time for creation that you've given the community isn't unreasonable, it's still nearly impossible for most to do without having the information and tools to do it. [Prjindigo, email to Auran]

Despite these obstacles, I was amazed by the commitment of time that many of the fan creators gave to the project. The Auran development team worked closely with many of these creators to ensure that their content meshed with the final *TRS2004* build. A few of the creators even arranged to take leave from their employment over the closing stages to ensure that they met the Auran deadlines. I did feel, though, that we were not effectively following through on our commitments to support the fan creators' efforts adequately. Our expectation of working closely with such a large group of fan creators on such a limited project timeframe was ambitious, if not unrealistic. We significantly under-estimated the level of support that many of the creators needed. But from an Auran business perspective, the project was a success. Many of the creators were also very happy with the outcomes and continue to be an integral part of the ongoing *Trainz* project. When *TRS2004* was released in October 2004, the package included outstanding, high-quality content provided by this voluntary pool of fan labor. Thirty-five third-party fan creators had contributed content to the CD release and many fan community members had participated in the beta-testing process.

The *Trainz* team identified that trying to work with the large group of fan content creators in the *TRS2004* project resulted in frustration, misunderstandings and communication problems for both the fan creators and the Auran team. The group was just too large to manage and support effectively. Auran management therefore decided to reduce the size of the third-party program fan group and recently disbanded the official third-party content creation program, to be replaced by a new *Trainz* Partnership Scheme. Direct support from the development team is now limited to select groups of creators who have submitted project proposals that are approved by Auran management. By working with a smaller number of organized creators, the development team can more carefully and selectively focus its support efforts. This decision also means that we are unable to continue providing direct support for the broader fan content creator community. Auran is effectively endorsing an elite tier of fan content creators who will enjoy access to greater levels of direct support and information. They will, for example, have access to early builds of *Trainz* code. Auran is the gatekeeper, restricting access to early builds of the core *Trainz* platform.

Some fan creators expressed immediate concern and disappointment about our decision to disband the original third-party support group. Magicland, for example, posted to a forum thread: "Personally, I was sur-

prised when the 3rd party group was disbanded, as originally the concept (or at least my understanding of it) had been to forge a closer working relationship with Auran, with better access, feedback, etc., and then it turned out just to be a factory for TRS content which shut down when that shipped" [9]. Others expressed similar views in forum posts and emails. Marlboro comments:

> Well, a sound corporate course is plotted. Never had any doubts that Auran would think or act any different from any other commercially driven entity. They got to this point by utilizing hundreds of thousand of free hours provided by the community (be it 3rd party, beta, whatever) . . . but it was always obvious that that ain't good enough for a "corporate" future . . . For me it's a game, a hobby and mostly fun. If there is corporate background noise—fine. But if that noise levels increase too much it's time to tune in a new station. [10]

This foregrounds many of the controversies and conflicts that have shaped the *Trainz* third-party content-creator network. However, after reviewing the *TRS2004* third-party program outcomes, Auran management decided to continue integrating fan content with official *Trainz* releases. Outsourcing of content production to the fan creators will continue to be integral to the *Trainz* project. The next version, *Trainz : Driver Edition* was released in 2005 and prominently featured fan content. The content creators' views on our plans are varied: there is no singular *Trainz* fan position on these issues. For many, these creative activities emerge from their shared passion for trains and rail, for others it concerns the satisfaction derived from carefully crafting a detailed model, or the social status gained within the *Trainz* community for freely sharing their creations. In some instances, this productive activity is freely given. Others pursue the commercial opportunities that are available for their creative endeavors.

The intersection of these diverse practices and interests generates conflict and tensions concerning how the rights to material are to be negotiated and who should have access to information and support. Auran's ultimate concern is profitable business outcomes, and this means production processes that are carefully managed, scheduled and regulated. Many of the third-party creators, on the other hand, are motivated by their passionate investment in trains and rail and by the social rewards that are associated with their position as high-profile creators in the fan community. The ways in which these different practices and understandings come together are uneven and even conflict. The Auran *Trainz* team itself is far from united in its understanding of this collaborative production process. Producers, programmers, artists, community development managers and CEOs have very different understandings of how the relationships should be managed. But it is from these uneven, multiple and messy practices, negotiations, actants and materials that partici-

patory culture is being made and negotiated. The fact that the work of the fan creators on the *Trainz Railroad Simulator 2004* project did not entirely mesh with Auran's project schedule points to how this voluntary workforce can be unruly, difficult to control and guided by their own interests and agendas.

Conclusion

I argue that Auran's reliance on fan content is not simply a case of the exploitation of unknowing fans as a source of free labor [8, pp. 70, 79–80]; gamers are not only well aware of these practices, they are also sophisticated practitioners who participate in them. These complex and necessary entanglements of the proprietary and the non-proprietary, the commercial and the non-commercial, are not necessarily an appropriation or incorporation of fandom by corporate bottom-line agendas. The more difficult and urgent questions concern the implications and uptakes of gamers' direct participation and involvement in these production processes. The problem here is that such *ad hoc* fan content creation networks do not fit comfortably within the frame of corporate project schedules. They're unruly, messy and disruptive. They challenge our understandings of what a software project is and how it should be managed. Terranova suggests that these reconfigurations of the relations between production and consumption within an "open and distributed mode of production" are "already the field of experimentation of new strategies of organization" for modulating the "relation between value and surplus value" [8, pp. 96–97]. These emerging dynamics between Auran and the *Trainz* fans indicate a significant reconfiguration of the networks through which categories such as fan, consumer, producer and developer are made. Auran's effort to incorporate fan content creation into the game development process struggles with the problem of fundamentally reorganizing the project to support this kind of work. The player creators are never fully integrated into the design and development stages of the project. What would it mean to radically re-organize the development process and associated organizational structures to account for and support the fan content creators' contributions? Game companies such as Auran are yet to fully engage with the implications of this question.

References

1. Banks, J. A. *Participatory Culture and Enjoyment in the Video Games Industry: Reconfiguring the Player–Developer Relationship.* PhD Dissertation. University of Queensland, 2004.

2. Banks, J. A. "Gamers as Co-Creators: Enlisting the Virtual Audience—A Report from the Net Face." In M. Balnaves, T. O'Regan, and J. Sternberg (eds.), *Mobilising the Audience*. University of Queensland Press, Brisbane, 2002.
3. Kline, S., N. Dyer-Witheford, and G. De Peuter. *Digital Play: The Interaction of Technology, Culture and Marketing*. McGill-Queen's University Press, Montreal, 2003.
4. Hartley, J. "The 'Value Chain of Meaning' and the New Economy." *International Journal of Cultural Studies* 7(1) (2004): 129–141.
5. Humphreys, S. "Productive Players: Online Computer Games' Challenge to Conventional Media Forms." *Journal of Communication and Critical/Cultural Studies* 2(1) (March 2005): 36–50.
6. Jenkins, H. "Interactive Audiences?" In Harries, D. (ed.), *The New Media Book*. British Film Institute (pp. 157–170), London, 2002.
7. Castells, M. *The Internet Galaxy: Reflection on the Internet, Business, and Society*. Oxford University Press, Oxford, 2001.
8. Terranova, T. *Network Culture: Politics for the Information Age*. Pluto Press, London, 2004.
9. Magicland. "Beta Tester Tickets?" *Trainz Online Forum* http://forums.auran.com/TRS2004/forum/showthread.php?threadid=61599&rcferrerid=5. (Last accessed June 4, 2004).
10. Marlboro. "Moving Ahead with 3rd Party Support: The Trainz Partnership Scheme" *Trainz Online Forum*, http://forums.auran.com/TRS2004/forum/showthread.php?threadid=63622&referrerid=5. (Last accessed June 25, 2004).

Part III

Spaces and Places of Play

12. Push. Play: An Examination of the Gameplay Button

STEPHEN N. GRIFFIN

Introduction

In one of the first treatises devoted to digital game design, Chris Crawford discusses the complexity of creating an input/output computer control structure that provides both "expressive power" and "expressive clarity" [1]. Due to the difficulty of creating a simple communication language that affords a rich set of meaningful gameplay choices, he argues for the use of simple input devices and deep sets of interrelated, interactive game elements [1]. His solution is to develop rich interaction solely through software [1]. This is an implicit acceptance of a cognition-centered approach to game design, and one that appears to be the preference of many digital game developers [2,3]. Unfortunately, this approach, along with controllers based on this approach, does not allow developers to explore the full gamut of gameplay opportunities.

Civilization has a long relationship with systems of play, one that goes at least as far back as ancient Egypt [4]. Since this time, a significant variety of games have resulted, many of which are not based solely upon symbolic action or the application of preset input to a defined game space. Many games exists in which the abilities and idiosyncrasies of the body are essential to the play and enjoyment of the game. There are systems of play that involve not only thinking but also ones that involve locomotion, performance, and prop usage [5]. Consequently, there is no apparent reason why video game interaction should be restricted to an approach or to an input device defined by symbolic input.

The Button

The button is a central feature in the short history of video games. Of the thirty or more home gaming systems released since the debut of the Odyssey, all have included one or more buttons on the system's game controller [6,7]. The Atari VCS had one button; the Nintendo game pad had four; the current Playstation controller has ten. Personal computers, another prominent means for playing video games, are also reliant on button-based input [6,7]. Both the keyboard and the mouse employ variations of the device. Over the last thirty years, games such as *Tank, Space Invaders, Asteroids, Donkey Kong, Street Fighter II,* and a large assortment of other video arcade systems have also made the button a primary means of taking action [6,7]. Going even further back into game history, the button was also prominent in the play of one of the video game medium's more immediate ancestors; it was instrumental in the transformation of pinball from a game of chance to a game of control [6,7]. Buttons were first used to activate "flipper bumpers" in 1947's *Humpty Dumpty.* No longer left to the fates, players were finally able to control the roaming protagonist of pinball's stylized worlds. The button was the player's sole link to an electromechanical microworld, perhaps leading to the current, long-standing relationship between video games and the biased-switch.

Fictive Potency

All games are artificial. The play of a game is made possible by the carefully created boundary between the real and the unreal world, which allows the actions and events of a game to take on meaning and to have significance apart from what they typically signify [8]. For example, to an observer of a session of *Tony Hawk's Pro Skater,* the player may only be pressing buttons while watching a screen, but to the player, each button press is the calculated move of a master street skater. The button sits at the border of what Salen and Zimmerman, after Huizinga, call the "Magic Circle" [9]. As a special time and place, the magic circle enables the elements and events of a game to acquire significance [9]. However, it is not an objective phenomenon, external to a player, rather it is an artificial reality established by agreement to the rules of a game [9]. Consequently, a player's voluntary engagement with a button is not only a means to an end but also an act of participation that accepts the limits and artificiality of the encounter—it is a commitment to "play" the game.

　　The button is a catalyst for the transformative power of the video game medium. Combined with the phenomenon of play, it enables the player's actions to take on many meanings in the feedback loop of an ongoing game

[10]. In one moment, pressing a particular button can cause the player's character to swing a mighty sword. In the next, it can cause the same character to lift a delicate artifact. Using the device can have drastically different consequences depending on the situation. Its identity is highly reflective of the gameplay context. Equally important, the button offers the player little resistance when moving from intent to action in the game space. Due to the established limits of the encounter and the simplicity of the control method, the player is permitted to forget about the physical device in order to concentrate on interacting with the events of the game [2]. The method of interaction is essentially transparent. Generality and clarity are the reasons for the button's fictive potency and perhaps the causes of its continual use in gameplay control.

Physicality

Put to use in many everyday products, the button is an excellent means for reducing the need for skillful engagement; it consolidates multiple actions to one point of control, reducing the potential for user error [11]. However, the button offers little opportunity for natural, human-scaled interaction [12]. In its most common form, the button is a biased electrical switch. Used in a video game system, it enables a monitoring computer program to recognize press and release commands. However, it also has another less obvious function: the button is an artifact of automation that reduces gesture to symbolic action. Used for jumping, punching, grabbing, and even raping in video play-spaces, the button reduces complex action to a matter of choice. The idiosyncrasies and pleasures of the body are extraneous when interaction is equated to functional value [13]. Automation values productivity and efficiency, not physical expression [13].

While the button successfully affords video game "play," its lack of support for embodied interaction possibly impedes the development of the medium. Current buttons are not suitable for intimate, performance-based play; they are incapable of capturing the nuance of corporeal expression. The hand's movements are situated in time and space while the biased-switch is instantaneous. Consequently, the button is unable to participate in a dialogue with the fingers. The pleasures of the hand [14,15] can play no part when the control structure is defined by the symbolic nature of button-based input.

The significance of the interface's physicality is a well-understood point for musical performers. Effort and expression are recognized as being deeply linked phenomena [13]. The tangibility of the instrument affords discovery at the interface [16], and gestural interaction affords affective responses by the performer [17]. The physicality of an instrument contributes to the musician's intimacy with the sound and ultimately the expressiveness of the music

[18]. The inability of the modern controller button to support embodied interaction is a significant limitation and possibly an obstacle to the medium's growth as an expressive activity.

Conclusion

From the homemade control boxes for Steve Russell's *Space War* [19], arguably the first video game, to the state-of-the-art controllers for the Nintendo Gamecube, the button has been continually employed for video game "play." With such a long-standing association, one has to wonder if the relationship between the button and the video game is more than mere scaffolding in the development of the medium. Perhaps the button is the quintessential video game control. If so, revision, not replacement would be the way forward.

The dependency of video game control on the button reflects a disregard for the body's abilities. By relying on this artifact of automation, the video game medium must adopt a cognition-centric approach to interaction—giving up the pleasures and benefits of physical involvement. However, the modern controller button is not without its merits; it is a catalyst for the transformative power of the video game medium. An opportunity exists for the development of a button system that maintains the generality and clarity of modern controller buttons while providing a tangible structure suitable for both supporting playful interaction with the hands and capturing the resulting input. Whether or not this is a contradiction remains to be seen.

References

1. Crawford, C. *The Art of Computer Game Design: Reflections of a Master Game Designer.* New York, NY, McGraw-Hill/Osborne, 1984.
2. Church, D. "Formal Abstract Design Tools." In *Game Developer* (August 1999).
3. Sieberg, D. "The World According to Will." Available at http://archive.salon.com/tech/feature/2000/02/17/wright/idex.html. 2000.
4. Tylor, E. B. "The History of Games." In E. M. Avedon, and B. Sutton-Smith (eds.). *The Study of Games.* Huntington, NY, Robert E. Krieger Publishing Company, 1979.
5. Redl, F., P. Gump, and B. Sutton-Smith. "The Dimensions of Games." In E. M. Avedon, and B. Sutton-Smith (eds.). *The Study of Games.* Huntington, NY, Robert E. Krieger Publishing Company, 1979.
6. Demaria, R., and J. Wilson. *High Score! The Illustrated History of Electronic Games.* New York, NY, McGraw-Hill/Osborne, 2002.
7. Kent, S. *The Ultimate History of Video Games.* Roseville, CA, Prima Publishing, 2001.
8. Huizinga, J. *Homo Ludens: A Study of the Play Element in Culture.* Boston, MA, The Beacon Press, 1955.

9. Salen, K., and E. Zimmerman. "This is Not a Game: Play in Cultural Environments." In *Proceedings of Level Up: DIGRA 2003,* Digital Games Research Association. 2003.
10. Poole, S. *Trigger Happy: Videogames and the Entertainment Revolution* (pp. 59–64). New York, NY, Arcade Publishing, 2000.
11. Shneiderman, B. "Direct Manipulation: A Step Beyond Programming Languages," in *IEEE Computer* 16(8): 57–69 (August 1983).
12. Buxton, W. "There's More to Interaction than Meets the Eye: Some Issues in Manual Input." In D. A. Norman, and S. W. Draper (eds.), *User Centered System Design: New Perspectives on Human-Computer Interaction.* Hillsdale, NJ, Lawrence Erlbaum Associates, 1986.
13. Ryan, J. "Effort and Expression." In *Proceedings of the 1992 International Computer Music Conference.* San Francisco, CA, Computer Music Association, 1992.
14. Focillon, H. "In Praise of Hands." In G. Hogan, and G. Kubler (trans.), *The Life of Forms in Art.* New York, NY, Zone Books, 1992 (Original Work published 1934).
15. Gibson, J. "Observations On Active Touch." *Psychological Review* 69(6): 477–491 (November 1962).
16. Wessel, D., and M. Wright. "Problems and Prospects for Intimate Musical Control of Computers." In *Proceedings of CHI '01 Workshop New Interfaces for Musical Expression (NIME'01),* (Seattle, 2001), ACM SIGCHI, 2001.
17. Wanderley, M. M., and M. Battier (eds.). "Electronic Controllers in Music Performance and Composition" (Round Table). In *Trends in Gestural Control of Music.* Paris, France, Ircam—Centre Pompidou, 2000.
18. Moore, F. R. "The Dysfunctions of MIDI." *Computer Music Journal* 12(1): 19–28 (Spring 1988).
19. Graetz, J. M. "The Origin of Spacewar." In *Creative Computing* magazine (August 1981).

13. *Evolution of Spatial Configurations in Videogames*

CLARA FERNÁNDEZ-VARA, JOSÉ PABLO ZAGAL,
AND MICHAEL MATEAS

Introduction

Any game takes place within a space, so that its rules are in force within its boundaries; Huizinga called this "the magic circle" (a phrase recently revived by [1]). Spatiality is one of the fundamental properties of digital environments, as defined by Murray [3]. Videogames take place within a digital environment, and make use of the spatial properties of digital environments to create new types of spaces [1,3]. The representation of this virtual space has always been constrained by technological affordances; as technology advances, the configuration of those spaces has also developed and become more complex.

This chapter addresses these spatial configurations in videogames from early games until today, focusing on how they position the player with respect to the playfield, and how they affect gameplay. The basic spatial configurations are defined by a few features which combined can account for most videogame spaces.

We are aware of a similar analysis, carried out by Wolf [4], to which this chapter presents an alternative. Wolf compares videogames with other media, mainly film, and considers the influence of technology on the creation of spaces. However, his analysis lacks a historical perspective, and the strict comparison to film misses what the intrinsic properties of the digital medium bring to videogames. The analysis will focus on the main gameplay spaces of every game, disregarding types 11 and 9 in Wolf's classification—maps, which the player can call up on the screen or overlay the main space, and the split screen methods that some multiplayer games use.

The scope of this chapter is limited to how computers generate visual spaces procedurally, rather than how they import spaces from other media, such as digitized videos or photographs. Thus, games such as text adventures, *Dragon's Lair* or *Mad Dog McCree* will not be accounted for by the terms defined here; these games deserve typologies and analyses of their own, which are indeed related to constructions of space in written prose or cinema.

The present analysis is based on concepts and terminology within the Game Ontology Project [5]. This project intends to generate a language and vocabulary for the critical analysis of games. Rather than developing definitions for what a game is, or aiming at a generic classification of games, the ontology focuses on the analysis of design elements cutting across a wide range of games, in order to describe their design space and inform their critical analysis.

Spatial Configurations: Features

Gameplay and space are related by cardinality of gameplay, which defines how the player can move around the game world. Cardinality of gameplay refers to the degree of freedom the player has with respect to the control of movement in a game. The cardinality is defined by the number of axes that the player can use to move entities around (X, Y, Z), that is, side to side, up and down, back and forth. This term only refers to the movements the player can perform, independently of other actions or the effects they may have in a different dimension (e.g., shooting), because these do not affect the way the player moves within the game world.

- One-dimensional (1D) gameplay: the player can move along a single axis, X or Y.
- Two-dimensional (2D) gameplay: the player can move along two axes, X and Y, or X and Z. We have not found any instances of a game that allows Y and Z cardinality.
- Three-dimensional (3D) gameplay: the player can move along the three axes, X, Y and Z.

Cardinality of gameplay is related to, though different from, cardinality of the game world, which refers to the way in which the player can navigate the space. At the same time, they are both different from the spatial representation, which can be either in two dimensions or in three, but it does not mean that the player can move around in those same dimensions. As we will see in the examples, the differences between both cardinalities and the representation can have a direct influence on the gameplay.

Another basic feature of the spatial configurations is the dichotomy between discrete and continuous spaces. The screen is the basic unit of space

in videogames, since it frames the interface. This dichotomy considers how the virtual space is contained within that basic frame, whether the game world is encompassed within a single screen, or extends beyond its limits. In the second case, the representation must be segmented, and the player will experience that space in a fragmented way.

This segmentation can be realized either in a discrete or a continuous way. Discrete segmentation occurs when the screen contains one fragment of the game world, which the player navigates; when she reaches the limits of that fragment, the screen refreshes to a different segment of that space. Usually every segment contains a challenge of its own, which may be to overcome the obstacles to reach the next screen. (For a more detailed discussion of different types of gameplay segmentation, see [6]). This segmentation may also affect the game world, e.g., the player character can move from one segment to another, but the enemies will not follow the character to the next segment (e.g., *Prince of Persia*, PC, 1989). On the other hand, the space is represented continuously when the screen is showing with a scroll—Wolf compares this to a tracking shot [4, p. 58]—or moving the point of view of the player as she moves around.

After defining these three basic concepts, let us continue with the different spatial configurations per se. Table 13.1 shows how these concepts combine to define different spatial configurations in 2D, while Table 13.2 shows the configurations in 3D representations of space.

Table 13.1: Spatial configurations in 2D representations of space

	Single screen	One-dimensional gameplay	Two-dimensional gameplay
Discrete	Galaxian Centipede Frogger Donkey Kong Pacman (wrapped) Asteroids (wrapped) Time Pilot	Athletic Land Pitfall (1.5 cardinality)	Adventure Prince of Persia Metal Gear The Legend of Zelda: Link's Awakening The Legend of Zelda: Oracle of Seasons The Legend of Zelda: The Minish Cap
Continuous	N/A	Spy Hunter Operation Wolf Defender	Nemesis/Gladius (Locked scrolling) 1942 (Locked scrolling) Yoshi's Island (Including locked scrolling in some levels)

Table 13.2: Spatial configurations in 3D representations of space

	Single screen	One-dimensional gameplay	Two-dimensional gameplay	Three-dimensional gameplay
Discrete				
	Technic Beat	N/A	Myst	Metal Gear Solid
Continuous				
	N/A	Gran Turismo	Battlezone Myst III: Exile Wolfenstein 3D Doom	Unreal Tournament

Two-Dimensional Spaces

These spaces are represented on a 2D plane, the point of view of the player moves up and down the surface. There are only two axes of representation (X, Y), which mark the cardinality of gameplay—those are the axes that the player can move along. The cardinality of the game world, as we will see, depends on how these two concepts interact.

Two-Dimensional Single Screen

In single-screen games, the dimensions of the game world coincide with the size of the screen. This is the most basic configuration used by early gaming technologies, for example, early arcade games such as *Galaxian* (1979), *Centipede* (1980), *Frogger* (1981), and *Donkey Kong* (1981), and the early Atari consoles. The player has a complete view of the state of affairs at a glance, which allows for the development of global spatial strategies; this is why this type of spatial configuration is singled out. This would later become the mode of the first strategy games (e.g., *Sim City* (PC, 1989)), since it provides a god-like point of view.

A technique used to enrich 2D spaces is the wraparound (also see [4], p. 56), which affects the cardinality of the game world. This is a feature of 2D spaces, by which when an entity reaches the limits of the game world, it reappears on the opposite side. It is a convention rather than an actual representation of a space. In single-screen arcade games such as *Asteroids* (1980) and *Pac-Man* (1981), wraparound is a way to "extend" the space, and make orientation more complicated.

Time Pilot (Arcade, 1982) presents a special configuration within this type. The player controls an airplane in the middle of the screen; the objective

is to destroy every wave attacking the airplane. The space scrolls towards the direction the player chooses, making the space virtually unbounded, since the enemy airships will follow the player wherever she goes. The game world is what is displayed on the screen, there is no external space to be mapped out, and that is what makes the space in *Time Pilot* different from other spaces extending beyond the limits of the screen.

Two-Dimensional Space, One-Dimensional Gameplay

In most videogames, the game world is larger than the screen, so it has to be shown in segments. Most of the definitions below deal with the how this segmentation can take place, and its effects on gameplay.

a. Discrete: The most basic way to extend the space beyond the screen is by making different screens adjacent to each other; the player accesses the next screen when the entity she controls gets to the exit of the previous one. This is a direct evolution from the single-screen space, since every screen will contain a challenge (instead of the whole level), which will have to be overcome to reach the next one. In the case of 1D games, the screens are usually linked horizontally. The player can only go to either side; once a direction has been chosen, the player can only go in that direction. Jumps may be allowed, but that only compensates for the fact that there is no point in going back. *Athletic Land* (MSX, 1984), a *Pitfall* imitator, is a strong example of this type of space. *Pitfall* (Atari 2600, 1982) itself is a weak example, since every screen has two levels, and the player may opt to advance to the right either on the surface or through the tunnels, which adds half an axis to the cardinality of gameplay. In either case, the enemies in each screen never follow the player character to the next one.

b. Continuous: Space is usually presented continuously in a scroll, bestowing the gameplay with a sense of progression. The cardinality of gameplay dictates that the game world must be arranged either vertically or horizontally. Race games with a vertical point of view, such as *Spy Hunter* (Arcade, 1983), are a clear example of this. The player moves from side to side on the road; accelerating and braking affect the speed of the scrolling movement, but not the direction of the car—the only way to go is forward.

This configuration can also have wraparound, as in *Defender* (Arcade, 1980), to represent a 2D space wrapping around in a cylinder (see Figure 13.1), where the player's point of view revolves around the Y axis. In *Operation Wolf* (Arcade, 1987), an early first-person shooter, this configuration gave a static position to the player, who would move from side to side to kill her enemies.

Figure 13.1: 2D wraparound

Two-Dimensional Space, Two-Dimensional Gameplay
When the cardinality of gameplay includes moving along both the X- and Y-axes, the game world can extend to the four directions, complicating the space and demanding that the player use her sense of orientation.

a. Discrete: A strong example of this type of space is the original *Prince of Persia* (PC, 1989), where the dungeons extend to four directions. The maze-like configuration of the space was complicated because it was segmented, and even though enemies would not follow the player from one screen to the next, some fulcrums would open gates in another screen, breaking the self-containment of earlier games.

Metal Gear (MSX, 1986) combined the fragmentation of the game world with gameplay. A pioneer stealth game, if the soldiers were alerted of the presence of the player character they would raise the alarm and start chasing him, but only within the boundaries of every screen. The segmentation of the representation affected the events in the game world—if the player went on to another space, the alarm would be immediately called off.

Earlier games combined a segmented maze with wraparound to complicate the cardinality of the game world. *Adventure* (Atari 2600, 1980) as analyzed in [4], p. 62, is a strong example of this, featuring mazes impossible to map in 2D.

Some games in *The Legend of Zelda* saga (Oracle of Seasons (GBC, 2001), and *The Minish Cap* (GBA, 2004)) also take advantage of this segmentation to create a maze. This maze is a series of screens, where the player has to choose the correct direction according to a set of instructions, but which cannot be drawn in a map. For example, the player has to go left in the first screen, then right, which does not take her back to the previous screen, but is actually the next step in the maze. This is an impossible space in the real world, but possible in videogames by the segmentation of the game world.

b. Continuous: The earliest form of this type would be an evolution of the single-screen shoot-'em-up, where gameplay was 1D; e.g., in

Galaxian the ship could only move side to side. Games such as *Nemesis* (MSX, 1986), the origin of the *Gladius* saga, extended the cardinality of the game world gameplay, so that there was an enhanced sense of traveling. This configuration, however, also brought about what we call locked scrolling: the game world is advancing constantly forward, the ship can move in the four directions within the screen, trying to keep up with the scrolling but the player cannot speed up that scrolling.

1942 (Arcade, 1984) is another example of this type of space, with a twist—apart from moving in the four directions, the player has a limited number of loops which allows her airplane to jump briefly to another height, adding half an axis to the gameplay, so to speak.

Two-dimensional spaces scrolling in the four directions would be a later technical development, allowing larger spaces to be navigated in a continuous fashion. *Yoshi's Island* (SNES, 1995) successfully combines different 2D configurations to provide diverse gameplay in every level. The first levels use 1D gameplay with scrolling screens, evolving into 2D gameplay in subsequent levels; it even adds locked scrolling to 2D gameplay every few levels, making the progress in the game more difficult.

Three-Dimensional Spaces

One basic representation of 3D spaces is using isometric perspective, which allows the player to have a general view of the game world at a glance, as in *Marble Madness* (Arcade, 1984). This type of representation is usual in strategy / simulation games, such as *Sim City 2000* (PC, 1995), or *The Sims* (PC, 2000).

Another 3D representation is the use of perspective, resorting to 3D rendering to calculate the vanishing points. Early videogames, such as *Battlezone* (Arcade, 1980), used wire-frames to represent the objects in the space; polygonal 3D rendering took longer to latch on to videogames, when processing speeds allowed refresh rates fast enough to provide smooth gameplay.

Three-dimensional game worlds invite navigation and exploration, since they take place within a 3D real-time environment. The concept of "camera" as the point of view has an important role in gameplay, for example, when looking around to locate one's enemies or to find the way out of a building. Thus 3D games may offer multiple points of view (first-person, third person, floating camera) that the player can choose.

Most times, 3D game worlds extend beyond the limits of the screen, although there are some examples of single-screen 3D games. *Technic Beat*

(PS2, 2004) allows the player to move the camera around and choose her preferred point of view.

Three-Dimensional Space, One-Dimensional Gameplay

We have not come across any examples of discrete representations of space within this category, so this configuration is continuous by default. The natural example seems to be the 3D version of racing games, such as *Gran Turismo* (PS, 1998), which have the same controls and therefore same cardinality of their 2D counterparts. The point of view limits the view of the player's opponents; therefore racing games usually show an overlaying 2D map of the game world, to facilitate the player's orientation and relative position with other racers.

Three-Dimensional Space, Two-Dimensional Gameplay

Three-dimensional representations usually take advantage at least of two of their axes for gameplay.

a. Discrete: This is a special configuration, by which the game world is shown in captions that fade in/cut to the next image as the player chooses a direction in which to move. It slows down the pace of navigation; therefore it seems suited for puzzle games such as *Myst* (PC, 1995). We are including these games here because the captions being reproduced are procedurally generated first, and then captured and used as a static image (with overlaid animations when relevant).

b. Continuous: Continuous 3D representations allow the player to navigate a 3D real-time environment. This is the format that Battlezone took; more recently, it is also a refinement from the previous space, such as in *Myst III: Exile* (PC, 2001).

Wolfenstein 3D combined these spaces with shoot-'em-up mechanics so successfully it sparked off the First-Person Shooter genre. The player could move backwards and forwards, side to side and shoot with different weapons. The enemies would also move in those same directions, so that the cardinality of the game world was also 2D.

Doom (PC, 1993) improved the formula, by actually making the cardinality of gameplay clash with the cardinality of the game world—there were several floors, and the player had to find the way to climb up, because she could not jump. However, the game world physics allowed the player to fall to a lower floor, expanding the cardinality of the gameplay down the vertical axis.

Three-Dimensional Space, Three-Dimensional Gameplay

Because the cardinality of the game world and gameplay are the same, the freedom of movement is larger; on the other hand, this configuration also

requires a better sense of orientation, since the point of view of the character is always contained within the screen.

 a. Discrete: The cardinality of the game world can be hampered by segmenting the 3D representation using different camera views. This is the case of *Metal Gear Solid* (PS, 1998), where the point of view imitates that of surveillance cameras in some areas, which seems adequate for a stealth game. This is also a natural evolution of the discreet spatial segmentation of the first game, with a twist—the game world is continuous, so that if the alarm is triggered in one area, the soldiers will chase you wherever you go, and the alarm will only turn off after one minute if they do not find you.

 b. Continuous: This type of space seems to be appropriate for action games, where the player can move around doing acrobatics if needed. A first-person shooter such as *Unreal Tournament* (PC, 1999) seems to benefit specially from this type of spatial configuration, where dodging the opponents' shots and reaching places to take cover are fundamental to the gameplay.

Conclusion

Our discussion of spatial configurations highlights how the development of technology allows spaces to increase in size (extending beyond the single screen) and complexity. We have also noted how the cardinality of the gameplay space is usually minor relative to that of the game world and its representation, for example, a space represented in 3D may only be navigable in two dimensions. As technology has progressed, an increasing number of games have achieved spatial configurations where the cardinality of the representation is equal to that of the game world, and finally to that of the gameplay.

Technical development does not cancel out previous spatial configurations, but rather expands them, and even allows contrasting the different gameplay models that they allow. *Pacman Vs.* (GC, 2003), for example, allows one player to play the classic *Pac-Man* on a Gameboy Advance connected to the Gamecube, while up to four other players play the game on the TV-screen as the ghosts, within a 3D labyrinth. The cardinality of gameplay and game world are the same, but the different spatial representations demands different gameplay strategies depending on whether the player is playing Pac-Man or a ghost. The goals will be different for either character, as well as the way in which the player orientates herself—the labyrinth appears fragmented to the player-ghost, and therefore feels more confusing than to the Pac-Man player, who can see her relative position within the space and from the other players.

We have defined the basic features defining spatial configurations in videogames. Technology is not likely to bring about new ones, since we have reached a point where the cardinality of gameplay and game world coincide with that of the representation. What may happen is that technology may thrive in the creation of new game world cardinalities, by exploiting the segmentation of the representation (as in the *Zelda* maze) in 3D, generating spaces, which change on the fly as the player navigates them, or reproduce 3D models of Escher-like spaces. The way is open to create new game worlds that are impossible to conceive in the real world.

References

1. Novak, M. "Liquid Architectures in Cyberspace." In , M. L Benedickt (ed.), *Cyberspace: First Steps*. Cambridge, MA, MIT Press, 1991, pp. 225–254.
2. Salen, K., and E. Zimmerman. *Rules of Play: Game Design Fundamentals*. Cambridge, MA, MIT Press, 2004, xv, 672 p.
3. Murray, J. H. *Hamlet on the Holodeck: The Future of Narrative in Cyberspace*. New York, Free Press, 1997, xii, 324 p.
4. Wolf, M. J. P. "Space in the Video Game." In Wolf, M. J. P (ed.), *The Medium of the Video Game*. Austin, University of Texas Press, 2002, p. xvi.
5. Zagal, J., M. Mateas, C. Fernández-Vara, B. Hochhalter, N. Lichti. "Towards an Ontological Language for Game Analysis." In *Proceedings of International DiGRA Conference*, 2005.
6. Zagal, J., M. Mateas, and C. Fernández-Vara. "*Gameplay Segmentation in Vintage Arcade Games*" In M. Bittanti and I. Bogost (eds.), *Ludologica Retro, Vintage Arcade (1971–1984)*, Costa & Nolan, In press..

14. *Fictive Affinities in* Final Fantasy XI: *Complicit and Critical Play in Fantastic Nations*

WILLIAM HUBER

Introduction

To interrogate the game as a text (that is, as an object, rather than as a space of social practice) is to ask, *for what question is this artifact an answer?* When this method is applied to an open-ended, hugely multiplayer role-playing game (MMORPG), we can look at the ways in which the game generates the space of play and the tasks of play, and at the positions in which the player is situated by the game. *Final Fantasy XI* [1] is a persistent-world MMORPG produced in Japan, for a global market, by Square-Enix in 2002. Content is added continuously to the game, and it remains among the most popular MMORPGs on the market as of this writing.

If we apply a revised version of Altman's [2] synthetic model of genre, the game is semantically a fantasy-game, and syntactically a massively multi-player role-playing game; these two categories of genre are not completely autonomous from each other, as the most popular massively multiplayer games have consistently been those set in fantasy environments [3].

Fantasy in Literature and in Game

Anglo-American modern heroic fantasy as a genre in literature and film has its immediate origins in nineteenth-century romantic literature, particularly the work of William Morris. A pronounced sense of geography informed his work, and this sense of geographic displacement and imagination becomes more pronounced in the work of Edward Plunkett Lord Dunsany, C. S. Lewis, Edgar Rice Burroughs, and J. R. R. Tolkien. In the interwar period in

Japan, fantastic literature was also negotiating questions of fictive and real spaces. Miyazawa Kenji wrote *Ihatov*, which was a project of an imaginary Slavic identity onto his home prefecture, Iwate. There are marked differences between the Anglo-American and Japanese traditions of fantastic space and displacement (and, at least until recently, the latter often critiqued or nuanced the former without reciprocation or recognition). These differences are part of a broader range of characteristics marking the Japanese fantastic tradition [4], particularly its readiness to insinuate the heroic-fantastic into the real world.

The two strands of fantastic literature described here both emerge in the setting of the consolidations of nation-states and the emergence of discourses of the folk (see Harootunian [5]), of what Marilyn Ivy [6] described as a "discourse of the vanishing," which informed and mobilized the discipline of anthropology [7]. The genre of heroic fantasy can be seen in this light, as one by which questions of race, nation and ethnos are worked out in fictional geographies. By migrating these questions to the game environment, different modes of articulation become possible: the relationship between the player, the terrain, and the fiction of the nation becomes playable as procedure, rather than received as narration. Theorists such as Tristan Todorov [8] and Rosemary Jackson [9] have offered structural and psychoanalytic readings of the genre. However, these readings do not easily survive application to the game environment; instead, those theories of fantasy which emphasize its relationship to mimesis, such as those of Katherine Hume [10], may be more suitable. The fantastic is ultimately an *episteme*, which, as Hume describes, is created by processes such as replacement, subtraction, and augmentation. In this sense, the game-as-fantasy might be seen as the fulfillment of the logic of the heroic-fantastic, at least that of utopian or dystopian national landscapes. The process by which the familiar is mapped selectively by addition (adding magic, binding race and nation) or subtraction (compressing class difference, removing technology, fixing categories of nation and race) is by necessity ideological. That the fantasy-game may fulfill the fantasy-narrative is predicted by W. R. Irwin's theory of the (literary) fantastic as game [11].

The complete structure of any fantasy MMORPG is very complicated, and an exhaustive outline is beyond the scope of this chapter. However, certain features are fairly universal—the player-avatar is a collection of values, some of which are static—race, name, gender—and some of which are dynamic—jobs, skills, abilities, health, and inventory. The player then participates in a persistent world by fighting opponents, completing missions, augmenting his/her abilities, etc. The motivations for play range from the challenge of improving performance, to conviviality, to participation in a fictional world and aesthetic enjoyment.[1]

Epistemes of Place

Final Fantasy XI contains elements consistent with other games in the Final Fantasy franchise. The series does not, as a rule, consist of true sequels: each game is fictively autonomous from the others, yet share certain mechanics and features, such as monsters, systems of mobility, skill systems, etc.

After installation, the game begins with a cinematic cut-scene, a dramatic representation of the sacking of a human city by monstrous *Orcs,* one of the *Beastmen* races against whom the playable races fight (see below). The scene depicts a young boy who is saved from massacre by the self-sacrifice of his sister. It is then revealed that this event took place "twenty years ago"; the next scene shows an advancing column of warriors of the playable races, carrying banners of three countries, returning to the sacked city. The young boy, now a grown man, is among them. The scene depicts a harmony of these races and nations in their *Reconquista;* they glance towards each other with comradely assurance and purpose. In fact, this reference to the re-conquest of European lands from Moorish invasion is clearly not accidental: the very landscape of the city in the cut-scene markedly resembles historical depictions of the medieval Spanish countryside.

Specifically, the war was waged between the "free nations" (i.e., the homelands of the player-characters) of the world of *Vana'diel,* and a collective of "partially sentient" races called the *Beastmen* led by a "Shadow Lord." In this introduction, and in the extra-textual material that accompanies the game, the player is led to assume that these bestial monsters are an ongoing menace to the wellbeing of the civilized world. Thus, the historical context of the game is the wake of a destructive total war; players are told that they, as adventurers, are chartered with the recovery of territory in the name of civilization.

Character creation follows this introduction, in which the player selects the character's race, gender (one race is all female, one is all male, and the others are dimorphic) and appearance. The player selects their initial job class and selects a nation from which to begin. There are three cities from which the player can begin, and this choice will determine the initial relationship with the fictional elements of the world. The cities are metropoles of empires, dominated by different racial groups. These national identities are constructed through techniques drawn from the actual history: the discourses of cartography [12], of visuality [13], and of ethnology.

The city of *Bastok* is dominated by *Humes* (humans), who are described as versatile, industrious, and technical. Their cardinal flaw is revealed, by a mechanism quite late in the game, as *apathy.* They dominate the hulking *Galka,* a playable refugee all-male race that provides heavy labor to Bastok, characterized by *anger.* Bastok is visually represented by a pastiche of refer-

ences to actual historical places and culture: the racial tension in an industrial republic strongly suggests the American experience of race, particularly in the era of industrial growth in the early twentieth century. While certain other tropes suggest other elements—many names are vaguely Germanic, and the Galka are depicted as having dual identities, having been given "English" names like "High Bear" and "Wandering Eagle" by the Humes, and often reverting to "authentic" Galka names as an act of protest. The architecture of the city suggests Chicago in its early years; artifacts that are marked as originating in Bastok are functional, utilitarian, and suggest mid-twentieth century philosophies of design.

The city-nation of *San D'Oria* is dominated exclusively by the *Elvaan*. In an idiosyncratic departure from the post-Tolkien fantasy-literature tradition, the *Elvaan* are militaristic and suspicious of both magic and technology. Their cardinal vice is *arrogance*. San D'Oria is a monarchical empire, described as being in a state of decline, eclipsed by the emerging technological republic of Bastok. The names of non-player San D'Orians are vaguely French; the architecture is a mix of pre-modern European styles, with something of a northern European early Renaissance tendency. San D'Oria is also the seat of Vana'diel's religious authority, with a papacy (the *papesque)* ruling from a central cathedral, and an activist clergy engaged against apostasy. These images of Catholic authority have a pre-history in earlier Final Fantasy games, particularly Final Fantasy X. It may be appropriate to see references to national religion as a reflection on the history of the so-called state Shinto in the Meiji period, which would play an active role in Japanese politics until the U.S. occupation, as much as it is to the role of Christianity in Western social and political history.

The third initial city-nation is *Windurst,* built by the diminutive, magically powerful *Tarutaru,* who physically resemble children. They share control of the city—in a harmony which contrasts sharply with the racial tension that troubles *Bastok*—with the female[2] *Mithra,* who came to Windurst to support it during the past war, and remained as new citizens. In contrast to Bastokian technological dominance and San D'Orian militarism, the Windurstian *Geist* is that of neutrality, magic, and academic research. The city is managed by five research ministries (mapping onto the traditional five modalities) led by professors. The architecture and flora of Windurst suggest that of Australia, Oceania and Indochina, with curvilinear stonework and oblong wood structures (often built on stilts over water). Much of the characterization of the place suggests a kind of Polynesian-centered pan-Asianism. This reference recalls the historical debates over *Yamatai* and Japanese ethnogenesis [14], which in turn informed and legitimized Japanese foreign policy throughout the twentieth century. At the same time, another "East" is said to exist, associated with piracy (the *Tenshodo,* the organized crime syndi-

cate active throughout Vana'diel), with specifically Asian items and job classes (*Monk, Ninja, Samurai*).[3] The cardinal vice of the Mithra is *envy;* that of the Tarutaru is *cowardice*. After the player has selected an initial city, the player is thrown into the game, and is soon chartered with a mission. The player will soon be engaged in conflict with aggressive Beastmen. Three of the Beastmen races dwell spatially proximate to the three major cities; the fourth, the *Goblins,* are largely nomadic (and, in some cases, co-exist peacefully with the playable races). The Beastmen live in cities that are pre-industrial. There is a language of visual metaphor which weds them to real-world ethnicities just as with the player-races, but the real-world ethnicities are those of subaltern or "non-national" ethnicities.

The ethnic references of the Beastman create a bridge which insinuates Vana'diel into earth history. The three major regional Beastmen races are the *Orcs,* a vaguely frog-like people which inhabit the terrain near San D'Oria, the *Quadav,* a tortoise-like people dwelling near Bastok, and the *Yagudo,* a bird-like race inhabiting the regions near Windurst. The races are dissimilar to each other in both their cultures and their historical relationships with the playable races: the *Yagudo* are nominally at peace with Windurst; the *Quadav* are in a state of open war with Bastok. The visual depiction of Orc artifacts and dress link it with Native American cultures; that of the Yagudo with Micronesian (and to a lesser extent, African) cultures, while the Quadav are visually depicted in Greco-Roman military gear and described as having a caste-like society, suggesting the Hellenized sub-continent of antiquity. These references link the races here with those historically confronted with the expansion of modern nation-states (the sub-continental experience of British rule, the Native American experience of American expansion, and the experience of Oceanic societies under European and Japanese domination—though it is noteworthy that the relationship which maps most closely to that which involves Japan is marked by a truce absent from other relationships in the game).

In game-practice, these distinctions initially mean little. The player is more likely to be attacked by these races without provocation while engaged in a mission early in the game. Players often describe themselves as having a vendetta against one or another of these races, based on the frustrations experienced attempting to accomplish goals within the game. This is the first mechanism of complicity in the relationship between the nation-states of Vana'diel and its aboriginal races.

The economics of Vana'diel resemble that of contemporary MMORPGs, with markets for in-game resources. A common activity of many players is *farming,* which refers not to agricultural labor, but of engaging in battle with creatures in order to obtain resources to sell or use in craft-industry. "Beastmen" races are frequently 'farmed' by powerful players, who kill dozens of

them at a time to obtain valuable resources. Also, economic power is tied to mobility and strength. In the initial stages of the game, a player must purchase items locally—arbitrage is available only after considerable experience. Thus follows the second major game-mechanism of complicity: the *Conquest*.

The Conquest is an ongoing competition among and between the three player-states. According to the game's expository, the conflict is managed by the Duchy of *Jeuno*, a neutral island-city that exists physically and politically as a cosmopole in-between the three metropoles (and, according to exposition, the force responsible for the victory over the Beastmen in the preceding war). The goal of the *Conquest* is to dominate various regions of the game by winning battles and extracting resources from it more successfully than the rival's nations. Players who obtain a *sigil* from certain non-player characters win conquest points for themselves and their nation-state when fighting. If, however, no nation enjoys significant dominance over others in that region, it is said to be dominated by the Beastmen. Dominance in the Conquest lasts for a fixed interval of game time (about a week in real time), and members of the dominating nation enjoy certain benefits: a favorable balance of trade, lowered costs of goods, and access to the goods which originate from each region being dominated. When a nation-city does not control a region, the NPC[4] vendor reports that "it is difficult to obtain goods from a region which [our nation] does not control" [1]. This increases the cost of those goods for players, particularly those who do not yet enjoy significant mobility.[5] Players can join expedition parties to take regions in the name of their nations, by fighting and killing Beastmen and other creatures.

A third mechanism of complicity is in the social nature of the mechanic of the game itself. Advancement in the game is virtually impossible without coordinated efforts between players. Most players form parties of six to increase their abilities. Optimizing performance in a party is the primary responsibility of a given player to fellow players, since performance failure by one player can lead to the death of the character (which is, in the structure of the game, a loss of valued experience points and the investment of time represented by it). Most inter-player conflicts (not in a competitive sense) come from frustration with inadequate performance by other players: online forums like *Allakhazam* (http://ffxi.allakhazam.com) and *Killing Ifrit* (http://ffxi.killvoid.com) have many angry denunciations of the abilities of others.[6]

Epistemes of Time

The fictional "truths" of Vana'diel are revealed by different game mechanisms over time, in play. Non-player characters in different positions—some of considerable authority, some modest—relate bits of "oral history" to those

who initiate discussions with them. While there are a number of devices oper-
ating to create a sense of world-immersion, there are two closely related ones
by which fictive episteme is revealed. There are *quests,* which are tasks carried
out at the behest of non-player inhabitants of the world and by which one
builds one's *fame* (or reputation capital, a prerequisite for many game
resources) and wins in-game rewards, and there are *missions,* which are always
at the behest of the state; the successful completion of the missions raises
one's *rank.*

The state of the world revealed by the missions is that of the uncertainty
of received history. In the missions, one learns, among other things, that the
Beastmen were not singularly responsible for the state of hostilities; that the
Quadav were, in fact, protecting their nurseries from marauding Humes; that
the Yagudo are a religious people aware of environmental degradation. This
trope, of radical epiphany, recurs throughout the Final Fantasy series, but in
the case of this game, the rhetoric of inescapable complicity is enforced
structurally.

The quests also reveal the truth of the world, but largely outside the
political apparatus of the city-nations. One noteworthy quest is an ongoing
one, called *An Explorer's Footsteps.* The player can get this quest fairly early in
the game, and can incrementally advance on the quest, but will probably not
exhaust the quest for some time: though the quest is not required in the
canonical advancement in the game, many players take the quest in order to
receive specific rewards, including a valued map. The player is asked by the
NPC mayor of the town of *Selbina* to obtain clay impressions from monu-
ments which dot the landscape of the world, which were left by a duo of
explorers in the past. Each of the monuments reveals the history of the explo-
ration (and, in a sense, pre-conquest) of the region in which it was located. It
is revealed in this quest, for example, that when the Quadav learned of the
non-martial motivations of the explorer who visited their region, he was
treated with hospitality and given a tour of their city. The narratives revealed
by the quests act as a kind of alternate history, with a range of temporal
scales, to that of the histories-of-state that the missions unfold.

Through these mechanisms of revelation, the complicity of the player in
historical processes unfolds. This complicity is inescapable—one has many
choices in the game, but none allows for significant historical agency. The
only truly open narrative is that of one's performance as understood by other
players. There is one subtle exception, but otherwise, one's political position
is fixed by the circumstances into which one arrives by entering the game.

Additionally, this complicity is enforced socially: the game constructs
obligations between players, which overshadow any fictional choices one
might take. In a sense, this can be read as a representation of the local nature
of complicit action. As part of a contemporary Japanese discourse about war

and complicity, this recalls the ongoing controversies surrounding the Yasukuni war shrine and references in textbooks to the actions of the Imperial Army during the Pacific War. It is in this light that the game itself (and, arguably, the entire Final Fantasy series) participates in a discourse of war, place and memory [15].

Notes

1. Richard Bartle's typology of MMORPG players is helpful, yet the player motivated by exploration of the world has more varied characteristics in visual worlds than in textual ones, and I would suggest that the visual fictions of place, of represented other-worldiness, are distinct from those of the narrative fictions, or "lore." The possibility of the visual and spatial exploration of the persistent world harkens back to the experience of Myst. See Bartle, R. A. *Designing virtual worlds*, New Riders Publishing, Indianapolis, Indiana, 2004.
2. According to extra-textual expository, males exist, but do not participate in public life; they are never represented visually.
3. Recently added content in the game has made references to a "far West," describing a new food item—salsa—as having its origins there. For more on the nature of the creation of another "East" as a body of knowledge in Japanese discourse, see Tanaka [1].
4. A non-player character: that is, a computer-controlled agent and character whose behavior and speech may change, depending on the state of the world, the player, and the game.
5. Accelerating mobility is a structural feature of all Final Fantasy games and many other fantasy role-playing games. In the Final Fantasy series, the modes of transportation are iconic of the game itself; the chocobo is a yellow ostrich-like bird that was introduced in Final Fantasy II, and can be rented by players in Final Fantasy XI after about twenty levels of job advancement—at least thirty to forty hours of play, typically. Later, the player can teleport from zone to zone, or take an airship after completing some arduous prerequisites.
6. In a personal interview with Yasu Kurosawa, U.S. producer of Final Fantasy XI, I was told that the dominant complaint of Japanese players is frustration with the lack of preparation and discipline demonstrated by American players. In the same interview, he shared his feeling that, for the producers of the game, the cross-cultural play environment was its most important feature, and the one of which they were most proud.

References

1. Tanaka, H. Final Fantasy XI, Square-Enix, 2002.
2. Altman, R. *Film/Genre*. London, BFI Publishing, 1999.
3. Woodcock, B. S. "An Analysis of MMOG Subscription Growth." Available at MMOGCHART.COM, 2005. (Last accessed July 15, 2006).
4. Napier, S. J. *The Fantastic in Modern Japanese Literature: The Subversion of Modernity*. London, Routledge, 1996.

5. Harootunian, H. D. "Figuring the Folk: History, Poetics and Representation." In S. Vlastos, (ed.), *Mirror of Modernity: Invented Traditions of Modern Japan,* University of California Press, Berkeley, 1998, pp. 144–159.

6. Ivy, M. *Discourses of the Vanishing: Modernity, Phantasm, Japan.* University of Chicago Press, Chicago, 1995.

7. Bremen, J.v., and Shimizu, A. *Anthropology and Colonialism in Asia and Oceania.* Curzon, Richmond, Surrey, 1999.

8. Todorov, T. *The Fantastic; A Structural Approach to a Literary Genre.* Cleveland, Press of Case Western Reserve University, 1973.

9. Jackson, R. *Fantasy, the Literature of Subversion.* London and New York, Methuen, 1981.

10. Hume, K. *Fantasy and Mimesis: Responses to Reality in Western literature.* New York, Methuen, 1984.

11. Irwin, W. R. *The Game of the Impossible: A Rhetoric of Fantasy.* Urbana, University of Illinois Press, 1976.

12. Thongchai, W. *SIAM Mapped: A History of the Geo-Body of a Nation.* Chiang Mai, Thailand, Silkworm Books, 1994.

13. Anderson, B. R. O. G. *Imagined Communities: Reflections on the Origin and Spread of Nationalism.* London and New York, Verso, 1991.

14. Tanaka, S. *Japan's Orient: Rendering Pasts into History.* Berkeley, University of California Press, 1993.

15. Igarashi, Y. *Bodies of Memory: Narratives of War in Postwar Japanese Culture. 1945–1970.* Princeton, Princeton University Press, 2000.

15. Lesser-Known Worlds: Bridging the Telematic Flows with Located Human Experience through Game Design

DEBRA POLSON AND MARCOS CACERES

Introduction

When the developers of hybrid spaces become involved with the planning of cultural environments, it is obligatory that these environments become participants in the world of global information flows in the form of "intelligent buildings" and "smart offices." As a result, the places in which we find ourselves are becoming parallel infrastructures of both the telematic (telecommunication infrastructures) [1] and urban "spaces of flow" [2]. Telematics improve processing and circulation of information, services, communication and exchange. Urban spaces, on the other hand, are the sites of human experience, social interaction, and construction of identities by groups and individuals.

Scoot is a location-based game that has taken place in various cultural locations in Australian capital cities. In creating *Scoot,* we, as its developers, selected places according to their technological, sociocultural, and historical potentials for gameplay. In this way, we approached the game design as if the locations were a game world and we were designing a real-world game modification. Game modifications are normally designed by game fans, so it became a priority to first create a game aesthetic and narrative that players could participate in and later edit and build upon. The initial game events are an opportunity to expose the potentials of the sites' telematics and to sample possible ways to subvert that for creative and collaborative expression in an effort to extend social interactions.

We start by reviewing a number of current location-based games (LBGs) to analyze how city locations are represented in the gameplay. We then look

for how current computer games connect players in collaborative ways to extend social interactions. Finally, we discuss how these games informed and influenced the design of *Scoot*.

Location-Based Games and the Culture of Place

There are a number of examples of this relatively new form of game design: all are played out across different cultural locations and with different tools of play ranging from mobile phones equipped with location aware technologies, such as *Mogi* in Tokyo, Japan [3], to augmented reality devices like *AR Quake* in Adelaide, Australia [4]. However, not all of these examples claim to be designed in and for a unique physical location. Some of the examples that are closest in form to *SCOOT* are *Geocaching* [5], *I Like Frank* in Adelaide [6] and *Botfighters* [7] as they are designed to enable play in specific locations. Although these games employ innovative uses of technology and result in interesting player collaborations, we found that these games are normally limited to simple treasure hunts, chase sequences, and combat scenes that do not necessarily engage participants in the specific culture of the sites they enter. They tend to treat the environment as a "stage" for play rather than a potentially dynamic agent with multiple features, histories, local stories, etc. In Los Angeles, the geocaching community has gained a reputation of being "geotrashers" who have been famously accused of using the parks as arenas of play with little concern of the ecological impacts [8].

Some games are more sensitive to the cultural value of the locations they employ, for example, *GeoQuest* of Marseille (by Ludigames and France Telecom, 2002) [9] and *Close Encounters* [10] in Los Angeles. We mention these here as exemplars for slightly different reasons. Firstly, although *Geoquest* is a mediated experience, it was designed in Marseille, France, specifically for families and the historically minded. The game's style combined an adventure story and puzzle hunt that revealed historical facts to players as they progressed. To participate, players subscribed to receive SMS clues when they entered specific cells of a mobile phone network. The creators of *Close Encounters* challenged the newly forming patterns of play by setting up a game that invited "geocachers to proactively step out from the cyber-realm into the charged terrain of racial politics" by sending them into Leimert Park, a predominantly African American neighborhood not normally visited by this demographic. The creators ensured that the players did not skim the surface of the site, but encouraged them to engage with the place and people. Evidence of their interaction with locals was to be posted on the geocache web site. These examples have either begun with a narrative taken from the site or invited the players to share their own experiences of the place. Either way, we would argue that the resulting images or story artifacts are an engaging

read that inspire a richer relationship to the site and provide a means for extending social interactions.

Alternate Reality Games

Alternate Reality Games (ARGs) are siblings of LBGs as they blur the edges between the game world and the real world the players inhabit. Elements of play can be provided to players in almost any form including email, land mail, faxes, websites, instant messaging, Internet Relay Chat (IRC) channels, etc. An early version of an ARG, known as the *Beast*, was produced by Microsoft and Dreamworks as a publicity game leading up to the release of the 2001 Steven Spielberg film *Artificial Intelligence* (AI).

In early April 2001, movie fans started to notice a series of distributed clues and narratives on film posters that led to web sites, which led to phone numbers, etc. It appeared to be some sort of game. However, there did not seem to be any evidence of game rules or rewards. "Websites and offline identities have been created for characters and sentient machines from AI (the film), for organizations inhabiting the world where the film is set, and even for some of the fictitious people credited with making the movie. The websites give fans a hint of the story played out in the film, and some intriguing clues about who does what to whom" [11]. Narrative clues could be found on web sites, in HTML source code, voice recordings left on phones, and photographs and packages left in public bathrooms across New York, Chicago and Los Angeles.

According to researcher Jane McGonigal [12], when this game came to an end, some players had been so immersed in the experience that they wanted to stay engaged with the community they had formed, and continue with these collective activities. When the attacks on New York occurred on September 11, 2001, a particular community of players calling themselves the Cloudmakers re-gathered with the intention of resolving the mystery of the attacks using the methods of collaboration they had established while playing the *Beast*. However, this seemed extreme to some of the Cloudmakers who refused to participate reminding the members that "this is not a game."

The producers of the *Beast*, however, maintained that it was not a game; in fact, the alternate reality gamers now normally refer to this style of game as a TING (This is Not a Game). This is a tribute to the game-designers' ability to design a series of events that enable a highly immersive and engaging experience for gameplayers, particularly as it is set in their normal existence of space and time.

It is this phenomenon that we are most interested in: an experience that engages players beyond the virtual environment into the realms of reality. For

an LBG to be successful, it must alter the players' perception of their own space, increasing their agency and motivation to be collaborative authors of the experience. This allows for a new kind of engagement in the culture of cities, and also broadens opportunities for social interaction and creative production for both locally and globally connected inhabitants.

Games as an Opportunity to Extend Social Interactions and Support Creative Production

It is commonly accepted that "players use games as mechanisms for social experiences" [13]. As part of our user research into creating *Scoot*, we asked approximately eighty first-year university students how they preferred to play games and why. The options for discussion were:

1. playing at home alone competing against the computer;
2. playing with others in the same physical location with networked computers (as in a LAN party);
3. playing with others remotely (as with MMORPG, and FPS).

We found that by far the most preferred option was playing with others in the same physical location. Under these conditions players' group communications and interactions throughout the event were simply an extension of existing social dynamics. In any given group the hierarchy of game status depended on the genre of game being played. This is when the group dynamic is shifted depending on the skills of the individuals. For example, a player may be a huge challenge to others when playing a strategy game, but if they switched to a combat game he/she may become a weak opponent. When players play in groups, the dynamics change again. We also found that competing groups were the ultimate way to play; it meant that in the same game session the group could both compete and collaborate at the same time. At the end of gameplay the group would often recount the events that unfolded, even if they played the same game multiple times, they had a new story to tell and debate each time.

The narratives that emerge from these groups and broader gamer communities are evidence of the game's ability to motivate complex social interactions and valuable cultural artifacts. These artifacts are produced as a result of "pre-play," "in play," and "post-play" interactions between game developers and gameplayers. Some of the interactions and artifacts are designed, while others emerge unexpectedly. Traditionally pre-play game communications are trailers, teasers, and discussion forums. These set up an opportunity for gamers to gather around the game in anticipation of its release. Before the game is even played, gamers can compete for game status by flagging their

knowledge of the game history or what's to come. In-play interactions generally revolve around in-game action, whereas post-play interactions offer the best potential for players to be producers of creative texts.

Games are already about interactions within worlds in common. Whether players play a game simultaneously (such as at a LAN party) or they play separately, playing is a shared experience. For dedicated gameplayers an orbiting community is essential in maintaining their relationships to both the game world and to the other players. This is sustained through gamer communities that are critically and/or creatively sharing experiences. Most developers recognize this and supply fan website kits, modding tools, forums, etc. In these arenas, players respond by producing shared texts such as fan fiction, strategy guides, FAQs, and more substantive contributions like new game levels (mods) and machinimas. The *Halo* and *Halo 2* games are great examples of how a game can inspire creative production. Not only do players vigorously publish to official Bungie sites [14] and to unofficial forums and fan art sites [15], but there are also fans that produce substantial creative works using the game as a production tool. For example, the Drunken Gamers (now Red vs. Blue) [16] have already produced multiple episodes of both *Halo* and *Sims* machinimas.

We consider mods to be most relevant to our development of *Scoot*. A mod is a custom level or unique game, created from an existing game engine. Some modders simply create new game levels maintaining the world, play, and rules of the original game, while others use the level editor as an opportunity to create unique environments by importing custom made graphical and sonic assets. There are active game communities dedicated to the distribution and criticism of mods [17].

The success of a game can be dependent on the ability of the game to facilitate collaborative and creative social interactions beyond the in-play action. These communities become loyal and active participants establishing interdependent relationships between game developers and gameplayers as co-producers of content.

When we began to develop *Scoot*, we decided to include authentic inhabitants of the site as part of our design team. We did this expecting to ensure that the game afforded authentic connections to the site. Our first iteration of *Scoot* was designed and played at the Creative Industries Precinct in Brisbane, Australia. This Precinct included a University from which a number of students joined our design team and since have been designing other iterations of the game in other cities. Other stakeholders of the site became involved: music and theatre production departments and the Precinct's marketing department all contributed to the design of the game. As a group we produced our own version of the CIP as a kind of real-world mod.

The first iterations of *Scoot* were designed as game events that occurred over one to three days in technologically rich environments. Later we created a second version of *Scoot* (*Scoot Curatorial*) that was a web form that acted as a game-event curatorial tool.

SCOOT 1 *as a Location-Based Game Event*

Scoot is a location-based game that has been designed and hosted in two different cities in Australia in an attempt to observe peoples' responses to the game as an experimental intervention in their everyday cultural places. *Scoot* was designed with maximum potential for moments of delight that occur when a clue is found, a puzzle is resolved, and/or a physical challenge is successfully overcome. These moments occur primarily when the user realizes a new use for a familiar device or space.

The Locations

The Creative Industries Precinct (CIP) in Brisbane, Australia, was the first location for *Scoot,* and the second was designed and hosted at Federation Square, Melbourne. In many ways the two sites are quite similar, except that Federation Square is a much more public place "the size of an entire city block, Federation Square is a living, breathing focus for Melbourne and Victorian community life" [18]. The CIP is part of the "Kelvin Grove Urban Village" (KGUV) project set in the suburb of Kelvin Grove, on the very edge of the Brisbane CBD "where a government and university have come together to plan and build a new integrated community" [18]. As well as being a place of urban renewal with various opportunities for community engagement, this is a site that boasts advanced digital facilities and is therefore a rich technological "node" whose infrastructure is connected to multiple remote partner "nodes" throughout the country and overseas. The KGUV imagineers state that: "It (the CIP) provides a unique opportunity for designers, artists, researchers, educators and entrepreneurs to easily connect and collaborate with others to create new work, develop new ideas and grow the creative industries sector in Queensland" [18].

However, we were not convinced that the existent communities were aware of the potentials of the site. Even if they were, it is not apparent how they were to access these global digital facilities. It became our desire to design a location-based game that would explicitly intervene in and reveal the physical and telematic infrastructures of the site in an effort to increase a sense of access and agency for the local inhabitants.

Figure 15.1: One of the postcard designs for *Scoot 1* at the CIP. Event details and registration information were printed on the back.

Pre-Play

In order to inform potential players of the pending *Scoot* game-event, we placed postcards in the area, emailed community groups and advertised in various local publications. These initial texts introduced the game concept, the narrative motivation to play, the game aesthetics and possible prizes involved. *Scoot 1* at CIP offered I-pods and *Scoot 1* at Federation Square promised a Nintendo DS and complimentary games to the highest scorers. These prizes were supplied by local stakeholders in the sites. The registration instructions were also available in these texts. The registration information was fed to a database which gave the design team the ability to send emails and mystery SMS messages as game teasers (Figure 15.1).

In-Play

When the game began, the players received a mystery SOS in the form of an SMS that led them to the virtual world of *SCOOT* situated online. There, they soon discovered the existence of a parallel world—a distorted facsimile of their local environment. The buildings and grounds are similar, yet mutated, and inhabited by a number of odd characters. Early in the game the players realized that there is a tear in the fine fabric that separates the world of *SCOOT* from their real world. Players also soon discovered that some *SCOOT* inhabitants are planning to bring their sinister carnival to the real world. They have begun by sending strange objects from the virtual world into the real world. In order to repair the damage and avoid invasion, players must seek out help,

solve clues, and complete various challenges. Some of these challenges were in the physical world where the players had to seek out these strange objects (interactive sculptures) and SMS particular solutions back to *SCOOT*, while other challenges occurred in the virtual world of *SCOOT* in the form of puzzles and games (Figure 15.2).

Scoot provided various means for players to communicate both online and on the site (Figure 15.3). There were discussion forums where players would discuss difficulties in finding or resolving clues. In both sites there were large public displays that we used to indicate directional prompts with character animations (Figure 15.4). Other uses for public displays included SMS message boards, which allowed players to communicate on site. Naturally they began using these to express gratuitous textual graffiti, but soon players started to use it strategically to assist or decoy other players.

Post-Play

During play, the players are introduced to a number of *Scoot* characters (see Figure 15.5), either as non-player characters in the virtual world or as animations displayed on screens in the site. At the end of the game players are invited to draw their own *Scoot* character ideas (see Figure 15.6) and submit them to the designers for possible development in the next *Scoot* event. This was a very popular activity as the young players were more than willing to contribute creatively. It provided many opportunities for moments of delight, as some players were excited at the realization that you could get jobs as character designers.

Since this *Scoot* version is an event that is played and completed within a set time, there are not tools in place to enable players to continue participating as individuals or as collectives. *Scoot 1* at Federation Square was targeted to a family demographic during school holidays. Both the parents and the younger players were interested in how they may be able to design an SMS game set in their own neighborhoods. This partly inspired the development of the next version of *Scoot*.

SCOOT 2 as a Curatorial Tool

Dungeons & Dragons (D&D) was another longtime inspiration for designing a complementary Scoot curatorial tool. *D&D* requires a Dungeon Master (DM) to curate the game experience and a group of players to complete it. *D&D* provides a dynamic example of how a simple framework can inspire players to cooperatively design complex narratives and quests of game characters, environments, and events with the intention to then collaborate to compete against an imagined foe.

Figure 15.2: This is a corner of Federation Square as seen from the center of the Square

Figure 15.3: This is the interface of one of the Flash games, "Juggler," that illustrates how the site is represented in the parallel virtual world of *Scoot*

Figure 15.4: The "Alert Drone" is placed in a prominent position in the site. According to the game narrative, "Omega Carnega," the carnival leader of Scoot, has sent it. The scrolling LED text only reveals a clue if the player holds down the button on the top. But in doing so, a random sound blasts from the inside.

Figure 15.5: A sample of some of the *Scoot* Characters. The 4 characters on the left are player avatars that can be moved around the virtual world in search of clues. On the right are the "dodgy" non-player characters that present the players with challenges.

Figure 15.6: Images designed by young players of *Scoot 1* at Federation Square

In this vein, this version of *SCOOT* is a web site that allows individuals and groups to create a customized set of puzzles (clues and solutions) that can be instantly distributed to others via SMS. *Scoot Curatorial* is much less mediated by the design team and thereby has a much higher potential for increased player agency. This is accomplished by creating a more complicated system (but much less complicated game interface) that acts as a framework to support participatory design methods. There is little rich media and a very simple interface consisting of instructions and text fields to fill in. The information entered into the fields later becomes the SMS content that drives players through the site.

The important difference in the design approach is that the "players" become co-designers. By having knowledge of *Scoot* they are equipped with a formula for analyzing their location as a game world and their mobile phones as a play device.

Conclusion

Scoot was successful at encouraging players to consider their local places as sites for creative engagement and for imagining their mobile phones as potential gameplay devices. Ultimately, we plan to combine the versions into a single game interface that can be used by players to both play and design a *Scoot* mod in any location. This would require the virtual world of *Scoot* that now resides on the web, to be accessed on a mobile device that allows players to create and submit creative content while on location.

References

1. Graham, S., and S. Marvin. *Telecommunications and the City: Electronic Spaces, Urban Places.* London, Routledge, 1996.
2. Castells, M. *The Power of Identity.* Vol. 2, Madrid, Blackwell, 1996.
3. Mogi. Available at http://www.mogimogi.com/. (Last accessed July 15, 2006).
4. Wayne Piekarski and Bruce Thomas, ARQuake: The Outdoor Augmented Reality Gaming System, Communications of the ACM,2002 Vol 45. No 1, pp. 36–38. Available at http://wearables.unisa.edu.au/projects/ARQuake/www/papers/piekarski-acm-comms-2002.pdf. (Last accessed August 28, 2006).
5. Geocaching—The Official Global GPS Cache Hunt Site. Available at http://www.geocaching.com/ (Last accessed July 15, 2006).
6. Blast Theory. I Like Frank in Adelaide. Available at http://www.ilikefrank.com/. (Last accessed July 15, 2006).
7. Botfighters. It's Alive. Available at http://www.botfighters.com/botfighters2/start.jsp. (Last accessed August 28, 2006).
8. Shaw, B. "MINNESOTA: GPS Treasure Hunt Under Fire." St Pauls Pioneer Press. Wisconsin June 02, 2003. Available at http://www.twincities.com/mld/twincities/news/local/5992641.htm. (Last accessed July 15, 2006).
9. Bellows, M. "Wireless Gaming Review." *Electronic Gaming Monthly,* December, 2003. Available at http://findarticles.com/p/articles/mi_zdegm/is_200312/ai_n9505490. (Last accessed August 28, 2006)
10. Ulke, C., and M. Herbs. "Close Encounters" (Location-based Game). C-Level, October, 2002.
11. Cloudmakers. Available at http://www.cloudmakers.com. (Last accessed July 15, 2006).
12. McGonigal, J. "This is not a Game: Immersive Aesthetics and Collective Play." In A. Miles, *Proceedings of the 5th International Digital Arts and Culture Conference,* RMIT University, 2003. Available at http://www.seanstewart.org/beast/mcgonigal/notagame/paper.pdf. (Last accessed August 28, 2006).

13. Lazzaro, N. "Why We Play Games: Four Keys to More Emotion." In *Proceedings of the International Game Developers Conference*, San Francisco, 2005. Available at http://www.xeodesign.com/xeodesign_whyweplaygames.pdf.

14. Bungie Community Site. Available at: http://halo.bungie.org. (Last accessed July 15, 2006).

15. Elite Vs Brute—Hal02 Fan Art. Available at http://www.sheezyart.com/view/27656/. (Last accessed July 15, 2006).

16. Red vs Blue. Available at http://rvb.roosterteeth.com/info/. (Last accessed July 15, 2006).

17. Select Parks. Available at http://www.selectparks.net/. (Last accessed July 15, 2006).

18. Kelvin Grove Urban Village. Available at http://www.kgurbanvillage.com.au/. (Last accessed July 15, 2006).

16. Framing Virtual Law

PETER EDELMANN

Introduction

The past few years have seen increasing interest in virtual worlds on the part of legal scholars, and while theorists have taken a variety of approaches to the normative aspects of virtual worlds, two trends are apparent. On one hand, there are the legal scholars and developers whose focus is on the application and significance of the laws of the actual world to the virtual world, including areas such as constitutional rights and freedoms [1,2], property [3], corporate charters [4], contracts [5] and criminality [6,7,8]. On the other hand are the researchers and designers whose primary focus is on the normative orders within the virtual worlds themselves, with concerns including the structure of virtual justice systems [9,10,11], technological hierarchies [12,13] and the relationship to external normative orders [10,14,15]. This is not to say that the two trends are incompatible, and in fact many of the writers cited above have put their minds to the oscillation between the actual and the virtual which was highlighted over a decade ago by Julian Dibbell in his widely read account of virtual rape [16]. As the analysis in this chapter will demonstrate, however, many of the aspects of law related to virtual worlds are not usefully subsumed under a simple "real-virtual" dichotomy, regardless of the extent to which the dichotomy is problematized through the recognition of its complexities or oscillations. This chapter proposes an analytical model that provides a framework within which phenomena related to virtual worlds can be more usefully distinguished. While the framework does not, in and of itself, resolve the complex problems related to the convergence of multiple normative orders in virtual worlds, it is hoped that it will provide a tool with which such issues can be discussed and studied in a clearer and more coherent fashion.

Analytical Framework

Ludologists such as Huizinga conceptualize games as occurring within a "magic circle" which separates them from the normal rules of real life. Attempts to define a single magic circle with respect to virtual worlds have been unsatisfactory, at least in part because participants disagree about where to trace the outer limits of the circle. Building on the work of games theorists and virtual world designers, five frames or layers which interact simultaneously in creating the phenomena associated with virtual worlds can be usefully distinguished.

Actual
Interface
System
Instantiation
Virtual

At the outermost edges of the model are the two poles commonly referred to as real and virtual. In this chapter, I will follow the terminology employed by Pierre Lévy [17] and Marie-Laure Ryan [18] in referring to the actual rather than the real, since much of what occurs in the other frames of the model is as real as the participant's "real-life" surroundings. The interface consists of the input/output and communication mechanisms through which the virtual world participant connects to the virtual world system. This could include, among other things, a screen and keyboard, network architecture and relevant software. The system is a rule-based structure which controls and manages input and output streams in relation to activity in the virtual world. Instantiation consists of the discourse produced or permitted by the system layer. Depending on the world in question, the instantiation could take the form of simple text, or some combination of text with graphics or audio. Finally, the virtual frame is the fully immersed world as it would be experienced by a fictional character who is not aware they live in a fictional world. The virtual frame is thus the level at which dragons or interstellar travel may be a part of everyday reality, while references to final exams or phone bills have no relevance whatsoever.

There are multiple sources of inspiration for the approach proposed here, ranging from virtual world design to sociology. The application of frame-based analysis has been extensively developed in the work of Erving Goffman, who highlights the multiple frames in which we are constantly engaged in the course of everyday social interaction. Goffman's work illustrates two important issues about the subject at hand: first, that oscillation between

multiple frames is not unique to virtual worlds, and second, that it is possible for participants to act in multiple frames simultaneously without suffering cognitive dissonance. An important distinguishing feature of virtual worlds, however, is that not all the interaction takes place IRL ("in real life"). The work of literary theorists such as Marie-Laure Ryan is of great assistance in exploring the relationship between the fictional world projected by a text and the actual world within which the reader is situated as she reads the text. A virtual world, by definition, is the result of the production of signs in a context which maintains the coherence of the fictional frame. As Ryan points out, this is precisely what the creators of fictional worlds do in other media, such as the novel.

The four-layer model proposed by Aarseth in his 1997 *Cybertext* for understanding the functioning of role-playing cybertexts reflects several of the features of the framework proposed here, placing primary emphasis on the system layer. This is consistent with a general trend among ludologists to focus on the mechanics of digital games, often downplaying the importance of more discursive elements. The cybertext, for Aarseth, is primarily an interaction between the user and the system, rather than between the participant and the virtual world, and his model thus provides a useful approach to understanding the mechanics of cybertexts, focusing on the physical production and manipulation of signs. However, without placing the system within the context of its role in shaping the discursive practices which instantiate the world and in mediating the feedback loop connecting actual world participants to the virtual frame, one is left with the impression that the system is an end in itself. While the system level may well be the primary focus for a certain subset of participants (hard-core gamers come to mind), the possibility of immersing oneself in the virtual frame cannot be discounted as a significant source of attraction to virtual worlds. The architecture of MUD servers, as described by designers such as Bartle [19], Koster [20] and Evans [21], also provides useful groundwork for the frames surrounding the system layer of the proposed model. While there are a large number of implementations of MUD server architecture, Koster and Bartle identify four conceptual layers which must be integrated into any virtual world server, ranging from the most basic input-output functions of the driver to the higher-level sign production of the instantiation. Although the model presented here does not follow these existing models exactly, it is telling that the same structures have been distinguished by others in a variety of disciplines. While it would be helpful to explore existing work further, the goal of this work is to explore the model as it applies to the legal aspects of virtual worlds.

Actual World

Five rough-looking men stepped out of a black sedan and burst into the Seoul PC café where Paek Jung Yul hangs out with Strong People Blood Pledge, his clan of online gamers. "Is the wizard here?" demanded one of the toughs, asking for the player who killed his character in an online game called *Lineage*. The "wizard" was there, alright, and he was feeling bold. He boasted that he had offed the gangman's virtual character just for the fun of it. Bad idea. The roughnecks dragged the 21-year-old into the urinal and pummeled him until he was covered with real-world bruises. [22]

According to Levander [22], the authorities even use the term "off-line PK" to describe the practice described in the passage above. Even on the North American *Lineage* servers, a semi-regular message appears in players' chat windows reminding them that combat, "like your sword and armour" should stay in the game. According the National Police Agency in Seoul, of the 40,000 cybercrimes committed in Korea in 2003, 22,000 of them were related to online games [23].

Both the hardware of virtual world clients and servers, as well as the wetware (physical bodies) of the participants are generally located within the territorial jurisdiction of one or more of the legal systems of the actual world. There has been a great deal of discussion over the past few years about the extent to which the laws of the actual world ought to be applied to activities in the virtual frame, in particular with respect to property and deviance, two areas explored in greater detail below. There is no question that a vast array of activities associated with virtual worlds are currently regulated and protected by laws of the actual world, ranging from the corporate charters and employment contracts of the companies and designers who create virtual worlds, to the rights of participants not to be physically assaulted while sitting at their computers. In other areas, it is not as clear the extent to which the laws of the actual world ought to apply to the activities related to a virtual world. For example, the laws pertaining to gambling, taxation, sexual harassment or a number of what Jack Balkin calls "communication torts" are somewhat more complicated to understand in the virtual environment, and there is some discussion of the ways in which these laws might be applied by the courts of the actual world. This suggests the primary defining characteristic of the laws of the actual world from the perspective of the proposed analytical model: recourse and enforcement in the actual world, either through the courts or other regulatory mechanisms.

Interface

The interface is the physical medium used by participants to interact with the system layer, which includes a number of levels ranging from the screen and

keyboard to software clients and network protocol stacks. At the outer edge of the interface are the physical input-output devices such as the screen, speakers and keyboard which allow the participant to transmit to and receive information from the system. The connection to the network presents an interesting threshold from a legal perspective, placing users in the murky and rapidly evolving realm of cyberspace law. While it is beyond the scope of this piece to explore the plethora of legal issues related to cyberspace, suffice to say that it has been an increasingly fertile area for both study and litigation, a trend which will undoubtedly continue into the foreseeable future. The network itself can be broken down into multiple layers, from the higher-level software applications like the client to the physical wires, routers and switches which actually carry the electrons between the participant's machine and the server. The OSI model defines a number of intervening layers which allow for the efficient encoding and transmission of data from the client to the server and back in a feedback loop potentially spanning thousands of kilometers. In an approach analogous to this one, Craig McTaggart has proposed employing the OSI reference model as a template to assist legal theorists and jurists in making more coherent distinctions between the different levels at which cyberspace law operates [24]. While McTaggart's model could be fruitfully applied to virtual world interfaces, their importance is highlighted here before focusing on one of the aspects of the interface which will have the most far-ranging implications in the other frames: the EULA.

The End User Licence Agreement (EULA) is a contract of adhesion which participants in most commercial virtual worlds must accept before being permitted to connect to the system layer, and ultimately the virtual world itself. The EULA, along with the Terms of Service (TOS), will generally purport to set out the respective rights and responsibilities of the virtual world's owners and participants. While the details of EULAs would provide a very fruitful area for further research, one of the most significant aspects is the right of the game managers to ban participants for certain types of behaviour. Through the EULA, participants will also generally agree to waive their rights to certain recourses in the courts of the actual world, while at the same time providing a basis for the owners to pursue remedies in those courts for breaches of the normative order established within the remaining layers of the proposed model. The EULA thus provides a contractual and conceptual portal that simultaneously attempts to shield virtual world managers from the laws of the actual world, while providing additional strength and legitimacy to the internal normative order. One could see the EULA evolving into a kind of social contract or constitution for the virtual world which would bind the sovereign, and enshrine a set of rights for players/avatars. In effect, the idea of a bill of rights for players has already been proposed in Raph Koster's "Declaration of the Rights of Players" which includes such things as freedom

of speech and assembly, non-discrimination, due process and a right to privacy [25]. While the Declaration is an interesting discussion piece, it should be noted that Sony Online Entertainment, for which Koster is Chief Creative Officer, still exhibits a marked preference for a more traditional contract of adhesion. This is perhaps not surprising given the power dynamics in play, as fundamentally it is the owner of the virtual world who decides whether or not a participant will be allowed to access the server. Banishment is a very real and common sanction in the privatized public spaces of twenty-first-century cyberspace, and there is little or no recourse available to the involuntary exiles. University of Michigan linguist and cyberspace theorist Peter Ludlow had his avatar Urizenus banned from *The Sims Online* because of investigative reporting in an out-of-world website called the *Alphaville Herald*. The power relationship established at the interface level can thus have wide-ranging implications for behaviour within the other frames of our model, in this case creating potentially chilling effects on speech deemed threatening to the interests of the virtual world owners in the actual world.

System

> In the initial plan of Habitat, avatars could snatch items from each other and run away with them. The Habitat community did not like this feature and complained. The god/wizards of Habitat responded by coding away the possibility of theft. Likewise, the avatars in Habitat could originally kill each other. Again, many users complained. The programmers responded by limiting avatar murder to the uncivilized borderlands of Habitat's environment. [26]

The system and instantiation layers reflect to a large extent the distinction made by Lawrence Lessig between code and law [27]. Code is essentially regulation through infrastructure, which, for example, has been an integral part of urban planning for a long time. Rather than use the law to set speed limits, urban planners have learned to build features into the cityscape which control the amount, speed and flow of traffic. Drivers who are intent on driving quickly will simply be so frustrated by the tight turns, speed bumps and roundabouts in residential areas that they will stick to the main thoroughfares, regardless of the legal speed limit in the residential area. Regulation and control of the virtual world at the system level is thus what Lessig would refer to as code. The rules are physically built into the system, meaning detection and enforcement are not really issues because the very structure of the virtual world makes the prohibited conduct impossible. The ability to kill other players or steal their virtual belongings is commonly regulated in this way. Law, on the other hand, acts at the level of the instantiation, or at that of the virtual world itself, by proposing certain rules of conduct or guidelines which may or may not be enforced. The code may support these types of rule-based

systems by providing for sanctions at the system level (e.g., toading) or the level of the interface (e.g., banning). The ability to regulate the social environment of a virtual world through changes in code is made clear by Daniel Pargman with respect to his observation of the administration of *SvenskMUD:*

> What makes muds and other social virtual environments unique is the tight coupling between the technical and social system—an effect of the fact that a mud in use is a social system within an artifact. The artifact effectively determines both the possibilities and the constraints of the microsociety in question. A central problem at every SvenskMud-meeting I have attended is how to gently tweak the system technically so that the desired social effects appear. [15]

In fact, one of the most difficult lessons for the wizards of LambdaMOO was that the distinction between purely technical decisions and social decisions was impossible to make in a virtual world whose very physical structure was a function of the technical decisions of the programmers [28]. The wizards attempted to transfer their power over the infrastructure to the residents of the virtual frame. The petition and ballot system in LambdaMOO provides an excellent illustration of the ways in which legislators can use infrastructure towards regulatory ends. The relationship between code and law is thus not one of two watertight compartments, but in effect is much more interactive and interdependent.

The system layer, while being an effective tool for certain types of regulation, is not sufficient to establish and maintain the complex normative orders of virtual communities. The effective regulation of a virtual world is only achieved through a delicate and dynamic interplay of rules and code. An attempt by Paul Schwarz [11] to develop a system of morality which could be implemented into computer-based virtual worlds illustrates the difficulties of quantifying actions on an automated moral scale. While a human referee can assess the context of a given action, building a model which rewards players for actions in accord with their avatar's moral code proves to be a challenging endeavour. Regulation purely through code sets the regulator up for an extended game of "find the bug": just as the operators of virtual worlds can use code to control behaviour in the world, so can players take advantage of errors or loopholes in the code-base to gain advantages. In effect, the search for such "exploits" is a common pursuit in many worlds, and the operators find themselves in a constant game of catch-up to keep exploits from destabilizing the world. A single serious gold dupe (ability to illicitly multiply a resource) can be enough to destabilize the in-world economy. The judicious use of rules thus becomes essential to be able to justify intervention in cases of abuse of the code. There are also aspects of the virtual world that simply cannot be regulated by code because the complexity would be overwhelm-

ing. In an attempt to maintain a family atmosphere, many games have integrated filter software to eliminate profanity before it even reaches the screens of minors. However, the task of filtering phrases such as "|= |_|C|< U @55H0|_E" is notoriously difficult for programmers [8]. While worlds such as *Toontown* have chosen to only allow participants to communicate with phrases in a preset menu, most worlds employ referees or game managers to regulate these kinds of behaviour in the instantiation or virtual frames.

Instantiation

There are two aspects of the instantiation level which are of interest in the current context. First, the instantiation consists of the signifiers whose signified constitute the virtual world. Ownership of intellectual property for in-world creations is one of the major points of contention between the owners and the players in virtual worlds, particularly in the social worlds which depend on users to create much of the content in the world. The original text-based MUDs were for the most part run on surplus time scavenged from university mainframes, and not only the content, but the server code-bases were freely shared between virtual worlds, which were run by a few individuals as a hobby. Although there were commercial MUDs, it was really with the advent of the graphic MMORPGs that we have seen the issue of intellectual property take centre stage in the struggle for power in the virtual landscape. For example, in one highly commercialized social world called *There*, players must find ways to obtain "Therebucks" (the virtual currency) in order to maintain their virtual selves and obtain property or services. One of the most common virtual businesses is the design of virtual clothing which is sold to other players in exchange for Therebucks. The contract of adhesion between the owners of *There* and the players upon registration is very clear on the status of intellectual property in the world: There Inc. purports to own everything, including player-created content. This can be contrasted with Linden Labs, owners of *Second Life*, which allow players to keep the rights to the virtual content they create in the world. Yet Linden Labs will maintain control not only of the servers on which the world runs, and more importantly of the code-base for the graphics engines and other software needed to connect to the world and keep it running. Thus, even when we see a willingness to give up some control over content, the infrastructure remains firmly in the company's hands. Much like any other medium, the core narratives in virtual worlds are also often proprietary, particularly in the so-called licensed worlds like *Star Wars Galaxies*. While this dynamic may be less problematic in a non-interactive medium like film, in an interactive medium in which large numbers of people spend significant amounts of time, the ownership of the central fiction, as well as any user-contributed content, will become a signifi-

cant issue.

Secondly, the instantiation deals with what narratologists would call extra-diegetic discourse, which is to say utterances which are not in and of themselves part of the virtual frame, in the way that dialogue between characters would be. The establishment and maintenance of the magic circle is one of the key elements in the formation of a frame within which play can occur. The structured rules of a game assist somewhat in fostering the emergence of a magic circle, but they also require implicit and explicit cooperation between participants within a meta-frame outside the game. In his "A Theory of Play and Fantasy" [29], Gregory Bateson discusses the cognitive frames surrounding play, and the kinds of meta-communication that players engage in to establish and maintain the validity of the magic circle. In examining animal behaviour during play, Bateson identifies three types of communication: messages which are mood signs, messages which simulate mood signs (e.g., during play), and finally messages which distinguish between the other two types. According to Bateson, the third type of message consists of meta-communication which draws a frame around play, much as the frame around a painting establishes the limits of a conceptual realm, within which different rules of perception and interpretation apply. The ability to make reference to the frame of the magic circle is a key element in games since it will play a significant role in the systemic cooperation essential to creating the necessary conditions for game play. This approach to understanding the establishment of the magic circle corresponds closely to the types of "out of character" meta-communication identified by Goffman as an integral part of the maintenance of coherent identities across frames. Within the instantiation layer of our model fall utterances which have a source external to the virtual frame, but give rise both to the normative order within it as well as maintaining the coherence of the magic circle around it. In the above discussion of discourse, the relationship between the structure of the system layer and the discourse from which the virtual world arises has been indicated. The system layer defines the types of discourse which can be instantiated, and the actors who may make such utterances. Without discourse, however, the physical rules of the system layer do not acquire the meaningful context that is essential to the participant's experience of the virtual frame.

Virtual

We inhabit a nomos—a normative universe. We constantly create and maintain a world of right and wrong, of lawful and unlawful, of valid and void. The student of law may come to identify the normative world with the professional paraphernalia of social control. The rules and principles of justice, the formal institutions of the law, and the conventions of a social order are, indeed, important to that world; they are, however, but a small part of the normative universe that

ought to claim our attention. No set of legal institutions or prescriptions exists apart from the narratives that locate it and give it meaning. For every constitution there is an epic, for each decalogue a scripture. Once understood in the context of the narratives that give it meaning, law becomes not merely a system of rules to be observed, but a world in which we live. [30]

Each virtual world has an underlying fictional universe based on a more or less elaborate narrative structure, often based on a theme or established cultural narrative such as *Star Wars* or Tolkien's Middle Earth. A community will form around this theme, and develop a set of practices consistent with the underlying fictional structure of the world. The individuals in the community define their avatars in relation to the fiction, developing an identity tied to the virtual world's *nomos*. The enforcement and alteration of the normative order within the virtual world must be undertaken in a way consistent with the fictional universe. While different worlds have chosen to deal with this dilemma in a variety of ways, there is a clear consensus that any regulatory undertakings within the game world must be integrated into the base fiction. "Toading" is a perfect example of this phenomenon—the punishment is clearly situated within the medieval fantasy realm, and the regulatory action is thus framed in terms coherent to the primary fiction. While this might not seem to be a major limitation on the regulatory powers of the virtual sovereign, in practice the need to maintain fictional coherence can be a significant constraint. One of the most fundamental constraints is the inability to "go back in time." Because the worlds are persistent and there are constantly players logged on, any attempt to retroactively regulate behaviour would be potentially disastrous for fictional coherence. While in theory the operators could shut down the machine and turn back to a prior saved version of the game, such rollbacks are generally only undertaken in the most extreme situations—for example, where the very existence of the world in question is threatened. Even in such cases, while the members of the community might see the action as a fundamental violation of the basic narrative, the *nomos* will often find a way to integrate the event. However, a virtual community will only tolerate so much disruption of its core narratives before cohesion begins to be affected and members leave.

In most worlds, the players enforce the *nomos* amongst themselves, insisting that other players remain in character or adhere to the normative order of the game. Interestingly enough, certain violations of the normative order of the fictional universe are actually part of the underlying narrative and are considered acceptable behaviour on the part of the player, even if the avatar will be severely punished if apprehended. Player killing is a good example of this phenomenon, as it has simply been made physically impossible in many worlds—an example of the coding approach to regulation. Other worlds, such as *End of the Line*, have left the possibility for player killing in the code,

but the player community has organized its own in-game sanctions involving a system of bounties which are placed on player killers. The murderous avatars, although they are violating the normative order of the fictional world, are still part of the underlying narrative, which includes bandits and unsavoury characters. The structure of the legal system in a virtual world could thus be in any form imaginable, from the most repressive tyranny to virtual anarchy. In some worlds, such as *LambdaMOO* or *A Tale in the Desert,* there are relatively sophisticated virtual legal systems in which laws are written, codified and enforced using tools available in the virtual frame. In other worlds, more informal norms develop among the participants, both across the population and within its various subcultures.

Conclusion

One can therefore see the multiple layers of *nomos* operating on the actions in the virtual world, with the constant potential for an action perceived in one frame by the actor being understood by another participant in a different frame. Many worlds have seen the development of guilds, clans and mafias which, much like in the real world, are subcultures with their own set of norms, often coordinated through websites and communiction tools outside the virtual world. Such virtual communities have been known to span several virtual worlds, and often include contact between members in the actual world, either through previously established relationships (roommates, siblings, etc.) or through organized events (e.g., Everquest Fan Faire). In *The Sims Online,* an organization which called itself the Sims Shadow Government (SSG) [31] stepped in to fill a void left by the owners of the virtual world (Maxis) who chose not to deal with what many players saw as problematic behaviour. There has been some speculation as to the actual power wielded by SSG, even in relation to Maxis, since it would appear that the SSG may have been capable of seriously disrupting or even shutting down the virtual world. Similar power dynamics exist with the guilds or clans in other worlds, and in-world protests against the owners or designers are not uncommon when players are dissatisfied with the effects of management decisions on the in-world *nomos.* In *Everquest,* for example, a warrior clan threatened to block access to one of the main portals to the world if their grievances were not addressed—using their ability to obstruct movement at the system level to pressure the world managers to negotiate with them [32]. In *World of Warcraft,* a significant number of accounts were terminated after a similar in-world protest slowed the physical servers to a crawl. In Korea, such disputes and protests can involve thousands of demonstrators, many are reported on in the broadsheets of the actual world [22], and even involve participants physically protesting at the offices of the company in the actual world. While

the model presented here admittedly cannot solve or even explain the reasons for such phenomena, it is to be hoped that the proposed distinctions do allow for a more coherent analysis of the underlying dynamics.

References

1. Balkin, J. "Law and Liberty in Virtual Worlds." *New York Law School Law Review* 49(1), pp. 63–80 (2004). Available at: http://www.nyls.edu/pdfs/v49n1p63–80.pdf. (Last visited July 24, 2006).
2. Jenkins, P. "The Virtual World as a Company Town—Freedom of Speech in Massively Multiple Online Role Playing Games." *Journal of Internet Law* 8(1), pp. 1–21 (2004). Available at http://ssrn.com/abstract=565181. (Last visited July 24, 2006).
3. Lastowka, G., and D. Hunter. "The Laws of the Virtual Worlds." *California Law Review*, pp. 1–74 (2004). Available at http://papers.ssrn.com/abstract=402860. (Last visited July 24, 2006).
4. Castranova, E. "The Right to Play." *New York Law School Law Review* 49(1) pp. 185–210 (2004) Available at http://www.nyls.edu/pdfs/castronova.pdf. (Last visited July 24, 2006).
5. Burke, T. "Play of State: Sovereignty and Governance in MMOGs." [no page numbers] (August 2004). Available at http://www.swarthmore.edu/SocSci/tburke1/The%20MMOG%20State.pdf. (Last visited July 24, 2006).
6. Williams, M. "Virtually Criminal: Discourse, Deviance and Anxiety within Virtual Communities." *International Review of Technology and Computer Law* 14(1) (2000): 95–104.
7. Brenner, S. "Is there Such a Thing as 'Virtual Crime'?" *California Criminal Law Review* 4 (2001): 101. Available at http://www.boalt.org/CCLR/v4/v4brenner.pdf. (Last visited July 24, 2006).
8. Lastowka, G., and Dan H. "Virtual Crime" State of Play Conference (New York Law School, 2003).
9. Mnookin, J. "Virtual(ly) Law: The Emergence of Law in LambdaMOO." *Journal of Computer-Mediated Communication* 2(1) (1997). Available at http://jcmc.indiana.edu/v012/issue1/.
10. Sanderson, D. "Online Justice Systems." (March 2000) Gamasutra. Available at http://www.gamasutra.com/features/20000321/sanderson_pfv.htm.
11. Schwarz, P. "Morality in Massively Multi-Player Online Role-Playing Games." (April 2000). Available at http://www.mud.co.uk/dvw/moralityinmmorpgs. html.
12. Whitlock, T. "Technological Hierarchy in MOO." (1994). Available at http://tecfa.unige.ch/pub/documentation/MUD/papers/TechHier.txt. (Last visited July 24, 2006).
13. Reid, E. "Hierarchy and Power: Social Control in Cyberspace." In P. Kollock, and M. Smith (eds.), *Communities in Cyberspace*. New York, Routledge, 1999.
14. MacKinnnon, R. "Punishing the Persona: Correctional Strategies for the Virtual Offender." 1996. http://actlab.utexas.edu/~spartan/punish.txt. (Last visited July 24, 2006).
15. Pargman, D. "Code Begets Community: On Social and Technical Aspects of Managing a Virtual Community." PhD Dissertation, Linköping University, 2000.

16. Dibbell, J. "A Rape in Cyberspace or How an Evil Clown, a Haitian Trickster Spirit, Two Wizards, and a Cast of Dozens Turned a Database Into a Society." (*The Village Voice*, 36–42, December 21, 1993). Available at http://www.juliandibbell.com/texts/bungle.html.
17. Qu'est ce que le virtuel? (Paris: *La Découverte*, 1998).
18. Ryan, M.-L. *Possible Worlds, Artificial Intelligence and Narrative Theory* (Indianapolis, Indiana UP, 1991).
19. Bartle, R. *Designing Virtual Worlds* (Indianapolis, New Riders, 2004).
20. Koster, R. "Overall MUD Architecture." 2000. Available at http://www.raphkoster.com/gaming/book/6b.html.
21. Evans, S. "Building Blocks of Text-Based Virtual Environments." BA Thesis, University of Virginia, 1993. 18/10/98. Available at http://lucien.sims.berkeley.edu/MOO/TechnicalReport.ps.
22. Levander, M. *"Where Does the Fantasy End?"* (*Time Magazine*, 157:22, 2001). Available at http://www.time.com/time/interactive/entertainment/gangs_np.html. (Last visited July 24, 2006).
23. Duk-kun, B. *"Police Say Game Sites Bed of Cyber Crime."* (*The Korea Times*, August 7, 2003). Available at http://times.hankooki.com/lpage/nation/200308/kt2003080718330611980.htm. (Last visited July 24, 2006).
24. McTaggart, C. *"A Layered Approach to Internet Legal Analysis."* *Mcgill Law Journal* 48(4) (2003): 571.
25. http://www.raphkoster.com/gaming/playerrights.html.
26. Dibbell, J. *My Tiny Life*. New York, Owl Books, 1998.
27. Lessig, L. *Code and Other Laws of Cyberspace*. New York, Basic Books, 2000.
28. Curtis, P. "Not Just a Game: How LambdaMOO Came to Exist and What It Did to Get Back at Me." In C. Haynes and J. R. Holmevik (eds.), *Highwired: On the Design, Use, and Theory of Educational MOOs*. Ann Arbor, Michigan University Press, 1998, pp. 25–44.
29. Bateson, G. "A Theory of Play and Fantasy." *Psychiatric Research Reports* 2 (1955): 39–51.
30. Cover, R. "Nomos and Narrative." *Harvard Law Review* 97(1) (1983): 4.
31. Available at http://www.simshadow.com/. (Last visited December 14, 2004).
32. Available at http://www.thesteelwarrior.org/forum/perpage=1&display= &-pagenumber=1.

Part IV

Making It Work: Design and Architecture

17. Socio-Ec(h)o: Ambient Intelligence and Gameplay

RON WAKKARY, MAREK HATALA, ROBB LOVELL,
MILENA DROUMEVA, ALISSA ANTLE, DALE EVERNDEN,
AND JIM BIZZOCCHI

Introduction

This chapter describes the preliminary research of an ambient intelligent system known as socio-ec(h)o. Socio-ec(h)o explores the design and implementation of an ambient intelligent system for sensing and display, user modeling, and interaction models based on game structures. Ambient intelligence computing is the embedding of computer technologies and sensors in architectural environments that combined with artificial intelligence, respond to and reason about human actions and behaviours within the environment.

Ambient intelligent spaces lend themselves extremely well to physical and group play, and here describe our design of an interaction model and supporting system based on physical play. The overall research goal of this project is to understand to what degree physical play and game structures such as puzzles can support groups of participants as they learn to manipulate an ambient intelligent space. Future evaluation of this project will allow us to more fully answer this question. To date we have designed and implemented the prototype and interaction model. We have incorporated formative feedback through a participatory design process. This approach allowed for the concurrent development of the concept, interaction model and prototype environment.

In this chapter, we provide an overview of background concepts and related research. We then describe the game structure and prototype of our environment, including a technical overview of the system. We discuss the utilized games research concepts and our approach to group user models

based on Bartle's game types [1], and our ecologically inspired design approach to socio-ec(h)o. We conclude with a discussion of our work to date and future research.

Background

Key contextual issues in socio-ec(h)o include related research in the area of play and ambient intelligent spaces, and literature linking play and learning.

Björk and his colleagues have observed progress toward fully ubiquitous computing games, yet they identify the need to develop past end-user devices such as mobile phones, personal digital assistants and game consoles. Accordingly, we need to better understand how "computational services" augment games situated in real environments [2]. Recent projects have investigated the play space of responsive environments and tangible computing utilizing sensors, audio, and visual displays. For example, Andersen [3], and Ferris and Bannon [4] engage children in exploratory play and emergent learning through sensor-augmented objects and audio display. Andersen's work reveals how theatrical settings provide an emotional framework that scaffolds the qualitative experience of the interaction. Ferris and Bannon's work makes clear that a combination of simple feedback and control leads children to widely explore and discover a responsive environment.

In the Nautilus project, Strömberg and her colleagues employ bodily and spatial user interfaces as a way of allowing players to use their natural body movements and to interact with each other in a group game within a virtual game space [5]. Strömberg observes that in physical and team games such as soccer or dodge ball, players coordinate their physical movements and rely heavily on communication to be successful. In their findings, participants reported that controlling a game through one's body movement and position was "new and exhilarating." In addition, playing as a team in an interactive virtual space was found to be engaging, natural and fun.

In relation to the above research, socio-ec(h)o builds on the theatrical, simple and physical interaction models in order to develop a game structure approach that lies between exploratory play and a structured game for adults within an ambient intelligent environment. In addition, we extend the notion of a game structure to an interaction model for the environment rather than a virtual game space. We also build on the idea that action, play and learning are linked in such physically based environments.

In respect to the links between action, play and learning there is a substantial amount of literature. Dewey argued for the construction of knowledge based on learning dependent on action [6]. Piaget, through his child development theory, believed in the development of cognitive structures through action and spontaneous play [7]. According to Piaget, constructivist learning

is rooted in experimentation, discovery and play, among other factors. Papert extends Piaget's notions by investigating the knowledge-construction process that emerges from learners actually creating and designing physical objects [8]. Malone and Lepper consider games as intrinsic motivators for learning [9]. Subjective motivations like challenge, curiosity, control and fantasy may occur in any learning situation; other motivations like competition, cooperation and recognition are considered to be inter-subjective, relying on the presence of other players/learners. Design related theories have placed activity at the center of design action as in Nardi and O'Day's activity theory based on information ecologies [10]. Schön argues that design is a series of actions involving experimentation and learning in the framing and re-framing of a design situation [11].

Game Structure and Prototype

Description and Scenario

The aim of our game is for a team of four players to progress through seven game levels. Each level is completed when the players achieve a certain combination of body movements and positions. At the beginning of each level, players are presented with a word puzzle as a clue in discovering the desired body states (see Figure 17.1). The levels are represented by changes in the environment in light and audio. The levels are progressively more challenging in terms of body states and more complex in terms of the audio and visual ambient display. The physical environment currently consists of a circumscribed circular space (the area in which we can detect motion), surround sound audio, theatrical lighting, and two video projection surfaces.

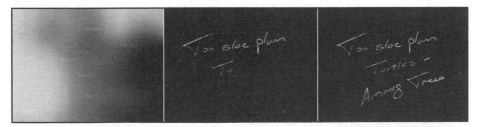

Figure 17.1: Depicted above are frames from a thirty-three second video introducing a level to players. The images at the beginning of the video provide a sense of the environmental change the players are trying to achieve for that level. This is followed by a clue in the form of a word puzzle aimed at helping players discover the desired body state. In this example, the puzzle is "Too sloe plum turtles—among trees."

Table 17.1: This table describes the socio-ec(h)o game schema

Theme	Levels	Body state	Goal	New game skill
Discovery of light	1	"high-low"	create day	body position
Day for night	2	"moving low"	create night	movement/duration
	3	"loosely moving"	create day	proximity
Rhizome	4	"dense center—scattered edge"	create spring	sequencing
	5	"this way slow—low to high"	create winter	sequencing/duration
Biota	6	"two low moving—two high"	create summer	composition
	7	"ringing around the rosie"	create fall	composition & location

Here is a short scenario of participants in the socio-ec(h)o environment:

Madison, Corey, Elias and Trevor have just completed the first level of socio-ec(h)o. They discovered that each of them had to be low to the ground, still, practically on all fours. Once they had done that, the space became bathed in warm yellow light and filled with a wellspring sound of resonating cymbals. Minutes earlier, the space was very dim—almost pitch black until their eyes adjusted. A quiet soundscape of "electronic crickets" enveloped them. They discussed and tried out many possibilities for solving the word puzzle, "Opposites: Lo and behold." They circled the space in opposite directions. They stood in pairs on opposing sides of the space. At Corey's urging, the four grouped together on the edge of the space and systematically sent a player at a time to the opposite side in order to gauge any change in the environment. Nothing changed. Madison, without communicating to anyone realized the obvious clue of "Lo" or "low." While Corey was in mid-sentence thinking-out-loud about the puzzle with Trevor, and trying to direct the group into new body positions, Madison lowered herself to a crouching position. The space immediately glowed red and became brighter. The audio changed into a rising chorus of cymbals—not loud but progressively more pronounced. Corey and Trevor stopped talking and looked around at the changing space. Madison, after a pause began to say "Get down! Get down!" Elias stooped down immediately and the space became even brighter. Corey and Trevor dropped down in unison and the space soon became bathed in a warm yellow light like daylight. The audio reverberated in the space. A loud cheer of recognition came from the group, "Aaaaahhh! We got it!" Corey asked everyone to get up. As soon as they were all standing, the space became pitched black again. They dropped down again and the space was full of light. They had learned how to "create daylight" in the space. They had completed level one.

Soon after, a new word puzzle was presented to them in a short video projected on two scrims hanging from the ceiling: "The opposite of another word for hello but never settles." The lights have become very dim now and the audio has a slightly more menacing quality to it. Level two will clearly be more challenging. . . .

Figure 17.2: Scenes from the final participatory design workshop in which the relationship between body states and word puzzles were explored. The system utilized is an early prototype with the substantive functions implemented. As players lower themselves, the environment becomes progressively darker and the ambient audio more pronounced. Note: the display response is not the same as depicted in the scenario. In this exercise, the goal was to create darkness rather than light.

We formalized our game structure into a schema of levels, body states and goals (see Table 17.1). As earlier described, the game has seven levels. The body states are the body movements and positions that players must discover in order to complete a level. Goals are the change in environment players are aiming to achieve. The goals are implicit and not explicitly stated for the players. Each level has a beginning quality of light and audio. As the players progress toward achieving the right body state, the environment incrementally shifts toward the goal state of the environment. For example, as depicted in the scenario, when Madison lowered herself, the environment gradually shifted toward the goal of creating day. As each of the other three players followed Madison, the environment responded to movements of each player (see Figure 17.2).

In addition, the schema includes new game skills and themes. We assigned each level a generic skill in relation to each body state and level. Despite the specific body state, the generic skill acquired at each level is required in order to discover the more complex body states at higher levels. Themes allowed us to design an implied progressive narrative based on natural evolution. Again, the specific themes and even the narrative are not known to the participants, rather they provide an underlying structure for

body states, goal states and game skill acquisition. We intend for the progressive narrative to provide a sense of coherency across the levels, and to loosely map increased challenge to the reward of a more complex display.

Technical Prototype

The technical system for socio-ec(h)o includes three key components, a sensing system, reasoning engine, and display engine.

Sensing System

The sensing engine comprised a twelve-camera Vicon MX motion capture system (www.vicon.com) and a custom program written in Max/MSP. Each participant is differentiated by unique configuration of reflective markers worn on their backs. The system senses for discrete parameters such as velocity, position (x,y,z), orientation, proximity, and movement. It measures across each unique player for participation and duration. Data is transmitted to the reasoning engine for high-level interpretation.

Reasoning Engine

The reasoning engine provides the intelligence for the system. It interprets the sensing data samples, identifies the level of body states completion, and manages the narrative flow of the socio-ec(h)o experience. The engine receives sensing data from the sensing system and interprets it in terms of high-level group behavior. For example, the sensing system sends data on predefined parameters such as velocity and body positions and the reasoning engine synthesizes the parameters to determine if a given body state is achieved. The characteristics and their combination, and in some cases their sequence determine the 'intensity' of the state. Another factor influencing the intensity of a state is the group user model that is dependent on the combination of user types as identified by Bartle classifications (see "Description of Game Concepts and User Model"). The role of the engine is to manage the flow in the game by sequencing of the states and managing the timing of the state transitions. The reasoning engine is rule based and allows seamless modification and extension for other applications. The reasoning engine feeds its output, state intensity, and state transition to the display engine.

Display Engine

The display engine has two components, an audio and a lighting component. The audio display engine for socio-ec(h)o provides a sound ecology for each individual level of the system; it is custom software programmed in Max/MSP. We developed and structured the audio content on the principles of acoustic ecology and feedback-as-communication [12]. In addition, the audio display provides a gradient response to the participants, telling them

how close they are to achieving their goal. The audio display system can alternate between stereo and multi-channel formats and localized and ubiquitous sound. The audio content follows the theme of evolution by utilizing sampled sound and several different sound processing techniques creating a shifting ambient soundscape that moves from simple, abstract sound to rich, environmental sound.

Lighting is manipulated with a DMX 512 controller via a Max/MSP patch. A small light grid and theatrical style lighting instruments and color scrollers are used. A lighting console was created to control multiple lights and color in concert through a cue list mechanism. Cues were written to simulate the various themes at each level.

Both the audio and the lighting systems take their cues from the reasoning engine, and respond to game aspects and configurations specified in the reasoning engine. Thus, the response of the display systems can potentially be used to provide feedback based on a variety of parameters such as how well participants are working together as a group.

Integration

The three components described above run on their own servers. The integration is achieved by lightweight communication protocol that is transferred over the User Datagram Protocol (UDP) communication channel. We consider uni-directional UDP communication appropriate for the real-time applications. Although the sensing system is capable of capturing data at the rate of thirty frames per second we are using slightly longer sampling rate of 200 ms for data transferred between the servers. Considering the nature of the output (sound and video) this rate is sufficient for the required fine-grained response.

Description of Game Concepts and User Model

We investigated the play and game aspects of socio-ec(h)o through short ethnographic sessions, workshops among the researchers, and games research theory. We explored a range of game concepts including traditional game theory notions such as Nash's Equilibrium to contemporary games research [13,14,15]. Our aim was to encode a form of play for groups that lays between a structured game and open-ended play. Each level acted as a kind of group puzzle—that is, a game with a single solution or winning state [16]. The alignment of increasing difficulty of level solutions with the increasing skill of the participants as they proceed through the experience is consistent with Csikszentmihalyi's model for developing a state of flow [17].

In the end, we relied on our participatory design process to evolve our game structure. This was especially helpful since we were exploring social

aspects of gaming such as communication, collaboration and shared cognition. In addition, our approach was highly physical which required an empirical approach to understanding our concepts. Theoretically, we utilized Bartle's concepts of collaborative play in Multi-User Dungeons (MUDs) and MUD Object Oriented systems (MOOs) to help us formulate a group user model to support the reasoning within our system [1]. Bartle identified four types of MUD player styles: achievers, explorers, socializers, and killers. Achievers seek in-game success, explorers satisfy their environmental curiosity, socializers value human interaction, and killers exercise their will at the expense of other players.

The group user model in socio-ec(h)o is constructed based on Bartle's typology. The group user model is applied in the interpretation of the individual actions in the environment and the level with which individual actions contribute towards an overall group activity. The display response in socio-ec(h)o is adjusted with respect to the group composition. We are currently investigating our hypothesis that by considering Bartle's types participants have a better experience and more quickly become skilled interactors.

An Ecologicical and Participatory Approach

The key components of our ambient intelligent model are addressed as a systemic whole; they include interaction, reasoning, response and technology. For example, we investigated the balances between sensor technologies in relation to gesture, inference rules and display responses. Our design approach—inspired by an ecological frame—is centered on human activity and is participatory design driven, informed by observation and theory.

The concept of an ambient intelligence ecology emerged from findings in a previous research project known as ec(h)o. We discovered that ec(h)o had successfully balanced incongruent elements to form a dynamic and coherent system. Components such as interaction, reasoning, audio display and technology shaped the ambient intelligent environment around the purpose of a museum visit [18]. In ec(h)o we explicitly utilized an information ecology approach as an ethnographic analysis of the museum as well as a scaffold for our design decisions [19]. Nardi and O'Day describe ecology as a system of people, practices, values, and technologies in a local environment. They argue that the ecology metaphor shifts the focus to human activity rather than on technology [10].

The current research, socio-ec(h)o represents a preliminary exploration of the concept of an ambient intelligent ecology. The experimental nature of the project, its laboratory setting, and the fact that participants cannot be considered to be part of a relevant or definable ecology limit the degree to which this research fully explores the concept. Nevertheless, we feel this is a

starting point in investigating an ambient intelligent ecology design approach. At this stage, we found the use of participatory design workshops to be a key component of an ambient intelligent ecology approach. The workshops simultaneously addressed issues of interaction, reasoning, response and technology. We ran five workshops that progressively explored open-ended concepts to more defined concepts. These workshops included investigations of the continuum between play and game, the physicality of our interaction model, the social aspect of play within our type of space, puzzles and narrative and finally the relationship between our body states and word puzzles. It was evident to us that we required an empirical and qualitative understanding of our concepts, interaction, technology use and prototyped environment while we were designing them.

Discussion

In designing an interaction model and supporting system for the play and learning of a complex system, many issues relate to the communication and action between participants and between the group of participants and the system.

Embodied Cognition and Communication

In our design, a successful participant experience relics on a tightly coupled system emerging out of real-time, goal-directed interactions between participants, and between participants and the responsive environment. The nature of these interactions influences the challenge, enjoyment and success within the environment. Communication is key to solving the puzzles and coordinating actions. While the verbal discussion among participants is frequent and active, the physical nature of the interaction model and game structure emphasizes explicit embodied action, cognition, and communication. Players actively work out the puzzle physically, as well as communicate actions and ideas physically. In many respects, the interaction model is founded on an embodied cognition view of interaction [20,21]. Success in the game requires a quality of interaction in which mind, body, and environment mutually interact and influence one another positively.

From the perspectives of the design of the interaction model and system, we realized it was important to decide where not to specify interaction and system functionality. In many respects, we learned to off-load formalized interaction among participants to the situated dynamics of a group of people working toward a shared goal, that is, people will communicate together in whatever form possible given the resources in the environment without the need of formalizing communication modes. In addition, the system does not

need to encode or sense actions or behaviours that are not relevant to the desired body state at a given level, that is, no response from the system is a perceived response. We feel we supported an embodied and inter-subjective approach through limited means such as design constraints. For example, limiting sensing actions to whole body positions and movements rather than gestures opened gestures up to unique, specific and complex communication between participants. Ignoring or not encoding large parts of the embodied action supported a wide range of exploration of body movements.

Selective Real-Time Response

We were, however, selective as to when and how the system did respond to participants' actions. The system responds when it appears that the group is on a trajectory toward the desired body state. The response is conceptually similar to someone telling another if they are close to a goal by stating if they are cool, warm, or hot. Through our participatory design workshops we learned that four factors had to be met in our response in order to achieve this type of support through a changing environment. The response had to be in perceived real-time, the feedback is on a gradient related to the proximity to the goal, a reward is given for achieving a goal, and a response is mapped to the make-up of the group. The quality and nature of physical action requires an accepted real-time response. Given that we require a minimum duration before a body state is recognized, we had to find the threshold for what was understood as a required time to hold a position versus a perceived lag or failure of the system. A gradient response is critical in aiding players in understanding they are on the right track. The response is coordinated between the audio and the lighting. The nature of the gradient response is well illustrated in the scenario and Figure 17.2. An audio reward is given once a state is completed. This is needed since the continuum of coordinated actions and durations is not explicit to the participants. Based on the different groups of players determined as a composite of Bartle types, we modified response and time. While we have yet to fully evaluate this approach, we anticipate a group of achievers will expect a different response or precision of action than a group of primarily explorers. With this in mind, we also provided a range of word puzzles of differing difficulty and challenge.

Empirical Nature of Designing Ambient Intelligent Systems

An ambient intelligent ecology, as stated above, is an ongoing investigation of how we might define a design process specific to the challenges of ambient intelligence. Given the centrality of situated human activity and the need to develop an interaction model and system as a systemic whole—reducing the

process or system to discrete elements is not a reasonable approach. While a theoretical approach to the design and system helps frame the problem and support design decisions, ultimately it is an empirical process such as ethnography or, in this case, participatory design that yields useful qualitative and quantitative understanding of how to design the interaction model and system. The application that arises, such as socio-ec(h)o, becomes a specific ecology of constraints, affordances and system functions that is situated and relies on a unique dynamic of embodied action between people and environment.

Conclusion and Future Work

In this chapter we have reviewed related research and have shown how our system builds on theatrical, simple, and physical interaction models in order to develop a game-based approach to ambient intelligence that relies on exploratory play with a conceptually structured interaction model. We discussed the links between play, learning, and action that we extended into an embodied cognition approach. We provided a description of our game structure and prototype from conceptual and technical perspectives, and we discussed how we use Bartle's game types as the basis for our user types and group user model. We introduced our approach to designing ambient intelligent systems that is ecologically inspired. In our discussion, we explained the role of embodied cognition within our design, and elaborated on how we decided where and where not to formalize and encode embodied actions, cognition, and communication. We detailed how the success of the experience relied on selective responses that were real-time, gradient, provided rewards and were unique to different group user models. Lastly, we stressed the empirical nature of the design work and the role of participatory design in developing our system.

Future work includes a series of evaluations of the system to better understand the influence of the game structured interaction model, the supporting user model, and the display. In particular, we aim to understand how our approach enables a better experience and more skilled interactors within an ambient intelligent environment.

Acknowledgments

We would like to gratefully acknowledge the support of Canadian Heritage for funding the Am-I-able Network for Mobile, Responsive Environments and this project. We would also like to acknowledge funding support from the Social Sciences and Humanities Research Council and the Natural Sciences and Engineering Research Council.

References

1. Bartle, R. (1996). Hearts, clubs, diamonds, spades: Players who suit MUDs. Journal of MUD Research. Available at http://journal.tinymush.org/v1n1/bartle.html.

2. Bjork, S., J. Holopainen, P. Ljungstrand, and K.-P. Akesson. "Designing Ubiquitous Computing Games—A Report from a Workshop Exploring Ubiquitous Computing Entertainment." *Personal and Ubiquitous Computing* 6 (2002): 443–458.

3. Andersen, K. "'ensemble': Playing with Sensors and Sound." In *CHI '04* extended abstracts on Human factors in computing systems, ACM Press, Vienna, Austria, 2004, pp. 1239–1242.

4. Ferris, K., and L. Bannon. " . . . a load of ould boxology!" In *Proceedings of the Conference on Designing Interactive Systems: Processes, Practices, Methods, and Techniques* (London, England, 2002), ACM Press, pp. 41–49.

5. Strömberg, H., A. Väätänen, and V.-P. Räty. "A Group Game Played in Interactive Virtual Space: Design and Evaluation." In *Proceedings of the Conference on Designing Interactive Systems: Processes, Practices, Methods, and Techniques* (London, England, 2002), ACM Press, 56–63.

6. Dewey, J. *Democracy and Education: An Introduction to the Philosophy of Education.* New York, The Macmillan Co., 1938.

7. Piaget, J., and Piaget, J. *To Understand is to Invent: The Future of Education.* New York, Grossman Publishers, 1973.

8. Papert, S. *Mindstorms: Children, Computers, and Powerful Ideas.* New York, Basic Books, 1980.

9. Malone, T. W., and M. R. Lepper. "Making Learning Fun: A Taxonomy of Intrinsic Motivations for Learning." In R. Snow, and M. Farr (eds.), *Aptitude, Learning, and Instruction: Cognitive and Affective Process Analyses,* Hillsdale, N.J., Lawrence Erlbaum, 1987.

10. Nardi, B. A., and V. O'Day. *Information Ecologies: Using Technology with Heart.* Cambridge, MA, MIT Press, 1999.

11. Schön, D. A. *The Reflective Practitioner: How Professionals Think in Action.* New York, Basic Books, 1983.

12. Truax, B. *Acoustic Communication.* Ablex Publishing, London, 2001.

13. Björk, S., and J. Holopainen. *Patterns in Game Design.* Hingham, MA, Charles River Media, 2004.

14. Carse, J. P. *Finite and Infinite Games.* New York, Ballantine Books, 1987.

15. Salen, K., and E. Zimmerman. *Rules of Play: Game Design Fundamentals.* Cambridge, MA, MIT Press, 2004.

16. Kim, S. "What is a puzzle?" Available at http://www.scottkim.com/thinkinggames/whatisapuzzle/index.html. 2000. (Last accessed March 12, 2005).

17. Csikszentmihalyi, M. *Flow: The Psychology of Optimal Experience.* New York, Harper & Row, 1990.

18. Wakkary, R., K. Newby, and M. Hatala. "Ec(h)o: A model of participation." In *Communicational Spaces Conference,* 2003. Available at http://www.ualberta.ca/COMSPACE/coneng/html/papers/Wakkary.pdf.

19. Wakkary, R., and D. Evernden. "Museum as Ecology: A Case Study Analysis of an Ambient Intelligent Museum Guide." In Museums and the Web 2005 Selected

Papers (Vancouver, British Columbia, 2005), Toronto, Archives and Museum Informatics, pp. 151–162.

20. Clark, A. *Being There: Putting Brain, Body, and World Together Again*. Cambridge, MA, MIT Press, 1997.
21. Wilson, M. "Six Views of Embodied Cognition." *Psychonomic Bulletin & Review* 9(4) (2002): 625–636.

18. *Shadowplay: Simulated Illumination in Game Worlds*

SIMON NIEDENTHAL

It has long been a commonplace in gaming communities that "good graphics does not equal good gameplay." Originally growing partly out of resistance to hardware industry agendas, this platitude has, in its extreme versions, ossified into a simple and ultimately less-than-useful dichotomy. But given the capacity to dynamically engage the senses that is inherent in interactive media, a better question for us to pose is "what sort of visual experiences best support gameplay?" One way to approach this rather large question is to focus on our experience of simulated illumination in gaming environments. For, despite skepticism towards game graphics, the fact is there are currently a number of very enjoyable games in which light plays a key role. In *Thief 2* and *Silent Hill 2*, categorized as "first person sneaker" and "survival/horror" games, respectively, a consideration of light can be found not only in the way in which the game spaces are illuminated, but also in the sensorium that is encoded into the game's Artificial Intelligence. In this sense, both players and non-player characters respond to illumination decisions made by game designers and the gamers themselves.

Before we investigate illumination decisions further, it is necessary to create a framework for analyzing the contribution of simulated illumination to the gaming experience. Quite clearly, there is a lack of vocabulary with which to speak and think about light in games and the effect upon the player. This chapter will argue that a foundational understanding for studying lighting design in game environments can be forged by first surveying existing illumination practices. Pre-rendered 3D-computer animation is created using similar digital tools, and the field has begun to develop its own form of cinematography. But the free navigation afforded by games requires us to look to other practices outside of filmic media, such as architectural lighting.

Finally, games as interactive experiences must be examined for their own unique potentials. After all, in a game the player sees and is seen, illuminates and is illuminated in turn.

As media artifacts and interactive experiences, games draw from various sources of knowledge about light to achieve their effects. The existing professional practice perhaps closest to game illumination is computer-generated animation. As with films such as *Toy Story,* most digital games take place in environments created within 3D-software packages that take film technologies as organizing metaphors. In 3D-Studio Max, Softimage, and Maya, surface geometry is refined with a combination of texturing tools and simulated light sources. In some companies, a programmer working as a technical director defines the lights, while in other settings digital artists set lights within 3D-software packages and export them to the rendering engine for evaluation and fine-tuning. Lighting decisions for a game must be constantly balanced with the need to maintain a frame rate adequate for real-time playback; the quantity of lights in a game scene is determined by the rendering engine. Some rendering engines allow the digital artist to employ eight lights; really good engines up the number to several hundreds [9]. Although in the past the real-time demands of digital games have limited the use of complex lighting setups and effects, a number of new rendering engines, techniques and workarounds allow game designers increasing control of the illumination spaces of their games, opening to them the sort of choices that were afforded digital animators a decade ago.

Since then, the computer-generated animation industry has begun to generate its own form of cinematography, led by companies such as Pixar, whose aesthetic draws heavily upon traditional film lighting practice. Sharon Callahan [3] identifies five objectives of lighting in a digital animation scene:

1. Directing the viewer's eye
2. Creating depth
3. Conveying time of day and season
4. Enhancing mood, atmosphere, and drama
5. Revealing character personality and situation.

If we apply these objectives to an analysis of *Silent Hill 2,* we can see that there are useful contributions, as well as important limitations, to a filmic approach. First, light qualities are employed to direct the player's eye, an important part of locating useful objects in any adventure game. Health drinks, medical packs, and ammunition to be acquired in a space leap out through contrast and specularity. Depth in exterior scenes is simultaneously created and limited through atmospheric perspective of fog, as well as darkness. Although *Silent Hill 2* is largely an interior game, played out in decayed, boarded-up spaces, larger lighting decisions do convey time of day and inter-

act in an interesting way with the player's experienced sense of time. The game begins in daytime, and then, after leaving Brookhaven hospital, the player emerges into a nightscape. A gray dawn permeates the final stage of the game at the Lake Side hotel; thus *Silent Hill 2* is played out over one day. Depending on how skillful the player is, this may or may not correspond to the player's own sense of game time. A cinematic sensitivity to the power of light to enhance mood, atmosphere, and drama is readily apparent in *Silent Hill 2*. The overall low-key lighting strategy in the game is perfectly in tune with the horror genre, and provides one of the greatest sources of the game's pleasures. Finally, one can point to a number of ways in which illumination helps to sketch character and motivation in a cinematic way.

In the opening expository pre-rendered scene, James Sunderland, the game's protagonist, stares into a mirror and relates the receipt of a letter from his dead wife. This scene introduces us to a somewhat ambiguous character, and as the game plays out we are called upon to speculate about James's motivations and role in his wife's death. The illumination here, coming from above and leaving his eyes in shadow, is a cinematic convention often associated with characters whose motivations are unclear. In *The Godfather*, for example, cinematographer Gordon Willis chose the same lighting strategy to make the title character appear more mysterious [13]. The case of top lighting the face in such a way that the eyes remain in darkness is an example of the way in which a lighting convention can come into dialogue with deeply ingrained behaviors. According to studies of how humans read faces, we devote great mental energy to analyzing the gaze of others, and it has been speculated that in evolutionary terms this is how we evaluate intentions and whether or not we are likely to become prey. It follows then that the obscuring of the whites of the eyes and the specular highlight from the eyeball through shadowing [1] would tend to leave us somewhat unsettled.[1]

As the foregoing example makes clear, a cinematic approach to game lighting is appropriate as a means of analyzing pre-rendered cut scenes, as well as useful in helping us understand larger lighting strategies that relate to game genres, time of day, narrative elements, and mood. But it is also quickly apparent that games as interactive experiences differ from films in significant ways. First, a film scene is of limited duration, and generally must communicate a quantity of information in that time. Games, on the other hand, allow free exploration and examination. In addition, film scenes are lit to be recorded from the camera. A fixed perspective for viewing a game environment of course cannot be assumed (though some games have context-sensitive framing that is a kind of middle state between free exploration and fixed perspectives). So though a film lighting perspective is useful for our understanding of how games function as media artifacts with certain narrative

elements, the task of lighting the interactive game world, then, also participates in the traditions of real-space practices such as architectural lighting.

If we accept that our experiences of simulated illumination are analogous in some way to our experience of light in real space,[2] there is a body of research on the light effects that can be re-purposed within game design. Recently there has been increased interest in studying the qualitative and non-visual effects of light, the ways in which illumination levels and color influence how people feel and behave. Several themes have emerged from current research. Quite clear gender differences occur; men and women respond differently to cognitive tasks under differing levels and colors of light [5]. Risk-taking also appears to be a phenomenon that is affected by our luminous environment [8].

Very interesting implications for game design emerge from experiments on the effect of light on decision-making. According to Costykian, decision-making is one of the defining hallmarks of the gaming experience [4]. One interesting thesis that comes out of light research is that light may affect decision-making through its impact on autonomic arousal—our overall state of alertness—affect, our emotional condition or mood, and vision, our ability to receive visual phenomena under given light conditions. Belcher and Kluczny suggest that "Mood and vision compete with decision strategies for working memory capacity. If the subject is in a good mood, and/or if the luminous environment renders difficult the visual task, selection of a decision making strategy that eases cognitive strain . . . may ensue" [2]. The authors posit that in particular illumination conditions we are more likely to employ quicker heuristic strategies rather than engage in detailed analysis. *Silent Hill 2* is an excellent environment in which to trace this line of thought with reference to the experience of the player. There are a number of different types of decisions that one is called upon to make in the game: Should I blast this zombie? How do I solve this puzzle? Clearly some decisions are on the level of reflex, others require analysis. Belcher's model suggests that tasks such as killing approaching zombies, which are solved best by applying heuristics rather than launching into detailed analysis, are supported by luminous surroundings that would be described as poor or low acuity lighting, often the case in *Silent Hill*. The significance of this for the game lighting designer is that there is room for subtle modulation of tactical and strategic effect in the matching of the lighting environment to the desired game experience.

We can employ a simple game taxonomy to map architectural and filmic sources of light knowledge appropriately to game design. Craig Lindley proposes a triangular model integrating ludology, narration and simulation. Lindley's ludological definition of a game, the basic assumption of game theory, is "a goal-directed and competitive activity conducted within a framework of agreed rules"; a narrative is loosely defined as "an experience

structured in time"; and simulation is "a representation of the function, operation or features of one process or system through the use of another" [7]. One benefit of generating such a taxonomy, as Lindley points out, is that it can help us apply knowledge to game design in a productive way: "The distinctions of the taxonomy also allow us to see where techniques from other fields can be applied. For example, acknowledging the narrative elements of a game indicates where methods for the construction of narratives, heavily developed for film script writing, can be applied within games."

Overlaying illumination practices upon this game taxonomy also demonstrates how other types of lighting knowledge can contribute to game lighting design. Narrative can clearly be supported by illumination techniques coming from 3D-computer animation and film, especially relevant in pre-rendered cut scenes. Our understanding of how light influences people in real space has consequences for the "goal directed and competitive" activities of ludic behavior, through arousal, affect, risk-taking and decision-making. Knowledge of the digital simulation of light has come to games from computer graphics, and an example of how our experience of light can be foregrounded in simulations can be seen in the current crop of fireworks simulators [10].

So far I have been concentrating upon illumination decisions made by professionals, but what is interesting about games is that these decisions are increasingly being made by players. Tactical lighting decisions by the player are an important part of the game experience in *Silent Hill 2*. Early on in the game, one acquires a flashlight, and must continually decide whether or not to use it. With the light on, objects to be acquired in an environment leap out through contrast and specularity, and one can read the maps picked up as overviews of each space. The light is comforting; without it, one moves through a twilight gloom almost sub-aquatic in character. The player must choose from moment to moment how to illuminate the scene, and the decisions are crucial for survival and continued forward-movement in the game. Konami's website tips the player off to the significance of illumination in balancing the game's risks and rewards:

> The monsters have eyes and ears, and will use these to locate James. If they are not alerted to James' presence, they may not attack. Turning off the flashlight and carefully bypassing unnecessary confrontations is advised, however, with the flashlight off, James cannot search or look at the map and his accuracy with projectile weapons is severely impaired. [12]

The attention to light in *Silent Hill 2* thus goes far beyond storytelling and world definition; it also directly engages the player and becomes a key part of the gameplay.

But as the foregoing snippet from Konami suggests, illumination decisions in game design do not just affect the player's surrogate and perspective, they also shape the conditions for interaction with non-playing characters through the game's AI. For the game *Thief,* in which the game experience is built around avoiding detection while accomplishing missions, a sensory system was developed with the aim of increasing the suspense of possible discovery. Tom Leonard relates the aim of the game's developers:

> The primary requirement was creating a highly tuneable sensory system that operated within a wide spectrum of states. On the surface, stealth gameplay is about fictional themes of hiding, evasion, surprise, quiet, light and dark. One of the things that makes that kind of experience fun is broadening out the grey zone of safety and danger that in most first-person games is razor thin. [6]

Artificial Intelligence vision in *Thief* is simulated through a viewcone and raycast-based system, and framed in terms of "awareness" and "visibility." Visibility is defined "as the lighting, movement, and exposure (size, separation from other objects) of the entity . . . the lighting of the player is biased towards the lighting near the floor below the player, as this provides the player with a perceivable way to anticipate their own safety."

Finally we must consider digital games not just as a repository for existing lighting practices. One of the most interesting experiences in *Thief 2* is the development of a kind of self-reflexive awareness about illumination. The degree to which one is present in light or darkness in a scene, for reasons given above, strongly affects one's fortunes in the game, and is fed back to the player through the "glowing crystal" in the interface. This dynamic awareness has the capacity to alter one's sensitivity to illumination after leaving the game. The contribution from the interface engages the player in the sort of "double consciousness" of the game as both mediated and directly felt that is, according to Katie Salen and Eric Zimmerman, one of the most promising areas of future game development [11].

Illumination decisions in games take many forms, are made by both designers and players, and have strategic and tactical consequences for the game experience. But whether one is seeking to evoke a world or set up the conditions for perception and interaction, light allows us to advance our goals for the felt game experience, be they the evocation of suspense, dread, comfort, or ecstatic abandon. Light engages us through our bodies, our nervous systems, and our collective social interactions. Digital games, in which light is made present through a combination of media conventions, computer graphics algorithms and sensory phenomena, thus represent an arena in which the aesthetics of light and the mechanics of perception are open for exploration and redefinition by designers and players alike.

Notes

1. Thanks to Steve DiPaola for this insight.
2. This assumption requires a sub-argument. In the late '60s a debate emerged between J. J. Gibson and Goodman on the nature of the experience of viewing a picture. Goodman's position was that we learn to "read" a picture and that it functions as a kind of text. Gibson countered that the experience of looking at a picture is analogous to how we see in real space: "a picture is a surface so treated that (it) contains the same kind of information that is found in the ambient optic arrays of an ordinary environment." He also writes, more succinctly, that "interpretation depends on sensations." I take Gibson's side, and believe further that his stance can be transferred to a consideration of dynamic simulations such as games. The argument of this chapter is that our experience of simulated light is not just informed by our experiences within media and by ingrained "codes" of light, nor are our perceptual systems simply cultural constructs. What makes light so interesting is the way in which socially informed media conventions come into dialogue with our bodies and senses, which have their own codes.

References

1. Alton, J. *Painting with Light.* Berkeley, CA, University of California Press, 1995, p. 113.
2. Belcher, M. C., and Kluczny, R. "A Model for the Possible Effects of Light on Decision Making." *Lighting Design + Application* (1987): 21.
3. Callahan, S. "Storytelling through Lighting, a Computer Graphics Perspective." In A. A. Apodaca and L. Gritz (eds.), *Advanced Renderman,* San Francisco, CA, Morgan-Kaufmann, 1999, p. 338.
4. Costykian, G. "I Have No Words but I Must Design." Available at http://www.costik.com/nowords.html.
5. Knez, I. "Effects of Light on Non-visual Psychological Processes." *Journal of Experimental Psychology* 21 (2001): 201–208.
6. Leonard, T. "Building an AI Sensory System: Examining the Design of Thief: The Dark Project." In *GDC 2003.* Available at http://www.gamasutra.com/gdc2003/features/20030307/leonard_02.htm.
7. Lindley, C. "Game Taxonomies: A High Level Framework for Game Analysis and Design." Available at http://www.gamasutra.com/features/20031003/lindley_01.shtml.
8. McCloughan C. L. B., P. A. Aspinall, and R. S. Webb. "The Effects of Lighting upon Mood and Decision Making." In *Proceedings of CIBSE National Lighting Conference,* Bath, London, Chartered Institution of Building Services Engineers, 1996, p. 239.
9. Olsén, D. Conversation (December 4, 2003) and Polfeldt, D. (December 3, 2003), Modern Games, Malmö, Sweden.
10. Pyroinfinity. Available at http://www.pyroinfinity.tv/en/default.asp.
11. Salen, K. and E. Zimmerman. *Rules of Play: Game Design Fundamentals.* Cambridge, MA, MIT Press, 2004, pp. 450–455.
12. Silent Hill 2. Available at http://www.konami.com/silenthil12/.

13. "Visions of Light: The Art of Cinematography" (1993). Directed by Arnold Glass-man and Todd McCarthy, American Film Institute, USA.

19. *Achieving Realistic Reactions in Modern Video Games*

Leif Gruenwoldt, Michael Katchabaw, and Stephen Danton

Introduction

With the explosive growth in the game industry, game developers are constantly seeking new methods for creating a more immersive and believable gaming experience for players of their games, both to remain competitive and to provide their players with greater satisfaction and enjoyment. This has led to the development of more life-like graphics and audio systems, improved individual artificial intelligence, realistic physics engines, fluid animation, and a variety of other technologies that have advanced the state-of-the-art in video games.

One thing that modern video games still lack, however, is a sense of relationship or social network binding the characters and objects in the game world to one another; this sentiment is expressed eloquently by Lawson [1]. Without this, game developers have to largely rely upon scripted behaviors and events to mimic realistic character reactions to events that occur in the game world. Since a developer can only script so much, and a game is stuck with whatever scripts it ships with, this method is ultimately limited. Consequently, players often sense a disconnection in the game world that leads to a break in immersion and a loss of believability.

Work in developing reputation systems for games has drawn some attention recently in an attempt to address this problem. For instance, the games *Ultima Online* [2] and *Neverwinter Nights* [3] provide reputation systems, but do so with some restrictions and drawbacks; for example, in *Ultima Online,* reputation changes have unrealistic immediate global effects, regardless of who witnessed the actions precipitating the changes. The work by Alt and King [4] shows promise, but requires more flexibility and generality; for

example, it supports only a limited relationship set, does not track relationships between non-player characters, and has not been applied to game world objects and complex group situations.

To address these outstanding issues, our current work investigates the development of a Realistic Reaction System (RRS) for modern video games. This system models and maintains the relationships between the various characters and objects in the game world over time dynamically, and provides methods by which characters can query the relationship network to formulate appropriate reactions in behavior, dialogue, and so on. In the end, RRS provides game characters the information they need to respond appropriately to the situations with which they are presented.

We begin this chapter with a general overview of relationships and relationship networks in general, as well as a discussion on augmenting artificial intelligence controllers for non-player characters with this relationship data. Following this, we provide architectural details of RRS, and outline its implementation using Epic's Unreal Engine [5]. We then discuss our experiences with using RRS in an Unreal game mod [6], and its use in our *Neomancer* project [7,8], currently under development. We finally conclude with a summary and discussion of directions for future work in this area.

Relationships and the Relationship Network

The relationship network forms the infrastructure for RRS. This network models all of the relationships between all of the characters, groups of characters, and objects of interest in the game world. One can envision this network as a graph-like structure, with the characters, groups, and objects as nodes in the graph, and the various relationships that exist between them as edges (directed or undirected, depending on the relationship).

There are numerous possible types of relationships that exist between entities in the relationship network. Each of these types can have subtypes, and so on, resulting in a hierarchical tree of relationship types. For example, main types of relationships can include: emotional, familial, business, leadership, ownership, membership, and so on. If we were to expand the membership branch, for example, there are relationships to denote belonging to groups in the game, such as ethnicity, social caste, profession, community residence, and so on. This hierarchy can be easily expanded with additional types and subtypes as necessary. Furthermore, each relationship has several attributes. These attributes include origin, history, regularity, strength, polarity, and validity. Relationship-specific attributes can also be assigned where appropriate.

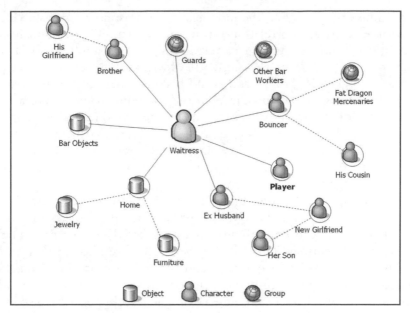

Figure 19.1: Example relationship network

With the relationship network, relationship types, and relationship attributes, RRS has a great deal of expressive power at its disposal. Consider the example relationship network shown in Figure 19.1.

In this example, the focal point of the network is a waitress working in a bar. She has direct relationships established between various objects, characters, and groups in the game world, such as objects in the bar, other workers in the bar, her home, her brother, and the game player. Through these entities, she has indirect relationships with other entities, such as her brother's girlfriend. Each of these relationships can have types and values. As one example, she might find the jewelry and furniture in her home to be more valuable than bar objects, as she is in an ownership relationship with the objects in her house, but not with those in the bar. As another example, she might have emotional relationships with the bouncer in the bar and her ex-husband, although she might feel affection for the bouncer and not be so fond of her ex-husband.

Affecting Relationships

Relationships in the relationship network can be affected in numerous ways. The most direct method is by the filtered input of game events into the network. Once they are passed on to the relationship network, events cause either the creation of new relationships between entities, the replacement of

one relationship by another, the modification of existing relationship attributes, or the removal of a relationship from a system. To maintain history, however, it is likely best to mark a relationship as obsolete instead of completely removing it from the network. Revisiting the example scenario depicted in Figure 19.1, a patron could become disruptive in the bar and damage the tables and other objects in the bar. This would create a rather negative relationship with the waitress, due to her standing relationship with the bar objects. If her ex-husband came to her rescue and expelled the unruly patron, this could change or replace the waitress's relationship with him to a more positive relationship, and might even affect the budding relationship she was building with the bouncer.

Relationships are also affected by game events indirectly, by their propagation through the relationship network. Depending on the nature of the event and how it affects entities in the network directly, the event can be felt by other related entities. How this indirect influence affects other entities depends on the entities in question and the relationships between them. Propagation can occur when two entities directly interact with one another, for example, in two characters having a dialogue. Propagation can also spread along relationships without direct contact over time depending on the initiating event, much in the same way that reputation and notoriety spread throughout a community. As an example of propagation, we revisit the scenario in Figure 19.1 once more. If we suppose that the Fat Dragon Mercenaries, a group with which the bouncer is associated, begin to terrorize the residents of the town in which the bar is situated, news of this could propagate back to the waitress. Since the bouncer is associated with this group, her relationship with him could be changed for the worse, or replaced with a different one entirely, if we suppose that the mercenaries killed her brother in the process.

Time also affects relationships. Given enough time, relationships drift towards a neutral state, in the absence of events or interactions that would otherwise act to strengthen them. Relationships, in essence, must be fed and nurtured to endure.

Querying Relationships and Formulating Reactions

In order to produce effective responses within a game, the relationship network within RRS must be queried. In other words, game entities such as characters must be able to search the relationship network, uncover relevant relationships and relationship attributes, and use this information to formulate the correct behavior, dialogue, and so on for the current situation. Other game entities may query the relationship network to formulate context appropriate content, such as missions or quests that reflect the current state

of the game and the social network that exists within it. To support this ability, a querying and matching facility has been defined. This provides game ready, efficient access to relationship information whenever it is required.

Augmenting Artificial Intelligence Controllers with Relationship Data

We now examine how to augment artificial intelligence controllers using relationship data from a relationship network. Since scripting, state machines, and rule-based systems are the most widely used techniques in implementing game artificial intelligence [9] and scripting tends to be too static to be truly reactive, we will focus our attention on the last two techniques. Generally, an artificial intelligence controller can be augmented to use relationship data in its decision process by querying the relationship network and using this data as additional game state to regulate state transitions or rule firings. In a state machine, this will require additional specialized transitions and/or specialized states; in a rule-based system, this will require additional rules with specialized firing conditions.

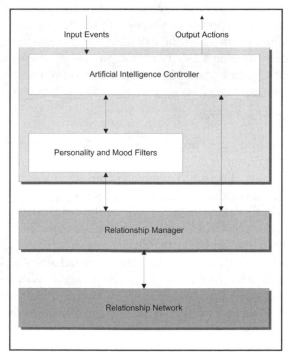

Figure 19.2: Architectural overview of RRS

Care must be taken in using this relationship data, however. Using raw relationship information will result in an explosive increase in the size and complexity of state machines or rule systems using it, because the number of possible relationships and relationship attribute values could be quite large. This would make programming artificial intelligence for games quite difficult and tedious. If relationship information, however, was filtered and aggregated, much of this complexity can be removed, resulting in state machines and rule systems that are far more manageable and easy to use.

For details on how to augment artificial intelligence controllers with relationship data, and examples of this process, the reader is urged to consult [10] for more information.

The architecture required to facilitate RRS is depicted in Figure 19.2, and discussed in detail below.

Artificial Intelligence Controller

The artificial intelligence controller provides the core decision-making functionality for a particular non-player character in the game, accepting input events and formulating appropriate actions in return. As discussed earlier, in a gaming environment, this module will likely be driven by a state machine or rule-based system of some kind. For more details on controller design and implementation, Champandard [9] serves as a good reference.

Personality and Mood Filters

Personality and mood filters are used to provide further customization and specialization to artificial intelligence controllers, which allow for more varied non-player characters. These filters work by modifying the way input events are processed into relationship changes or by modifying results from relationship queries before they are processed by the controllers. This allows different characters to record and retrieve relationship data differently, resulting in different behaviors even when the characters are driven by fundamentally the same controller. This also enables character behavior to be tuned over time as a personality develops throughout the game, or as moods shift. These filters, when necessary, can be bypassed by the artificial intelligence controller, providing direct contact with the relationship manager for the character.

Different personality traits can be parameterized and used in these filters, such as intelligence, aggressiveness, attentiveness, disposition, prejudices, and so on. For example, a character that is generally pessimistic could have its relationship changes adjusted more negatively than a character would have otherwise. Continuing the scenario in Figure 19.1, if the waitress suffered

from long-term abuse growing up, she might have a pessimistic view of the world that causes a negative impact on the relationships established with other people. Different moods and emotional states can also be used in filters for similar effects. For example, a character that is in an exceptionally good mood at a given time could have results of its relationship queries modified in a positive fashion, causing it to act better towards other characters it might not have otherwise. Continuing the scenario again, if the waitress is having a good day in collecting tips, she may treat her customers better and adjust her dialogue with the player accordingly.

Relationship Manager

A relationship manager provides an interface to data from the relationship network to one or more non-player characters in a game. Typically, a relationship manager provides filtered or aggregated access to this data to simplify accessing and dealing with relationships in the artificial intelligence controllers of the corresponding characters. If the controllers had to make use of raw relationship data, they would be orders of magnitude more complex to deal with the large number of possible relationships and relationship attributes as was discussed earlier. While providing a filtered or aggregated view of relationship data, a relationship manager must also still provide access to raw relationship data to allow the construction of more robust artificial intelligence controllers able to respond to more specific situations.

No constraints are imposed on how filtering and aggregating are to take place in this architecture; the selection of algorithms and heuristics is up to the implementer, as this process can be game, class, or even character specific. Filtering and aggregating in a relationship manager can occur when relationship changes are submitted, to have this data pre-computed for when queries are made, or in an on demand basis, when queries for data are actually received. Which of these approaches performs better likely depends on the game in question and the mix of relationship changes versus queries; fortunately, since this process is encapsulated within each relationship manager, a relationship manager can tune its own behavior at run-time to provide the best overall results and performance without affecting the rest of the system.

Relationship Network

Relationships have been modeled to create connections between entities in a manner similar to the real world, capturing a variety of relationship types and subtypes. A relation is used to represent the association of one entity with another, whether those entities are characters, objects, or groups. A relation is described by both a perception and a description. The perception is used to

represent all relationship attributes pertaining to how a particular entity views the relation in question. The perception is, in essence, the relation entity's opinion of their relationship with the other entity in question. For example, continuing the scenario depicted in Figure 19.1, the waitress initially might have perceived that her relationship with the bouncer at the bar was one of love, when in fact it may not have been. The description of the relationship includes only the hard, solid facts surrounding the relationship in question. For instance, the description of the waitress's relationship with the bouncer could indicate that they have known each other for 3 years and they meet regularly on a daily basis at work.

Figure 19.3 illustrates the scenario in which one entity is aware of the existence of another entity but not necessarily vice versa, also referred to as a semi-relation in this work. Following the example from Figure 19.1, if the waitress were to observe the player doing something heroic, she would establish a semi-relation of admiration with the player, even if the player was unaware of the existence of the waitress in the case.

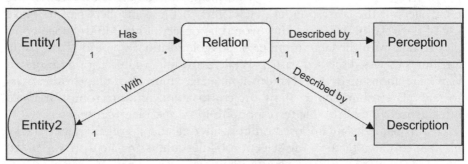

Figure 19.3: A one-way relationship, also known as a semi-relation

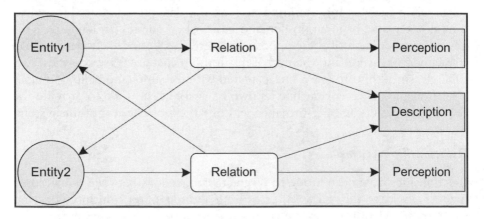

Figure 19.4: A full-relation with shared description and unique perceptions

Figure 19.4 illustrates the scenario in which the two entities are both aware of the existence of each other. This is called a full-relation in this work. This requires the use of two relation objects, two perceptions, but just a single description. There are two perceptions in this model because each entity is entitled to its own perception of the other entity in the relation. As seen in Figure 19.4, there is a common description though because facts contained, like the duration of the relationship and historical events in the relationship, are unambiguous. (The perception of these facts might differ between the entities in question, but the description contains the facts independent of these perceptions.) Continuing the above example from Figure 19.1, the waitress might now have a perception that she dislikes the bouncer due to his association with the Fat Dragon Mercenaries, even though he has a different perception and still loves her. The factual description of the relationship would be the same, however.

An advantage to modeling the relation as two separate relation objects is that each entity's perception can be hidden from the point of view of the other side of the relation. Consider the case in which the artificial intelligence controller for Entity1 is reacting to an event involving Entity2. Entity1 should only act based on its own perception and the common description attributes of the relation.

Implementation and Experience with RRS

A prototype of RRS has been developed for Epic's Unreal Engine [5] in UnrealScript. UnrealScript has many of the features of a traditional object-oriented language, providing excellent support for extensibility for the future. Games built on the Unreal Engine can take advantage of RRS by either extending a new game type added to support RRS, or by embedding the appropriate RRS initialization hooks into an existing game type. In addition, the RRS implementation in the Unreal Engine provides additional console commands to support manipulation of relationships manually from within the game. This allows game developers and designers to add relationship information during production from within the game itself, resulting in easy debugging and creation of content.

Artificial intelligence controllers in the Unreal Engine are in essence state machines, allowing them to be augmented with relationship data as described earlier. The facilities for maintaining the relationship network and its relations were developed as a collection of Unreal Script objects. A relationship manager was developed to aggregate this relationship data together using a collection of simple heuristics. A small number of personality and mood filters were also developed to provide more varied tuning of relationship changes and query responses. As simple examples, optimistic and pessimistic filters

Figure 19.5: Screenshot of LawDogs

were implemented to adjust the positivity and negativity of relationship changes, respectively, when required within a game.

After development, initial validation of RRS took the form of individual test cases. More extensive validation took the form of modifying the existing *LawDogs* game modification to Unreal Tournament 2003/2004 [6]. *Law-Dogs* was chosen primarily because its setting included a bar scene, which follows in line closely to the relationship network example presented in Figure 19.1, and introduced originally in [7]. *LawDogs* also had reasonably simple gameplay with straightforward and traditional artificial intelligence, making it a suitable first deployment for our work. Our experience with *LawDogs* demonstrated that the non-player characters in the game were able to react according to player interactions quite well. A screenshot of *LawDogs* with relationship data shown is given in Figure 19.5.

Based on this success, we are currently augmenting the artificial intelligence developed for the *Neomancer* project [7,8], an action/adventure/role-playing game being co-developed by the University of Western Ontario and Seneca College. It features richer characters and gameplay, and is better suited towards larger scale deployment and testing of our current work. A screenshot of a test character in *Neomancer* is shown in Figure 19.6.

We have encountered similar success with test non-player characters in *Neomancer* using RRS, and are currently expanding use of the system as the artificial intelligence controllers and characters in the game continue to be developed, refined, and enhanced. (The *Neomancer* project is expected to take up to three years to complete, and we have only completed the initial year of the project.)

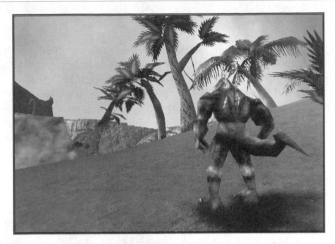

Figure 19.6: Screenshot of *Neomancer*

Concluding Remarks

By capturing game relationships and facilitating more appropriate character responses through linking relationship data to artificial intelligence controllers for non-player characters, our Realistic Reaction System can provide more immersive and compelling game play in video games efficiently and effectively. In the end, non-player characters will be able to react to player behavior in a more realistic fashion, leading to a better overall experience for the player.

Experimentation with an Unreal-based implementation of this system to date has proven successful, both in small and mid-size deployments of the system. Larger scale deployment in a commercial-grade game is currently under way and progress to date has been excellent. This new Realistic Reaction System demonstrates great promise for future development efforts.

In the future, there are many possible directions for research to take. We plan to complete our current development and deployments efforts with *Neomancer* and port the new RRS to other games and platforms for further research and development. To meet stringent performance constraints, we plan to investigate techniques to optimize RRS and minimize run-time overhead in manipulating and querying relationships in the system. While we have found that proper filtering and aggregation in relationship managers can greatly improve performance, additional performance improvements would always be quite beneficial. Finally, we also intend to extend our library of relationships, relationship managers, and personality and mood filters to allow RRS to support a wider variety of artificial intelligence behaviors in games by default.

References

1. Lawson, G. "Stop Relying on Cognitive Science in Game Design—Use Social Science." In *Gamasutra Letter to the Editor* (available at http://www.gamasutra.com-/php-bin/letter_display.php?letter_id=647). December 2003.
2. Grond, G., and B. Hanson. "Ultima Online Reputation System FAQ." *Origin Systems Technical Document* (available at http://www.uo.com/repfaq). 1998.
3. Brockington, M. "Building a Reputation System: Hatred, Forgiveness and Surrender in Neverwinter Nights." *Appeared in Massively Multiplayer Game Development.* Hingham, Massachusetts: Charles River Media, 2003.
4. Alt, G., and K. King. "A Dynamic Reputation System Based on Event Knowledge." *Appeared in AI Game Programming Wisdom,* Hingham, Massachusetts: Charles River Media, 2002.
5. Epic Games. *Unreal Engine 2, Patch-level 3339.* November 2004.
6. Castaneda, G., et al. LawDogs UT2003-UT2004 Modification. Available from project home page online at http://www.planetunreal.com/lawdogs. February 2005.
7. Danton, S. *Neomancer Game Design Document.* Unpublished manuscript, November 2004.
8. Katchabaw, M., Elliott, D., and Danton, S. "Neomancer: An Exercise in Interdisciplinary Academic Game Development." In *Proceedings of the DiGRA 2005 Conference: Changing Views—Worlds in Play.* Vancouver, Canada, June 2005.
9. Champandard, A. *AI Game Development.* Indiana, New Riders Publishing, 2004.
10. Gruenwoldt, L., M. Katchabaw, and S. Danton. "Creating Reactive Non Player Character Artificial Intelligence in Modern Video Games." In *Proceedings of the 2005 Game On North American Conference,* Montreal, Canada, August 2005.

20. New Design Methods for Activist Gaming

MARY FLANAGAN, DANIEL C. HOWE, AND HELEN NISSENBAUM

The idea that values may be embodied in technical systems and artifacts has taken root in a variety of disciplinary approaches to the study of technology, society, and humanity [1,2,3,4]. A pragmatic turn from this work sets forth values as a design aspiration, exhorting designers and producers to include values in the set of criteria by which the excellence of technologies is judged. For those who commit to the goal of creating systems embodied with values, the ideal world is one whose technologies further not only instrumental values such as functional efficiency, safety, reliability, and ease of use but also the substantive values to which societies and their peoples subscribe [5]. In technologically advanced, liberal democracies, such values may include liberty, justice, enlightenment, privacy, security, comfort, trust, and community. It is one thing to subscribe, generally, to these ideals, or even to commit to them, but putting them into practice in the design of technological systems is not straightforward. Integrating values into game design can be considered a form of political or moral activism, in that this type of work is an intentional effort to bring about social or political change. We are still at the beginning of thinking systematically about the practice of designing with values in mind and even conscientious designers face practical challenges—namely, a sparseness of methodologies. The aim of this short chapter is to sketch one such methodological approach for incorporating values during design, highlighting one aspect of a larger values investigation in RAPUNSEL (http://www.RAPUNSEL.org), a research project with the goal of building a networked multiplayer game that teaches middle-school aged girls Java programming.[1]

 The methodology for incorporating values in technology has been influenced and refined by the experience of two of the co-authors in their work on the project. While our focus here is on methods for incorporating values in

the design process, our goal is not to replace well-established design method-ologies [6], or the iterative design methods specific to game design [7,8], but rather to augment them.[2] Our stance places values among other criteria of excellence in technical design, such as functional efficiency, reliability, robustness, elegance, and usability.[3] In the current iteration of the RAPUN-SEL game, players use Java to program their characters to perform increas-ingly complex dance behaviors. To obtain continuous informal feedback, the team works with "design partners" middle-school girls who act as project co-designers and advisors [9]. RAPUNSEL is a useful test case for such a study as it is saturated with values questions and commitments.

The project grew out of the initial insight that the marked absence of women in technology, particularly in computer science, was at least due in part to the style in which scientific subjects were taught.[4] Accordingly, the team proposed the working hypothesis that, for female adolescents, socially oriented environments might be more conducive to learning such skills. As online computer games are a significant pastime for the target audience, RAPUNSEL was designed to leverage this social game space while position-ing programming as an essential skill for navigation, interaction, and advancement. This activist agenda immediately placed RAPUNSEL in a politically charged context that foregrounded values. Subsequently, other important values emerged in each phase of the project that included author-ship, collaboration, creativity, gender-equity, and subversion.

The Method

The method we have developed is comprised of three components: discovery, translation, and verification; each of which we consider to be aspects, or dimensions, of a single investigation that feedback into one another in itera-tive fashion.

Discovery

The goal of this activity, devoted to "discovering" the values that are rele-vant to, or inform a given design project, is to produce a list of values, bring-ing into focus what is often implicit in a design project. What are the systematic steps a conscientious designer might follow in order to "discover" the list of values relevant to any given project? A promising heuristic that emerged in the context of RAPUNSEL was to answer this question by reflecting on likely sources of values, including:

1. **Definition Values** are those articulated in the funding proposal or high-level project description. In RAPUNSEL, one such goal was

"to address gender inequities" by constructing "a game environment to teach disadvantaged middle-school girls to program computers" [10].

2. **Collateral Values** emerge as designers grapple with specific design features. Generally not present in the definition of a project, these appear in consideration of the specific alternatives for a functional element. An example is the reward system for RAPUNSEL, where designers opted for a mechanism that would reinforce larger project goals of cooperation in emerging social behaviors.

3. **Designer Values** are those inherent in the beliefs, commitments, economic, cultural and disciplinary backgrounds of team members. One example of a designer-introduced value was 'diversity,' which emerged in prototypes exploring other, more technical, issues. Diversity in RAPUNSEL is manifest through the integration of contrasting game goals like social recognition and competition, designed to meet the needs of a wider range of player/learners.

4. **User Values** may be discovered through traditional HCI and usability methods that assess not only what people care about, but also how they might justify and/or rank these elements. Results from focus groups, for example, offer one perspective on explicit value commitments but are not always consistent with the behavioral observations of usability testing [11]. In RAPUNSEL, the team found prototyping to be an essential component in discovering users' beliefs, preferences, and values.

Translation

Where discovery serves to identify those values pertinent to a design project, translation is the activity of expressing these values in design; that is, transforming value concepts into corresponding design specifications. This occurs in tandem with the more general design activity of transforming general ideas, intentions, and concepts into material form. In our experience, designers must constantly balance the need to meet functional requirements with the embodiment of the values and constructs on which the system is grounded.

A practical example of translation in RAPUNSEL involved making a clear way to find and edit code in an understandable "inventory" (Figure 20.1), and to facilitate cooperation, a value that had emerged early on and needed clever implementation in the game. One of the ways designers sought to manifest this value was to develop robust mechanisms for sharing code among players, allowing several participants to work together to solve a problem. Further, not only were players rewarded upon writing new code, but

also when a player chose to share such code with another. After considering various implementation strategies, a system was devised in which players could compose, accumulate, and transport code segments across game contexts in virtual "notebooks."

As a game's reward system is often tightly coupled with the values it expresses, implementing code-sharing in this space highlighted an important value we wished to establish. It is important to note that the mechanism described above only enables code-sharing, but it is through RAPUNSEL's unique scoring system, which incrementally rewards players both for authoring original code and for sharing it, that the value of cooperation is motivated. Each time a player's code is viewed by another, the author receives several points; when the code is actually borrowed and used by another player (and travels throughout the game world), the originator receives many more points, thus encouraging players not only to concoct the interesting and inventive dance sequences, but also to share them in peer-to-peer fashion.

In sum, through the integration of transportable code with a reward system that encouraged sharing, we were able to organically implement collaboration in both the technical framework and the game mechanic. An added appeal of this solution over others we considered was that it rewarded players with the accumulation of knowledge, as represented by code segments, rather than with material items.

Values in Conflict: Resolving, Dissolving, and Trading Off

Throughout any project, there is the potential for conflicts to arise between design principles in the context of particular decisions. In general, engineering is rife with such conflicts—whether to favor safety over cost, transparency over privacy, aesthetics over functionality, with many more appearing at layers of finer granularity. Our experience with RAPUNSEL pointed to two strategies for dealing with such conflicts in the realm of values. In one set of cases designers would discover that the problem was not the result of fundamental incompatibilities between values themselves, but rather the outcome of conflicting material constraints these values seemed to impose on the given system or device. This realization steered us to look for solutions in the design itself. We labeled this approach "dissolving conflict." Often, however, it was not possible to completely dissolve a conflict through redesign, but rather to pursue a trade-off where key parties (with conflicting values) either arrive at a compromise or agree on which value outweighed the others. Again, RAPUNSEL served as a valuable test bed for these cases as many such debates emerged. Examples include whether to represent characters as human or other, sexualized or neutral body types, controlled or autonomous characters, and whether to implement a first- or third person point of view.

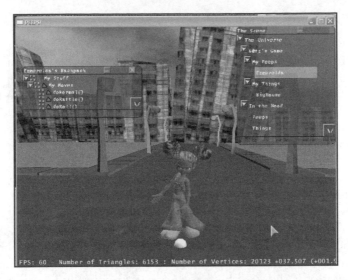

Figure 20.1: A screenshot from a prototype showing a player's 'method-list' and scene-graph, tools which enable control of the world via code.

Verification

In the activity of verification, designers assess whether their intentions have been realized; in this case, whether values have been successfully implemented within the desired functional constraints of the system. Depending on the context, verification is likely to take on diverse forms which include internal testing among the design team, usability studies, interviews and surveys with a range of interested parties, as well as more traditional quality assurance measures such as automated and regression-oriented testing. In such testing, it was necessary to determine not only that a particular value was successfully implemented in a specific component, but also that its implementation did not detract from prior value-oriented decisions. In RAPUNSEL, testing via prototypes (as suggested in research by Glass [12], Laurel [13], Rettig [14], Zimmerman [8]) has proved an especially useful tool in verifying that design decisions adequately handled the complexities of value-oriented trade-offs. The team has benefited from an iterative approach to assessing design outcomes, which suggests that working in tight, iterative cycles proves particularly effective in facilitating the incorporation of feedback from the wide range of people with an interest in the project [11, 15, 16]. Future work will examine additional verification practices specific to value-oriented investigation.

Summary of Methodology

In brief, we have outlined a systematic approach to embodying values in design through three distinct activities: Discovery, in which a list of values relevant to a project are compiled; Translation, where values are implemented in material design features; and Verification, when implementations are tested to ascertain whether value-oriented intentions have been met. Although these phases are presented in order, it is important to note their iterative and mutually informing nature. Discovery, for example, will likely begin early in a project but may remain in progress throughout, not simply because designers have been less than thorough, but rather because of the evolving nature of the design process where such conflicts are but one dynamic aspect. In fact, each of these steps is revisited cyclically throughout the duration of any given project.

The design methods presented here in brief have been incorporated in a longer publication forthcoming. We hope this short chapter provides an initial framework for those wishing to more systematically incorporate values into their design work.

Notes

1. *Rapunsel* is a large multi-disciplinary collaboration aimed at designing and implementing an experimental game prototype intended to encourage interest and competence in computer programming in middle-school aged girls. This ongoing, three-year project includes a variety of interlinked components: engineering, pedagogy, interface, graphics, networking, and more. These components map roughly to core expertise of the three project Principal Investigators (PIs); coding tasks primarily managed by the computer science team led by Ken Perlin (New York University); game design led by Mary Flanagan (Hunter College); and educational assessment led by Andrea Hollingshead (University of Illinois at Urbana-Champaign).
2. We are grateful to Dean Neusma for suggesting we bridge our work with other more general design methodologies. Although this task is too great for this paper, we acknowledge a need for further development along these lines.
3. The framework we have developed for incorporating values in software design owes debt to other important, related efforts such as participatory design, value sensitive design (where systematic consideration is given to the interests of all stakeholders (Friedman 1996)), Reflective Practice, an approach advocated by practitioners such as Schon (1983) and Critical Technical Practice advanced primarily by computer science practitioners in artificial intelligence [1,5,17].
4. Unambiguous data on the death of women in technology is well-documented in Brunner [3], Flanagan [8], and Inkpen [13].

References

1. Hughes, T. Human-Built World: How to Think about Technology and Culture. University of Chicago, Chicago, 2004.
2. Latour, B. "Where Are the Missing Masses? The Sociology of a Few Mundane Artifacts." In W. Bijker and J. Law (eds.), Shaping Technology/Building Society, Cambridge, MIT Press, 1992, pp. 225–258.
3. MacKenzie, D., and J. Wajcman. The Social Shaping of Technology, Milton Keynes, Open University Press, 1985.
4. Winner, L. "Do Artifacts Have Politics?" Chapter in The Whale and the Reactor: A Search for Limits in an Age of High Technology. Chicago, University of Chicago Press, 1986, pp. 19–39.
5. Mitcham, C. "Ethics Into Design." In R. Buchanan and V. Margolis (eds.), Discovering Design. Chicago, University of Chicago Press, 1995, pp. 173–179.
6. Norman, D. A., and S. W. Draper. User-Centered System Design: New Perspectives on Human-Computer Interaction. Hillsdale, Erlbaum, 1986.
7. Crawford, C. The Art of Computer Game Design, 1982. Available at http://www.vancouver.wsu.edu/fac/peabody/game-book/Coverpage.html. (Last accessed 27 August 2006).
8. Zimmerman, E. "Play as Research: The Iterative Design Process." Game Lab, 2003. Available at http://www.gmlb.com/articles/iterativedesign.html (Last accessed 27 August 2006).
9. Druin, A. "Cooperative Inquiry: Developing New Technologies for Children with Children." In Proceedings of CHI 1999, Pittsburgh, PA, pp. 592–599.
10. Flanagan, M., A. Hollingshead, and K. Perlin. HRD-0332898: RAPUNSEL. Proposal to the Gender in Science and Engineering Program (GSE) of the National Science Foundation, 2003. Also involved Jan L. Plass and Ricki Goldman of NYU.
11. Eysenbach, G., and C. Kohler. "How do consumers search for and appraise health information on the World Wide Web? Qualitative study using focus groups, usability tests, and in-depth interviews." BMJ 324 (7337) (2002): p. 9. Available at http://bmj.bmjjournals.com/cgi/content/full/324/7337/573. (Last accessed 27 August 2006).
12. Glass, R. L. Facts and Fallacies of Software Engineering. Lebanon, Addison-Wesley Professional, 2000.
13. Laurel, B. The Utopian Entrepreneur. Cambridge, MIT Press, 2001.
14. Rettig, M. "Prototyping for tiny fingers." Communications of the ACM 37(4) (1994): pp. 21–27.
15. Bødker, S., and K. Grønbæk, "Design in Action: From Prototyping by Demonstration to Cooperative Prototyping." In Greenbaum, J., and M. Kyng (eds.), Design at Work: Cooperative Design of Computer Systems. Hillsdale, Erlbaum, 1991, pp. 197–218.
16. Shneiderman, B. "Universal usability." Communications of the ACM 43(3) (2000): pp. 84–91.
17. Agre, P. E. "Toward a Critical Technical Practice: Lessons Learned in Trying to Reform AI." In G. Bowker, L. Gasser, L. Star, and B. Turner (eds.), Social Science, Technical Systems, and Cooperative Work: Beyond the Great Divide. Hillsdale, Erlbaum, 1997, pp. 131–158.

18. Brunner, C. "Opening Technology to Girls: The Approach Computer-using Teachers Take may Make the Difference." Electronic Learning 16(4) (1997): p. 55.
19. Dourish, P. J., F. P. Sengers, and P. Wright. "Reflective HCI: Towards a Critical Technical Practice." Workshop. Extended Abstracts: Proceedings of CHI 2004 (CD-ROM), pp. 1727–1728.
20. Flanagan, M. "Next Level: Women's Digital Activism through Gaming." In A. Morrison, G. Liestøl, and T. Rasmussen, Digital Media Revisited. Cambridge, MIT Press, 2003, pp. 359–388.
21. Friedman, B. "Value-Sensitive Design." Interactions 3(6) (1996): pp. 17–23.
22. Inkpen, K., K. S. Booth, M. Klawe, and R. Upitis. "Playing Together Beats Playing Apart, Especially for Girls." In Proceedings of Computer Support for Collaborative Learning 1995, pp. 177–181.
23. Mateas, M. "Expressive AI." SIGGRAPH Art and Culture Papers. In Proceedings of SIGGRAPH 2000, pp. 51–58.

21. *Adaptive Game Technology as a Player-Centered Approach to Game Design*

Darryl Charles, Michael McNeill, Moira McAlister,
Michaela Black, Adrian Moore, Karl Stringer,
Julian Kücklich, and Aphra Kerr

Introduction

It may be argued that much commercial game design is already player-centered because publishers and developers invest considerable time and money in market research and game testing. However, most current approaches focus on finding out what the player wants from the product before or while it is being made—primarily the developer's task—or by working out what will sell the game most effectively—often the publisher's task. Current developer player-centered approaches typically comprise practices ranging from the involvement of players in the development process by alpha/beta testing and play testing through to game patching after a game's release and making software development kits (SDKs) available for player game modifications (mods). In this way the developer is often concerned with tailoring the design of a game according to the requirements of a limited group of potential players. Publishers, on the other hand, are often more focused on reaching a wider group of consumers and so may encourage the developer to gear the game not only to their usual demographic but also to try and reach out to new players.

However, as Kline et al. [1] and Kerr [2] point out, publishers may not have as strong an interest in widening the appeal of games as they claim. They highlight the fact that software development is a risky business. Most products fail. This creates a powerful incentive to stick with the tried and trusted approaches and ride on the coattails of proven success. Such reproduction

gives game culture a strong tendency to simple self-replication, so that shooting, combat, and fighting games, once established, proliferate.

The approaches that we propose in this chapter demonstrate that the accessibility of games may be enhanced while still satisfying the experienced gamer. It is possible to dynamically tailor a game to individual players (in-game) by using player modeling techniques [3] and adaptive game technologies [4]. These dynamic approaches reduce the dependency on collecting data about player requirements and the player demographic. By focusing on variations in learning and playing styles and correlating these with personality profiles, we may avoid the problems created by stereotyping players on the basis of age or sex [5]. Some research indicates that females purchase games less often than their male counterparts [6] and while this is not a straightforward issue, adaptive game design may offer a partial solution to the gendered nature of digital games as a cultural activity.

Every player is different; each has a different preference for the pace and style of gameplay within a game, and the range of game playing capabilities between players can vary widely. Even players with a similar level of game playing ability will often find separate aspects of a game to be more difficult to them individually, and the techniques that each player focuses on to complete the various challenges a game offers can also be very different. This is at the core of our reasoning that adaptive game technology can have an important role to play in next-generation games. It can be used to moderate the challenge levels for a player, help players avoid getting stuck, adapt gameplay more to a player's preference/taste, or perhaps even detect players using or abusing an oversight in the game design to their advantage ("exploits"). Players often use "exploits" in order to make it easier for them to succeed in the game even if their enjoyment of the game may be lessened because of the reduced challenge. That is, players will often repeat a successful strategy over and over again because it leads to a predictable win, even if it ruins the game to a certain extent.

Important issues such as the deficiency of game completions by players, teaching players effectively, the problem of "beginnings" [7], as well as the niche quality of current games and their lack of accessibility to a wider market [8] are relatively well known both within the games industry and the games research community. However, these are only beginning to be addressed properly. Much current player-centric game design uses straightforward approaches such as empowering players to control the quality of their own gameplay experience by providing enough flexibility and variety in gameplay choices. Some games incorporate in-game player support systems, such as hints in the form of visual clues in the landscape, NPC guidance, or maps suggesting a way forward. Other games are more responsive to an individual player, for example, in *Crash Bandicoot 3: Warped* (SCEA, 1998) if a

player repeatedly fails at the same point in the game then a mask is provided to the player character which acts as a shield, and in *Mario Kart 64* (Nintendo, 1996) where "rubber banding" is used to help weaker players.

It is especially rare to see the use of dynamic technology within games that is responsive to individual players. One quite well-known attempt at this type of technology is the "auto-dynamic difficulty" approach in *Max Payne* (Take 2 Interactive, 2001) [9]. In this game the difficulty level is altered by increasing the numbers of enemies in a room (or the difficulty of killing them) by observing features of the player's game playing. Statistics on a player's average health, shot accuracy, number of times shot, numbers of times killed, etc. may be recorded to help make a decision in-game as to how difficult the game should be for the player. The approach that we propose resembles "auto-dynamic difficulty" in the dynamic response to a player in-game. We believe that dynamic modeling techniques along with adaptive mechanisms that alter the game according to the needs of an individual player can provide the game designer with an effective alternative approach to game design, and we will discuss our reasons for this throughout the rest of the chapter.

Current Approaches to Player-Centered Game Design

Many current structured approaches for player-centered game design are rooted in research into human factors from the mainstream computing realm and for many years this type of research has argued for the importance of a user-centered approach when designing software. Considerable research has been performed on user-centered design for productivity software within the general computing domain, e.g., office applications, but ideas and theories that specifically address user-centered game design are only beginning to be constructed. It is important to keep in mind, however, that there is an important difference between usability and playability. As Kücklich [10] points out "While increasing the usability of a media technology usually means making its functionality as accessible as possible to the user, playability often depends on withholding certain options from the player. It is quite crucial in many games that the player does not have access to the full range of options the game offers initially, but only after the player has invested some time in the game. The playability of a game is actually increased by this strategy of deferral, because it challenges the player to spend an increased amount of time playing the game."

Nevertheless, it has been shown that software usability methods can be applied to digital games in order to improve user satisfaction and decrease task-based failure and error rates among users. Research methodologies frequently used in computer systems design—especially in user interface design

and experimental psychology—have also been applied to the evaluation of games: user studies [11] and heuristic testing [12,13,14] are two such approaches. Much of the evaluative studies performed with gamers concentrate on evaluating a game by observing players and/or by asking players a series of questions designed to find out the subject's opinions on a range of issues such as gameplay, game story, mechanics and usability [15]. Additionally, it is widely accepted that there will be many groups of people involved in user-testing: developers, publishers, programmers, artists, marketing personnel, and even license-holders—not forgetting gamers themselves—hardcore gamers, first-timers, and social gamers.

Microsoft's user-testing group [16] suggests that evaluation of games can take a number of guises, including observing individuals and groups in a variety of settings (out-of-game and in-game) and performing usability tests or surveys. Gamboa et al. [17] suggest that there are several advantages to questionnaires: they can get unbiased individual responses, provide hard numbers, collect subjective data, be used for evaluations, be generalized to a population, and provide for subgroup analysis. Noted weaknesses of questionnaires are that the answers you get relate to the questions you ask (are you asking the right questions?), collecting behavioral data is not easy, questionnaires can be time-consuming and costly and they can suffer from sampling problems. Focus groups, another popular technique, also suffer from particular strengths and weaknesses.

All of the above activities, if carefully orchestrated, can lead to a better understanding (for designers of games) of how players can get more fulfillment from a game, but there are significant challenges in designing the evaluation procedures. Involvement of real gamers is important, but representative samples of intended target groups must be engaged; subjective observations need to be recorded and interpreted correctly and tests or surveys must be constructed using meaningful and valid heuristics. Fulton [18] reports on the challenges of getting good feedback and the difficulties of ensuring it can be delivered to the development team in a timely and meaningful way. If performed early in the development lifecycle such techniques can lead to a better game—indeed Pagulayan reports that the impact can be significant [19], although the costs can be high and there is never a guarantee of success [20]. It is clear, though, that most of the current effort in this area is in terms of user-testing the game before it is released, and not, as we propose, to develop a better understanding of players in order to adapt the game dynamically, after release.

Pagulayan et al. [21] highlight some of the crucial aspects of effective user-centered game design and many of these relate to our reasons for investigating adaptive game technologies. For example, they point out the importance of getting the levels of challenge right for players and dealing with the

different skill levels of players. They state that a choice of easy-normal-hard levels at the beginning of a game is not normally an effective mechanism for differentiating between different player abilities—an argument also made by game designer Scott Miller [9] in advocating the auto-dynamic difficulty technology of *Max Payne*. Players rarely choose anything other than a normal difficulty mode and Miller argues that with the rate of technology improvements in other areas of game development it is a shame that many games still deal with the difference in player ability in such a simplistic manner. The issue is to "maintain the challenge, reward and progress for the unskilled player without severely hampering the skilled player" [21]. Pagulayan et al. [21] also point to the value of intrinsic over extrinsic reward in that players are more likely to continue to play if they feel powerful and clever [22]. Rather than reward players only with new weapons, power-ups, and content, we need to provide opportunities for a player to succeed in a game by overcoming challenges (at or just above their skill level for their gameplay preference).

The importance of maintaining the right level of challenge is underlined by the research conducted by Csikszentmihalyi and Csikszentmihalyi [23] on flow: "The universal precondition for flow is that a person should perceive that there is something for him or her to do, and that he or she is capable of doing it. . . . Optimal experience requires a balance between the challenges perceived in a given situation and the skills a person brings to it." In other words: flow is the experience of hitting the "sweet spot" between the annoyance of a task that is perceived as trivial and the frustration of a task that is perceived as too difficult. This is also described as a balance between challenge and competence, or between complexity and boredom. Therefore, one of the goals of adaptive game design should be to keep the player in a state of flow by increasing the difficulty when the game appears too easy for the player, and decreasing it when it appears to hard.

Hopson [24] investigates contingencies in game design (contingencies are rules which govern when a reward is provided), suggesting that variable ratio contingencies and variable interval contingencies may lead to more activity, challenge, and, by implication, more enjoyment. Here we see a questioning of the "one colour suits all" premise which to date has been pervasive in games and this question re-appears in Cornett's work [25]. Cornett's research indicates that for certain game genres—especially MMORPGs—new players inexperienced with the genre may require specific support to get them to engage with the game. One approach suggested by Bateman [26] is that there may be value in user profiling for game design: specifically in applying the Myers-Briggs typology to gamers. This may lead to better understanding of the types of people most likely to play games of a particular genre. Questions arising from this include whether or not particular game genres can be opened up to new (different) types without 'losing' established player types.

Understanding, categorizing, and modeling players as we will see in the next section are not trivial tasks. However, the effective modeling of players is an important aspect of adaptive technologies and a new form of game: one which reveals itself in different ways depending on the player type and according to particular play styles.

Understanding and Modeling Players and Non-Players

An essential aspect of effective adaptive game design is in understanding game players in order to model them accurately. By understanding players, we not only mean working with existing game players through play or usability testing—we also mean conducting empirical research in public and private game spaces into the culture and experiences of digital game and non-game players. Unfortunately much of this work is highly localized and small scale—yet it does throw up some interesting issues.

A survey (see Table 21.1) conducted by the Computer Entertainment Software Association (CESA) in Japan in 2001 found that the numbers of people who 'still play' games has decreased to 27.8 percent while the numbers that had stopped playing had increased between 2000 and 2001 [27]. CESA categorized their total population into four consumer categories: active, dormant, prospective, and disinterested. Disinterested customers were those who had never played and did not want to, or had played and had no intention of playing again. These constituted the largest proportion of those surveyed at 35.8 percent. Dormant customers were players who were waiting for games to be made which would make them want to play again. These constituted 28.1 percent. Only 27.8 percent were described as active players, down from almost 40 percent in 1999.

While dormant customers were divided almost evenly between males and females, females constituted a larger proportion of the prospective and disinterested groups. In addition, while the average age of active game players was 23.4, the average age of dormant customers was 31.6 years. Prospective and disinterested players were aged 33.4 and 37.2 years, respectively. Clearly the industry has a large potential market of females and people aged above 25 years, which it is not as yet satisfying, at least in Japan. People in the non-active groups responded that they were too busy with work to play games, games were too complicated or games were not fun.

Industry surveys like this one both challenge and reinforce certain stereotypes. While more females and people over thirty years of age are playing digital games than in previous decades, the most frequent game players are males, by a factor of two, and the highest proportion are aged between seven and twelve years. The Japanese survey also points to the perceived limitations

Table 21.1: Categorization of gaming customers in Japan, 2001 and 1999[1]

	PERCENTAGE OF GENERAL PUBLIC	
GAME PLAYERS	2001	1999
Active	27.8	39.3
Dormant	28.1	24.3
'I used to play but now stop playing. I want to try again only if any software interests me'		
Prospective	8.3	12.2
'I have never tried but I want to try if any software interests me'		
Disinterested	35.8	24.2
'I have never tried and I won't' *& 'I used to play but I won't anymore'*		

Source: CESA, 2002:58–62

of current game software and the need for a greater range of software if dormant and prospective consumers are to be reached. More radical tactics may be needed to reach disinterested consumers. Surveys like these point to a large potential market which remains unsatisfied or unmoved by current games.

When we start to review current studies of game players the picture is arguably even more complex. While survey after survey points to increasing rates of 'access' to digital game playing platforms [28,29] most large surveys tend to hide a range of barriers which more ethnographic and interview based research starts to uncover [1,2,30,31,32,33]. Thus we find that content is only one of the factors which influence who plays, how often and how. We also find that player preferences and pleasures cannot be easily mapped on to content types or genres—hence the problems faced by existing user-centered design and usability testing of specific titles [34,35]. As Richard Bartle [36] points out "400,000 people play *EverQuest*, but 600,000 other people who bought the boxed set don't play it."

Research that tries to differentiate between different player types often tends towards overly simplistic categorizations—such as the binary opposition between casual and hardcore players—or, conversely, towards highly specific typologies such as Bartle's [37] observations of different behavioral traits in online games. A player typology for adaptive game design thus faces a twofold challenge: it must be specific enough to allow for widely different play-styles as well as general enough to be applied across different genres, platforms and cultures.

This dilemma points at a potential contradiction between adaptive game design and emergent gameplay. If adaptive game design is to be understood as a top-down approach that attempts to create a 'prescriptive' player typology which can then be used to make the gameplay more enjoyable for players, this requires gathering a large amount of gameplay data in order to be able to anticipate all the possible ways a game could be played. If, on the other hand, adaptive game design is to be understood as a bottom-up approach that aims at achieving adaptivity by emergence, this requires an absence of pre-conceived ideas about which forms play in a specific situation might take.

From a cultural point of view, it seems obvious that the top-down approach must necessarily simplify the complexity of gameplay behavior in order to succeed. A player typology that attempts to anticipate different styles of play simply cannot take into account all the factors that might potentially influence the gameplay experience. Conversely, from a technical point of view, it seems obvious that a level of emergence that would be able to adapt to every possible play-style is impossible to implement within the limits of current technology.

For the time being, we must keep in mind that our aim is not to create a perfect adaptive system, but to propose ways of achieving more adaptivity within existing game architectures. At present, all we can do is point out ways of using the potential of current computing technology to enhance the enjoyment of people who already play games. Dynamic player modeling seems especially promising in this respect as it allows for a form of game design that creates a heuristic player typology "on the fly." However, we would like to stress the fact that a higher level of adaptivity, which might also attract new types of players, requires a fundamental change in the way games are designed. Truly adaptive gameplay can only be the result of a design strategy that embraces emergence and yields a high level of control to the player.

Adaptive Game Design

Adaptation may be defined "as ability to make appropriate responses to changed or changing circumstances" [38] and as biological creatures use this form of problem solving regularly it is not surprising that many of the techniques used in computing to build adaptive systems are actually based on nature [39], e.g., artificial neural networks, case base reasoning systems, artificial immune systems, or evolutionary algorithms. Adaptation as such is strongly connected to learning and we may use it to learn about a player in order to respond to the way they are playing, for example, by adjusting a computer opponent's strategy [40] so as to present a more appropriate challenge level. Learning and adaptation are viewed by some as a having a crucial part to play in next-generation games. For example, Manslow [41] states

that:

> The widespread adoption of learning in games will be one of the most important advances ever to be made in game AI. Genuinely adaptive AIs will change the way in which games are played by forcing each player to continually search for new strategies to defeat the AI, rather than perfecting a single technique.

A game may be adapted through changes to

1. A player's character;
2. Non-player characters in the game;
3. The game environment or game state.

The first of these is perhaps the most interesting because an alteration of the player character in this way can lead to a greater sense of embodiment. Although it doesn't quite relate to adaptation, Poole provides an example from Metal Gear Solid 3: Snake Eater (KCEJ, 2004) [42] to illustrate how a player's actions can alter the state of their player character and so how they play. If their character gets hurt there is a consequence to the player character's well-being and the gameplay—if the character has been injured then progress is hindered until the injury is treated. This feedback loop of action-consequence-action can instill a great sense of embodiment that increases immersion in the game. The use of player modeling and adaptation may lead to the same sort of sense of embodiment if the adaptation directly affects the player character for appropriately designed games.

The most obvious way to adapt a game is to change the difficulty level of non-player character opponents or modifying the behavior of friendly non-player characters—depending on the type of game. Non-player characters can be used to provide clues or support to a player according to their needs and playing preferences. In fact there are a host of imaginative ways in which a variety of non-player characters can be used to affect the choices open to the player and even altering the game narrative.

The game environment can also be modified in response to the player—this can be anything from increasing the number of items that can be picked up, e.g., heath, bullets, etc. through to the actual landscape and topography of the world changing. The designers of the RPG *Fable* (Microsoft, 2004) set out to create a game world where the game landscape would change in response to a player's evolving character and the actions that they performed—if they were evil then the world would become corrupted before their eyes and the opposite being the case if they were good. In the end most of the more ambitious aspects of this technology were not realized in *Fable* but this game still demonstrates the possibilities of the technology. A player may enjoy a heightened sense of immersion and enjoyment in playing a game if they feel that the game is responsive to them as an individual.

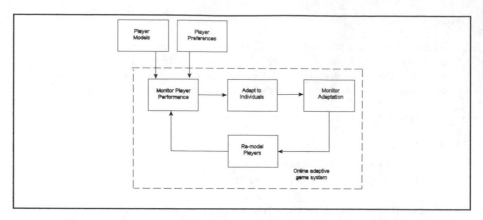

Figure 21.1. A potential framework for an adaptive game system

Though there are only a few practical examples of the use of adaptive technologies in current commercial games and game research [43,44], successful research in related areas demonstrates the potential of this technology—particularly research on Intelligent Interfaces [45] and Intelligent Tutoring Systems which is very focused on user modeling and adaptation [46,47]. Our approach has some similarities to recommender systems for online e-commerce stores—for example, the CEO of Amazon, Jeff Bezos, has been quoted as saying "If I have 2 million customers on the Web, I should have 2 million stores on the Web" [48]. In the same way we wish to design game systems that provide each player with a separate experience.

We suggest a framework for adaptive games based around the system illustrated in Figure 21.1. The modeling of players is a crucial aspect of this approach because if our models are inaccurate or inappropriate then the whole system falls down. In addition, as explained previously, how we choose to differentiate between players is not normally a straightforward issue, and in fact, this process will vary between game genres. We believe that we should not assume that our modeling is always flawless and we should not only take care about selecting the variables that define player characteristics, but for many games it would be useful to provide player preferences to the system to form part of the player model. As Manslow points out it is wise to use as much useful prior knowledge in the model as possible [41].

The feedback loop in this system provides an element of control in the system so that if a model no longer fits as a player learns to play the game, then the player may be shifted to another existing population profile i.e., using population shift ideas [49], or if none exists, a new profile can be created. Another affect may be more drastic, where the rules that depict a model no longer represent the players efficiently and so re-modeling is required because of concept drift [50,51]. Naturally, players will learn and adapt to

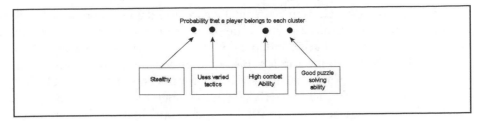

Figure 21.2. A factorial approach to player modeling

the game as they play. Some players will learn faster than others, and additionally, various players tend to excel in different aspects of the game—each player plays and progresses in their own unique way. Therefore, the models that we use at the beginning of the game may no longer be entirely appropriate as the game develops. Perhaps the reclassification of a player (due to population shift) will suffice in some cases; however, it may be better to account for a concept drift in our original classification by updating our models on the basis of new data. In many cases the drift may be slight but this can still have a significant impact on the response of the game to the player, especially if the drift continues over a long period of time.

Adaptation algorithms may or may not incorporate machine-learning but the system adopted must potentially be able to operate within the gameplay session[2] in real time. The effects of adaptation on the player can be monitored quite easily by observing game data, checking how quickly a player is progressing, monitoring the length of gameplay sessions and other similar in-game data. However, this type of data may not be satisfactory by itself and it may also be useful to monitor player emotions [52] such as frustration levels [53] by taking measurements from game control pads [52] or more advanced sensors.

Most existing approaches to player modeling are based on working out how the player should be modeled using in-game variables and then developing a player model by observing and recording data from these variables for each player. More complex player information is much harder to model as we require a better understanding of player behavior and more care needs to be taken in pre-constructing the framework for the model—we may not be able to construct a model by observing simple statistics in the data. However, models with this sort of higher order player profiling may be more useful for ensuring a more appropriate adaptation to individuals, as research has demonstrated in other fields, such as fraud detection [54]. One possible approach for forming a more complex or higher order profile of a player is to use a factorial model like the one shown in Figure 21.2.

This example could be used for an adaptation mechanism in action-adventure games—other types of games would require a different set of fac-

tors. Using this approach we may manually partition data space to attach different meanings to various aspects of the data, i.e., the stealthy factor would be informed by a number of independent game variables that can tell us about a player's stealth level in a game. In the example above, each player would have a four factor profile with four real numbers in the range of 0 to 1 that uniquely identify each player's playing characteristics. For example, a player with a numerical profile of (0.8, 0.2, 0.2, 0.5) may tend to prefer to play a game by avoiding direct, close-up conflict. Of course, there are some difficulties with setting up this sort of model and working out which game variables to use and how to partition them so as to be useful in identifying independent traits of player behavior. An experienced game designer may be able to work this out manually by trial and error. However, it is also possible to use data mining tools [55,56] or unsupervised statistical techniques such as factor analysis [57] to identify correlations between the variables and then we can attach a meaning to them. We must also put an interpretation on the combinatorial patterns of the game playing factors for each player. There are many methods from the realm of AI that can be used to implement this technology.

Several issues need to be addressed about adaptive game technology. One concern is that players may disapprove of the technology because it may result in a game experience that differs for each player and therefore players can't easily compare experiences and/or boast their successes. However, it must be noted that there are two opposing player desires to take into account:

1. The desire of a player to learn the rules so as to master the game;
2. The avoidances of "sameness" or lack of variety of gameplay.

We believe that the benefits of adaptive games to the majority of players (particularly beginners) in terms of tailoring an appropriate level of challenge and gameplay style for a player—not to mention replay value—outweigh the drawbacks. Players already modify their own gameplay through cheats, guides, walkthroughs, and modifying games [58] to enhance the game experience, and so there is a precedent for the use of adaptive technology for a similar purpose.

A second concern relates more to the profiling and modeling aspects of the technology, which assumes that a particular game save will always be used by a single person. While this generally is the case with PC games it is often not the case with console games because the playing of a game (on a particular game save) may be shared by several friends or family. This is a significant issue currently, but as next-generation consoles begin to appear, online play and thus logon from a console will become more prominent—and perhaps user switching as used on PC operating systems may come into use. As

gamers become more connected in the next generations of gaming hardware then the potential for online profiling will increase rapidly. One can imagine a player storing a game profile on a remote server for use in online games but also having the choice to logon to this profile for single player (non-networked) games so that the gameplay may be adapted to their particular profile. Microsoft already uses a limited form of player profiling on their Xbox Live network for "player-matching"; however, there is much more scope in this technology for accurately tailoring the gameplay experience to the player and finding appropriate players to play with or against through more advanced player models and profiles.

Another concern often raised relates to the difficulty of testing adaptive products and the extra time that is required in development. Using adaptive technology in-game, particularly with machine learning, inevitably means that the game often cannot be fully tested. Many game publishers require a guarantee that a game has a very low percentage of game bugs and that they do not significantly impact the key aspects of the gameplay. If adaptive technology is responsible for introducing an unforeseen but significant game bug, then players could be entitled to a refund, which would be a serious issue for both the publisher and the game developer. The emergent or unpredictable properties of adaptive technology make the design of a game more challenging but this should not prevent us from being adventurous because the rewards are potentially great. For example, if the adaptive technology is restricted by architectural design as it is for the learning of the creature in "Black and White" then problems can be constrained and controlled so that gameplay can only be altered in restricted ways and within predetermined boundaries.

Conclusion

There are many approaches to player modeling, and in fact you could argue that digital games inherently have an in-built model of players because the designer has a specific type of gamer in mind when they design the game (even if they do this subconsciously). In this chapter we have proposed an approach through which a game developer can make a more conscious effort to model players in a game's design and development. By adopting a framework similar to the one that we have suggested, a game may be designed to be more responsive to a wider range of players by incorporating dynamic models of different players into the game technology.

We believe that the potential benefits of adaptive technologies in games are clear; however, the effective incorporation of the technology into games is not without difficulty. For example, as discussed earlier, player preferences and pleasures cannot be easily mapped to content, gameplay, or genres—

though this should be more easily handled by adaptation. Additionally, if we are to define a player typology for adaptive game design, it must be specific enough to allow for widely different play-styles but general enough to be applied across different genres, platforms and cultures. However, with the adaptive approach that we have discussed it is not necessary to categorize players rigidly a priori, but by designing flexibility into the adaptive technology, accurate models can be developed dynamically during the game. That is, the combination of relevant prior information on typical player typologies along with specific in-game data can be used to construct the most appropriate model for a player.

To progress our work in this area, future work will focus on developing our understanding of the differences in players in order to inform the design of player models and suitable associated adaptive technology. Using these models we will implement a variety of adaptive systems for games to test the effectiveness of the approach and in particular investigate approaches that dynamically re-model the player by identifying and distinguishing between population shift and concept drift. We plan to test the technology in a number of small scale games.

Notes

1. Percentages for total population based on generalizations made from original samples of 1013 in 2001 and 1111 in 1999.
2. This may not need to be the case if some of the "number crunching" is performed between levels or at other processor friendly times.

References

1. Kline, S., N. Dyer-Witheford, and G. DePeuter. *Digital Play. The Interaction of Technology, Culture, and Marketing*. Montreal and Kingston, McGill-Queen's University Press, 2003.
2. Kerr, A. "The Business of Making Games." In J. Rutter and J. Bryce (eds.), *Understanding Digital Games*. London, Sage (2006).
3. Houlette, R. "Player Modelling for Adaptive Games," AI Game Programming Wisdom II, Charles River Media, Boston, 2003, pp. 557–566.
4. Charles, D. and M. Black. "Dynamic Player Modelling: A Framework for Player-Centered Digital Games," *International Conference on Computer Games: Artificial Intelligence, Design and Education*, Microsoft Campus, Reading, November 8–10, 2004.
5. Kerr, A. "(Girls) Women Just Want to Have Fun: A Study of Adult Female Gamers." In *Level Up, The First International Conference of the International Digital Games Research Association*, University of Utrecht, The Netherlands, 2003.
6. Merripen, C. "Increasing the Bottom Line: Women's Market Share," *Game Developer Magazine* 12(2) (2005): 16–22.

7. Poole, S. "On beginnings," *Edge Magazine* 139 (August 2004): 24, Future Publishing (UK).
8. Redeye, "Content with the Playgrounds," *Edge Magazine* 139 (August 2004): 22, Future Publishing (UK).
9. Miller, S. "Auto-Dynamic Difficulty," website forum debate (last accessed February 22, 2005). Available at http://dukenukem.typepad.com/game_matters/2004/01/autoadjusting_g.html.
10. Kücklich, J. "Play and Playability as Key Concepts for New Media Studies." STeM Centre, Dublin City University, 2004.
11. Desurvire, H. "Faster, Cheaper: Are Usability Inspection Methods as Effective as Empirical Testing?" I. J. Nielsen and R. L. Molich (eds.), *Usability Inspection Methods*, New York, John Wiley & Sons, pp. 173–202, 1994.
12. Falstein, N. and H. Barwood, "The 400 Project." Available at http://theinspiracy.com/400_project.htm. (Last accessed March 21, 2005).
13. Federoff, M. "User Testing for Games: Getting Better Data Earlier." *Game Developer Magazine,* June 2003, pp. 34–40.
14. Malone, T. W. "Heuristics for Designing Enjoyable User Interfaces: Lessons from Computer Games," In John C. Thomas and M. L. Schneider (eds.), *Human Factors in Computing Systems,* Norwoord, NJ, Ablex Publishing Corporation, 1982.
15. Desurvire, H., M. Caplan, and J. A. Toth. "Using Heuristics to Evaluate the Playability of Games," in *ACM SIGCHI 2004* (Late Breaking Results Paper), April 24–29, Vienna, pp. 1509–1512.
16. Fulton, B., and M. Medlock. "Beyond Focus Groups: Getting More Useful Feedback from Consumers." Presentation at *The Game Developers' Conference, 2003,* San Francisco, CA. Available at http://mgsuserresearch.com/publications/. (Last accessed 08/08/2006).
17. Gamboa, M., R. Kowalewski, and P. Roy. "Playtesting Strategies." *Presented at the Game Developer's Conference,* San Jose, CA, March 2004.
18. Fulton, B. "Beyond Psychological Theory: Getting Data that Improve Games." In *Game Developer's Conference 2002 Proceedings,* San Jose, CA, March 2002. Reprinted on the front page of Gamasutra.com on May 21, 2002.
19. Pagulayan, R. J., K. R. Steury, B. Fulton, and R. L. Romero. "Designing for Fun: User-Testing Case Studies." In M. Blythe, K. Overbeeke, A. Monk, and P. Wright (eds.), *Funology: From Usability to Enjoyment,* Norwell, MA, Kluwer Academic Publishers, 2004.
20. Fulton, B. and R. Romero. "User-testing in a Hostile Environment: Overcoming Resistance and Apathy in your Game Company." *Presented at the Game Developer's Conference,* San Jose, CA, March 2004.
21. Pagulayan, R. J., K. Keeker, D. Wixon, R. L. Romero, and T. Fuller. User-Centered Design in Games. In J. A. Jacko and A. Sears (eds.), *The Human-Computer Interaction Handbook: Fundamentals, Evolving Technologies and Emerging Applications.* Mahwah, NJ, Lawrence Erlbaum Associates, pp. 883–906 (2003).
22. Malone, T. W. "What Makes Things Fun to Learn? A Study of Intrinsically Motivating Computer Games" *Technical Report CIS-7 Xerox PARC.* Palo Alto, CA, 1980.
23. Csikszentmihalyi, M., and I. S. Csikszentmihalyi. *Optimal Experience: Psychological Studies of Flow in Consciousness.* Cambridge; New York, Cambridge University Press, 1988.

24. Hopson, J. "Behavioral Game Design." Presentation at *The Game Developer's Conference,* San Jose, CA, March 2004. Available at http://mgsuserresearch.com/publications/. (Last accessed 08/08/2006).

25. Cornett, S. "The Usability of Massively Multiplayer Online Roleplaying games: Designing for New Users," *ACM SIG CHI 2004,* Vienna, vol. 6, no. 1, pp. 703–710, April 24–29, 2004.

26. Bateman, C. *Boon R, 21st Century Game Design,* Boston, MA, Charles River Media, 2005.

27. CESA. Games White Paper. Tokyo, Computer Entertainment Software Association, 2002.

28. ESA. Industry Sales and Economic Data, 2003 Consumer Spending Poll, Entertainment Software Association, 2003.

29. ESA. Essential Facts about the Computer and Video Game Industry. Washington, Entertainment Software Association, 2004.

30. Livingstone, S. "Young People and New Media. Childhood and the changing media environment." London, Sage Publications, 2002.

31. Kerr, A. "Girls Just Want to Have Fun. Strategies of Inclusion: Gender in the Information Society." In N. Oudshoorn, E. Rommes, and I. van Sloten (eds.), Strategies of Inclusion: Gender in the Information Society, Vol. III. Surveys of women's user experience, pp. 221–232. Trondheim, Centre for Technology and Society NTNU, 2001.

32. Taylor, T. L. "Multiple Pleasures: Women and Online Gaming." *Convergence: The Journal of Research into New Media Technologies* 9(1) (2003): 21–46.

33. Taylor, T. L. "Power Gamers Just Want to Have Fun?: Instrumental Play in a MMOG." *Level Up. Digital Games Research Conference,* Utrecht University, Utrecht University and DIGRA, 2003.

34. Ray, S. G. "Gender Inclusive Design. Expanding the Market." Hingham, Massachusetts, Charles River Media, 2004.

35. Kerr, A., Kücklich, J., Brereton, P., "New Media: New Pleasures?" *International Journal of Cultural Studies, Vol. 9, No. 1,* 63–82 (2006).

36. Bartle, R. "A Wish List for Massively Multiplayer Games." Available at http://www.mud.co.uk/richard/og01.htm, 2001.

37. Bartle, R. "Hearts, Clubs, Diamonds, Spades: Players Who Suit Muds." Available at http://www.mud.co.uk/richard/hcds.htm, 1996.

38. Kaukoranta, T., J. Smed, and H. Hakonen. "Understanding Pattern Recognition Methods." AI Game Programming Wisdom 2, Charles River Media, Boston, 2003, pp. 579–589.

39. Thomas, D. "New Paradigms in Artificial Intelligence." AI Game Programming Wisdom 2, Charles River Media, 2003, pp. 29–39.

40. Johnson, S. "Adaptive AI: A Practical Example." AI Game Programming Wisdom 2, Charles River Media, 2003, pp. 639–647.

41. Manslow, J. "Learning and Adaptation in Games." AI Game Programming Wisdom, Charles River Media, 2002, pp. 557–566.

42. Poole, S. "Snake in the Grass." *Edge Magazine* 147 (March 2005): 120, Future Publishing (UK).

43. Graepel, T., J. Herbrich, and J. Gold. "Learning to Fight." In *Proceedings of the International Conference on Computer Games: Artificial Intelligence, Design and Education, 2004,* pp 59–67.

44. Spronck, P., I. Sprinkhuizen-Kuyper, and E. Postma. "Online Adaptation of Game Opponent AI in Simulation and in Practice." In Q. Mehdi, and N. Gough (eds.), *Proceedings of the 4th International Conference on Intelligent Games and Simulation*, 2003, pp. 93–100. EUROSIS, Belgium.

45. Livingstone, D., and D. Charles. "Intelligent Interfaces for Digital Games." In *AAAI-04 Workshop on Challenges in Game AI*, July 25–26, 2004, pp. 6–10.

46. Beal, C., J. Beck, D. Westbrook, M. Atkin, and P. Cohen. "Intelligent Modeling of the User in Interactive Entertainment." In *AAAI Spring Symposium on Artificial Intelligence and Interactive Entertainment*, Standford, 2002, pp. 8–12.

47. Brown, J. S., R. R. Burton, and A. G. Bell. "SOPHIE: A Step Towards a Reactive Learning Environment." *International Journal of Man-Machine Studies* 7(1975): 675–696.

48. Schafer, J. B., J. Konstan, and J. Riedl. "Recommender Systems in E-Commerce." In *ACM Proceedings E-Commerce*, Denver, 1999, pp. 158–166.

49. Kelly, M. G., D. J. Hand, and N. M. Adams. "The Impact of Changing populations on Classifier Performance." In *Proceedings of Fifth the ACM SIGKDD International Conference on Knowledge Discovery and Data Mining*, 1999, pp. 367–371.

50. Black, M. M., and R. J. Hickey. "Maintaining the Performance of a Learned Classifier under Concept Drift." *Intelligent Data Analysis* 3(6) (December 1999): 453–474.

51. Tsymbal, A. "The problem of concept drift: definitions and related work." *Technical Report TCD-CS-2004–15*, Department of Computer Science, Trinity College Dublin, Ireland, 2004.

52. Sykes, J., and S. Brown. "Affective Gaming: Measuring Emotion through the Gamepad." In *Human Factors in Computing*, ACM Press New York, NY, USA, pp. 732–733, CHI 2003.

53. Gilleade, K. and Dix, A. "Using Frustration in the Design of Adaptive Videogames." In *Proceedings of ACE 2004, Advances in Computer Entertainment Technology*, ACM Press, June 3–5, 2004.

54. Fawcett, T. and F. Provost, "Combining Data Mining and Machine Learning for Effective User Profiling." In *Second International Conference on Knowledge Discovery and Data Mining*, 1996, pp. 8–13.

55. Kennerly, D. "Better Game Design through Data Mining," Gamasutra. com, http://www.gamasutra.com/features/20030815/kennerly_01.shtml. (Last accessed August 15, 2003).

56. Pearce, C. "Sims, BattleBots, Cellular Automata God and Go," A Conversation with Will Wright by Celia Pearce. Available at http://www.gamestudies.org/0102/pearce/. (Last accessed September 5, 2001).

57. Yee, N. "Motivations of Play in MMORPGs: Results from a Factor Analytic Approach." The Daedalus Project (web article). Available at http://www.nick-yee.com/daedalus/motivations.pdf (Last accessed 08/08/2006).

58. Kuecklich, J. "Other Playings—Cheating in Computer Games." Others Players conference. Denmark, IT University of Copenhagen, December 2004. Available at http://itu.dk/op/proceedings.htm. (Last accessed 08/08/2006).

22. Build It to Understand It: Ludology Meets Narratology in Game Design Space

MICHAEL MATEAS AND ANDREW STERN

Introduction

A primary goal of the emerging field of game studies is to understand the form and structure of games: what are the features of games, how are these features organized, in what ways do they combine to create different types of games. Usually this means analyzing games that have already been built. By constructing taxonomies and morphologies of existing games, researchers can map out game design spaces, identify the boundaries of game design, and help delineate which interactive experiences are and are not games.

The process of understanding the form and structure of games can include identifying and characterizing features of games that are pleasurable and rewarding to players. In this way, game studies can play an important role in informing the development of new games. For example, one such pleasurable feature of games is agency [1]—meaning the player has actual, perceptible effects on the virtual world—a term beginning to be used by practicing game designers [2].

Of course, some game scholars may have no intention to contribute to the design process of new games; they are studying games purely for the sake of understanding them. Yet it is possible that a deeper understanding of the form and structure of games could become a useful set of tools for game designers, even offering prescriptive arguments, at least indirectly, for what features make games successful, or are feasible to implement.

However, if game studies is limited to analyzing existing games and design spaces, it can be problematic to imagine or theorize about potential game features outside of these design spaces. Models concerned with the

nature of games and their features run the risk of being incomplete or wrong, simply because certain design spaces have not yet been explored. Further, it may be risky to "wait" for commercial game developers to venture into unexplored design territory to serve as fodder for game studies research, because developers' motivations are heavily biased by economic and marketing concerns. That is, certain regions of design space may get little or no exploration if they don't result in moneymaking AAA titles.

In this chapter we argue that building games, informed by the analysis of previous games, can play a key role in game studies. Building games within already sampled regions of design space provides a more complete understanding of these regions, without relying on only what commercial game developers happen to provide. Building games that explore new regions of design space helps uncover game forms that commercial developers have not yet ventured into, and allows us to directly experiment with some of the more vexing questions in game studies, helping the field avoid making taxonomic and prescriptive errors.

A Stalled Debate

Among the current open questions in game studies, we are concerned in particular about the present state of the ludology vs. narratology debate, that is, the long-debated conundrum: can gameplay and narrative combine, and to what extent do games and narrative overlap? Currently among game scholars, often referred to as ludologists, there is a sense of fatigue or malaise about this question [3,4], or claims that the debate never took place [5]. The debate has been sterile, primarily abandoned with no satisfactory progress. While it seems ludologists have largely retreated from "radical" positions they may have held—the extreme position being that games, in their purest form, have nothing at all to do with narrative—we fear that the status-quo position is only marginally different.

Our concern is that ludologists believe that games are uniquely agency-rich experiences, and while games can include narrative, explicit in-game narrative can at best only play a superficial role, e.g., as a largely linear layer on top pure gameplay. If pushed, a common ludological position may be that narrative is fundamentally incompatible with agency, a primary pleasure of games, and therefore is inherently less fundamental to the game experience. Based solely on the unsuccessful efforts to date of game developers to build agency-rich narratives, this is not an entirely unreasonable conclusion for ludologists to draw [6].

Player agency lies at the heart of the tension between games and narrative, and it is precisely here where building experimental, agency-oriented games is especially adept at resolving this tension. In the design and engi-

neering of *Façade* [7,8,9,10], we explicitly wanted to push on the question of the compatibility of agency and narrative. This meant both creating an architecture that affords the authoring of non-linear, player-responsive narrative performed in real-time, and implementing a small but complete, high-agency interactive drama within that architecture.

Here we present *Façade* as a case study of building a game that more deeply explores agency and narrative, and discuss how it responds to ludological arguments on this topic. Following this, based on our experimental results we will attempt to draw more general lessons about what building games can offer game studies.

Build It to Understand It

To focus *Façade* on the core of the ludology vs. narratology debate, it was important that it have enough of the requisite characteristics of games and drama to be considered both.

Like contemporary games, *Façade* is set in a simulated world with real-time 3D animation and sound, and offers the player a first person, continuous, direct-interaction interface, with unconstrained navigation and ability to pick up and use objects. More importantly, as in successful games, the player is intended to have a high degree of agency. A player has agency when she can form intentions with respect to the experience, take action with respect to those intentions, and interpret responses in terms of the action and intentions; i.e., when she has actual, perceptible effects on the virtual world. Player agency can be further classified into local agency and global agency. Local agency means that the player is able to see immediate, clear reactions to her interaction. Global agency means that the long-term sequence of events experienced by the player is strongly determined by player interaction; that is, what the player does in the moment should strongly influence which significant events or plot points occur in the future. Also, as in games, the player should be able to discern the underlying rules of the simulation, and have the option to pursue winnable conditions, achieved through the use of agency-oriented action.

Like drama, particularly theatrical drama about personal relationships such as *Who's Afraid of Virginia Woolf?* [11], *Façade* uses unconstrained natural language and emotional gesture as a primary mode of expression for all characters, including the player. Rather than being about saving the world, fighting monsters or rescuing princesses, the story is about the emotional entanglements of human relationships, specifically about the dissolution of a marriage. There is unity of time and space—all action takes place in an apartment—and the overall event structure is modulated to align to a well-formed Aristotelian tension arc, i.e., inciting incident, rising tension, crisis, climax,

and denouement, independent of the details of exactly what events occur in any one run-through of the experience.

Narrative Incompatibility?

Before describing the nature of *Façade*'s game design and system architecture, it is useful to further describe the debate over agency and narrative as we understand it. Those who argue against games with narrative agency point to a supposed predetermined or predestined nature of narrative—that strong narrative structures have complex sequences of cause and effect, complex character relationships and sequences of character interactions. Since player interaction can at any moment disrupt this narrative structure, the only way to maintain the structure is to remove or severely limit the player's ability to affect the structure. This effectively eliminates global agency, forcing the player down a predetermined path. Ludologists might argue that narrative must inevitably mean a diminishment in player agency, and cannot be an integral part of high agency game design. That is, narrative cannot operate at the heart of a game; at best it can be a relatively simple layer above the core gameplay action.

Furthermore, some ludologists argue that narrative is fundamentally inconsistent with interaction, since for them, narrative refers to a completed temporal structure, while interaction refers to a potential temporal structure—the trace produced by interaction. A pro-story response is that interactive stories should not contain a single completed story line, but rather a potential story space, where the trace of any single player experience carves a particular story trajectory through this space. A ludological response to this may be to claim that such a story system is technically impossible, as it would require better-than-human generative AI to build [12,13].

"Head Games": Simultaneous Game and Narrative

Because the mechanics of game agency are well understood and reasonably straightforward to implement, today's most pleasurable high-agency interactive experiences are games. Player moves such as running, jumping or shooting, playing a card, or moving a pawn directly cause scores, stats, levels or abstract game-piece configurations to change. (Simulations of physical environments and resource-bound systems have more complex states, but can still be represented numerically in understood ways.) However, to date, a high-agency interactive story has yet to be built. Existing game design and technology approaches, that focus on the feedback loop between player interaction and relatively simple numeric state, seem inappropriate for modeling the player's effect on story structure, whose complex global constraints

seem much richer than can be captured by a set of numeric counters or game pieces.

Our solution to this longtime conundrum is to recast interactions within a story world in terms of abstract social games. At a high level, these games are organized around a numeric "score," such as the affinity between a character and the player. However, unlike traditional games in which there is a fairly direct connection between player interaction (e.g., pushing a button to fire a gun) and score state (e.g., a decrease in the health of a monster), in our social games several levels of abstraction may separate atomic player interactions from changes in social "score." Instead of jumping over obstacles or firing a gun, in *Façade,* players fire off a variety of discourse acts in natural language, such as agreement, disagreement, praise, criticism, flirtation and provocation. While these discourse acts will generate immediate reactions from the characters, it may take story-context-specific patterns of discourse acts to influence the social game score. Further, the score is not communicated to the player via numbers or sliders, but rather via enriched, theatrically dramatic performance.

As a friend invited over for drinks at a make-or-break moment in the collapsing marriage of the protagonists Grace and Trip, the player in *Façade* unwittingly becomes an antagonist of sorts, forced by Grace and Trip into playing psychological "head games" with them [14]. During the first part of the story, Grace and Trip interpret all of the player's discourse acts in terms of a zero-sum affinity game that determines whose side Trip and Grace currently believe the player to be on. Simultaneously, the hot-button game is occurring, in which the player can trigger incendiary topics such as sex or divorce, progressing through tiers to gain more character and back-story information, and if pushed too far on a topic, affinity reversals. The second part of the story is organized around the therapy game, where the player is (purposefully or not) potentially increasing each character's degree of self-realization about their own problems, represented internally as a series of counters. Additionally, the system keeps track of the overall story tension level, which is affected by player moves in the various social games. Every change in each game's state is performed by Grace and Trip in emotionally expressive, dramatic ways, ultimately progressing to one of several endings customized to the particular details of the history of actions of the player. On the whole, because their attitudes, levels of self-awareness, and overall tension are regularly progressing, the experience takes on the form and aesthetic of a loosely plotted domestic drama.

Note that in one important way, *Façade* has the potential to violate a key characteristic of good drama: well-formedness. Normally, *Façade*'s drama manager regularly propels the action forward to enact a dramatically paced, if loosely plotted, tension arc. In the event that the player acts wildly,

Figure 22.1: Grace and Trip in Façade, viewed from the player's first-person perspective

uncooperatively or crazily, Grace and Trip will attempt to cover up and retain the integrity of the dramatic arc. However, if the player persists in acting inappropriately, for believability's sake Grace and Trip are forced to give up and throw the player out of the apartment, ruining the drama, ending it prematurely. This reaction from the drama manager is necessary for true player agency—if players are given an interface with the expressive freedom to ruin the experience, they should be free to do so if they wish.

Richness Through Coherent Intermixing

Even with a design solution in hand for resolving the tension between game and story, an organizing principle is required to break away from the constraints of traditional branching narrative structures, to avoid the combinatorial explosion that occurs with complex causal event chains [15]. Our approach to this in *Façade* is twofold: first, we divide the narrative into multiple fronts of progression, often causally independent, only occasionally interdependent. Second, we build a variety of narrative sequencers to sequence these multiple narrative progressions. These sequencers operate in parallel and can coherently intermix their performances with one another.

 These narrative sequencers, and the necessary supporting infrastructure to expressively perform real-time drama and offer players a naturalistic interface to participate, are parts of a hierarchy of heterogeneous layers of *Façade*'s software architecture, listed here from the bottom up:

- procedural and key-frame animation in a non-photorealistic rendering style, first-person user interface using keyboard to speak and navigate, mouse to gesture and use objects

- library of low-level reactive behaviors, e.g., emoting, speaking, gesturing, walking
- long-term autonomous behaviors, e.g., fixing drinks, nervously fiddling with a toy
- joint dialogue behaviors (jdb)—coordinated performance of individual pieces of dialogue and action, e.g., a line of dialogue where Grace accuses Trip of being hypocritical
- natural language processing—convert player's typed text into one or more of 30 discourse acts, e.g., "nice photo" becomes the discourse acts Refer To Italy and Praise
- beats—collections of jdbs focused on narrative goal, e.g., over the course of a minute, at Trip's objection, Grace tries to get the player to disparage their new furniture
- mix-in progressions—short progressions of jdbs designed to mix in two beats at any time, e.g., Trip interjects a response to the player's mention of sex
- discourse management—in order to react to player dialogue or action, choose a jdb to integrate into the current performance, based on the current discourse context
- drama management—regularly choose from among a collection of beats, each annotated with preconditions and effects on story tension, to match an overall tension arc.

We do not have the space here to further describe *Façade*'s implementation; we ask the reader to refer to our recent chapters on structuring content, reactive behavior and natural language processing [8,9,10].

Preliminary Evaluation

As of this writing, weeks before *Façade* is to be released to the general public, formal user studies of playing *Façade* are just beginning [16]. We offer our own brief analysis informed by anecdotal evidence based on conversations with, and reading the dialog traces of dozens of beta-testers.

During the production of *Façade*, within our "limited" authoring effort (beyond the building of the architecture, *Façade* required approximately three person years just for authoring, which is more than a typical art/research project but far less than a typical game industry project) we made the trade-off to support a significant degree of local agency, which in the end came at the expense of global agency. Combined with the reality that the time required to design and author narrative behaviors is substantial, only 27 beats were created, resulting in far lower global agency than we had initially hoped for. This points to the need for more generative systems in the future, to achieve more significant global agency in the narrative.

Further, creating a loose, sparsely plotted story afforded greater local agency, but provided fewer opportunities for global agency. However, the richness of content variation, and the at least moderate degree of global agency achieved, does encourage replay.

A major challenge we encountered, and one of *Façade*'s shortcomings, is always clearly communicating the state of the social games to the player. With traditional games, it is straightforward to tell players the game state: display a numeric score, or show the character physically at a higher platform, or display the current arrangement of game pieces. But when the "game" is ostensibly happening inside the characters' heads, and if we intend to maintain a theatrical, performative aesthetic (and not display internal feelings via stats and slider bars, a la *The Sims*), it becomes a significant challenge. In our estimation *Façade* succeeds better at communicating the state of the simpler affinity and hot-button games than the more complex therapy game.

Informed by the above experiment, we will try to understand what building games can offer game studies.

Exploring Design Space

In any design field it is common to conceptualize built artifacts, whether they are buildings, consumer appliances, or games, as residing in a design space. Every point in design space represents a specific design, including the features and design decisions that compose that design. For the game design space, each point in the space represents a specific game and the specific set of design decisions for that game. Not all points in a design space are of equal value. There are of course many more bad points in design space than there are good ones; if this were not the case, design would be easy.

Design space does not have a nice, uniform structure; it is difficult to explore. The term "space" may conjure in the reader's mind an image of a nice, simple Euclidian space, like the three-dimensional space that we inhabit. If the game design space had a similar, simple structure, then there would be some relatively small set of completely independent design decisions that would form the axes (the basis vectors) of the space. Design would merely consist of tuning each of these independent knobs to "dial in" different points in design space. In reality, design decisions are rarely independent, exist at many different levels of granularity, and take on heterogeneous discrete values.

To make matters even more complicated, the set of all possible design decisions is not defined in advance. Innovative games often innovate by discovering new design decisions and game features that open up a new, previously unknown region in design space. If one were inclined to build a formal model of the game design space, rather than looking like the more uniform

spatial structures studied in mathematics, it would look like the search spaces studied in AI, in which a heterogeneous collection of operators (each operator corresponds to a possible design decision) modifies a search state (the search state would represent the design so far), with the added complexity that the system can dynamically invent new operators (AM and Eurisko [17,18] are classic examples of such a program). But for our purposes in this chapter, we are not interested in formally defining the notion of design space, but rather in using the intuitive notion of design space, as it is understood in design science [19], to clarify the role of building games within game studies.

Wicked Problems

Game design is an instance of what Rittel and Webber termed "wicked problems" [20]. For wicked problems, any attempt to create a solution changes the understanding of the problem. That is, the definition of the problem and proposed solutions mutually define each other. (Tame problems, on the other hand, have well-defined problem statements and solution criteria.) Rittel and Webber identify a number of features of wicked problems, including:

- There is no definitive statement of a wicked problem. In fact, you do not really understand what problem you were attempting to solve until you have a solution. In game design one may start out with a "problem statement" like "Create a game in which you roll a sticky ball around and pick up stuff" or "Create a game in which you're an unwitting guest at a couple's marital meltdown," but these statements in no way specify well-defined problems. It is only when the game has been built that the real design problem to which the game is a solution is understood.
- Wicked problems have no stopping rule. Since there is no well-defined problem, there are no well-defined criteria for having solved the problem. In game design, the process ends when time and/or monetary resources are exhausted, in which case designers make whatever compromises and features cuts are necessary in order to ship the game, or when the game is considered "good enough" given the resources spent, or when the game is cancelled (the organizational reality changes).
- Solutions to wicked problems are not correct/incorrect but rather better/worse or good enough/not good enough. Since there is no well-defined problem-statement or stopping rule, there is no way to define a correct solution. Solutions can only be compared relative to each other (better/worse) or relative to a social or economic context (good enough/not good enough). In game design this often means

that a new game is judged relative to previous, similar games. This also points to the importance of frequent and early play testing; in the absence of formal criteria, relative judgments of different designs can only be made empirically.

- Every wicked problem is essentially unique. There are no predefined classes of solutions that can be applied to specific wicked problems. There may be heuristics or rules of thumb that help a designer to navigate the design space, but defining the problem and solution as a whole is a unique design challenge. In game design this means that every game presents unique design challenges. Only if a game were essentially a complete copy of a previous game would the problem be tame rather than wicked.

- There is no immediate nor ultimate test of a solution to a wicked problem. Solutions to wicked problems generate unforeseen consequences; it is impossible to know ahead of time what all the consequences of a solution will be, nor to know when all the consequences have played out. In game design this means that any specific game can change the nature of the game design space by changing audience expectations, by having unexpected cultural ramifications, and by expanding or changing the notion of what constitutes a game.

For a wicked problem such as game design, exploring design space consists of navigating the complex relationships and constraints among individual design features, while at the same time discovering or inventing new features and approaches that expand the design space. All existing games form tiny islands of partially understood regions of design space; all around these islands lies a vast ocean of unexplored potential design space waiting to be brought into existence through the invention of new features and approaches, and mapped out through the hard empirical work of exploring a variety of designs.

Like any craft practice, game design makes use of rules of thumb, case studies, and best practices as a way to manage the complexity of local regions of design space. One of the roles of game studies can be to help map game design space, to develop tools, analyses and languages for navigating this space. Work on game design languages [21,22], whether based on rules [23], design patterns [24,25], or the identification of ontological design categories [26], of game studies work that attempts to provide local maps of design space through a principled reflection over previous designs. While such work is valuable, the wicked nature of the game design problem requires that the construction of experimental games plays a significant role in mapping game design space. Specifically, making games is required to discover new regions in design space, to understand the relationship between the game architec-

ture and design space, and to probe the local islands that have already been partially explored through previous designs.

Exploring New Regions in Design Space

By the wicked nature of game design, there are no theoretical frameworks that allow one to formally pose and answer game design problems. To return to the ludology vs. narratology debate, given the game design problem "Create an interactive story in which the player experiences both local and global agency," there exists no theoretical framework that allows one to formally define the problem and solution criteria, determine whether the problem has a solution or not, and, if it does have a solution, generate a description of the solution. Rather, the search for a solution to this problem is simultaneously a search for a problem definition. In this case, the heart of the difficulty defining the problem lies in defining what is meant by "story" and "agency" (and the closely related term "interaction"). While it may be tempting to provide a priori definitions of story and interactivity, and from these, to conclude that interactive story is impossible, or, conversely to argue that all games are symbolic narratives or potential narratives (in the sense of being tellable),[1] both positions fail to provide insight into the underlying design space. The first brute impossibility result denies the wicked nature of game design, while the second permissive notion of narrative makes all games already interactive stories, denying that there is a design problem to be solved.

Alternatively, one might attempt a non-design answer to the ludology vs. narratology debate through an empirical investigation of the relationship between narrative and agency in existing game designs. Certainly from such an investigation one might conclude that narrative, when it exists, is always a linear or quasi-linear structure superimposed on top of gameplay, as described earlier. But of course such an analysis is based only on the tiny islands of design space that have been partially sampled by existing games. The study of existing games tells you little about the vast, unexplored regions of this space. Normative analyses of game design problems which are based solely on a priori theoretical frameworks or on an empirical analysis of existing game designs run the risk of being proven wrong tomorrow by a game that samples a previously unexplored region of design space. Theoretical and empirical analyses certainly provide the designer with useful approaches, techniques and vocabulary for thinking about the design problem. But such analyses can never be strongly normative. The only way to explore new regions of design space is to make things. In our case, building Façade samples a new point in design space that combines high-agency gameplay and story by structuring interaction around real-time, language-based social games, managing multiple, hierarchically overlapping progressions, and communicating game state

via rich, dramatic performance. As a wicked problem, only by actually trying to build an interactive drama could we have ever identified this design region.

The Relationship Between Design and Architecture

There is sometimes a tendency in game design to consider the design activity as separable from implementation. However, a full understanding of the design space requires understanding the relationship between authorship and the game architecture. The technical realities of game architectures help structure the complex relationships and trade-offs in the design space. Any paper-and-pencil design assumes a game architecture—that there will be, for example, mechanisms for putting objects and characters on the screen, for describing and rendering 3D levels, or for animating complex fighting moves. Even more importantly than representation, the game architecture structures the game's detailed response to player interaction. That is, the architecture structures the game's decision-making logic, and thus structures the possible gameplay mechanics available to the designer. Thus, the game AI itself becomes a design resource, not a mere "implementation detail"; the AI architecture provides the language for thinking about game behavior [27]. The architecture becomes the medium within which the designer writes the game by providing authorial affordances that support the designer in expressing her design intentions [28].

When an architecture supports a game concept, its affordances will structure the local design space in such a way as to facilitate the designer's search through this space. The architecture will make it easy for the designer to explore meaningfully different design variations while automatically taking care of many of the details. When an architecture does not support the game concept, the designer will find herself constantly fighting against the architecture; the architecture will not provide the designer control over appropriate details while simultaneously forcing the designer to manually author details she does not care about, making design variations difficult to express.

Industry attempts to create interactive stories have made use of existing game architectures. Their failure to create high-agency interactive stories results from the poor affordances existing architectures offer for stories. Blank page attempts to design high-agency stories run into a brick wall as soon as you try to actually implement the design. Without a design and architecture mutually constraining each other, attempts to design for "character" or "plot progression" are doomed to failure precisely because existing game architectures don't provide authorial support for these concepts. As a result, narrative is commonly reduced to a linear overlay on top of the actual game mechanics.

We were able to build *Façade* precisely because our design effort was "total" in the sense that we simultaneously designed story-and-character-based interaction mechanics as well as an architecture to support these mechanics. By building a game AI in which character behavior, the mixing of multiple character behaviors, and story progression are first-class concepts, our design and architecture co-evolved to provide local structure for this point in design space. Since technical and conceptual problems in the game design space are inextricably intertwined, exploring new regions of design space requires architectural exploration through building experimental games.

Mapping Existing Design Regions

Understanding the design implications even of existing game architectures requires a procedurally literate analysis [29]. Playing games (surface observation) does not allow one to fully map out the local design space even for highly sampled regions of design space. Much of the design space structure is embodied in the architecture. For example, Wolff [30] provides an architectural analysis of visual representation in Atari 2600 games, an analysis that would be impossible to achieve by only looking at the surface details of the games. Deeper understanding of already sampled regions of design space, such as Atari 2600 games, requires setting oneself new (wicked) design problems and solving them within the constraints of an existing architecture. Making experimental games is necessary not only for exploring new regions in design space, but also to facilitate the analysis of already highly sampled regions of the space.

Conclusions

The process of building the interactive drama *Façade*, with the explicit goal to explore new ways to deconstruct the potential events of a dramatic narrative into small grained-size pieces, annotated to allow the system to dynamically mix and sequence the pieces in response to player interaction, has helped us understand that there do in fact exist narrative structures that allow for both local and global agency, that can offer a satisfying dramatic experience for players. Our playable results, albeit in need of further refinement, suggest that ludologists' possible assumptions about the compatibility of narrative with agency, including the technical impossibility of generative story systems, are overreaching and premature.

Note

1. These characterizations are caricatures of strong ludological and narratological positions.

References

1. Murray, J. H. *Hamlet on the Holodeck: The Future of Narrative in Cyberspace.* New York, The Free Press, 1997.
2. Hall, J. "The State of Church: Doug Church on the Death of PC Gaming and the Future of Defining Gameplay." Available at http://www.gamasutra.com/features/20041123/hall_01.shtml, 2004.
3. Juul, J. Blog post: "The definitive history of games and stories, ludology and narratology." Available at http://www.jesperjuul.dk/ludologist/index.php?p=66, 2004.
4. Grand Text Auto. Blog post: "Computer Games at SSNL's Narrative Conference." Available at http://grandtextauto.gatech.edu/2004/04/25/computer-games-at-ssnls-narrative-conference, 2004.
5. Frasca, G. "Ludologists Love Stories Too: Notes From A Debate That Never Took Place." In *Proceedings of International DiGRA Conference,* 2003, pp. 92–99.
6. Aarseth, E. "Genre Trouble: Narrativism and the Art of Simulation." In N. Wardrip-Fruin and P. Harrigan (eds.), *First Person: New Media as Story, Performance and Game,* Cambridge, MA, The MIT Press, 2004, pp. 45–55.
7. Mateas, M. and A. Stern. "Towards Integrating Plot And Character For Interactive Drama." In *Proceedings of Socially Intelligent Agents: The Human In The Loop, AAAI Symposium,* Sea Crest, MA, 2000, pp. 113–118.
8. Mateas, M., and A. Stern, "A Behavior Language: Joint Action and Behavioral Idioms." In H. Predinger, and M. Ishiuka (eds.), *Life-like Characters: Tools, Affective Functions and Applications,* Berlin, Springer 2004, pp. 135–162.
9. Mateas, M. and A. Stern, "Natural Language Understanding in Façade: Surface Text Processing." In *Technologies for Interactive Digital Storytelling and Entertainment, 2nd Int'l Conference,* Darmstadt. Berlin, Springer, Vol 3105, 2004, pp. 3–13.
10. Mateas, M., and A. Stern. "Structuring Content in the Façade Interactive Drama Architecture." *1st Annual Conference of Artificial Intelligence and Interactive Digital Entertainment,* Marina del Rey, CA, 2005. Available at http://www.interactivestory.net/papers/MateasSternAIIDE05.pdf.
11. Albee, E. *Who's Afraid of Virginia Woolf?* New York, Signet, 1962.
12. Aarseth, E. *Cybertext.* Baltimore, Johns Hopkins University Press. 1997.
13. Frasca, G. "Response to Mateas." In N. Wardrip-Fruin, and P. Harrigan (eds.), *First Person: New Media as Story, Performance and Game,* Cambridge, MA, The MIT Press, 2004.
14. Berne, E. *Games People Play.* New York, Grove Press, 1964.
15. Crawford, C. "Indirection." *Journal of Computer Game Design* 3 (1989). Available at http://www.erasmatazz.com/library/JCGD_Volume_3/Indirection.html.
16. Knickmeyer, R., and M. Mateas. "Preliminary Evaluation of the Interactive Drama Façade." In *Proceedings of the ACM Conference on Human Factors in Computing Systems* (CHI), Portland, OR, April 2–7. New York, ACM Press, 2005, pp. 1549–1552.

17. Lenat, D. *AM: An Artificial Intelligence Approach to Discovery in Mathematics as Heuristic Search.* PhD thesis, Stanford University, 1976.
18. Lenat, D. "Eurisko: A Program which Learns New Heuristics and Domain Concepts." *Artificial Intelligence* 21 (1983), pp. 61–98.
19. Simon, H. *Sciences of the Artificial.* MIT Press, Boston, 1969.
20. Rittel, H., and M. Webber. "Dilemmas in a General Theory of Planning." In *Policy Sciences 4*, Elsevier Scientific Publishing, Amsterdam, 1973, pp. 155–159.
21. Church, D. "Formal Abstract Design Tools," in *Game Developer*, 1999.
22. Costikyan, G. "I have no words & I must design." *Interactive Fantasy* (1994). Available at http://www.costik.com/nowords.html.
23. Falstein, N. "The 400 Project." Available at http://www.theinspiracy.com/400_project.htm, 2004.
24. Bjork, S., and J. Holopainen. *Patterns in Game Design.* Hingham, MA, Charles River Media, 2005.
25. Kreimeier, B. "The Case for Game Design Patterns." Available at http://www.gamasutra.com/features/20020313/ kreimeier_01.htm, 2002.
26. Zagal, J., M. Mateas, C. Fernández-Vara, B. Hochhalter, and N. Lichti. "Towards an Ontological Language for Game Analysis." In *Proceedings of International DiGRA Conference*, 2005.
27. Mateas, M. "Expressive AI: Games and Artificial Intelligence." In *Proceedings of International DiGRA Conference*, 2003.
28. Mateas, M. "Expressive AI: A Semiotic Analysis of Machinic Affordances," in *Proceedings of the Third Conference on Computational Semiotics and New Media*, University of Teesside, UK, 2003.
29. Mateas, M. "Procedural Literacy: Educating the New Media Practitioner." In *On the Horizon: Special Issue on Future Strategies for Simulations, Games and Interactive Media in Educational and Learning Contexts*, Drew Davidson (Ed.), v. 13, n. 1, 2005, pp. 101–111.
30. Wolff, M. J. P. "Abstraction in the Video Game," In M. J. P. Wolff and B. Perron (eds.), *The Video Game Theory Reader*, Routledge, NY, 2003, pp. 47–66.

Part V

Learning to Play:
Playing to Learn

23. Interactive Story Writing in the Classroom: Using Computer Games

Mike Carbonaro, Maria Cutumisu, Matthew McNaughton,
Curtis Onuczko, Thomas Roy, Jonathan Schaeffer,
Duane Szafron, and Stephanie Gillis

Introduction

Computer games offer a new medium for creative writing—immersive stories where the "reader" is an active participant in the narrative. These stories are rich in visual and audio texture and decisions made by the reader influence how the story unfolds, possibly even changing the outcome. Traditional pen-and-paper story writing has the author specify everything textually. In interactive stories, the "writer" uses computer tools to create visual representations of an imagined world; vibrant colors and visual objects replace textual adjectives and vivid descriptions.

The last five years have seen interactive story-writing technology mature to the point where it has become widely popular. Unfortunately, this technology requires the writer to also write sophisticated computer programs to control the interactions between the game components. For example, when the "player" steps on a particular stone in a corridor, scripting code must be written to recognize that the stone has been stepped on and to trigger an appropriate trap. Writing scripts to control this level of detail in a story is very burdensome to the writer, and is only able to be accomplished after extensive technical training. The goal of our research is to create an environment that enables non-programmers to write interactive stories without the need to provide scripts to control this level of detail.

Although gameplay can be used as an educational experience, we are more interested in game design than gameplay [1]. This is a relatively new endeavor [2]. The focus of the research described here is to use interactive

story writing as a new vehicle for creative expression. In a traditional story, the world is created using descriptive prose and the story is told through narrative prose. In an interactive story, the world is "painted" with a computer-aided design tool and the story is told dynamically as the player character (PC) navigates through the world. There are three potential benefits of using interactive story writing in the classroom. First, students can improve the skills necessary to effectively use an increasingly important communications medium. Second, they will learn important logical thinking skills, similar to computer programming, but in an environment that does not have the stigma of computer programming. Finally, this new medium provides an alternative mechanism for creative expression that may allow students to improve their expressive skills.

To reduce the scale of the problem to a manageable level, we decided to focus on computer role playing games (CRPGs). In our project, interactive stories are "written" by creating game adventures for BioWare's *Neverwinter Nights* (NWN) computer game system [3]. *Neverwinter Nights* was released in 2002 to critical acclaim, winning multiple awards (86 at last count). It was novel in that it provided a complete toolset for writing interactive stories in the NWN framework. The accompanying Aurora toolset has the capability to create story backdrops and scenery, and to populate the scenes with characters and supporting props. The scripting language NWScript can be used by the writer to specify plot components, character/prop behaviors, and their interactions. Scripting languages attempt to lessen the programming burden by presenting the user with a simplified specification language—but it is still too close to computer programming. Programming (writing) interactive games with such tools is slow, cumbersome, and fraught with error. Currently, no other game offers a better or more complete package for writing interactive stories.

Neverwinter Nights is a community game with over two million registered users at the BioWare site. Thousands of people create NWN stories and post them on the web for others to play. For example, the Neverwinter Nights Vault site [4] hosts more than 3,000 adventures. The most popular community adventure has been downloaded more than 250,000 times and the tenth most popular one has been loaded almost 100,000 times (as of March 2005).

If the interactive story-writing community is to grow, the tools used to create these stories must be improved; they must cater to non-programmers. ScriptEase is a high-level tool for writing interactive stories that frees the author from doing explicit computer programming [5]. In ScriptEase, the user specifies the story components by selecting from a palette of familiar story patterns (e.g., stepping on a trap and having something happen), and then customizing them for their story (e.g., specifying which trap, and what

is to happen when the trap is sprung). The goal of the ScriptEase project is to create a simple tool that enables a game designer (programmer or non-programmer) to generate a complex computer role-playing story with minimal effort.

To validate claims that ScriptEase is easy to use for non-programmers, we describe the first time it has been used in the classroom (a Grade 10 English class). In this pilot, the students learned to use the Neverwinter Nights and ScriptEase toolsets to write interactive stories. These stories were graded and were included as part of the assessment for the English course.

We begin this chapter with a description of the current state-of-the-art in interactive story writing: manual scripting. Non-programmers often find manual scripting very difficult and get frustrated during the story design and develop process. We then discuss a new approach to interactive story writing developed by our research team called ScriptEase, showing how its pattern-based approach can be used to quickly construct intricate stories without writing any scripting code. Following that, we discuss the differences between interactive story writing and traditional pen-and-paper story writing emphasizing the pedagogical differences that might be seen in a classroom setting. We then conclude by describing our pilot classroom study and provide insights on what was learned.

Manual Scripting

As we indicated above, NWScript is the language used for scripting stories in *Neverwinter Nights*. The language strongly resembles the C programming language; it is event based, meaning that when an event happens to an object (e.g., a treasure chest would have an event occur when it is opened or closed or when an item is added or removed from it), the script associated with that event is executed. For example, consider the common occurrence of taking an item out of a chest or putting an item into a chest. The object under consideration is the treasure chest, and the event that happens to it is that a shield is put into it. Figure 23.1 illustrates the NWScript code that a user might write to handle this event. When a shield is placed in a chest, the shield is destroyed, a nearby door is opened, and the character gains so-called experience points. While this might be easily readable by programmers, it is very confusing for non-programmers.

Essentially, the entire story has to be written using scripts similar to the one described above. This includes: interesting encounters with objects (e.g., having something exciting happen when an item in a chest is removed); non-player character (NPC) behaviors (e.g., having a character guarding a chest behave like one would expect a guard to behave); conversations (the text said by individuals has to be specified, and any actions that happen when text is

```
void main()
{
    object oItem = GetInventoryDisturbItem();
    int nItemBase = GetBaseItemType(oItem);
    if(GetLocalInt(OBJECT_SELF,"NW_L_M1S1Opened") == FALSE
            && GetTag(oItem) == "M1S1Shield" )
    {
        DestroyObject(oItem);
        object oDoor =
            GetNearestObjectByTag("M1Q5F03_M1Q5J1");
        AssignCommand(oDoor,ActionOpenDoor(oDoor));
        SetLocked(oDoor,FALSE);
        SetLocalInt(OBJECT_SELF,"NW_L_M1S1Opened",TRUE);
        RewardXP("m1q1_Never",50,GetPCSpeaker());
    }
}
```

```
Query
Author: ####
Subject: Skeleton Spawn when chest opened

Is there a way to make some skeletons spawn when
you open a treasure chest?

Response
Author: ####
Subject: Re: Skeleton Spawn when chest opened

Put something like this into the OnOpened Script
of the chest.
void main() {
    CreateObject(OBJECT_TYPE_CREATURE,
                "MY_RESREF",
                GetLocation(OBJECT_SELF));
}
where MY_RESREF is the BluePrintResRef of the
creature you want to spawn.
```

Figure 23.1: Disturbing an item in a chest using NWScript

Figure 23.2: Sample user query (1)

spoken must be specified—for example, when a PC says "No I won't give you my gold," the NPC may be required by the story to attack the PC); and the plot (you can only enter the room once you have discovered the secret password).

Neverwinter Nights provides a set of commonly occurring "canned" scripts that the user can adapt during the story-writing process. Although these canned scripts can be helpful in speeding up the story-writing process, they can also have the negative affect of limiting the storywriter's creative ability.

Essentially, for most interactive storywriters, this will constrain their capacity to express themselves to only those events that are easily accessible in the canned scripts.

Overcoming such constraints is an important design consideration when developing a new scripting environment for storywriters.

Computer role-playing games involve large virtual worlds with thousands of characters and objects, each of which has to be scripted to obtain the desired story. Each character or object may need multiple scripts (one for each event that it responds to). Writing the scripts can be a tedious and error-prone process. Testing scripts is difficult because of the non-linear nature of interactive stories. In fact, the only really effective way to test scripts is to play through the portion of the game relevant to that script. Unfortunately, this is labor intensive and, hence, expensive.

Most *Neverwinter Nights* storywriters are not programmers. There are few choices available to the writers for creating their story: they either use NWScript (and, hence, learn to program) or use a tool that reduces the programming burden. The Lilac Soul tool is widely used, but it provides only a

```
Query
Author: #####
Subject: Help me newb

I need a script for pulling a lever to make a door open.

Response 1
Author: #####
Subject: Re: Help me newb

Use the Lever to assign ActionOpenDoor (I think) to the
door - or signal a user defined event to the door, and
then have the door open itself - Alternatively load up
the prison floors from Chapter 1 of the official campaign
and rip the scripts from there.

Response 2
Author: #####
Subject: Re: Help me newb

1. Setup the door to have the tag "my_door" (or whatever)
2. Place the lever near the door
3. Edit the levers OnUsed script to read

   object oDoor = GetNearestObjectByTag("my_door");
   int nLocked = GetLocked(oDoor);
   // if the door is locked, unlock it, and vice versa
   SetLocked(oDoor, !nLocked);
   if (nLocked) { // if it was locked it is now unlocked
     AssignCommand(oDoor,ActionOpenDoor(oDoor));
   } else { // else close and lock
     AssignCommand(oDoor,ActionCloseDoor(oDoor));
   AssignCommand(oDoor,
   ActionDoCommand(SetLocked(oDoor,TRUE)));
   }
```

Figure 23.3: Sample user query (2)

mechanism for writing script fragments that then must be manually pasted into the appropriate event handlers [6]. In addition, although high-level menu commands such as "Give items(s)/XP/gold" generate scripting code such as "RewardPartyGP(21, oPC, FALSE)," there is no way to easily remove generated code from a script without trying to figure out what script code is generated by what menu commands. In practice, users choose one of these two options, and then turn to the community for help by posting to one of the NWN scripting forums. There have been almost 150,000 scripting-related postings to the BioWare forums (as of March 2005).

For non-programmers, scripting remains a mystery. Program code, like NWScript, is confusing and non-intuitive. Users tend to think in familiar high-level terms (like open a chest), not at the low-level programming details (such as calling GetNearestObjectByTag). Figure 23.2 shows a sample request for help posted to a scripting forum (the name has been removed). The request is simply expressed in non-programming terms and the (possible) solution comes back in programming terms—a communications disconnect. The response to the request is helpful, to a point. As a non-programmer, one has to trust the validity of the code given. However, comments of the form "something like this" leave the non-programmer confused, especially when the code as given does not work. In this example, the documentation is in error—it should be "OnOpen," not "OnOpened."

Figure 23.3 further illustrates the communications disconnect. Again, comments like "I think" (implying uncertainty) and "rip the scripts" (imprecise specification) cast doubt on the veracity of the proposed solution. The second response in Figure 23.3 is relatively rare—a precise specification of the changes needed. Unfortunately, almost all such postings come with the

caveat "Code presented in this post has not been compiled or tested!"

The problems do not end there. The non-programmer needs to know where to put the script (or fragment of script). Code fragments often must be composed or assembled and the scripter often does not understand how the parts go together. Invariably, these scripts must be customized. A fragment has placeholder values requiring customization (replacing the object(s) in the script with the object(s) needed by the user). These, and many other problems, make it challenging for a non-programmer to script an interactive game story.

ScriptEase

By computer game standards, NWScript is a state-of-the-art scripting language. However, the scripting language is difficult for non-programmers to learn (see Figure 23.1). It closely resembles the C programming language, requiring the user to understand concepts such as functions, types, and variables, as well as a large library of necessary routines. This is a serious impediment to making the story creation capabilities accessible to a non-technical audience.

ScriptEase is a scripting tool developed at the University of Alberta [5,7] that generates NWScript for *Neverwinter Nights*. The program provides a menu-driven, natural language interface that is used to specify the story. From the user specifications, the tool automatically generates the appropriate NWScript code to perform the desired actions.

Writing stories in ScriptEase is accomplished using patterns. The user specifies a pattern and then customizes it to suit their needs. For example, a frequently occurring pattern in fantasy games is to open a chest and have something happen. The user selects this pattern and then is presented with a window identifying the parameters to be set. The parameters identify the participants in the pattern (e.g., which chest does the pattern apply to), the pattern-related actions that are appropriate to the plot (a magical spell that is cast on the PC, a statue that animates, teleporting the player's character to another location, etc.), and special effects (e.g., a visual effect that occurs when the chest is opened).

A story is written by adapting existing patterns to specify the plot, character and prop interactions, character behaviors, and conversations. We now present an example to show the step-by-step process of writing a scene from an interactive story using ScriptEase.

The Container Disturb (specific item) toggle door pattern is a popular pattern for controlling the plot of a story. Some writers used it to deny access to a room by locking the door and not providing a key to that door anywhere in the story. Instead, they may place a chest in another room and put a spe-

cific item (such as a particular book) into that chest. The writer can then apply the pattern so that removing the book from the chest automatically causes the locked door to unlock and open. To insert this pattern into a story, a writer begins by using the Aurora toolset to lock the door of interest. Figure 23.4 shows the story (in a file labeled CastleExample.mod) opened in the Aurora toolset. To lock the door (labeled bedroom2) for a specific key, the writer selects the door, opens the Door Properties dialog box and selects both the Locked and Key required to unlock or lock checkboxes.

The Aurora toolset is then used to create a chest (labeled BookChest) and place it into a nearby room. The writer then opens the Inventory of the chest and drags a particular book (labeled The Origin of Magic) into the chest. Figure 23.5 shows the chest, its properties dialog box, its inventory, and the book that has been dragged into the inventory.

So far, the storywriter has used the Aurora toolset to populate the story with appropriate props to tell this part of the story. This is equivalent to using descriptive prose in a traditional story to describe the scene and set the stage for the action. At this point, the storywriter will use a ScriptEase pattern instead of writing narrative prose that describes how the story's protagonist removes the magic book from the chest to unlock and open the door. The storywriter opens the story (labeled CastleExample.mod) in ScriptEase and creates a New Specific Encounter called the Container Disturb (specific item) toggle door pattern as shown in Figure 23.6.

Each pattern has some roles associated with it that must be played by particular objects in the scene of the story being written. For this story, the writer selects each of the three roles associated with this pattern: The Container, The Specific Item and The Door and selects the objects that will play these roles: BookChest, The Origin of Magic and bedroom2, respectively. For example, Figure 23.7 shows how the user selects the tab for The Container role, clicks on the Pick button and then selects the BookChest as the container of interest from a dialog box that is very similar to the (by now) familiar Aurora toolset dialogs. Note that we have overlaid a type system on the NWN objects to reduce errors. For example, only the creature and placeable icons at the top of the Pick a blueprint dialog are not grayed out, since a "container" is an object that has an inventory and therefore must either be a creature or a placeable, as opposed to a door, or an item, etc. that have no inventories. Our type system (even though the writers do not know it is a type system) helps to reduce errors by only allowing the appropriate type of object to be picked for any particular pattern role.

Figure 23.4: Example story opened in the Aurora toolset

Figure 23.5: The chest and its properties in the Aurora toolset

After picking the objects that will play the roles, the writer could simply save and compile the story and exit ScriptEase. However, it would be a better story if the reader (player) had some hint that removing the book in one room unlocked and opened the door in the other. Therefore, we show how the writer can adapt this pattern to this particular story by causing a visual effect to appear on the appropriate door. This visual effect will draw the attention of the reader to the door that was affected. Figure 23.8 shows how the writer adapts the pattern by first opening the E (Encounter pattern) and the S (Situation it contains) to reveal the V (eVents), D (Definitions), C (Conditions), and A (Actions) that comprise it. The writer then adds a new action to fire an impact visual effect (labeled Unsummon), by selecting this action from a menu, similar to the one used to add the encounter in Figure 23.6. This particular visual effect was chosen since it can be seen from far away. The only action the storywriter has added is this last action. The other components of this pattern (Situation, Definitions, Condition and Actions)

Figure 23.6: Creating an encounter pattern

Figure 23.7: Parameters for a pattern

were revealed when the pattern was opened—indeed these other components (along with the roles) define the pattern.

After saving and compiling the story, the writer can "test-drive" the story by opening it in NWN. Figure 23.9 shows what happens when the PC (Serenity) removes the book from the chest. The basic graphics show the screen just before the book is removed and the insets show the parts of the screen that change, just as the book is dragged from the chest's inventory to the PC's inventory. The changes are shown as arrows from the two parts of the scene to the insets that show the change. The visual effect can be seen as white lines in the still picture, but this picture does not do justice to the actual game where the visual effect is a startling animation of billowing white light, accompanied by sound effects that draw attention to the door of interest.

The chest example shows the ease of using ScriptEase to create an interactive story. ScriptEase provides many benefits for simplifying the creation of interactive stories: It provides a simple menu-driven interface; all specifications are done using familiar story-element patterns; the user need not know

Figure 23.8: Customizing a pattern

Figure 23.9: Playing the story

anything about NWScript; ScriptEase organizes the (potentially) thousands of scripts; many common programming errors cannot happen as the patterns have been tested and debugged by the pattern designer, not the pattern user; by enabling game designers to generate their own interactive stories, this eliminates the need for a programmer to tell the story; creating interactive stories appeals to a wider audience of storywriters, making it a useful tool for the classroom.

Claims of being "easy to use" are often made in computing literature, and are rarely backed up with supporting evidence. With ScriptEase, we wanted to validate our claim that it is easy to use by non-programmers.

Interactive Story Writing

Interactive story writing is a relatively new medium for creative expression. Compared to traditional pen-and-paper (word processor) stories, interactive stories are fundamentally different in their requirements and in the skill set needed.

It is often difficult for students to start writing a traditional short story and many students complain: "I don't know where to start." In our experience, students have no difficulty starting an interactive story. Why? This fundamental difference is critical to understanding the pedagogical potential (and limitations) of interactive story writing.

To start a traditional story, it is necessary to set the scene of the story by writing a considerable amount of descriptive prose, before getting to the "good" part of telling the story. Thus students often limit their description of their setting, leaving the reader guessing and often confused. With an interactive story, the scene can be quickly "painted" using the Aurora toolset to add scene components. We hypothesize three main consequences of this difference that we believe make it easier to start an interactive story (and therefore make it more fun).

Writing descriptive text can require more technical skill than selecting and placing scene objects. In an interactive story, the user can create a mental image, and then select scenery, objects, and sound to realize it. Pen-and-paper approaches require the user to translate images into words. The quality of the result depends on extensive education in vocabulary, grammar, and creative writing.

Feedback is slow and often difficult to evaluate in the traditional approach. It can take a long time to write the descriptive text and when the author reads what he/she has written, it is often hard to know if the text adequately describes the scene, or whether the author's mental vision is compensating for what is missing from the text. Often the text must be read several times to discover what is missing or is inconsistent with the mental vision. With an interactive story, the author can set the scene quickly and view it immediately. This results both in a higher chance of alignment with the mental vision and less doubt as to whether the scene can stand alone without relying on information from the mental vision known only to the author. From a Computing Science perspective, this is visual debugging at its finest.

Early positive feedback from correctly setting part of the scene increases self-confidence in technical skills. Steady obvious incremental improvement of the story results in an increase in motivation since the author is (usually) getting closer to the goal, rather than making progress at an irregular rate due to false starts.

Creating an interactive story is, in many ways, more similar to writing a play than writing a short story. In a play, the author concentrates on the plot, theme, and character dialogue; other issues such as detailed scene descriptions, internal character subtleties, and flowing prose to tie it all together are not needed. An interactive story is similar: all of the effort goes into creating the plot and composing the interactions between the characters. Scene descriptions are simply expressed as pictures, without the need for elegant prose. Character subtleties, if not expressed as text such as in conversations, are currently beyond the capabilities of games such as *Neverwinter Nights.*

One major difference between interactive stories and plays is in the background characters populating a scene. For example, if the hero of the story goes into a store to buy something, the play author just assumes that there are other people in the store and that there is a cashier. Little time has to be spent on the details, since the author (and the readers) can infer the rest. In an interactive story, however, the details of the store must be specified. All background characters (such as the cashier, and other NPCs) must be programmed. This extra level of detail may put a significant onus on the story creator, depending on the needs of their story. However, this is precisely where a tool such as ScriptEase can be a big win. Character behaviors can also be patterns. There could be, for example, a "cashier" behavior. The storywriter could create a character in the story and assign the cashier pattern to it. This would allow the writer to add more realism to their story by easily populating a scene with additional characters exhibiting realistic behavior.

Classroom Pilot

Working collaboratively with a high school English teacher and a high school student, a series of tutorials were created (for the tools Neverwinter Nights, Aurora, and ScriptEase) [8]. The high school teacher developed and the high school student tested an interactive story-writing assignment targeted for High School English students. This process took several months and several iterations of the documentation.

Following this process, an interactive writing assignment was used as part of the curriculum in a Grade 10 English class, and administered over a two-week period in November 2004. It consisted of two components: (1) The students were taken on a 2-day field trip to the University of Alberta for the Neverwinter Nights, Aurora and ScriptEase tutorials (because of the availability of the computing equipment); and (2) Three eighty-minute English classes in the high school computer lab were devoted to allowing the students to work on their stories and extra computer hours were made available for those who wanted it.

We found that the students were generally highly motivated to work on their stories (twenty-one students completed the assignment). This became obvious early on when the students requested that additional computer lab time be made available for them to work. Part of the motivation likely came from the novelty of the classroom experience. Beyond that, however, there was a sense of excitement as the student's interactive story-writing capabilities increased.

In a regular English classroom, it is common for the teacher to have students "peer evaluate" each other's work. Students often interpret this as added work and are not very interested in what their peers have written since the stories are not professionally published. Therefore, the feedback is often minimal and of little benefit to either student. During the field trip and upon return to the school we noticed a strong sense of collaboration. Students were neither encouraged nor discouraged from helping each other, exchanging story ideas, and providing feedback on other students' stories. In fact, we did not even think about interpersonal collaboration in designing the activity. What we discovered was that students began collaborating on their stories from the beginning of the tutorial exercises without encouragement from their English teacher. One student would spontaneously say to the next student, "look what I tried" and the other student would immediately get involved by adapting the idea to his/her own story or by suggesting related things to try. Groups of students began gathering at one workstation or another observing particular students' activities. This encouraged all the students to produce better stories, knowing that their work was being seen and appreciated by their fellow students. Constructive collaboration within a community of learners provided students with an opportunity to improve their critiquing skills. We believe that it also resulted in better understanding of concepts since students would often try to explain things (that they had figured out by themselves or that were clarified by the teacher) to their peers. In some cases, the interaction went beyond merely giving instructions; it became interactive collaborative story development. From the Computing Science perspective, it appeared that some students had discovered the advantages of pair programming.

We were only able to observe collaboration during the two-day trip to the University of Alberta. However, collaboration continued throughout the assignment. The teacher contrasted this high level of interpersonal collaboration in interactive story writing with the collaboration in traditional learning activities: "ScriptEase created interaction among my students which was not typical of an individual activity such as story writing. This way of story writing encouraged collaboration before, during and after their stories were complete."

The teacher gave us additional insights into the student's experience, observing that some students with lower academic achievements became immersed in the assignment. A possible explanation is that the creative mechanism of interactive stories was easier for them or better suited to their capabilities. If so, this has exciting implications for the pedagogical development of creative "writing" courses. Gardner's work on different modes of intelligence and their connection to expressive modes (music, dance, etc.) seems to apply here, since our interactive stories contain visual and sound aspects [9].

The teacher reported that the students had a high level of curiosity about the capabilities of the interactive story-writing tools. Many students asked questions about tool features beyond what was introduced for their assignment, and some students took this one step forward by exploring these features even though no documentation was provided.

The one big mistake that we made in the pilot study was underestimating the time it would take the teacher to mark the assignments. While the teacher developed a rubric to mark the story, each graded component required the teacher to play-test the student submission. The result was that each story required several hours of grading time. Not knowing the details of a student's story, the teacher had to explore the student's game world to uncover all the subtleties of the story (for example, traps, hidden doors, and dead end passageways). For subsequent classroom use, we will ask the students to create storyboards for their interactive story. By having the students map out the major components of the story, the teacher can avoid most of the trial and error exploration aspects of the game. This is often done traditionally in the classroom through a written outline of the story provided by the student.

This pilot has been tremendously valuable for giving feedback on the use of interactive storytelling in general, the computer tools in particular, and ways to improve the tutorials, grading scheme, student-computing environment, and scope of the assignment. The initial experience was very positive for all parties. In particular, the teacher conducted a student survey after the assignment was completed and reported a very high level of satisfaction from the respondents. Most students gave a strong preference to doing another interactive story-writing assignment over a traditional story-writing assignment.

Future Work

The development of interactive story-writing technology is still in its early stages. ScriptEase has been two years in the making, and there is still much to do. Our current work is building behavior patterns, allowing the user to rapidly create scenes populated with a rich set of NPCs. Future work will include conversation patterns. Currently, creating conversations is cumbersome and

time-consuming, yet many types of conversations are really just frequently occurring patterns (e.g., a greeting, or a request for a service). Enhancing ScriptEase to include conversation patterns is a natural extension of our current work.

Our research goal is to make interactive story-writing technology available to non-programmers, demonstrate its pedagogical value in the classroom, and work towards popularizing this medium as a new form of creative literature.

Acknowledgments

This research was supported by the Natural Sciences and Engineering Research Council of Canada (NSERC), the Institute for Robotics and Intelligent Systems (IRIS), and Alberta's Informatics Circle of Research Excellence (iCORE).

References

1. McFarlane, A., A. Sparrowhawk, and Y. Heald. "Report on the Educational Use of Games," in *Teachers Evaluating Educational Multimedia Report,* 2002. Available at http://www.teem.org.uk/publications/teem_gamesined_full.pdf. (Last accessed March 8, 2007).
2. Robertson, J., and J. Good. "Story Creation in Virtual Game Worlds," in *Communications of the ACM* 48(1) (2005): 61–65.
3. BioWare. Available at http://www.bioware.com. (Last accessed July 15, 2006).
4. Neverwinter Nights Vault. http://nwvault.ign.com. (Last accessed March 8, 2007).
5. ScriptEase project. http://www.cs.ualberta.ca/~script. (Last accessed July 15, 2006).
6. Lilac Soul. Available at http://lilacsoul.proboards13.com/indesx.cgi. (Last accessed March 8, 2007).
7. McNaughton, M., M. Cutumisu, D. Szafron, J. Schaeffer, J. Redford, and Parker, D. "ScriptEase: Generative Design Patterns for Computer Role-Playing Games," in *19th International Conference on Automated Software Engineering,* 2004, pp. 88–99.
8. Tutorials and assignment available at http://www.cs.ualberta.ca/~script/scripteasenwn.html. (Last accessed July 15, 2006).
9. Gardner, H. *Multiple Intelligences: The Theory in Practice.* New York, Basic Books, 1993.

24. Games as a Platform for Situated Science Practice

RIKKE MAGNUSSEN

Introduction

How computational media can change science education has been an object of discussion for several years [1,2]. The claim in this chapter is that computers engender a new literacy and that the new representations' computational media allow can transform science education [1]. This has led to new designs of digital learning environments based on the notion that meaning is material, situated, and embodied and that abstract systems originally got their meanings through embodied experiences [1,3].

Science education has in recent years been an object of study and development of new game-based learning environments [4,5]. It has been argued that the active and critical learning about rich semiotic systems, learning through participating learning communities and the complex problem-solving that good games are theorized to involve, have much in common with science learning when understood as an active process of inquiry characteristic of real-life science [3,6]. Traditional science education has been criticized for being based on the memorization of facts and for creating little ownership and practical understanding of authentic scientific processes and methods [1,3]. Relatively little is known about how learning occurs through gameplay, or about the interaction that occurs when complex game-based learning environments are brought into a school culture [7].

Digital game media are well suited for simulating complex rule systems and real-life settings. Digital games offer a medium equipped for complex simulations integrating many different aspects of real-life learning environments and framing them in a graphical simulation the player can identify with and relate to. Access to a wider range of powerful representations supports

authenticity and makes it possible for players to tackle "real" problems in all their attendant complexity and difficulty. Thus when creating new game-based science learning environments, it is interesting to consider how we may use the game media to simulate science practice.

This type of game-based learning space is premised on the concept of situated learning, but being a simulation of a practice it is not learning in situ in the authentic context the simulation is based on [8]. The types of game-based learning spaces described here are specifically designed to bring "authentic" science practice into the classroom and I define this type of learning space as a "simulated situated learning space."

In the following discussion, I present the game *Homicide* which was designed for cross-disciplinary science education [9]. *Homicide* is an IT-supported role-playing game in which students play forensic experts solving a murder case. This game-based learning environment was designed to develop science competencies through a simulation of a practical learning situation. I provide an introduction to the game and present initial studies of *Homicide* "in action," and then I discuss the elements and perspectives of this type of game-based learning space.

Homicide the Game

Homicide is an IT-supported role-playing game where players play forensic experts solving four different murder cases. The game takes a week of school to play through and is organized as a combination of work in investigative groups (each working on their case) and meetings where groups share information about their individual case and are encouraged by the chief of police—the teacher—to set new goals in their investigation. The game ends when the groups present their theory to the other teams, writing an indictment based on the evidence and testimonies of suspects and witnesses. The interaction in the game is primarily between the students in the classroom and not a computer-student interaction as seen in most traditional computer games.

The game's interface provides the players access to videotaped interviews with "suspects," reports from the local police, maps and pictures of and information about evidence found at the crime scene. In the investigation process the investigators analyze the evidence through laboratory work and analytical processes, using technological and scientific theoretical and practical analysis methods that are available in the Forensic Handbook. Examples of these investigative processes include chemical analyses of samples from a suspect's hands to determine whether that person has gunshot residue on his/her hands, which would indicate that the suspect has fired a gun recently, and measurements of shooting angles to determine the height of the shooter.

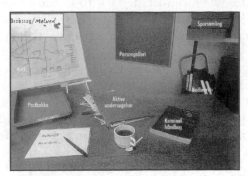

Figure 24.1: Interface for the game *Homicide*: the policeman's desk

The students have to handle different types of data and use different types of skills when they analyze interviews with the suspects, and empirical competencies in handling the data from their technical investigations.

The educational goals of the game are closely integrated in the fictional investigation process. The overall educational goal in the game is that it should support learning of, and working with, the process of inquiry as the basis of scientific investigation. The process contains different steps: problem definition, establishing hypotheses, conducting investigations, making observations, collecting data and explaining results. The methods used to solve the murders, the chemical tests and so on, are or appear authentic. Authenticity is both an educational tool, making the skills and knowledge easier to transfer to a realistic situation or perspective, and an artistic effect. The students have, of course, seen movies and read about police work, and the games' authenticity furthers their motivation.

Homicide "In Action"—Playing the Murder Game

Two studies of two eighth grade classes over one week were conducted as they played *Homicide*. These studies are the first of a larger planned experiment-based study aimed at investigating how the social context of school science education correlates with the game design and how design can be integrated with the social learning situation to create a game-based simulation of science practice.

Each of the studied classes played the full version of the game, which was orchestrated by the classes' science and language teachers. Video observation was conducted in schools, which documented investigation practices of each group and focused on direct interaction in pupils' processes of inquiry [10]. Special attention was paid to the pupils' practice at the different stages of the process, examining how the first hypothesis about possible suspects and

actions in their cases was formulated, what tools and actions were mobilized in the analysis of the data that was generated in the investigation process, and what their argumentation was in formulating a final theory. A twenty-minute focus-group interview was also conducted to probe the pupils' experiences and to document their thoughts and feelings about the game situation and their own understandings of the investigative process.

The general observation in both classes was that the game created an intense learning situation where the pupils organized work in their groups, created tools for the investigation process and actively discussed problems within and among the groups. In the following section I describe examples of two types of situations that are representative of the typical learning game situation in the class: (1) the creation and use of tools in the inquiry process and (2) examples of how the students learned from each other.

Creation of Diagrams to Use as Investigation Tools

Early in the game, the students began producing different types of diagrams to systematize the inquiry process with data collection and analysis and generation of hypotheses. In the game material there is an example of how to create a gallery of suspects in the case, but the pupils' diagrams differ in design and content (see the two figures below). With the aim of studying the pupils' inquiry process, these tools and the social interaction around using and creating these tools became the focus of the study.

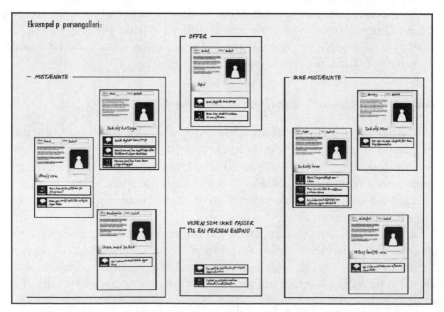

Figure 24.2: Example from the game material of how to create a gallery of suspects

Figure 24.3: Boy using a diagram for presenting his case

The following is an example from the initial phase of the game in one of the classes. A group has independently created a diagram and used it in their presentation of their case:

BOY: We have Niels Andersen here (points to a circle with the name in the centre of the diagram) who was killed. And here are . . . everybody is under suspicion. Flemming Berggren is under suspicion. Morten Møller and Ulla Winther (points) and these are the three people that are the most under suspicion. And Niels Andersen is a pusher and he has been involved in crime with his friend Flemming Berggren (points) and they have probably—this we don't know yet—but they have probably been dealing drugs together because they were convicted in 2001 for dealing drugs (points).

Rather than creating a gallery of suspects by mounting pre-produced posters on a wall, the students independently redesign the tool that is offered in the game. In the diagram produced by the group, the victim's relation to the suspects is represented by lines between boxes; the suspects are represented by square boxes with names. These boxes also contain information about occupation and earlier convictions. After this presentation, the rest of the groups in the class produced similar diagrams, but with different designs such as color-codes for representing different types of information. Some groups extended the use of the diagram by including knowledge about possible motives.

Students used diagrams as representations of their knowledge, for presenting their work at meetings, and also as a working tool. In this example a boy and a girl use the diagram for discussing a case in which a young

accountant, Marie Johansen, has been found dead. The boy and girl go through the information they have accessed by using a diagram they have just made. The girl points at the diagram while the boy writes down the information she gives him. At this point in the game, they have found out that Marie was having an affair with her boss, who is also her sister's, Anne Berg's, husband. Jens Kaspersen is a colleague to Marie.

BOY: Next is Jens Kaspersen,

GIRL: Jens Kaspersen. They both worked in the same company. And Marie Johansen was promoted, probably because she had a sexual relationship with the boss. Jens Kaspersen said so. And once Marie Johansen is dead and all this is over, he'll get her position. And that makes him a suspect, I think. But Anne Berg too . . .

BOY: We aren't trying to solve the murder right now.

GIRL: No, but she said that Marie deserved the promotion because she was very good at her job and very dedicated. That could be because she doesn't want to seem suspicious.

BOY: Yes, to confuse us.

GIRL: She might not know of Marie's relationship to her boss. So I think we should examine the footprints [near where the body was found] to see if they were made by a man or a woman.

In this example, the pupils used the diagram as a tool in forming a hypothesis, interpreting knowledge from interviews and crime scene evidence, and outlining a method with which to test it. The footprints may or may not support the theory that Marie Johansen was murdered by her sister, Anne Berg.

Representations of the Inquiry Process

Diagrams were also used as a tool to represent knowledge at different stages of the investigation process. One example of this was a group that created new diagrams as their work progressed.

Diagram A (see Figure 24.4) was produced early in the investigation process and contains all the initial information about the murder victim, Adam, and his relations to all the suspects in the case. The victim is represented by the central, yellow, square box, relations by lines and suspects by colored boxes. Each suspect is represented by a different color.

In Diagram B (see Figure 24.5) the complexity of diagram A is reduced to a simpler diagram with the three main suspects Said, Preben, and Ole. The group has also included data from the technical investigations they have made, such as analyzing footprints, and depending on which theory they support they are placed under the three different suspect profiles.

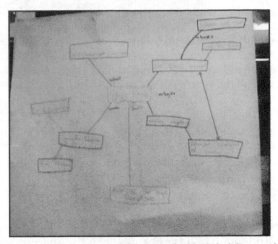

Figure 24.4: Diagram A was created in the initial investigation phase and contains information on all the suspects in the case and their relation to the deceased

Figure 24.5: Diagram B was created in a later phase of the game and only contains information about the three primary suspects Said, Preben, and Ole

In this example one of the girls describes the process to the researcher:

RESEARCHER: But how is that diagram (diagram B) different from this diagram (diagram A)?

GIRL: (Pointing to diagram B) this is just an investigation of whose footprints it is and other examinations we have made, and this one (pointing to diagram A) is a poster so we more easily can work out who it is. So we can get an overview over who we think it is. This one (pointing to diagram B) is more an investigation of some of the things we have done and this (pointing to diagram A) is a quick overview of all the people in the case.

The girl describes how the second diagram is a representation of the knowledge the group has at a later stage of the inquiry, after their various investigations and examinations of technical tests. Their investigations have resulted in a more specific suspicion of two of the suspects in the case. This example shows how the pupils, within the learning space of the game setting, can handle the relatively complex data they are confronted with.

Community Learning in the Game

Each group of students has different cases and is therefore not competing directly with the other groups. There is a general competition to solve the case, but as the groups have different cases there is no reason to withhold information from the other teams. Some characters appear in several cases and the groups can therefore assist each other by passing information among groups. The following is an example of two of the groups discussing methods and results. A boy from the second group is sitting at a table, busy making a poster to present the group's work at the upcoming meeting. A girl from the first group stands beside him and shows him her group's diagram.

GIRL: (Turns away to get the group's diagram) you have to see ours. It's really exciting. She was shot with a hunting rifle. And then we thought . . .

BOY: (Points to the victim's name at the diagram) who shot her?

GIRL: She was shot with a rifle.

BOY: Hmmm.

GIRL: Why?

BOY: Then it's probably someone that is a member of a hunting club

GIRL: Yes, because this guy there he sometimes goes hunting (pointing to one of the suspect's name, Poul Berg, in the diagram). Do you have anything on Poul Berg?

BOY: No.

GIRL: Do you have something on this guy (pointing at another name at the diagram).

BOY: He is the one that was killed in our case.

The girl then reports back to her group what the boy has told her. This is an example of how diagrams are used for exchanging ideas and methods within the social context of the game-based learning environment. How the game design can be a frame for this social learning will be further discussed below.

Discussion

In this chapter, I have presented *Homicide* and the first play tests of it. In these initial tests, the community of learners in the game-based learning environment has proven highly interesting. In the observations of the play-test, pupils handled large amounts of data to establish theories in the game-based learning situation and they independently re-designed the game tools in an effort to establish a coherent hypothesis. These tools became increasingly more sophisticated during the week-long play-test, indicating that the students not only used their individual skills, but that these operated on a methodological meta-level where tools and methods are evaluated and adjusted to meet the challenges of the game. Initially, only one group designed diagrams, but the other examples from the class interaction showed that the other groups not only learned this method from the first group, they went on to re-engineer those designs.

In solving the game tasks, the pupils worked together in and outside groups and ideas and methods were disseminated among groups in the class. This can happen in formal settings, as in the example of the meeting where a boy presented his case using a diagram, but also in more informal settings as in the example of the two children who discussed their different cases. This exchange and sharing of knowledge is not in any way surprising, but is in fact typical for children's and young people's learning praxis, especially in informal learning settings, something which has been identified as an important factor in children's learning from digital media [11,12,13]. It is relevant to take a closer look at the means that support this, as it is an important learning factor not just in relation to learning scientific subject matter, but also in terms of pupils developing their competences to actively participate in project-based learning and learning networks that in many ways differ from the formal educational system they meet at school.

These examples indicate that this IT-supported role-playing game supports the building of communities and communities of practice [14]. It is interesting to identify the game design elements that are likely to support these social processes, including its non-competitive elements that helped facilitate groups assisting each other instead of competing against each other. Another important design factor may be that the computer works more as an active assistant and database than as a gaming space. Most of the learning and

gaming action takes place away from the computer, around tables with printed case files or in a laboratory. How this enhances or limits social interaction and what the result would be of moving this physical interaction to an online setting will be the subject for future experimentation and discussion.

Finally, the game operates to support learners' roles and different communities of practice at different levels: first, there is a community of practice in the classroom consisting of students and teachers. On another level is the simulated science practice where students perform a scientific process of inquiry using the same tools as real-life experts, although in a fictional setting. Another important factor in the discussion of means that support community learning is the teacher's participation in the game. This will be the subject of future studies and experimentation, so I shall not go into an extended description of this element here, but will briefly describe a few preliminary observations. In the game manual, teachers are advised to try to play the role of the chief of investigation and try to simulate an "authentic" police investigation. They are advised to encourage the pupils to run the process independently and not try to control it. They are advised to play the role of the chief in the meetings that form part of the game, and to ask questions like: "What is your theory and why?" "What proof have you?" and "What do these investigations prove?" Some teachers easily take on this role in the simulated practice and constantly refer to the professionalism that is expected from the students. Other teachers maintain the classic teacher role and refer to the game as a set of exercises. What importance this has for the simulated learning practice is a subject for further investigation.

We also need a deeper understanding of what and how the children learn in these game-based learning environments and whether this knowledge— e.g., knowledge about the process of inquiry—can be transferred to other educational settings as a general approach to scientific problems. Very little is known, for example, about this game-based learning space, about how and why the design is effective and whether and how it may be adapted to other settings. The observations presented here raise several questions that might serve as a subject for future studies: what communities are formed in these environments and what roles do the players play? How do communities of practice in the classroom relate to communities of practice in the simulated science practice of the fiction? What roles do students take on in the simulation of science practice? We need a deeper understanding of social learning dynamics in game-based simulated situated science learning spaces and of how we integrate the social context of schools science education into the game design.

References

1. diSessa, A. *Changing Minds: Computer, Learning, and Literacy.* Cambridge, MA, The MIT Press, 2001.
2. Resnick, M. *Turtles, Termites, and Traffic Jams: Explorations in Massively Parallel Microworlds.* Cambridge, MIT Press, 1997.
3. Gee, J. P. *What Video Games Have to Teach us about Learning and literacy.* New York, Palgrave/St. Martin's, 2003.
4. Barnett, M., K. Squire, T. Higgenbotham, and J. Grant. "Electromagnetism Supercharged!" In *Proceedings of the 2004 International Conference of the Learning Sciences.* Los Angeles, UCLA Press, 2004.
5. Klopfer, E., and K. Squire. "Getting Your Socks Wet: Augmented Reality Environmental Science." In *Proceedings of the 2004 International Conference of the Learning Sciences.* Los Angeles, UCLA Press, 2004.
6. Gee, J.P. (2004c). Video Games: Embodied Empathy for Complex Systems, *Paper presented at E3,* Los Angeles, CA.
7. Squire, K., and S. A. Barab. "Replaying history." In *Proceedings of the 2004 International Conference of the Learning Sciences.* Los Angeles, UCLA Press, 2004.
8. Lave, J., & E. Wenger. *Situated Learning: Legitimate Periperal Participation.* Cambridge, UK: Cambridge University Press, 1991.
9. Magnussen, R., and C. Jessen. *Research Report, Homicide.* Denmark, Copenhagen, Learning Lab, 2004.
10. Stigler, J., and J. Hiebert. *The Teaching Gap: Best Ideas from the World's Teachers for Improving Education in the Classroom.* New York, Free Press, 1999.
11. Jessen, C. B. *Leg og Computerspil* (Children, Play and Computer Games). Odense, Odense Universitetsforlag, 2001.
12. Steinkuehler, C. A. "Learning in Massively Multiplayer Online Games." In *Proceedings of the 2004 International Conference of the Learning Sciences (ICLS).* Los Angeles, CA, 2004.
13. Sørensen, B. H., O. Danielsen, and J. Nielsen (eds.), *Learning and Narrativity in Digital Media.* København, Samfundslitteratur, 2002.
14. Wenger, E. *Communities of Practice, Learning, Meaning, and Identity.* Cambridge, Cambridge University Press, 1998.

25. Contexts, Pleasures, and Preferences: Girls Playing Computer Games

Diane Carr

Introduction

Women and girls in the West have reputedly refused to embrace computer games with the same zeal as their male peers. Variously motivated theorists from a range of disciplines have investigated the reasons behind the statistics, and proposed remedies for the situation. One thing these diverse efforts [1,2,3,4,5] have tended to share is an interest in girls and their gaming preferences.

Here the question of girls and their preferences is discussed with reference to observations of a computer games club at a single sex state school in South London. Play observations were combined with video documentation, interviews, and questionnaires in order to investigate these girls' gaming tastes. These observations suggest that when considering games, gender and preference, it is productive to employ a holistic and mobile or dynamic account of tastes and inclination—one that implicitly incorporates existing work within media and cultural studies on active and media literate audiences and their "reading histories" [6,7]. This is important because what became apparent over the course of a school term is that preferences are not static, nor do they emerge in a vacuum.

The problem with ascribing particular preferences directly or solely to player gender is that it divorces gaming tastes from the economic, social, and cultural forces that fuel and inform gaming practices. It is worth noting that here, again, the question of games and gender focuses on the feminine. Games, gaming, and masculinity is a topic calling for investigation, but one that is outside of the scope of this particular piece of research. Generally speaking, digital game developers, publishers, retailers, and their high-profile

marketing campaigns have addressed a male audience. One unsurprising result of this is that this sector of the market has swelled, while others have remained relatively untapped. There are signs that things are changing, and it is feasible that as games continue to shift out of the sub-cultural margins and into the mainstream, distinctions other than that of gender may become more pertinent; that diversity will be further accommodated, and that patterns of participation may alter.

It was certainly the case that for the nine 13-year-old girls in the gaming club, computer and video games were a routine part of their lives. They were all casual, rather than hardcore gamers, in that they played for a couple of hours a week, rather than hours per day (although there were signs that at least one of the players desired much greater levels of access). The girls talked with their friends about games, played at home, and when they visited family, and sought out information online or in gaming magazines occasionally. When interviewed the club members referred to games as a regular, pleasurable yet otherwise unremarkable part of their younger childhood. One of the girls, in fact, was jubilant that her dad had just promised her a new Game Boy as a reward for good grades. We issued questionnaires to fifty-five of the girls' classmates, and found similar results. There were certainly varying degrees of access, but most played digital games of one sort or another on a fairly regular basis.

Of course there are multiple factors active in contemporary culture and in the lives of male and female players, impacting on how games are regarded, and how players position themselves in relation to gaming culture. In the play sessions observed during this research, elements including humor, music, the attractiveness of certain male avatars, or the appetite for all things Harry Potter, were integral to the choices and preferences demonstrated. These 13-year-olds would discuss the merits of the different platforms, and particular games, not just as players, but as canny, proto-contenders in consumer culture. This discourse cannot be divorced from wider gaming culture (where it links with notions of cultish expertise), nor can it be entirely separated from considerations of gender, age, race or class.

Play and Situated Preference

Most of the participants who joined the computer games club were volunteered by the school, and a few girls heard about the club and joined up. The group quickly settled at nine members, with a few regular spectator/visitors and an ever-expanding waiting list. Once the club was up and running it became necessary to limit entry in order to prevent overcrowding. The club ran on Tuesday lunchtimes for the duration of a school term. There is no pretence in this discussion that this is a particularly "natural" situation. The

focus here is on the constituents of preference in a particular situation, and the links between access, context and preference—so the fact that this is an arranged rather than "found" scenario is not felt to be an issue. One or two adults were generally present, and would occasionally help out with technical issues or even join in a games session—but they did not orchestrate player groupings. In this instance the author did not participate in actual gameplay but rather observed and video-documented the sessions.

At the start of the term, and again at the end, the girls completed questionnaires on which they were asked to list their favorite games. On both questionnaires the girls listed a wide variety of games and genres: fighting and racing games were mentioned repeatedly, games from the *Grand Theft Auto* series were popular, as were action-adventure games and *The Sims*. In the context of this chapter, however, what is significant is that the girls listed a total of twenty-six games on the later questionnaire, and this included sixteen new games, nine of which they had played during the sessions. The girls' new favorites included named titles (*Midtown Madness 3, Jak and Daxter*), but also entirely new genres ("fighting games"). The initial preferences expressed on the first questionnaire presumably relate to games that the girls had previously accessed. The alterations shown in the later responses could reflect a number of variables—the girls being in a different mood, for instance. These shifts, however, also indicate that simply offering these users alternative games in a new context was sufficient to generate changes in their stated tastes. What this suggests is that when investigating gaming inclinations the relationship between previous access and expressed preferences should not be overlooked.

Certain site specifics were implicated in the preferences demonstrated by these users. These included the layout of the room, as well as timing, territory and hardware (whose turn it is, who got there first, etc.). Obviously the games supplied were also a factor in the girls' choices (see Table 25.1), as was the particular type of play offered by different games, and the allure of popular trans-media franchises. We attempted to supply a mixed bag of popular games, but with a limited budget we were reliant to some degree on the games that we had to hand. The games were piled on a table in the center of the room and the girls were free to help themselves. If a girl did not have a particular game in mind she might rifle through the available titles and pick out one based on its packaging, but if the gameplay did not appeal, it would soon be discarded.

While most of these games were picked and played at some point, certain games were picked with notable regularity. There was a Playstation 2 and an Xbox, and six PCs in the room. The consoles were near the door, and offered 2-player games. For these reasons the area around the consoles was the loudest and the most social part of the room and thus, *in this specific instance,* the

Table 25.1: Games supplied during the term

XBox	*Halo, Midtown Madness 3, Terminator 3, Dead or Alive 3, Buffy the Vampire Slayer*
PS2	*Jak and Daxter, Tomb Raider 4, Tony Hawks Pro Skater 4, Abe's Oddysee, Oni, Primal, Soul Reaver 2, Time Splitters 2, XIII, Enter The Matrix*
PC	*Deus Ex, Dino Crisis, Lord of the Rings; The Fellowship of the Ring, Neverwinter Nights, Warcraft 3, Tomb Raider 2, Baldur's Gate, The Sims, Harry Potter and the Philosopher's Stone, Tony Hawks Pro Skater 3, Black & White, Sid Meier's Civilization III, HalfLife, Harry Potter and the Prisoner of Azkaban*

consoles were less conducive to private or contemplative gaming than the PCs. As an outcome, the most popular games on the consoles were the ones that offered instant gratification, pace, tricks, humor, dual-play, and turn-taking, rather than games that were orientated towards narrative or that demanded sophisticated tactics. This meant that *Tony Hawks Pro Skater 4* (a skateboarding game), *Midtown Madness 3* (a comical driving game) and *Dead or Alive 3* (a fighting game) were consistently selected, and played for longest on the consoles. The stunts, options, character selections, and special moves in these games were accessed in an experimental, playful manner. Skills acquisition at the consoles did occur, yet it did not look particularly systematic—one player stated that she liked *Midtown Madness* "because I crashed into everything"—but another girl said that she enjoyed learning new tricks in *Tony Hawks,* while the girls who liked *Dead or Alive 3* appreciated that there were "loads of new moves to learn." One player remarked that "this game was good cos they had really good graphics and I'm always winning." The girls were happy to compete in *Dead or Alive*—the players occasionally sang or danced when they won a round—but instances of coaching were also frequent.

The PCs, on the other hand, were placed in a quieter section of the room and as an apparent consequence different genres were preferred. Here the girls generally put on headphones to settle in for thirty minutes of solo gaming. Onlookers were tolerated but interruptions were not welcome and there was little or no turn taking. Different games were tried out, but the most consistently popular were *The Sims,* the two *Harry Potter* games and the *Lord of the Rings* games. These action-adventure games reward a player's investment of time with characterization, sequential missions, or storytelling. The

Harry Potter games are "fun because [they] are just like the movie/book and you get to learn the spells." *The Sims* offers incremental complexity and the chance to take control—as one player explained: "I could make their lives enjoyable or miserable."

So, the division of the room into noisier and quieter areas, and into sociable or more private zones, combined with the styles of play (instantaneous, or more contemplative) that various games offered. In short, the preferences demonstrated by the girls were shaped by the context of play, in combination with the styles of play that various games offer, *and* the player's awareness of such offers. In each instance, the ability of the girls to recognize and actualize the pleasures promised by different games was enabled by their being literate in the forms of play available, and the kinds of experiences potentially on offer.

Text and Representation

As facilitators we made a concerted effort to include as many female avatars as possible, so a reasonable proportion of the games we supplied featured female leads—and showed images of the heroine on their packaging. These included *Oni, Primal, Enter The Matrix, Dino Crisis, Tomb Raider IV,* and *Tomb Raider II* (while in the RPGs *Baldur's Gate* and *Neverwinter Nights* the player has the option to construct a female lead character). For some women players the manner in which female avatars are included, excluded or depicted is certainly an issue (see www.womengamers.com for a discussion of "digital women"). These girls, however, showed no noticeable, additional interest in these games. In fact, we were impressed by the degree of ambivalence they inspired. Perhaps this was because of the girls' age, or because they were in a primarily female environment, or because they were in public. Whatever the reason, this disinterestedness is enough to suggest that 13-year-old girls playing games at a single sex school do not regard a female avatar as a particular bonus. When given the option to play as either a male or a female character, the girls would either show no preference and playfully switch between the options (as with *Dead or Alive 3*), or they might actually prefer to play with/as a male avatar despite having the option of a female—as was consistently the case with *Tony Hawks Pro Skater 4*.

We distributed a questionnaire to fifty-five of the club members' fellow students (same year, same school) in order to contextualize our observations of the gaming sessions. It included questions relating to games, access, and tastes. For instance, the girls were asked 'If you could create a computer game or video game character, what would they be like?' Nearly 60% of those who answered this question did not specify a gender for their character at all—they instead listed non-specific characteristics ("joyous," "funny,"

"loud," "adventurous," and "independent") or included the choice of male or female. Around 25% of the respondents wanted to play with funny or attractive male characters ("strong, buff male, muscley'" or "tall, strong and rich with good taste and style," "muscley, dark, good looking," "six pack, single plaits in hair"). The smaller remainder specified that they would create a female character. Interestingly, it was girls with the highest degree of access (i.e., girls with a games console at home that they considered "their own") who were the most likely to specify a gender for their avatar, plus they were slightly more likely to designate it male. In other words, the allocation of a particular gender or maleness to an avatar might not reflect the preference of a player, as much as it reflects that player's familiarity with console game conventions.

When asked to list the attributes of the best games at the gaming sessions, the girls gave the following responses: being in control (especially of *The Sims*), and having good music and graphics. A game should have choice and variety; it should be unpredictable. There should be action and a range of characters, and the possibility of interesting missions and tasks. Magic and adventure were listed as desirable. Plus, a game should be easy to learn, yet hard to play (but not *too* hard!). In order to demonstrate, of course, that there was anything particularly feminine about these preferences it would be necessary to contrast them with the preferences of these players' male peers (peers in terms of age, and also in terms of their being casual rather than hardcore gamers).

The presence of these desired characteristics, however, was no guarantee of popularity. Other factors still determine if a player will become aware of an unfamiliar game's offers and potentials—or not. For instance, none of the club members showed any interest in playing *Buffy The Vampire Slayer* until the penultimate week of term, when a few of the girls arrived early and found the sessions' facilitators playing it on the Xbox. What they saw of *Buffy*'s game-play was sufficient to spark their interest. Then, by passing around the controls, calling out instructions to each other, and shrieking at the 'scary bits,' the girls managed to convert it into a rowdy and sociable group activity. Thus several factors were complicit in their late predilection for *Buffy*. First, the game only became interesting after the girls had seen others engrossed by it. Secondly, after a term with *Tony Hawks* and *Dead or Alive 3*, the girls had become adept at generating their own preferred form of group play.

We had also supplied a number of RPGs for the PCs including *Baldur's Gate* and *Neverwinter Nights*. These games involve creating a central character, using spells and potions, and exploring a vast fantasy world. As noted, these players stated preferences for variation in character, magic, missions and adventuring, yet none chose to play these games. The players had no prior

experience with the genre, and this appears to have played a part in their disinterest. If the group had contained one RPG enthusiast it may have been enough to trigger curiosity in the others—just as watching others play had resulted in *Buffy* attaining last minute popularity. In this case, however, these games were unfamiliar and as a result they simply failed to register with these users.

This suggests that while preferences are open to alteration, there needs to be a motivating catalyst or transitional support when players are confronted by a complex and unfamiliar genre. Such a catalyst might be social—but it is also possible that it could be textual, or trans-textual: had these RPGs been set in "Harry Potter world," for instance, it is likely that the girls would have at least tried them, regardless of their unfamiliarity with the genre.

Conclusion

So, what computer games do girls like? The answer is that it depends. Socialization may well play its part, yet our gaming preferences will also depend on where we are, what we know, who we know, what we've tried, and what we've grown tired of. Distinctions in taste between male and female players reflect patterns in games access and consumption that spring from (very) gendered cultural and social practices. As this suggests, accounts of gaming preference need to be situated within a framework that incorporates reference to players' previous access to games and existing gaming knowledge. Gaming preferences need to be conceptualized within a paradigm that can accommodate mobility, increment, learning and alteration.

Different people will accumulate particular gaming skills, knowledge and frames of reference, according to the patterns of access and peer culture they encounter—and these accumulations will pool as predispositions, and manifest as preferences. Familiarity and competence feed into a player's experiences of gaming, partly determining the pleasures that he or she will expect, recognize and access, and thereby impacting on preferences that might be expressed as a result. Preferences are an assemblage, made up of past access and positive experiences, and subject to situation and context. The constituents of preference (such as access) are shaped by gender and, as a result, gaming preferences manifest along gendered lines. It is not difficult to generate data that will indicate that gendered tastes exist, but it is short sighted to divorce such preferences from the various practices that form them. To attribute gaming tastes directly, solely or primarily to an individual subject's gender, is to risk underestimating the complexities of both subjectivity and preference.

On a final note, it is absolutely possible that various factors bolstered the club members' enthusiastic engagement with games during the computer

gaming sessions described in this chapter. It could be argued that we created something of an artificial environment, an anomalous "bubble" where it was the norm that girls and women enjoy playing and talking about computer games. However, it is also true that outside of any such bubble, the relationship of girls—or boys, women or men—to computer games is just as constructed.

Acknowledgments

This chapter originated as a presentation for DiGRA 2005, which was in turn abridged from "Contexts, Gaming Pleasures and Gendered Preference"—an article in press with the journal *Simulation and Gaming*, D. Myers and J. Colwell, eds., December 2005, Vol. 36, No. 4). This research was undertaken with the support of the Eduserv Foundation. I would like to thank my colleague Caroline Pelletier, who was the primary facilitator of the game sessions.

References

1. Bryce, J., and J. Rutter. "Killing Like a Girl: Gendered Gaming and Girl Gamers' Visability." In *Proceedings of the Computer Games and Digital Culture Conferences,* Tampere, Finland, 2002.
2. Cassell, J., and H. Jenkins. *From Barbie to Mortal Combat: Gender and Computer Games.* Cambridge, MA, MIT Press, 2000.
3. Kerr, A. "Women Just Want to Have Fun: A Study of Adult Female Players of Digital Games." In *Proceedings of the Level Up: Digital Games Research Conference,* Utrecht, 2003.
4. Krotoski, A. *Chicks and Joysticks: An Exploration of Women and Gaming.* Entertainment and Leisure Software Publishers Association (ELSPA), 2004. London.
5. Schott, G., and K. Horrell. "Girl Gamers and their Relationship with the Gaming Culture." *Convergence,* 6 (2000): 36–53.
6. Buckingham, D., and J. Sefton-Green. *Cultural Studies Goes to School: Reading and Teaching Popular Media.* London, Taylor and Francis, 1994.
7. Jenkins, H. *Textual Poachers, Television Fans and Participatory Culture.* New York: Routledge, 1992.

Games Cited

1. *Baldur's Gate* (1998) Bio Ware Corp., Black Isle Studios/Interplay.
2. *Black and White* (2001) Lionhead Studios, EA Games.
3. *Buffy the Vampire Slayer* (2002) The Collective Inc., Electronic Arts.
4. *Dance Dance Revolution* (2001) Konami, Konami.
5. *Dead or Alive 3* (2002) Team Ninja, Tecmo Ltd.
6. *Deus Ex* (2000) Ion Storm, Eidos Interactive.
7. *Dino Crisis* (2000) Capcom, Capcom.
8. *Enter the Matrix* (2003) Shiny Entertainment, Atari Inc.

9. *Grand Theft Auto III* (2001) DMA, Rockstar Games.
10. *Half-Life* (1998) Valve Software, Sierra On-line Inc.
11. *Halo* (2001) Bungie Software, Microsoft.
12. *Harry Potter and the Philosopher's Stone* (2001) KnowWonder, EA Games.
13. *Harry Potter and the Prisoner of Azkaban* (2004) EA UK, EA Games.
14. *Jak and Daxter: The Precursor Legacy* (2001) Naughty Dog, Inc. SCEA Inc.
15. *Lord of the Rings, The Fellowship of the Rings* (2002) Surreal Software Inc., Black Label Games.
16. *Midtown Madness 3* (2003) Digital Illusions CE AB, Microsoft Game Studios.
17. *Neverwinter Nights* (2002) Bio Ware Corp., Atari Interactive, Inc.
18. *Oddworld Abe's Oddyssee* (1997) Oddworld Inhabitants, GT Interactive Software.
19. *Oni* (2001) Rockstar Canada, Rockstar Games.
20. *Primal* (2003) SCEE Cambridge, SCEA.
21. *Sid Meier's Civilization III* (2001) Firaxis Games, Infogrames Interactive Inc.
22. *Soul Reaver 2* (2001) Crystal Dynamics Inc., Eidos Interactive.
23. *Terminator 3: The Redemption* (2004) Paradigm Entertainment Inc., Atari Inc.
24. *The Sims* (2000) Maxis, Electronic Arts.
25. *Time Splitters 2* (2002) Free Radical Design, Eidos Interactive.
26. *Tomb Raider II* (1997) Core Design Ltd., Eidos Interactive.
27. *Tomb Raider IV The Last Revelation* (1999) Core Design Interactive, Eidos Interactive.
28. *Tony Hawk's Pro Skater 3* (2002) (for PC) Gearbox Software, Activision 02.
29. *Tony Hawk's Pro Skater 4* (2002) Vicarious Visions, Activision 02.
30. *WarCraft 3* (2003) Blizzard Entertainment, Blizzard Entertainment.
31. *WWF SmackDown* (2000) Yuke's Co. Ltd, THQ Inc.
32. *XIII* (2003) Ubisoft Montreal, Ubisoft Entertainment.

26. *Are Video Games Good for Learning?*

JAMES PAUL GEE

Introduction

A new research field is emerging around the hypothesis that video games are good for learning [1,2,3]. This hypothesis amounts to two claims. First, good commercial games are built on sound learning principles [2] that are supported by research in the Learning Sciences [4]. And, second, video game technologies hold out great promise, beyond entertainment, for building new learning systems for serious purposes in and out of school.

There are, of course, different types of video games, types which may well be better or worse suited for different learning goals. We can make a distinction between two major types of games, what I will call "problem games" and "world games," though the distinction is not air tight. Problem games focus on solving a given problem or class of problems (e.g., *Tetris, Diner Dash*), while world games simulate a wider world within which, of course, the player may solve many different sorts of problems (e.g., *Half-Life, Rise of Nations*). Classic early arcade games like *Super Mario* sit right at the border of this division.

The features of video games that hold out promise for good learning lead to key questions for research in the emerging field of games and learning. I will sketch some of these features and the accompanying research questions to which they lead. Some of the features that appear to make video games good for learning have little to do with the fact that they are games. Other features are more directly related to the "gameness" of video games. I start with features which have little to do with the fact that video games are games and then turn to features more directly connected to video games as games of a certain sort. However, we should keep in mind that the "non-game" features may not work as well for learning if they are detached from the "game" features. This, at least, is one key question for research.

Empathy for a Complex System

Consider scientific simulations, simulations of things like weather systems, atoms, cells, or the rise and fall of civilizations. Scientists are not inside these simulations in the way in which players are inside the simulated worlds of games like *Thief*. The scientist does not "play" an ant in his or her simulation of an ecosystem. The scientist does not discover and form goals from the perspective of the ant in the way a player does from the perspective of Garrett in *Thief*.

However, it turns out that at the cutting edge of science, scientists often talk and think *as if* they were inside not only the simulations they build, but also even the graphs they draw. They try to think from within local regions of the system being simulated, while still keeping in mind the system as a whole. They do this to gain a deeper feel for how variables are interacting the system. Just as a player becomes Garrett, a scientist can talk and think as if he or she were actually an electron in a certain state or an ant in a colony. For example, consider the following well-known example of a physicist talking to other physicists while looking and pointing to a graph on a blackboard [5]:

> But as you go below the first order transition you're (leans upper body to right) still in the domain structure and you're still trying to get (sweeps right arm to left) out of it.

> Well you also said (moves to board; points to diagram) the same thing must happen here. (Points to the right side of the diagram.) When (moves finger to left) I come down (moves finger to right) I'm in (moves finger to left) the domain state. (pp. 330–331)

Notice the "you's" and "I's." The scientist talks and acts as if he and his colleagues are moving their bodies not only inside the graph, but inside the complex system it represents, as well.

A key research question that arises here, then, is this: though video games and scientific simulations are not the same thing, can video games, under the right circumstances, encourage and actually enact a similar "attitude" or "stance" to the one taken by scientists studying complex systems? This stance involves a sort of "embodied empathy for a complex system" where a person seeks to participate in and within a system, all the while seeing and thinking of it as a system and not just local or random events. This does, indeed, seem similar to the stance players take when they play as Garrett in a game like *Thief* and seek to figure out the rule system that underlies the virtual world through which Garrett (and they) moves. We can go on to ask whether video games could create such empathy for the sorts of complex systems relevant to academic and other domains outside of entertainment (e.g., urban planning, space exploration, or global peace).

Simulations of Experience and Preparations for Action

Video games don't just carry the potential to replicate a sophisticated scientific way of thinking, they may actually externalize the way in which the human mind works and thinks in a better fashion than any other technology we currently have. Consider, in this regard, some recent research in the Learning Sciences [in the quotes below, the word "comprehension" means "understanding words, actions, events, or things"]

. . . comprehension is grounded in perceptual simulations that prepare agents for situated action. [6]

. . . higher intelligence is not a different kind of process from perceptual intelligence. [7]

What these remarks mean is this: human understanding is not primarily a matter of storing general concepts in the head or applying abstract rules to experience. Rather, humans think and understand best when they can imagine (simulate) an experience in such a way that the simulation prepares them for actions they need and want to take in order to accomplish their goals [8,9,10]. Effective thinking is about perceiving the world in such a way that the human actor sees how the world, at a specific time and place (as it is given, but also modifiable), can afford the opportunity for actions that will lead to a successful accomplishment of the actor's goals. Generalizations are formed, when they are, bottom up from experience and imagination of experience.

Video games are external (i.e., not mental) simulations of worlds or problem spaces in which the player must prepare for action and the accomplishment of goals from a particular perspective. Gamers learn to see the world of each different game in a quite different way. But in each case they must learn to see the virtual world in terms of how it will afford the sorts of actions they (where "they" means a melding of themselves and their virtual character) need to take to accomplish their goals (to win in the short and long run).

For example, players see the world in *Full Spectrum Warrior* as routes (for a squad) between cover (e.g., corner to corner, house to house), because this prepares them for the actions they need to take, namely attacking without being vulnerable to attack. They see the world of *Thief* in terms of light and dark, illumination and shadows, because this prepares them for the different actions they need to take in this world, namely hiding, disappearing into the shadows, sneaking, and otherwise moving unseen to your goal.

While commercial video games often offer worlds in which players prepare for the actions of soldiers or thieves, the question arises as to whether other types of games could let players prepare for action from different per-

spectives or identities such as a particular type of scientist, political activist, or global citizen, for instance. If games could play this role, they would speak to one of the deeper problems of education, the fact that many students who can pass paper-and-pencil tests cannot actually apply their knowledge to real problem solving [11].

Distributed Intelligence via the Creation of Smart Tools

Good video games distribute intelligence [12] between a real-world person and artificially intelligent virtual characters. For example, in *Full Spectrum Warrior,* the player uses the buttons on the controller to give orders to two squads of soldiers (the game *SWAT 4* is also a great equivalent example here). The instruction manual that comes with the game makes it clear from the outset that players, in order to play the game successfully, must take on the values, identities, and ways of thinking of a professional soldier: "Everything about your squad," the manual explains, "is the result of careful planning and years of experience on the battlefield. Respect that experience, soldier, since it's what will keep your soldiers alive" (p. 2). In the game, that experience— the skills and knowledge of professional military expertise—is distributed between the virtual soldiers and the real-world player. The soldiers in the player's squads have been trained in movement formations; the role of the player is to select the best position for them on the field. The virtual characters (the soldiers) know part of the task (various movement formations) and the player must come to know another part (when and where to engage in such formations). This kind of distribution holds for every aspect of professional military knowledge in the game.

By distributing knowledge and skills this way—between the virtual characters (smart tools) and the real-world player—the player is guided and supported by the knowledge built into the virtual soldiers. This offloads some of the cognitive burden from the learner, placing it in smart tools that can do more than the learner is currently capable of doing by him or herself. It allows the player to begin to act, with some degree of effectiveness, before being really competent: "performance before competence." The player thereby eventually comes to gain competence through trial, error, and feedback, not by wading through a lot of text before being able to engage in activity.

Such distribution also allows players to internalize not only the knowledge and skills of a professional (a professional soldier in this case), but also the concomitant values ("doctrine" as the military says) that shape and explain how and why that knowledge is developed and applied in the world. This suggests an important question for research: whether and how other "professions"—scientists, doctors, government officials, urban planners,

political activists (Shaffer 2004)—could be modeled and distributed in this fashion as a deep form of value-laden learning (and, in turn, learners could compare and contrast different value systems as they play different games).

Shaffer's [13,14] "epistemic games" already give us a good indication that even young learners, through video games embedded inside a well-organized curriculum, can be inducted into professional practices as a form of value-laden deep learning that transfers to school-based skills and conceptual understandings. However, much work remains to be done here in making the case that the knowledge, skills, and values that good games offer transfer to school and, in particular, to students' learning in traditional content areas.

"Cross-Functional Teams"

Consider a small group partying (hunting and questing) together in a massive multiplayer game like *World of WarCraft*. The group might well be composed of a Hunter, Warrior, Druid, Mage, and Priest. Each of these types of characters has quite different skills and plays the game in a different way. Each group member must learn to be good at his or her special skills and also learn to integrate these skills as a team member within the group as a whole. Each team member must also share some common knowledge about the game and game play with all the other members of the group—including some understanding of the specialist skills of other player types—in order to achieve a successful integration. So each member of the group must have specialist knowledge (intensive knowledge) and general common knowledge (extensive knowledge), including knowledge of the other member's functions.

Players—who are interacting with each other in the game and via a chat system—orient to each other not in terms of their real-world race, class, culture, or gender (these may very well be unknown or, if communicated, made up as fictions). They must orient to each other, first and foremost, through their identities as game players and players of *World of WarCraft* in particular. They can, in turn, use their real-world race, class, culture, and gender (for better or worse) as strategic resources if and when they please, and the group can draw on the differential real-world resources of each player, but in ways that do not force anyone into pre-set racial, gender, cultural, or class categories.

This form of affiliation—what I will call cross-functional affiliation—has been argued to be crucial for the workplace teams in modern "new capitalist" workplaces, as well as in contemporary forms of social activism, for example, in the Green movement [15,16,17]. People specialize, but integrate and share, as well. They organize around a primary affiliation to their common goals and use their cultural and social differences as strategic resources, not as barriers. The crucial research questions here are whether such collaborative

work in commercial games transfers to collaborative abilities in other settings and whether good video games designed around other sorts of content can teach collaboration and cross-functional teamwork for institutions like schools and workplaces. The Army, in particular, has made this assumption in regard to games like *America's Army*, but it remains to be empirically demonstrated in other domains.

Situated Meaning

Words do not have just general dictionary-like meanings. They have different and specific meanings in different situations in which they are used and in different specialist domains that recruit them [16]. This is true of the most mundane cases. For instance, notice the change in meaning in the word "coffee" in the following utterances which refer to different situations: "The coffee spilled, go get the mop" (coffee as liquid), "The coffee spilled, go get a broom" (coffee as grains), "The coffee spilled, stack it again" (coffee in cans). Or notice the quite different meanings of the word "work" in everyday life and in physics (e.g., I can say, in everyday life, that I worked hard to push the car, but if my efforts didn't move the car, I did no "work" in the physics sense of the word).

A good deal of school success is based on being able to understand complex academic language [16]—like the text printed below from a high-school science textbook. Such a text can be understood in one of two different ways: either verbally or in a situated fashion. When students understand such language only verbally, they can trade words for words, that is, they can replace words with their definitions. They may be able to pass paper-and-pencil tests, but they often cannot use the complex language of the text to facilitate real problem-solving, because they do not actually understand how the language applies to the world in specific cases for solving such problems. But if and when they do come to understand how the words apply to specific situations and for specific problem solutions, then they understand the words in a situated fashion. We have known for years now that a great many school students can get good grades on paper-and-pencil tests in science, for example, but can't use their knowledge to solve actual problems [11].

> The destruction of a land surface by the combined effects of abrasion and removal of weathered material by transporting agents is called erosion. . . . The production of rock waste by mechanical processes and chemical changes is called weathering.

People acquire situated meanings for words—that is, meanings that they can apply in actual contexts of use for action and problem solving—only when they have heard these words in interactional dialogue with people more

expert than themselves [18] and when they have experienced the images and actions to which the words apply [16]. Dialogue, experience, and action are crucial if people are to have more than just words for words, if they are to be able to relate words to actual experiences, actions, functions, and problem solving. As they can do this for more and more contexts of use, they generalize the meanings of the word more and more, but the words never lose their moorings in talk, embodied experience, action, and problem solving.

Since video games are simulations of experience, they can put language into the context of dialogue, experience, images, and actions. They allow language to be situated. Furthermore, good video games give verbal information "just in time"—near the time it can actually be used—or "on demand," when the player feels a need for it and is ready for it [2]. They do not give players lots and lots of words out of context before they can be used and experienced or before they are needed or useful. This would seem to be an ideal situation for acquiring new words and new forms of language for new types of activity, whether this be being a member of a SWAT team or a scientist of a certain sort. Given the importance of oral and written language development (e.g., vocabulary) to school success, it is crucial that this assumption be tested both in terms of the language players pick up from commercial games (e.g., young children playing *Yu-Gi-Oh*, a game which contains very complex language, indeed) and in terms of how games can be made and used for the development of specifically school-based (or other institutional) language demands.

Open-Endedness: Melding the Personal and the Social

In a video game, the player "plays" a character or set of them. The player must discover what goals this character has within the game world and carry them out, using whatever abilities the character has. In *Thief,* the player comes to realize that Garrett has specific goals that require stealth (for which Garret is well suited) to carry out. These are the "in game" goals the player must discover and carry out.

But in good open-ended games, games like *The Elder Scrolls III: Morrowind, Arcanum, The Sims, Deus Ex 2, Mercenaries, Grand Theft Auto,* and many more, players also make up their own goals, based on their own desires, styles, and backgrounds. The player must then attribute these personal goals to the virtual character and must consider the affordances in the virtual world (figure out the rule system) so as to get these personal goals realized along with the virtual character's more purely "in game" goals.

For example, in *The Elder Scrolls III: Morrowind,* a player may decide to eschew heavy armor and lots of fighting in favor of persuasive skills, stealth, and magic, or the player can engage in lots of face-to-face combat in heavy

armor. The player can carry out a linear sequence of quests set by the game's designers or can make up his or her own quests, becoming so powerful that the designer's quests become easy and only a background feature of the game. In *Grand Theft Auto III*, the player can be evil or not (e.g., the player can jump in ambulances and do good deeds), can do quests in different orders, and can play or not play large pieces of the game (for example, he or she can trigger gang wars or avoid them altogether). Even in less open-ended games, players, even quite young ones, set their own standards of accomplishment, replaying parts of the game so that their hero pulls things off in the heroic fashion and style the player deems appropriate.

This marriage of personal goals and "in game" goals is a highly motivating state. When people are learning or doing science, they must discover and realize goals that are set up by the scientific enterprise as a domain and as a social community. These are equivalent to "in game" goals. But they also, when effective, marry these goals to their own personal goals, based on their own desires, styles, and backgrounds. When they do this, there is no great divide between their scientific identity and their "life world," their personal and community-based identities and values. Good video games readily allow such a marriage, good science instruction should too. The research question here, then, is whether and how we could use video games to better achieve this marriage of "in game" goals (i.e., the goals that flow from an academic area or from the teacher) and personal goals and learning styles for school learning and learning in other sites.

Games as Games

So far I have discussed features of good video games that I believe facilitate good learning, but which are features not closely tied to the fact that video games are games. These features were

1. Video games can create an embodied empathy for a complex system
2. They are simulations of embodied experience
3. They involve distributed intelligence via the creation of smart tools
4. They create opportunities for cross-functional affiliation
5. They allow meanings to be situated
6. They can be open-ended, allowing for goals that meld the personal and the social.

None of this is to say that video games do these good things all by themselves. It all depends on how they are used and what sorts of wider learning systems (activities and relationships) they are embedded within. And this, indeed, raises one of the most important research questions for the field of

games and learning: What sorts of wider learning systems ought games to be embedded within if we are to leverage their powers for learning to the greatest degree? With what other activities—in game and out of game—ought they to be paired? What are the most effective roles for teachers in these learning systems?

The features we have looked at do not speak directly to video games as games (and games of a certain sort) and, indeed, these features all seem to be somewhat removed from the pleasures that games as games give us humans. However, it is certainly a leading question for research whether these features will work for learning well, or as well, if they are not embedded in video games that not only have these features but are good games, as well. What are the features that make a video game a game and a good game? What are the sources of the pleasures people draw from video games? How do these features relate to learning?

Hardly anyone has failed to notice how profoundly motivating video games are for players. Players focus intently on game play for hours at a time, solving complex problems all along. In an "attentional economy," where diverse products and messages, not to mention school subjects, compete for people's limited attention, video games draw attention in a deep way. It is clearly a profoundly important subject for research to understand the source or sources of this motivation. Such motivation is clearly foundational for learning.

Oddly enough, one hypothesis here is that it is problem solving and learning, as well as the display of mastery, that are themselves a key source of motivation in good video games. If this is true, then, we need to know why learning and mastery is so motivating in this context and not always as motivating in school. Here another hypothesis would be that learning and mastery are motivating in good video games precisely because they use the sorts of deep learning principles we have just discussed above, as well as others. But, of course, we need to know whether, when the content of a video game is based on more academic or specialized learning goals, the same sorts of effects can occur. Some people assume that things like science can never be made as enticing as fighting fictional wars in *America's Army* or running a family in *The Sims*, for example—but I know of no good scientist who does not find science motivating, entertaining, and life enhancing.

There are certainly features connected to video games as games that help explain both the motivation they recruit and the learning they enable. First, the role of failure is very different in video games than it is in school. In good games, the price of failure is lowered—when players fail, they can, for example, start over at their last saved game. Furthermore, failure—for example, a failure to kill a boss—is often seen as a way to learn the underlying pattern and eventually to win. These features of failure in games allow players to take

risks and try out hypotheses that might be too costly in places where the cost of failure is higher or where no learning stems from failure.

Every gamer and game scholar knows that a great many gamers, including young ones, enjoy competition with other players in games, either one on one or team based. It is striking that many young gamers see competition as pleasurable and motivating in video games, but not in school. Why this is so ought to be a leading question for research on games and learning. One thing seems evident, namely that competition in video games is seen by gamers as social and is often organized in ways that allow people to compete with people at their own level or as part and parcel of a social relationship that is as much about gaming as winning and losing. Furthermore, gamers highly value collaborative play, for example, two people playing *Halo* together to beat the game or the grouping in massive multiplayer games like *World of WarCraft*. Indeed, collaboration and competition seem often to be closely related and integrated in gaming, though not in school.

Beyond issues of motivation, failure, competition, and collaboration, the very ways in which games are designed as games seem to give them features that both enhance learning and a sense of mastery. This is a hypothesis that needs testing. Nonetheless, there are some features of the very design of video games that appear to be closely associated with well-known principles of learning. I list some of these design features below:

1. **Interactivity:** In a video game, players make things happen; they don't just consume what the "author" (game designer) has placed before them. In good games, players feel that their actions and decisions—and not just the designers' actions and decisions—are co-creating the world they are in and the experiences they are having. What the player does matters and each player, based on his or her own style, decisions, and actions, takes a somewhat different trajectory through the game world. The more open-ended a game is the more true this is, though in a more limited sense it is true of all games, since players must play them and play is a form of simultaneous "reading" (interpreting) and "writing" (producing). All deep learning involves learners feeling a strong sense of ownership and agency, as well as the ability to produce and not just passively consume knowledge.

2. **Customization:** In some games, players are able to customize the game play to fit their learning and playing styles, for example, through different difficulty levels or the choice of playing different characters with different skills. In others, the game is designed to allow different styles of learning and playing to work (e.g., there are multiple ways to solve the problems in the game), for example, in the

Deus Ex games and role-playing games like *Arcanum*. Customization, in the sense of catering to different learning styles and multiple routes to success, is an important learning principle in many different areas.

3. **Strong Identities:** Good games offer players identities that trigger a deep investment on the part of the player. This identity is often connected to a specific virtual character, though sometimes it is attached to a whole "civilization" (as in *Civilization* or *Rise of Nations*). When gamers are playing characters, strong identities are achieved in one of two ways: Some games offer a character so intriguing that players want to inhabit the character and can readily project their own fantasies, desires, and pleasures onto the character (e.g., Solid Snake in the *Metal Gear Solid* games). Other games offer a relatively empty character whose traits the player must determine, but in such a way that the player can create a deep and consequential life history in the game world for the character (e.g., in role-playing games like *The Elder Scrolls III: Morrowind*). Furthermore, in games, the identity of the character one plays is very clearly associated with the sorts of functions, skills, and goals one has to carry out in the virtual world. Many people have argued that identity (e.g., "being-doing a scientist" in order to learn science) in this sense is crucial for deep learning (e.g., [13,16,19]).

4. **Well-ordered problems:** Problems in good games are well ordered. In particular, early problems are designed to lead players to form good guesses about how to proceed when they face harder problems later on in the game. In this sense, earlier parts of a good game are always looking forward to later parts. This is part of what good level design is all about. Work on the mind and learning which takes a connectionist approach has argued that such ordering is crucial for effective learning in complex domains (e.g., [20,21]).

5. **Games are pleasantly frustrating:** Good games adjust challenges and give feedback in such a way that different sorts of players feel the game is challenging but doable and that their effort is paying off. Players get feedback that indicates whether they are on the right road for success later on and at the end of the game. When players lose to a boss, perhaps multiple times, they get feedback about the sort of progress they are making so that at least they know if and how they are moving in the right direction towards success. [19] has argued that such pleasant frustration is an optimal state for learning things like science.

6. **Games are built around the cycle of expertise:** Good games create and support what has been called in the Learning Sciences the "cycle

of expertise" [22], with repeated cycles of extended practice, tests of mastery of that practice, then a new challenge that leads new practice and new mastery. This is, in fact, part of what constitutes good pacing in a game.

7. **"Deep" and "Fair":** These are terms of art in the gaming community. A game is "fair" when it is challenging, but set up in a way that leads to success and does not design in features that virtually ensure failure over which the player has little or no control. A game is "deep" when game play elements (e.g., a fighting system in a turn-taking game) that initially seem simple, and, thus, easy to learn and use, become more and more complex the more one comes to master and understand them. Such terms, it would seem, would make good terms of art in the Learning Sciences, as well.

These are all basic features of the way many games are designed. They also appear to be important features for effective learning. Thus, they raise the question as to whether the sorts of features we discussed earlier—the ones less connected to games as games—are rendered more effective when in the presence of these more directly game-like features.

References

1. Shaffer, D. W., K. Squire, R. Halverson, and J. P. Gee. Video Games and the Future of Learning. Phi Delta Kappan, 87 (2006):104–111.
2. Gee, J. P. *What Video Games Have to Teach us about Learning and Literacy.* New York, Palgrave/Macmillan, 2003.
3. Gee, J. P. *Why Video Games Are Good For Your Soul: Pleasure And Learning.* Melbourne, Common Ground, 2005.
4. Bransford, J., A. L. Brown, and R. R. Cocking. *How People Learn: Brain, Mind, Experience, and School: Expanded Edition.* Washington, DC, National Academy Press, 2000.
5. Ochs, E., P. Gonzales, and S. Jacoby. "When I come down I'm in the domain state." In E. Ochs, E. Schegloff, and S. A. Thompson (eds.), *Interaction and Grammar.* Cambridge, Cambridge University Press, 1996, pp. 328–369.
6. Barsalou, L. W. "Language Comprehension: Archival Memory or Preparation for Situated Action." *Discourse Processes* 28 (1999a): 61–80.
7. Hawkins, J. (with S. Blakeslee). *Intelligence: How a New Understanding of the Brain Will Lead to the Creation of Truly Intelligent Machines.* New York, Times Books, 2004.
8. Barsalou, L. W. "Perceptual Symbol Systems." *Behavioral and Brain Sciences* 22 (1999b): 577–660.
9. Clark, A. *Being there: Putting brain, body, and world together again.* Cambridge, MA, MIT Press, 1997.
10. Glenberg, A. M., and D. A. Robertson. "Indexical understanding of instructions." *Discourse Processes* 28 (1999): 1–26.

11. Gardner, H. *The Unschooled Mind: How Children Think and How Schools Should Teach.* New York, Basic Books, 1991.
12. Brown, J. S., A. Collins, and P. Duguid. *Situated Cognition and The Culture Of Learning. Educational Researcher* 18 (1989): 32–42.
13. Shaffer, D. W. "Pedagogical Praxis: The Professions as Models for Post-Industrial Education." *Teachers College Record* 10 (2004): 1401–1421.
14. Shaffer, D. W. Epistemic games. *Innovate* 1.6 2005. http://www.innovateonline.info/index.php?view=article&id=81 (Last accessed July 14, 2005).
15. Beck, U. *World Risk Society.* Oxford, Blackwell, 1999.
16. Gee, J. P. *Situated Language and Learning: A Critique of Traditional Schooling.* London, Routledge, 2004.
17. Gee, J. P., G. Hull, and C. Lankshear. *The New Work Order: Behind the Language of the New Capitalism.* Boulder, CO, Westview, 1996.
18. Tomasello, M. *The Cultural Origins of Human Cognition.* Cambridge, MA, Harvard University Press, 1999.
19. diSessa, A. A. *Changing Minds: Computers, Learning, and Literacy.* Cambridge, MA, MIT Press, 2000.
20. Elman, J. Distributed Representations, Simple Recurrent Networks and Grammatical Structure. *Machine Learning* 7 (1991a): 195–225.
21. Elman, J. Incremental learning, or the importance of starting small. *Technical Report 9101*, Center for Research in Language, University of California at San Diego, 1991b.
22. Bereiter, C., and M. Scardamalia. *Surpassing Ourselves: An Inquiry into the Nature and Implications of Expertise.* Chicago, Open Court, 1993.
23. Clark, A. *Microcognition: Philosophy, Cognitive Science, and Parallel Distributed Processing.* Cambridge, MA, MIT Press, 1989.
24. Gee, J. P. *The Social Mind: Language, Ideology, And Social Practice.* New York, Bergin & Garvey, 1992.
25. Gibson, J. J. *The Ecological Approach to Visual Perception.* Boston, Houghton Mifflin, 1979.
26. Glenberg, A. M. "What is memory for?" *Behavioral and Brain Sciences* 20 (1997): 1–55.
27. Halverson, R. (September, 2005). What Can K-12 School Leaders Learn from Video Games and Gaming? *Innovate* 1.6 http://www.innovateonline.info/index.php?view=article&id=81. (Last accessed July 14, 2006).
28. Newell, A., and H. A. Simon. *Human Problem Solving.* Englewood Cliffs, NJ, Prentice-Hall, Inc., 1972.
29. Steinkuehler, C. A. "Massively Multiplayer Online Videogaming as Participation in a Discourse." *Mind, Culture, & Activity* 13 (2006): 38–52.
30. Steinkuehler, C. A. "Cognition and Learning in Massively Multiplayer Online Games: A Critical Approach." Unpublished Doctoral Dissertation, University of Wisconsin-Madison. 2005.
31. Squire, K. D. "Changing the Game: What Happens When Videogames Enter the Classroom?" *Innovate* 1.6 http://www.innovateonline.info/index.php?view=article&id=81, 2005. (Last accessed July 14, 2006).
32. Squire, K., and H. Jenkins. "Harnessing the Power of Games in Education." *Insight* 3(1) (2004): 5–33.

Contributors

JANET H. MURRAY is an internationally recognized interactive designer, the director of Georgia Tech's Masters Degree Program in Information Design and Technology and PhD in Digital Media, and a member of Georgia Tech's interdisciplinary GVU Center. She is the author of *Hamlet on the Holodeck: The Future of Narrative in Cyberspace* (Free Press, 1997; MIT Press 1998), which has been translated into 5 languages and is widely used as a roadmap to the coming broadband art, information, and entertainment environments. She is currently working on a textbook for MIT Press, *Inventing the Medium: A Principled Approach to Interactive Design,* and on a digital edition of the Warner Brothers classic, *Casablanca,* funded by NEH and in collaboration with the American Film Institute. In addition, she directs an eTV Prototyping Group, which has worked on interactive television applications for PBS, ABC, and other networks. She is also a member of Georgia Tech's Experimental Game Lab.

JOSÉ P. ZAGAL has an MSc in engineering sciences and a BS in industrial engineering from Pontificia Universidad Catolica de Chile. His doctoral research, with Dr. Amy Bruckman, deals with using online interactive environments for computer-supported collaborative learning. He is a member of the Electronic Learning Communities Lab (www.cc.gatech.edu/elc) and the Experimental Game Lab (egl.gatech.edu) at Georgia Institute of Technology. His research interests include video game theory, serious games, and online communities.

CLARA FERNÁNDEZ-VARA is a PhD candidate in Digital Media at the Georgia Institute of Technology. She is a researcher in the Experimental Game Lab, where she is part of the Game Ontology Project. Her research mainly focuses on the development of videogame theory in order to apply it to

videogame analysis, criticism and design. Her interests are included within the framework of Media Studies, with special attention to cross-media artifacts, from the standpoint of textual analysis and performance.

MICHAEL MATEAS explores AI-based art and entertainment, forging a new research discipline called Expressive AI. He is currently a faculty member in the department of computer science at UC Santa Cruz. While at Georgia Tech, Michael was the founder of the Experimental Game Lab, whose mission is to push the technological and cultural frontiers of computer-based games. With Andrew Stern, Michael created *Façade,* an interactive drama that uses AI techniques to combine rich autonomous characters with interactive plot control to create the world's first fully-produced, real-time, interactive story; *Façade* is available for free download at www.interactivestory.net.

NOLAN LICHTI received his BA in Computer Science from Goshen College and an MS in Information Design and Technology from Georgia Tech. He currently works as a software engineer developing insurance software for Liberty Mutual in Indianapolis, IN, which is about as exciting as it sounds. He still finds time to design and develop games but not enough time to finish them.

BRIAN HOCHHALTER is an independent researcher and alumnus of the Experimental Game Lab and Information Design and Technology Masters program at Georgia Tech. His work at EGL includes contributions to the Game Design Theory project and Triad, a game of short love stories. Brian currently works as an information architect with the National Center for Chronic Disease Prevention and Health Promotion as part of the CDC Information Technology Support Contract.

LAURA ERMI (MPsych), currently a psychologist working in the field of mental health, was from 1999 to 2006 a researcher at the Hypermedia Laboratory, University of Tampere (Finland). Her research interests have focused on user experiences in digital environments. In the field of game studies she has conducted research on players' experiences with digital games, including the gameplay practices of children, and gameplay experience evaluation of mobile, pervasive, and lottery games.

FRANS MÄYRÄ, PhD, is a Research Director at the Hypermedia Laboratory, University of Tampere. He has studied the relationship of culture and technology from the early nineties, particularly advocating academic study of games and other forms of popular media culture. He has specialised in the conflicting and heterogeneous elements in culture and published widely on topics that range from role-playing games to science fiction, fantasy and

demonic tradition in cultural history. Currently he is heading or otherwise actively engaged with several research and publication projects and is past President of the International Digital Games Research Association (DiGRA).

RENATA GOMES is a PhD student at the Department of Communications and Semiotics of the Catholic University of São Paulo (PUC/SP), Brazil, researching the semiotic aspects of autonomous videogame characters. She is a member of the Semiotic Research Group on the Language of Videogames at the Catholic University of São Paulo, leading a team to put together a database of all game-related research developed in Brazil.

ULRIKE SPIERLING is a professor in Media Design at the University of Applied Sciences (FH) in Erfurt, Germany. Previously, she was the head of the Research Department of Digital Storytelling at the Computer Graphics Center (ZGDV e.V.) in Darmstadt, where she developed a research agenda for interdisciplinary approaches to the design of technology for interactive storytelling and conversational interfaces. Her current research includes the development of authoring concepts, models and tools for non-programmers employing conversational agents for interactive digital storytelling and the design of knowledge media.

IAN BOGOST is an academic videogame researcher, game designer, and educational publisher. As Assistant Professor of Literature Communication and Culture at Georgia Institute of Technology, he teaches and researches digital media. He is the author of *Unit Operations: An Approach to Videogame Criticism* (MIT Press), *Persuasive Games: The Expressive Power of Videogames* (MIT Press), and co-editor (with Matteo Bittanti) of *Ludologica Retro: Vintage Arcade Games 1972–1984* (Costa & Nolan). Ian is also the founder of two companies, Persuasive Games, a game studio that designs, builds, and distributes electronic games for persuasion, instruction and activism, and Open Texture, a publisher of cross-media education and enrichment materials for families.

PATRICK CROGAN teaches film and media at the University of Adelaide. He has published work on film, animation and critical theories of technology as well as computer games. With more than 20 years of martial arts study behind him he has researched pain, performance and conflict in practical as well as theoretical modes in preparation for the text in this volume.

HOLIN LIN is a professor of the Department of Sociology at National Taiwan University. She received her PhD in sociology from the University of California at Davis in 1995. Her major research interests are computer-mediated communication, technology and society, and gender studies. She has written

on the social aspects of information technology, including social movements on the Internet, the digital divide, and new media ethics. She participated in a 3-year interdisciplinary project on Information Technology and Social Change sponsored by the National Science Council, Taiwan.

CHUEN-TSAI SUN received his BS in electrical engineering (1979), MA in history (1984) from National Taiwan University, PhD in computer science from the University of California at Berkeley in 1992. From 1991 to 1992 he was with the Lawrence Livermore National Laboratory, California, where he participated in research projects on fuzzy neural networks. Since 1992 he has been with National Chiao Tung University, Taiwan, where he is now a professor in the department of computer science and the director of the university library. He currently researches and teaches in creative evolutionary systems, digital learning, and computer simulation in social studies.

SETH GIDDINGS teaches in the School of Cultural Studies at the University of the West of England. He researches relationships between technology and culture, most recently video games and video game play as everyday technoculture. This research takes both written and moving image form. He has written on popular film, animation, media art, and new media and also teaches media production, with particular interests in the theory and practice of interactive media and the digital moving image. He is a co-author of *New Media: A Critical Introduction* (Lister et al., 2003, London: Routledge).

KENJI ITO is an historian of cultural and social aspects of science and technology in 20th century and contemporary Japan. He received his PhD degree from Harvard University in 2002 for his dissertation on the history of science in Japan. Topics of his publications include: Science and education; science, technology, gender; cultural history of robotics, popular perception of science and technology; science, technology and media; and social and cultural aspects of computer games. He has worked at the University of Tokyo and conducts research on Japanese role-playing games and amateur designers and is currently a co-organizer of the Digital Games Research Association (DiGRA) meeting in Tokyo, Japan.

JOHN A. L. BANKS recently completed a PhD ("Participatory Culture and Enjoyment in the Video Games Industry: Reconfiguring the Player–Developer Relationship") at the University of Queensland, School of English, Media Studies and Art History. He is currently a Research Associate at the Creative Industries Research Application Centre (CIRAC), Queensland University of Technology www.creativeindustries.qut.com/research/cirac/. John also works with Auran (a PC games development company located in Brisbane, Australia) as Online Communications Director. He is also a

researcher at the Australasian CRC for Interaction Design (ACID).

STEPHEN N. GRIFFIN is a Design Director at Cartoon Network and an adjunct professor in the Game Art and Design program at the Art Institute of Atlanta. He holds an MFA in Design and Technology from Parsons School of Design and has designed as well as programmed dozens of games for clients including Cartoon Network, Turner Classic Movies, Lego, Hasbro, Nickelodeon, VH1 and others. His mission is to find ways we can actually play while playing video games.

WILLIAM HUBER is a PhD student in the Art and Media History/ Theory/Criticism program at the University of California, San Diego. His primary research interest is the study of new media, including the critical and interpretive study of videogames, and temporality, subjectivity and agency in virtual worlds. Other topics of particular interest currently include contemporary Japanese visual culture, 19th and 20th century Japanese aesthetics, genre, and the development of new, interdisciplinary models of research for digital and other media. He is also co-editor of the videogame theory group blog, Ludonauts.com.

DEBRA POLSON has lectured in interaction design at Queensland University of Technology, has worked as an interface designer on interactive children's games, and continues to design location-based games funded by Australasian CRC for Interaction Design (ACID), Australian Center for The Moving Image (ACMI), Federation Square Victoria, and both the Brisbane and Melbourne City Councils. She researches immersive forms of game play that blur the edges between digital and physical realms, and focuses on community interactions that emerge from these experiences, designed always to reveal potentials for participants to creatively employ everyday devices to intervene in telecommunications infrastructures and actively re-imagine themselves as cultural participants in their everyday environments.

MARCOS CACERES currently works as a researcher for the Australasian CRC for Interaction Design (ACID) collaboratively designing, amongst other things, a technical infrastructure for a location-based game. More recently he worked as lead system designer on the award-winning Intimate Transactions project with the Transmute Collective, which received an Honourable Mention at Prix Ars Electronica in 2005. His main research interests lie in the ontology of new media works. Previously, Marcos taught interaction design and web development at the Department of Communication Design, Queensland University of Technology, Brisbane, Australia.

PETER EDELMANN began studying virtual worlds in the mid-1990s when he discovered text-based MUDs. Since that time, although he has participated

in a number of virtual worlds, he still managed to complete degrees in both Common and Civil Law at McGill University. He is in the final stages of completing a doctorate in the Interdisciplinary Studies programme at the University of British Columbia, planning to defend his dissertation on virtual worlds in early 2006. IRL, Peter practices criminal and immigration law in Vancouver, British Columbia. Please feel free to contact him at *peter@lexludi.ca*.

RON WAKKARY is Associate Professor in the School of Interactive Arts and Technology at Simon Fraser University in British Columbia. His primary research interests lie in design of interactive systems in the area of ubiquitous computing including responsive environments, personal technologies and tangible user interfaces, and the study of interaction design-related methods and practice. He is currently leading the Am-I-able Network for Responsive and Mobile Environments, a research network funded by Canadian Heritage, and researching the concept of everyday design, funded by the Social Sciences and Humanities Research Council.

MAREK HATALA is Associate Professor at the School of Interactive Arts and Technology at Simon Fraser University. Dr. Hatala received his MSc in Computer Science and PhD in Cybernetics and Artificial Intelligence from the Technical University of Kosice. His primary interests lie in areas of knowledge representation, ontologies and semantic web, user modeling, intelligent information retrieval, and eLearning. His current research looks at how semantic technologies can be applied to achieve interoperability in highly distributed and heterogeneous environments, what are the social and technical aspects of building distributed trust infrastructures, and what role user and user group modeling can play in interactive and ubiquitous environments.

ROBB LOVELL is a computer scientist, dancer/choreographer, and installation artist. He is currently completing a PhD at Simon Fraser University where he is continuing research into live media spaces. He has a Master of Science in Computer Science. Robb is an active dancer/choreographer and has performed with Semaphor DanceWorks Inc., Dance Arizona Repertory Theater, RSVP Dance, and as guest artist with Desert Dance Theater and a ludwig co. As an installation and visual artist his best-known work is Eidea, an artificial life world that interacts with weather and people to create a visual and auditory score.

MILENA DROUMEVA is currently completing a Masters in Interactive Arts and Technologies at Simon Fraser University, and beginning doctoral studies in Acoustic Communication and Acoustic Ecology. Her research centers on soundscape design methodologies for responsive environments, as well as

adaptation of design methodologies for auditory perception research. Milena has been studying sound from a variety of interdisciplinary perspectives, and aside from working in interactive and responsive auditory display design, she is an accomplished electroacoustic composer.

ALISSA ANTLE is a design researcher and interactive media producer whose research explores the design and evaluation of interactive technologies for children and youth. Alissa has led the design, development and production of interactive media products for companies including the Canadian Broadcasting Corporation, Brainium Technologies, Multiactive Education, Science World and her own start-up GoBe Media. Alissa received a PhD from the University of British Columbia for her work designing spatial interactive media. She is currently an assistant professor in the School of Interactive Arts and Technology at Simon Fraser University, Canada.

DALE EVERNDEN, graduate student, interaction designer, and research assistant, is studying to complete a Masters of Applied Science at Simon Fraser University. Current research interests lie at the intersection between design ethnography and Interaction design. Recent research work includes contributions to the Socio-Echo project (funded by Canadian Heritage Foundation), and a three-year SSHRC funded project on complexity and design. Previous research includes: *Project Echo*—an audio based augmented reality guide for museum spaces; and *Regossip,* a network game designed for PCs and mobile devices, that employed a text based interaction model to facilitate gossip exchange, collaborative authorship, and the building of social status. Dale has also worked as a User Experience Designer for the Corel Corporation.

JIM BIZZOCCHI is an Assistant Professor in the School of Interactive Art and Technology at Simon Fraser University in British Columbia. He teaches courses in Interactive Narrative, Game Design, and Video Production. His research interests include the emergent aesthetics of large-scale high-resolution video display, the design of interactive narrative, and the development of educational games and simulations. He is a practicing artist—as part of his video research he is making a series of experimental video productions in conjunction with the Banff New Media Institute. His research work has been selected for presentation and publication at numerous academic conferences and journals.

SIMON NIEDENTHAL is Associate Professor of Interaction Design at Malmö University in the School of Arts and Communication and serves as department chairperson for the undergraduate Interaction Design program. His articles on light, perception, virtual space and transdisciplinary discourses

have been published in scholarly periodicals including *Leonardo, Digital Creativity, Afterimage* and the *Journal of Architectural Education*. He is currently project leader of a Knowledge Foundation-sponsored project on game aesthetics and emotion, "Shadowplay: Simulated illumination in game worlds."

LEIF GRUENWOLDT has a passion for game development that began in high school with a website named 3D Palette that dedicated itself to game artists. His interest in programming, however, led him towards studying Computer Science at the University of Western Ontario. In his final year at Western, Leif met Professor Michael Katchabaw, who instructed a game development course and supervised Leif's undergraduate thesis project on game development. On graduation in 2005, Leif worked for a short time in the games industry before accepting a position with the Department of National Defense as a simulation software developer.

MICHAEL KATCHABAW is an Assistant Professor in the Department of Computer Science at the University of Western Ontario. His life-long interest in game development led him to introduce Western's first course in game development in the 2002–2003 academic year, which is now driving the adoption of a broader game program at Western. Dr. Katchabaw is a co-founder of Western's Digital Recreation, Entertainment, Art, and Media (DREAM) research group and has many on-going research projects in game design, game development, and various game technologies. He is also very active in the game studies and research communities.

STEPHEN DANTON has long been interested in game development. A graduate of the Department of Computer Science at the University of Western Ontario, Stephen was one of the first students in Katchabaw's game development course. His interest in games led to the formation of Horseplay Studios and the design of the game Neomancer. Stephen later spear-headed an initiative that brought together art and design teams at Seneca College and software development teams at Western to begin development on Neomancer. Stephen is currently lead designer on Neomancer, which is part way through its 2–3 year development cycle.

MARY FLANAGAN is an artist, designer, and writer, and her work reflects an integration of all these interests as she investigates everyday technologies through critical writing, artwork, and activist design projects. Flanagan's work has been exhibited internationally at museums, festivals, and galleries, including: the Guggenheim, The Whitney Museum of American Art, SIGGRAPH, The Banff Centre, The Moving Image Centre, New Zealand, and venues in Brazil, France, UK, Canada, Taiwan, New Zealand, and Australia.

Flanagan is known as a noted computer games scholar and faculty member in the Department of Film and Media Studies at Hunter College, NYC. Her research group and lab at Hunter is called TiltFactor http://www.tiltfactor.org and she has been awarded four National Science Foundation awards for her collaborative research among other grants and honors. http://www.maryflanagan.com.

DANIEL C. HOWE is a digital artist, researcher & doctoral candidate at NYU's Media Research Lab. His interests include generative systems for artistic practice (specifically for natural language); and the social/political aspects of technology design. Current projects include the ALTK, a toolkit for affective language generation; TrackMeNot, a software tool designed to protect the privacy of web-searchers; and Values-In-Design, a developing methodology for integrating social/political considerations in technical systems design. In addition to a background in creative writing and fine arts, Daniel has master's degrees in Computer Science (U. Washington) and Interactive Media (NYU/ITP), as well as 10 years experience as a programmer, software architect & educator. He is a regularly exhibiting digital artist with recent work featured in Leonardo, E-Fest06, ASCI05, Web3dArt, Experimental Typography, Thailand New Media Arts Festival, PixxelPoint, Artbots, Ars Electronica, & Terra Acoustica. He is the 2005–06 recipient of the Brown Fellowship for Electronic Writing. http://mrl.nyu.edu/~dhowe/.

HELEN NISSENBAUM, Professor, Department of Culture and Communication and Faculty Fellow, Information Law Institute, New York University, conducts research in the social, ethical, and political dimensions of information and communications technology. Her scholarly publications span the topics of privacy, property rights, electronic publication, accountability, the use of computers in education, and values in the design of computer and information systems. Her research on values in design, security, and privacy has been supported through grants from the National Science Foundation and the Ford Foundation. Nissenbaum's books include *Emotion and Focus, Computers, Ethics and Social Values* (coedited with D.J. Johnson), and *Academy and the Internet* (co-edited with Monroe Prince) and she is a cofounding editor of the journal, *Ethics and Information Technology.*

DARRYL CHARLES is a lecturer of Computing at the University of Ulster, Northern Ireland where he specialises in digital games teaching and research and leads the Digital Games Research Group, http://games.infc.ulst.ac.uk/. He obtained his PhD ("Unsupervised Artificial Neural Networks for the Identification of Multiple Causes in Data") in 1999, and since then he has published on game A.I. and artificial neural networks. His current research

focus is on player modelling and adaptive game technology for both entertainment and edutainment games.

APHRA KERR lectures on production and consumption aspects of media at the National University of Ireland, Maynooth. She wrote *The Business and Culture of Digital Games* (Sage Publications), runs a local website www.gamedevelopers.ie and is a member of the Irish IGDA chapter committee. Her personal web site is www.arts.ulster.ac.uk/media/kerr/

MICHAEL MCNEILL is Senior Lecturer in Computing Science, University of Ulster. Previously he lectured at the University of Sussex, where he graduated with a DPhil in Computer Graphics in 1994. He obtained a BSc (Hons) in Mathematics from the University of Bath in 1985. In addition to digital games, his interests include 3D rendering algorithms and architectures and medical applications of virtual reality. He has directed several research projects in computer graphics and the application of novel computing techniques in industry. He has over 70 publications in computer graphics and related fields.

MOIRA MCALISTER joined the University of Ulster as a lecturer in Computer Science in 2003. She is responsible for modules on computer networks, e-Learning and postgraduate projects. Her current research focuses on using digital games to build interactive learning environments. She is a founding member of the Games Research Group, has worked in Germany for Trend Micro as Global Training Services Manager, and was a contractor at the Business Systems section of Philips in The Netherlands. From 1992 to 2000 she was a senior lecturer, University of Sunderland.

MICHAELA BLACK joined the University of Ulster, Coleraine, as a Lecturer in 1999. Her DPhil was in the area of data mining and machine learning, and there is a patent pending on some of the algorithms that she developed (1996–99). Michaela has taught in a variety of areas: intelligence systems, knowledge base systems, Prolog and Java. Her research interests are in artificial intelligence, machine learning and data mining, and she combines that work with other specialised areas in the Games industry, Bioinformatics and Telecommunications.

KARL STRINGER is a Lecturer in Computing Science, University of Ulster. He holds a BSc in biology from the University of Ulster, a PGCE from the University of Manchester, an MSc in computer science from Queen's University, Belfast, and a PhD in physics from the University of Ulster. His research spans computing, physics and economics. His recent public-sector work is published in *Education Economics, IMA Journal of Management*

Mathematics and the *Irish Accounting Review*. He is also involved with the Centre for Software Process Technologies and is a member of the Institute of Biology and the British Computer Society.

JULIAN KÜCKLICH is a digital games researcher, and a PhD candidate in the Centre for Media Research, University of Ulster. His research interests include all areas of gaming culture, especially computer game modding, cheats and products of fan culture. His MA thesis is on computer games and literary theory, and he has published several articles on this. He's contributed to Medienobservationen *www.medienobservationen.lmu.de*, GameResearch-*www.gameresearch.com*, Philologie im Netz *www.phin.de* and Dichtung-Digital *www.dichtung-digital.de*.

ADRIAN MOORE is a lecturer in Computing at the University of Ulster. His research and teaching interests are in multimedia systems, computer graphics and Web applications development. He has developed a range of courses in Web development topics and provided consultancy in that area to local industry. His book, *Multimedia Web Programming*, was published in 2005 by Palgrave-MacMillan.

ANDREW STERN is a designer, writer and engineer of personality-rich, AI-based interactive characters and stories. With Michael Mateas he recently completed the interactive drama *Façade*, a 5-year art/research project; previously, Andrew was a lead designer and software engineer at PF.Magic, developing Virtual Babyz, Dogz, and Catz, which sold over 2 million units worldwide. Press for these projects includes *The New York Times, Newsweek, Wired* and *AI Magazine*. Andrew has presented and exhibited work at the Game Developers Conference, Independent Games Festival, SIGGRAPH, ISEA, Digital Arts and Culture, DiGRA, TIDSE, AAAI symposia, Autonomous Agents, and Intelligent User Interfaces.

MIKE CARBONARO is Associate Professor in the Department of Educational Psychology, University of Alberta. His interests focus on the application of computer technology in the area of teaching and learning as well as on relationships between computational cognitive modeling and human learning.

MARIA CUTUMISU (MSc) is pursuing a PhD degree at the University of Alberta, Department of Computing Science. Her interests range from virtual machines to generative design patterns and scripting languages for agent behaviors in interactive stories.

MATTHEW MCNAUGHTON (MSc) is now a PhD student in the Robotics program at Carnegie Mellon. His interests are in robotics, artificial intelligence, and software systems.

CURTIS ONUCZKO (BSc) is an MSc student in the Department of Computing Science at the University of Alberta. He is currently doing research on the topic of generative design patterns in computer role playing games.

DUANE SZAFRON is a Professor in the Department of Computing Science at the University of Alberta. His interests focus on using programming languages, tools and environments to integrate artificial intelligence in computer games.

THOMAS ROY is an undergraduate student in Computing Science at the University of Alberta. His interests focus on graphics in 3D computer games.

JONATHAN SCHAEFFER is a Professor in the Department of Computing Science at the University of Alberta. His research is in artificial intelligence, using games as an experimental test-bed.

STEPHANIE GILLIS (BSc, BEd) is a teacher at Cardinal Leger School in Edmonton, Alberta, Canada. Her interests include integrating technology into the curriculum and using technology to reach a broader student audience.

RIKKE MAGNUSSEN is a PhD candidate at the Centre for Learning Games at Learning Lab Denmark in Copenhagen. Her thesis research concerns the social learning dynamics in game-based science learning spaces. She has worked as a game researcher and developer for several years and has had an active part in establishing the Centre for Learning Games where researchers and game developers design and study new types of game-based learning spaces. She has published papers on social learning in game-based learning environments and player transformation of educational games and has been co-developer on several science games.

DIANE CARR is a Research Fellow at The Institute of Education, University of London. Her current research (2004–2007) into 'Computer games, motivation and gender' is supported by the Eduserv Foundation, while her previous research has involved the textual analysis of RPGs and action adventure games. Diane plays and has published theory on a variety of games including *Tomb Raider, Baldur's Gate, The Thing, Silent Hill, Civ III, Sim City* and *Enter the Matrix*. Diane recently co-authored a book for media studies students titled *Computer Games; Text, Narrative and Play* (Polity, 2006) and she hopes to complete her doctorate on meaning and representation in figurative computer games during 2006.

JAMES PAUL GEE is the Tashia Morgridge Professor of Reading at the University of Wisconsin-Madison. He received his PhD in linguistics in 1975

from Stanford University and has published widely in linguistics and education. His most recent books both deal with video games and learning. *What Video Games Have to Teach Us About Learning and Literacy* (2003) offers 36 reasons why good video games produce better learning conditions than many of today's schools. *Situated Language and Learning* (2004) places video games within an overall theory of learning and literacy and shows how they can help us to better understand deep human learning and lead us in thinking about the reform of schools. His new book, *Why Video Games Are Good for Your Soul*, shows how good video games marry pleasure and learning and have the capacity to empower people.

Colin Lankshear, Michele Knobel,
Chris Bigum, & Michael Peters
*General Editor*s

New literacies and new knowledges are being invented "in the streets" as people from all walks of life wrestle with new technologies, shifting values, changing institutions, and new structures of personality and temperament emerging in a global informational age. These new literacies and ways of knowing remain absent from classrooms. Many education administrators, teachers, teacher educators, and academics seem largely unaware of them. Others actively oppose them. Yet, they increasingly shape the engagements and worlds of young people in societies like our own. The *New Literacies and Digital Epistemologies* series will explore this terrain with a view to informing educational theory and practice in constructively critical ways.

For further information about the series and submitting manuscripts, please contact:

Michele Knobel & Colin Lankshear
Montclair State University
Dept. of Education and Human Services
3173 University Hall
Montclair, NJ 07043
michele@coatepec.net

To order other books in this series, please contact our Customer Service Department at:

(800) 770-LANG (within the U.S.)
(212) 647-7706 (outside the U.S.)
(212) 647-7707 FAX

Or browse online by series at:

www.peterlang.com